Re-Ordering the Universe

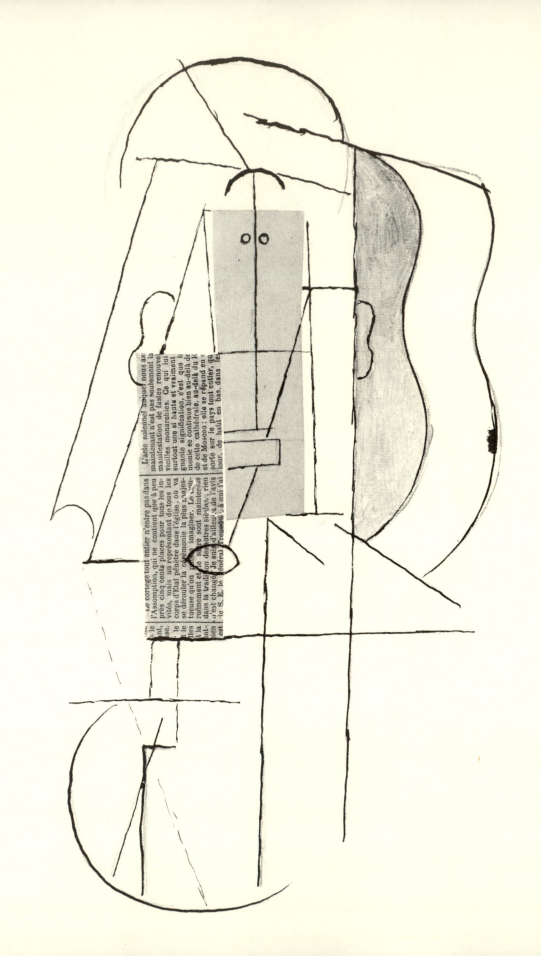

PATRICIA LEIGHTEN

Re-Ordering the Universe

Picasso and Anarchism, 1897-1914

PRINCETON UNIVERSITY PRESS

PRINCETON, NEW JERSEY

This book has been composed in Linotron Baskerville type

Clothbound editions of Princeton University Press books are printed on acid-free paper, and binding materials are chosen for strength and durability. Paperbacks, although satisfactory for personal collections, are not usually suitable for library rebinding

Printed in the United States of America by Princeton University Press, Princeton, New Jersey

Permission to quote from the following sources is gratefully acknowledged:

Pablo Picasso, Letters to Gertrude Stein. The Gertrude Stein Collection in the Collection of American Literature, The Beinecke Rare Book and Manuscript Library, Yale University.

Blaise Cendrars, *Selected Writings*. Copyright 1962, 1966 by Walter Albert. Used by permission of New Directions Publishing Corp.

Picture reproduction rights reserved by s.p.a.d.e.m. and a.d.a.g.p.

Earlier versions of parts of this book have appeared as follows: "Picasso's Collages and the Threat of War, 1912–13," *Art Bulletin*, December 1985; "Dreams and Lies of Picasso," *Arts*, October 1987; and "*La Propagande par le rire*: Satire and Subversion in Apollinaire, Jarry and Picasso's Collages," *Gazette des Beaux-Arts*, October 1988.

Library of Congress Cataloging-in-Publication Data
Leighten, Patricia Dee, 1946–
Re-ordering the universe: Picasso and anarchism, 1897–1914 by Patricia Leighten.
p. cm.
Bibliography: p.
Includes index.
ISBN 0-691-04059-1 (alk. paper)
1. Picasso, Pablo, 1881–1973—Criticism and interpretation. 2. Anarchism in art. I. Title.
N6853.P5L38 1989
709′.24—dc19 88-14065

To my parents
who deserve more than a dedication for the years
that led to this book

Contents

Illustrations

All works are by Picasso unless otherwise noted. Titles follow *Museu Picasso: Catàleg de pintura i dibuix*, Daix and Boudaille, and Daix and Rosselet, which have superseded Zervos for Picasso's work to 1916. Height precedes width for two-dimensional works, followed by depth for three-dimensional works. Code numbers are given for drawings in the Museu Picasso, Barcelona (MPB), and Musée Picasso, Paris (MP).

Color Plates

FOLLOWING PAGE 30

 I. *The Absinthe Drinker*, 1901. Oil on cardboard, 65.5 x 50.8 cm. Collection Mrs. Melville Hall, New York.

 II. *Self-Portrait*, Summer 1901. Oil on cardboard mounted on wood, 51.4 x 36.8 cm. From the collection of Mrs. John Hay Whitney, New York.

 III. *Nude on a Red Ground*, Summer-Autumn 1906. Oil on canvas, 81 x 54 cm. Musée de l'Orangerie, Paris, Collection Jean Walter-Paul Guillaume.

 IV. *The Harvesters*, Spring 1907. Oil on canvas, 65 x 81.3 cm. Collection Thyssen-Bornemisza, Lugano, Switzerland.

 V. *Mother and Child*, Summer 1907. Oil on canvas, 81 x 60 cm. Musée Picasso, Paris.

 VI. *Landscape with Two Figures*, Summer 1908. Oil on canvas, 58 x 72 cm. Musée Picasso, Paris.

 VII. *Guitar, Sheet-Music and Wineglass*, November 1912. Pasted papers, gouache, and charcoal on paper, 48 x 36.5 cm. Marion Koogler McNay Art Museum, San Antonio.

 VIII. *Bottle of Suze*, November 1912. Pasted papers, gouache, and charcoal on paper, 64.5 x 50 cm. Washington University Gallery of Art, St. Louis.

Black-and-White Illustrations

FOLLOWING PAGE 78

 1. *Portrait of an Old Man*, 1895. Oil on canvas, 58.5 x 42.8 cm. Museu Picasso, Barcelona (MPB 110.014).

 2. *Fisherman with Children*, 1896. Oil on wood, 10 x 15.7 cm. Museu Picasso, Barcelona (MPB 110.159).

 3. *Portrait of Pompeu Gener*, 1899–1900. Pen and wash on paper, 8.4 x 7.8 cm. Museu Picasso, Barcelona (MPB 110.240).

 4. Ramon Casas, *Garrote vil (Vile Garroting)*, 1894. Oil on canvas, 127 x 166.2 cm. Museo Español de Arte Contemporáneo, Madrid.

 5. *Caridad (Charity)*, c. 1899. Conté crayon on paper, 23.2 x 33.8 cm. Museu Picasso, Barcelona (MPB 110.783).

 6. *The Street Violinist*, c. 1899. Conté crayon and watercolor on paper, 23.6 x 33.6 cm. Museu Picasso, Barcelona (MPB 110.784).

Preface

THE COMBINATION of this book's two subjects, Pablo Picasso and anarchism, may at first seem startling, despite the frequent mention in Picasso biographies of the "wildness" of Barcelona at the turn of the century. The anarchist vision as a serious subject of debate and anarchism versus socialism as a live issue have passed out of view, with the odd result that socialism is now popularly conceived as the only revolutionary movement to have risen in the nineteenth century. That is not true, but it was the only one to survive the Great War. The anarchist ideas Picasso expressed in his work have been lost to us because of the disappearance of the anarchist movement itself. James Joll in his introduction to *The Anarchists* has observed:

> When a revolution succeeds, historians are concerned to trace its roots and unravel its origins and development, so that, very often, the whole chain of events leading to it over many decades is represented as an inevitable process, and each idea or episode is judged by the extent to which it helped or hindered the final result. On the other hand, the revolutions which failed are treated as blind alleys, and the men and ideas that inspired them are rarely studied for their own inherent interest.

My aim in this study is to illuminate a corner of history that has been obscured by subsequent events, one that significantly informed Picasso's intellectual development and his art.

This book is indebted to numerous people, but most of all to Jack J. Spector, whose warmth, generosity, and intelligence played an influential role in the development of the project. Joan M. Marter, too, helped with the book from the beginning, offering many fruitful suggestions and much timely encouragement. To my friends William I. Homer, Cleo McNelly Kearns, and George Kearns I offer profound thanks for their unflagging interest in discussing this subject and for their close reading of the manuscript at various stages. I am also deeply grateful to Robert Rosenblum and Linda Dalrymple Henderson for reading the manuscript and correcting some of its most glaring faults. Linda Nochlin and Edward Fry discussed many of this book's ideas with me and gave much appreciated encouragement. Robert Herbert has also offered timely appreciation of my work, and Josep Palau i Fabre kindly gave suggestions for research. My book is further indebted to the example of these scholars of modernism, with the additions of Roger Shattuck

and Meyer Schapiro, my teacher's teacher. I only wish I had been able to learn more of their art.

Every author needs to thank a crucial circle of friends, whose support is central to the completion of work. I have been especially lucky in my friends and colleagues, whose interest and plain goodwill have played a larger part than they could know. My students, too, have contributed ideas and enthusiasm that helped the book along. I have also been lucky in my editor at Princeton University Press, Eric Van Tassel, whose wit and patience have immensely eased the final phases of bringing forth this book, and in my copy editor, Janet Wilson. For their sensitivity and tolerance, my special gratitude goes to John Beldon Scott and Margaret Andersen. And to Steven Helmling, my husband, I offer the profoundest thanks for his help on every level of this project.

I would like to express my appreciation to the staffs of the libraries and archives where I worked, including, in Barcelona, the Museu Picasso, Museo de Arte Moderno, Arxiu Històric Municipal (Casa Ardiaca), and Arxiva Mas; and, in Paris, the Bibliothèque Nationale, Archives Nationale, Bibliothèque de l'Arsenal, Archives de la Préfecture de Police and Institut Français d'Histoire Sociale. My special gratitude for their help and suggestions goes to Sra. Rosa Maria Subirana of the Servei Projecció Internacional, Ajuntament de Barcelona, Sra. Magdalena Gual of the Museu Picasso, Sr. Juan Gaspar of the Sala Gaspar, and Mme. Hélène Strub of the Institut Français d'Histoire Sociale.

I would also like to express my gratitude to the University of Delaware for a General University Research Grant, which allowed me to travel to Barcelona and Paris in the summer of 1983, and to the Delaware Humanities Forum for a Research Fellowship in 1984–85, which provided support for the completion of part of the material of this book, published as an article in the *Art Bulletin* in December 1985.

I wish to thank the museums, galleries, and private collectors for granting permission to reproduce the paintings, drawings, collages, and sculpture in their collections. Photographs have been supplied by the owners or custodians of the works of art reproduced, except in the instances listed below. For supplying these photographs, I gratefully acknowledge the courtesy of: P. A. Ferrazzini, Geneva: 65; Vladimír Fyman: 56; Carmelo Guadagno: 16; Robert E. Mates: 19, 77; The Museum of Modern Art, New York: 84; Hubert Neumann: 87.

February 1988

Without poets, without artists, men would soon weary of nature's monotony. The sublime idea men have of the universe would collapse with dizzying speed. The order which we find in nature, and which is only an effect of art, would at once vanish. Everything would break up in chaos. There would be no seasons, no civilization, no thought, no humanity; even life would give way, and the impotent void would reign everywhere.

Poets and artists plot the characteristics of their epoch, and the future docilely falls in with their desires. . . .

The great revolution of the arts, which [Picasso] achieved almost unaided, was to make the world his new representation of it.

Enormous conflagration.

A new man, the world is his new representation. He enumerates the elements, the details, with a brutality which is also able to be gracious. Newborn, he orders the universe in accordance with his personal requirements, and so as to facilitate his relations with his fellows.
—Guillaume Apollinaire, *The Cubist Painters*

Re-Ordering the Universe

Introduction

In November 1912, Bulgaria, Serbia, and Montenegro had just gone to war against Turkey, launching the First Balkan War. Complex systems of open alliances and secret treaties on both sides threatened to draw France, England, Germany, Austria, and Russia into a general European conflagration, and hysteria broke loose on the front pages of newspapers throughout Europe. In Paris, alarmed citizens, who had been hearing French and German saber-rattling since the First Moroccan Crisis of 1905, read eyewitness accounts such as this of a battle between Bulgarians (them) and Turks (us) by a French journalist reporting from what would soon be the enemy side:

> Their forces were about three kilometers from our front lines, in the direction of Tchataldja, and a large party of their troops attempted, under cover of darkness, to enter the valley that separated them from us. However, the Turks had seen the movement in time. The sentries gave the alarm, and, a few moments later, the Ottoman infantry, very soon afoot, opened fire. Surprised to see their movement thwarted, the Bulgarians withdrew behind the hill they had just left. Their artillery appeared. It was the signal for a general attack.[1]

Journalists walking the battlefields also sent back horrifying and detailed firsthand reports of the cholera epidemic that hit the Turkish army, leaving thousands dead and dying on the path to the next engagement:

> Before long I saw the first corpse still grimacing with suffering and whose face was nearly black. Then I saw two, four, ten, twenty; then I saw a hundred corpses. They were stretched out there where they had fallen during the march of the left convoy, in the ditches or across the road, and the files of cars loaded with the almost dead were stretched out everywhere on the devastated route.
>
> How many cholera victims did I come upon like this? Two thousand? Three thousand? I don't dare give a precise figure. Over a distance of about twenty kilometers, I saw cadavers strewing the cursed route where a wind of death blows and I saw the dying march, ominous in the middle of troops indifferent and preparing themselves for combat.
>
> But I had seen nothing yet.[2]

In response to the threat of a larger war, the left wing immediately marshaled great numbers of demonstrators into the streets to listen to socialist, anarchist, and

pacifist speakers denounce the warmongering spirit of Europe and call on the working classes of all nations to refuse the mobilization orders that they saw threatening:

> At one o'clock, delegations arrived from every quarter of Paris and its suburbs, then until three-thirty the trams, buses and above all the subway, whose station "Pré-Saint-Gervais" is situated near the gate of the same name and the area of the "Butte du Chapeau Rouge," discharged thousands of pacifists, syndicalists and socialists, accompanied by their wives and children. They invaded not only the reserved area, but all the surrounding knolls. Also it is very difficult to estimate the crowd which, from three to four o'clock, circled on this immense space. . . . The militants speak of 100,000 people. Between this figure, perhaps exaggerated, and that of the police—20,000—there is room for an intermediary and somewhat more exact estimation of 40,000 or 50,000 demonstrators.[3]

Reports from the front were full of horror and gore. In addition to the vivid description of corpses on the roads and in battle, readers could follow the famine in Adrianople, under Turkish siege, and the march of the Serbian army through snow and ice to Monastir. Further, they could read the texts of the speeches to the crowd of 40,000 to 50,000 by pacifists, anarchists, and socialists against the "menace of a general European war," which these dispatches from the First Balkan War unambiguously represented to them.

Such accounts bring into focus a neglected aspect of a period known as la Belle Epoque—often supposed to have been obliviously frittering away the last hours before the First World War brought it sharply to a close—when everyone stopped in panic to contemplate a threatened and quite clearly foreseen end. These dispatches form a telling backdrop for a discussion of this period and its artists, who are usually presumed to have been engrossed in their formal experiments and deaf to the rumblings of war that finally shattered their world. Yet these reports on the events of the First Balkan War were assembled and juxtaposed not by this author, from some archival source, but by Pablo Picasso in his collage *Bottle of Suze*. This collage, made in November 1912 soon after the war broke out, represents a significant body of comparable works incorporating similar war, and antiwar, news.

How are we to make sense of this quantity of information that has been conveyed by, of all things, what is undeniably one of Picasso's more abstract works? Is it accidental, the product of Picasso's desire to use the "real-world" material of newsprint but without interest in its real-world content? Why then did he cut it so as to leave the columns of newsprint largely intact and wholly readable? How do we further make sense of the particular combination of subjects brought into the collage by these pieces of newsprint? War and antimilitarism were subjects dear to the hearts of the anarchists with whom Picasso is known to have sympathized in

his Barcelona years, but whom scholarship to date suggests he forgot after moving to Paris. How are we to respond to the inclusion of contemporary news in an image whose iconography evokes exclusively a Parisian café? A café is, among other things, a place where one goes to read newspapers (provided free by the establishment) and to talk. Does the newsprint in Picasso's collages function as a purely "textural" allusion, or a mere physical fact? Does it represent the newspaper but not the news?

These are some of the problems that seem to me to be posed by *Bottle of Suze*, which I "read" for the first time at the Picasso retrospective at the Museum of Modern Art in New York in 1980, and this book is my attempt to address questions they raised. As I proceeded with my research I was overwhelmed by the quantity of information bearing, often with astonishing directness, on Picasso's anarchist affiliations and loyalties in his pre-World War I career, affiliations that make particular sense of the juxtaposition of war news, accounts of the antimilitarist movement, and other subjects. A generation before Picasso, Sébastien Faure had defined anarchists as "individuals whose thought is inimical to Authority and who struggle, collectively or in isolation, against all disciplines and constraints, whether political, economic, intellectual or moral."[4] The anarchists' social critique and utopian vision of a harmonious future society especially appealed to avant-garde artists and writers at the end of the nineteenth century and were a highly visible part of the modernist movements in Barcelona and Paris, with applications in both the esthetic and political spheres.

Picasso was but one of scores of artists of the 1890s and early 1900s inspired by the larger libertarian movement, as it frequently meshed with the international Symbolist movement in art and literature at one end of its spectrum. Anarchist Symbolism insisted on an utter rejection of the past and its institutions of power, the artist's significant and heroic role in furthering "revolution," a highly sophisticated anti-intellectualism, and a complete surrender to spontaneity and intuitiveness. Such ideas helped form Picasso's view of himself as an artist in society, his ideas about spontaneity and inspiration, and about the virtues of "unsophisticated" primitive art, all of which made an impact on the development of his style and imagery. At the same time, accusatory themes of unemployment, prostitution, poverty, madness, and militarism in Picasso's art—not only in the "sentimental" Blue Period—recall the anarchists' sympathy with the *lumpenproletariat*, their antimilitarism, and their hatred of government and its role in creating what they saw as the intolerable social conditions of the day. We have heard many times that Picasso favored anarchism in his early years. But its importance for his work, and for his ambitions, even in Barcelona, has not been adequately recognized. Discussion of Picasso and his art has wrongly proceeded on the assumption that politics simply disappeared from his consciousness after the move from Barcelona to Paris in 1904.

5

An awareness of Picasso's political consciousness can profitably guide "readings" of his subsequent works that enrich our understanding of his complex art. The absence of politics from postwar discussions of his prewar work now seems remarkable in and of itself, though numerous reasons for such postwar "amnesia" regarding the engagé optimism of the modernist movement—on the part of Picasso as well as his chroniclers—are easily found. The disillusioning failure of the Left to prevent the catastrophe of the Great War discredited what now seemed a naive faith in internationalism and the fraternal unity of the laboring classes. Such idealistic concepts were equally contrary to the patriotism and swing to the right of the reconstruction period in France; and, on the left, the Russian Revolution seemed definitively to prove Karl Marx right and Mikhail Bakunin wrong.[5]

As forms of pure abstraction developed in the subsequent decades, critics assigned Cubism a crucial role as the seedbed of this new formalism, the birthplace of that disinterested play of line, color, and form that increasingly seemed most characteristically and uniquely "modern" in twentieth-century art. But Cubism could play this role only by shedding its prewar identity, and the politicized nature of the larger goals of much avant-garde art was bowdlerized by its surviving participants, Picasso included.

An investigation of the art, literature, contemporary political rhetoric, art criticism, memoirs, and documentary material of the *avant-guerre* discloses that Picasso's early encounter with anarchism in the artistic circles of Barcelona and Paris had a profound impact on his development as an artist and is an intrinsic part of the social and esthetic background necessary to an understanding of his work prior to World War I. It is not my goal to attempt to prove that Picasso was a doctrinaire anarchist with a program hidden in his work or that he was an avid consumer of tracts on political theory. Possibly Picasso never read an original word of Bakunin or Peter Kropotkin; it can be neither proved nor disproved. But even this would not mean that he was unfamiliar with the ideas of the major anarchist theorists or untouched by the political passions of his day. We have been mistaken in attempting to grasp Picasso's work without considering the character and extent of the left-wing milieu in which he was immersed in his early maturity in Barcelona and later in Paris.

The material presented here shapes itself most logically along chronological lines. After a brief look at the anarchist movement, particularly in Spain, Chapter 1 treats Picasso's first immersion in the anarchist/Symbolist milieu in Barcelona and his work prior to moving to Paris. His earliest work in Barcelona shares themes and styles with his generation of socially concerned artists, especially the younger generation of *modernistes*, as they responded to a period of social upheaval unprecedented even in Barcelona's turbulent history. While this group of artists, most notably Isidre Nonell and Picasso, are important for their innovative use of color, formal values, and expressive line, significantly such innovations served the more

explosively radical content, which they purposely sought out in the poverty-stricken districts, recording the starving, oppressed population of factory workers and the unemployed. No body of art better served Kropotkin's call for artists to "show the people how hideous is their actual life, and place your hands on the causes of its ugliness,"[6] and no group of artists in this period personally risked more in parading—in exhibitions and numerous publications—the government's failures before the eyes of the public.

Chapter 2 deals with the artistic/political milieu Picasso encountered in Paris after 1904, with special attention to the careers and influence of Guillaume Apollinaire, André Salmon, and Alfred Jarry, while Chapter 3 considers Picasso's art in his early Paris period, from 1904 up to and including *Les Demoiselles d'Avignon* of 1907. At a moment of crisis in the political and artistic movement in Barcelona, Picasso left permanently for Paris, where he rapidly made his way into a bohemia that was remarkably similar. Staying in close touch with the Spanish colony, he also made the acquaintances of Jarry, Apollinaire, and Salmon, all of whom shared a youthful immersion in romanticized anarchism. Paris had a more flamboyantly radical artistic tradition, which encouraged Picasso in the direction of increasingly innovative styles even as his subsequent work continued to manifest, highly inventively, ideas and assumptions of artistic/anarchist circles in Barcelona and Paris. In Barcelona, Picasso had been drawn to "radical" subjects—workers, *chômeurs*, street fights, strikes, prostitutes, derelicts—treated in an aggressively and pointedly anti-academic style. In Paris, his radicalism increasingly found in style, independent of subject, a vehicle for expression against the grain of the surrounding culture—expression that he intended, and his critical audience received, as "revolutionary." This shift represents both Picasso's response to the Parisian art world, including his competition with more established modernists like Matisse, and his own solution to esthetic problems posed by the anarchist theory popularized in Barcelona. By 1906 his application of crudely primitivizing forms to traditional subjects weighted with cultural meaning—most notably the female nude, the traditional vehicle for ideals of beauty—invested more than ever in radicalism of style to achieve a revolutionary effect. This stunningly culminated in the shocking crudity of *Les Demoiselles d'Avignon*, to which Picasso's friends reacted as if a bomb had gone off in their midst—a metaphor employed by Braque on his first viewing.

This push toward increasing difficulty, fragmentation, and dehumanization eventually took Picasso to the very edge of abstraction in the Analytical Cubist period—the subject of Chapter 4—prompting cries of "anarchism" from critics of every political hue. A long-forgotten feature of the milieu in which Picasso worked is the remarkable extent to which the critical and general audience of Cubism conducted a highly politicized discourse in response to the appearance and publicizing of the style. Any art can be profitably considered in relation to its social context, but this is more than a truism in Paris before the Great War, where discussion of

the arts was quite self-consciously political. To read the art criticism of the avant-guerre in dailies and journals representing the entire range of political opinion from extreme left to extreme right is to realize the extent to which French life was then saturated in a politicized rhetoric that insisted on the political implications of everything, especially art, and especially a self-consciously rebellious, "revolutionary," avant-garde art. From 1908 until after the war, Cubism was consistently attacked—or celebrated—in terms that took for granted that artistic canons were continuous with social conventions and that, as Gustave Kahn wrote, "in shattering a fragment of the artistic façade [the artist] touches the social façade."[7]

It is against this background that we must see not only Cubism but the prewar collages, the subject of Chapter 5. The shockingly abstract style of Picasso's Cubist period was never entirely divorced from subjects and themes already abundantly familiar from his earlier work, and images from Harlequin to café still life represent more than mere pretexts for the solution of formal problems. Nevertheless, the most hermetic Analytical Cubist canvases came to hover on the brink of complete abstraction, and in the collages Picasso found a fresh and startling way of introducing subjects that summoned radical ideologies and controversies to play a renewed role in his art. Thus the anarchists' social critique and romantic revolutionism exerted a discernible influence on much of his early work, but was most surprisingly, and articulately, manifested in the collages of autumn 1912, when the First Balkan War plunged Europe, and Picasso's bohemian milieu not least, into anxious preoccupation with the possibility of war engulfing the Continent.

The political reports glued into these early collages had special resonance for an artist deeply tied to the anarchist, antimilitarist traditions of Barcelona and daily exposed to, if not immersed in, the raging arguments over the pan-European war universally acknowledged to be threatening. Further, the pieces of newsprint are often wittily and tellingly tied to the Cubist images of the cafés, where such arguments and discussions about the threat of war took place. The iconography of the early collages insistently sets us among the tables, bottles, liqueurs, and, indeed, newspapers of an artistic and political bohemia whose denizens feel both alienated from and responsible for (such is the world-historical scope of their ambition) that larger culture they can live neither with nor without. During November and December of 1912, when the political crisis was at its peak, the collages virtually supplanted the activity of painting in Picasso's work.

To scholars and students of modern art I hardly need emphasize that neither Cubism nor the collages are generally understood in this light, although current scholarship on Cubism has begun to venture beyond the boundaries laid down by the formalism of the decades after World War I. The history of Cubism, the development of its style, and, after William Rubin's pioneering work of 1977, "Cézannisme and the Beginnings of Cubism," the relative contributions of its early inventors are now well known. Thanks in part to Edward Fry's valuable translation

of documents in 1966, we are familiar with the apologias of the supporters of Cubism.[8] But most scholars have been preoccupied with the brilliance of Picasso and Braque's formal innovations. Only in the last decade have iconography and personal content been discerned in works long seen as among Picasso's most abstract, for example, Linda Nochlin's study of the allusive and symbolic significance of color, including the Cubist period, and Robert Rosenblum's study of the role of word play in the masthead and headline fragments in the *papiers-collés*.

Other recent studies have revealed ideas, themes, witticisms, and personal revelations in Picasso's proto-Cubist works, most concentrating on *Les Demoiselles d'Avignon*, beginning with Leo Steinberg's study of sexual ambivalence in that seminal work.[9] And much scholarship of the last decade has illuminated possible influences on and intellectual backgrounds of the Cubist movement, for example, Linda Henderson's work on the role of mathematics.[10] But the relation of the painters themselves to the larger society in which and against which they created their art and, in turn, that society's general view of them are elements of the total picture that have been lost. The adversarial impulses that motivated the development of Cubism—impulses that were "revolutionary" in a more than metaphorical sense—have been denied, obscured, and forgotten ever since the mobilization orders were announced on August 2, 1914. The éclat of patriotism with which the Great War opened, the centralized government control under which it was conducted, and, in the postwar period, the rightward swing of public discourse and the disillusion of artists and intellectuals combined to produce a profound and generalized amnesia about the motives and ambitions that impelled and inspired the Cubist revolution. Picasso's political awareness of and response to contemporary events are not the only forces that shaped his work, but any account—of him or of modernism generally—that omits politics leaves out something essential.

This book will consider Picasso's political ideas and passions, with all their idiosyncrasies and inconsistencies, and their role in his work from 1897 to the First World War, with a concluding chapter briefly considering Picasso's later encounters with political issues and his responses to them. If Kropotkin's anarchist esthetics called upon artists to create a revolutionary art, Picasso's radical Cubist style made of this esthetic imperative a liberating assault on tradition, on the past, and hence, as contemporary critics of Cubism did not fail to notice, on society. We need to study the social context of avant-guerre Barcelona and Paris in order to understand the world against which Picasso struggled and out of which his art, including his Cubism, emerged. Complicated networks of social, economic, and political forces affect every person in every period, and little has been done to see the development of early modernism against this backdrop—a view, I am convinced, that will make it look rather different. But I do not undertake the entire task here. My approach is empirical. How market forces worked themselves out in Picasso's oeuvre, to what degree he remained within the confines of bourgeois art patron-

age, are important questions for the social history of Picasso's art, but they are not the subjects of this book. My efforts to retrieve a lost political context for his early career have nothing to do with analyses of market forces and patronage, nor with an attempt to offer a theory of Picasso's relations to ruling-class (or other) ideologies.[11] Nor, on the other hand, am I attempting to depict Picasso as an ideologue or covert political activist, surreptitiously encoding anarchist directives in his work.

Rather, my subject is the conscious, rather than the unconscious, politics of Picasso's art before the war. My desire is to look from a new perspective at an all too familiar terrain in hopes of regaining some knowledge of the world in which Picasso and his contemporaries lived, of the ideas that moved him, of the way his art carried on a dialogue with and against the society in which he found himself. My study is not Picasso as an object of historical forces (though surely the subject needs attention), but Picasso as a self-conscious agent in history, aspiring to master, manipulate, and direct what he perceived to be his "historical" material, granting all its problems of contradiction, inconsistency, and ambivalence. (This is only to say that in this, as in other aspects and periods of his art, Picasso is his usual difficult mix.)

In sum, it is my conviction that to view Picasso's pre-1914 career against the backdrop of its social context will challenge accepted notions about his art in several ways, the most important of which are the following:

(1) There is a "content" in even those reaches of Picasso's work that have long seemed to be concerned only with "style." In arguing thus, this study is in the line of recent work by Steinberg, Rubin, Henderson, Rosenblum, Nochlin, and others, which has demonstrated that there are representational, even iconographic, interests, and therefore thematic motives, in works that have seemed most obdurately "abstract." Picasso was drawn from the very beginnings of his career to subjects that were implicitly political, both for him and for his culture: on the one hand, socially critical images of urban street life (beggars, workers, prostitutes), on the other, utopian images of pastoral harmony (harvests, peasant dancers). In the paintings and collages of his Cubist period, the furniture of café life evokes a setting where artists and bohemians gathered to drink and argue. The newspaper clippings (long seen as mere "textural" gestures or as objects "real" yet devoid, somehow, of allusive meaning and social context) introduce in the most literal way possible the subjects Picasso and his friends (and the rest of Europe) were debating.

(2) The motives animating Picasso's Cubist style are the same as those registered in his choice of subject matter. Style here is not a neutral vehicle for the disinterested esthetic play of line, color, and form, but a formal attack on artistic tradition that Picasso's contemporaries understood to be an attack on the forms and traditions of society itself. Formalist discussion for thirty years encouraged a rhetoric that disjoins "style" and "form" from "subject matter" and "content," as if

the interests these polar terms designate were not merely complementary, but antithetical and mutually exclusive: as if Picasso's seemingly antirepresentational style were a repudiation or even a transcendence of all possible subject matter and all such merely human concerns as subject matter would imply, in favor of a disinterested, motiveless meditation on the act of seeing. Here was a Picasso made in the formalist's own image. American formalism now seems a product very characteristic of its time and place, the university culture of the 1950s. It is in the American grain to imagine a place beyond politics and history reserved for the highest domestic and private ideals. To escape history, the past, politics, has been the motive of every immigrant to these shores since 1621; and in the Eisenhower 1950s, with the threat of McCarthyism and the country's most respectable intellectuals proclaiming "the end of ideology," it is understandable that American art historians would retreat into a neoestheticism.[12]

Recent theoretical discourse, such as that of Rosalind Krauss,[13] likewise restricts its attentions to structure and form, and Krauss rightly sees herself in a line with the New Critics, those academic formalists of the midcentury (John Crowe Ransom, Allen Tate, W. K. Wimsatt, et al.) who likewise eschewed biography for the concentration on play within the boundaries of the artwork. Krauss's approach is self-consciously based on a rejection of historical considerations (and the "disease of biography") in favor of a Saussurean model of the signification of form and proceeds with indifference to conscious meanings Picasso's art may have had for him. But for many it is as clear now as it was obscure thirty years ago that "the act of seeing" is profoundly implicated in politics. It was clear to Picasso, too, and his effort to change our ways of seeing was anything but disinterested and apolitical.

(3) Picasso's relation to the progressive historicism of the nineteenth century in general and the revolutionary utopianism of anarchism in particular was entirely deliberate—both conscious and self-conscious, however inconsistent, idiosyncratic, or (to any beholding eye) lacking in rigor. The sublime politics that possessed Picasso's imagination in his early career tell us much not only about particular works but about his largest aspirations as an artist and the world-historical role he believed (or hoped) art could play in the grand story of human progress. This view contradicts the image of Picasso, which he himself did much to shape and promote, as a spontaneous genius, a conduit for those unconscious expressions now seen as tellingly appropriate for the new century. The esthete formalist here joins hands with some of the most "political" of European Marxist or post-Marxist critics, pledging allegiance to the image of Picasso as an "intuitive" and "instinctive" genius. This image recommends itself because implicit in it is the notion that work that comes from its creator's hand without informed calculation, intellectual content, and self-conscious intent is therefore uniquely honest and uniquely valuable testimony to the interpretations critics wish to find in it. To put the case so is probably a bit too harsh, since it was Picasso himself who authorita-

tively sponsored this image of Picasso-the-unconscious-genius. This vision of the artist as an anti-intellectual, quasi-natural force, a vehicle of transhistorical and transindividual energies, a conduit of instinctual impulses and unmediated "primitive" spirit, is itself an entirely anarchist vision. Much more than merely expressing the zeitgeist, Picasso played with anarchist (and other) ideas consciously and purposely investigated ways of making a "modern" art that often directly expressed a number of political beliefs. Complex, varying, and even contradictory aims in Picasso's art in this period, and his refusal to discuss his "esthetics" at almost every point in his life, have dogged our understanding, and Picasso has played no little role in obfuscating—often prankishly—past motives to serve present exigencies.

We need not deny the powerful intuitive and irrational elements in Picasso's art to affirm the conscious and controlled ones. Indeed, there may be much in his art of which he was unaware, but there was also much that was on his mind, and some of it we have seriously come to misunderstand: Cubism in general, and the collages in particular, are not content-neutral; and neither Picasso nor the art milieu of the avant-guerre was apolitical. His art was addressed to a far from apathetic audience at a charged moment and participated in a public discourse that was unusually politicized.

Picasso's political attitudes, revealed both overtly and obliquely at various moments in his life, informed his art in important ways throughout the period studied here. They play a significant role in his Cubist work, tying it both to his earlier and subsequent artistic careers and to the fabric of its own historical moment. Donald Kuspit has recently called for an end to what he names the "authoritarian esthetics" of formalism: instead of embracing art-for-art's-sake as an ethical position, critics and art historians should address why and how the impersonality of abstract works has denied "the problem of being in the world."[14] If this is a new project for art history, it is an old one for Picasso.

1. The Proper Subject of Art

Anarchism and Picasso's Barcelona Period , 1897-1904

You poets, painters, sculptors, musicians, if you understand your true mission and
the very interests of art itself, come with us. Place your pen, your pencil, your
chisel, your ideas at the service of the revolution. . . . Show the people how hideous
is their actual life, and place your hands on the causes of its ugliness. Tell us
what a rational life would be, if it did not encounter at every step the follies
and the ignominies of our present social order.
—Peter Kropotkin, *Paroles d'un révolté*, 1885

IT HAS OFTEN been said that the youthful Picasso spent his time with anarchist
sympathizers at Els Quatre Gats, the café-meeting place of the avant-garde in Bar-
celona and his second home during that period.[1] But the artistic overlapped the
political in Barcelona in the 1890s far more extensively than has yet been recog-
nized. To the avant-garde of that city, identification with the anarchist cause meant
a great deal more than sympathy for the downtrodden masses or for the outra-
geous acts of individual violence that later came to characterize anarchism in pop-
ular imagination.[2] Throughout Europe, the rise of the anarchist movement in the
nineteenth century was in direct response to the development of a rich body of
theory rivaling Marxism. Such writers as Pierre-Joseph Proudhon, Mikhail Baku-
nin, and Peter Kropotkin were widely read and even more widely popularized
throughout Europe, and their theories particularly appealed to avant-garde writ-
ers and artists in the second half of the century. Courbet, Wagner, Mallarmé,
Pissarro, Signac, Jarry, and Apollinaire, to name only some of the better-known
figures, numbered themselves among those who—usually romantically—equated
artistic with political liberation in anarchist terms. *Symbolisme* especially came to be
associated with the anarchist movement and its creed of extreme individualism as
a stand against bourgeois society. One can safely say that the avant-garde artistic
circles in Barcelona and Paris were saturated with anarchist politics and esthetic
postures.[3] But in order to understand the importance anarchist ideas had for
Picasso and his work in Spain and France, after his move to Paris in 1904, it will
be necessary to look briefly at the basic outlines of the anarchist movement and at
the highly politicized and militantly "modernist" atmosphere in Barcelona.

The Anarchist Movement

Proudhon and later anarchists rejected the social system in which they lived and offered an ideal vision of an anarchist future.[4] Although, as in any political movement, factions passionately argued various theoretical positions, the body of followers saw themselves as anti-authoritarian, anti-industrialist, antimilitarist, antipatriotic, antiparliamentarian, antiproperty, and antireligion; they were pacifist and internationalist; they embraced individual independence and liberty, the social necessity and moral virtue of work, and, following Kropotkin, imagined a future society of small groups enjoying "natural" relations of interdependence and "mutual aid." Although regional pride and ethnic differences were approved, nationalism and patriotism were despised as manipulative fictions that exploited laborers and inevitably led to wars waged for the profit of those in power. Proudhon, living as he did during the rise of the conscript army, saw war as the most tragic injustice of the social system. Antimilitarism became one of the most important themes in the later nineteenth-century libertarian movement and is of special significance for Picasso's work immediately prior to the First World War.

The Russians Bakunin, an active revolutionary and organizer, and Kropotkin, the great thinker of the movement in the late nineteenth century, built on Proudhon's ideas, so that by the 1880s and 1890s there existed a body of anarchist thought. Bakunin added the violence of an activist, and for a time—which he later regretted—he embraced Sergei Nechaev's "propaganda of the deed," which rationalized and glorified individual acts of terrorism.[5] Kropotkin felt that the real solution to society's ills lay with the peasantry, in part because they still had those primitive roots of "mutualism," which he saw as the natural form of society: men and women, if uncorrupted by coercive government, will naturally and freely aid their fellows in pursuit of the general well-being of all.[6] Kropotkin developed esthetic ideas out of the profound conviction that "primitive" societies—and "primitive" arts—express themselves in more natural, more spontaneous, and therefore truer, ways.

Distinct camps developed over numerous issues, including the relation of the individual to society and methods of action. On the one hand, the Reclus brothers, Kropotkin, and Jean Grave, editor of the influential *Les Temps Nouveaux*, promoted "anarchism-communism," in which the individual would exist in harmony with larger society. On the other, basing their ideas on Nietzsche and Max Stirner, were the extreme individualists, such as Georges Sorel, who saw their only duty as a refusal to allow the self to be compromised. After the turn of the century, syndicalism, a form of labor union, further split the ranks between those willing to work within an organized structure and those militant individualists for whom such an organization contradicted the very idea of anarchism. Thus an enormous number of related and often contradictory theories, attitudes, and social critiques

centered in the anarchist movement during the late nineteenth and early twentieth centuries. A wide range of allegiances and permutations affected not only the political figures involved but also the artistic and literary figures with whom they mingled, who were often no less passionate about issues of individualism and *la propagande par le fait*. The artistic and political bohemias of Barcelona and Paris were especially attracted to the most extreme individualist rhetoric of destruction, which could be metaphorically expressed in their art without actually requiring them to live out its injunctions literally.

Art and the role of the artist were central issues for the anarchists in a way that distinguishes them from the Marxists. Kropotkin believed artists were critical to the success of anarchism and exhorted them to hasten the revolution by behaving as if it had already taken place (a call that would later be acted out by Jarry and his followers in amusingly literal ways). Though Kropotkin himself envisioned an ideal art along the lines of ancient Greece, his ideas inspired two generations of genuinely revolutionary art. For the modern artist to cultivate strategies of primitivism and spontaneity in both art and life was to rebel against the static forms of bourgeois morality and bourgeois art. Kropotkin's primitivism, and emphasis on the role of art in changing social consciousness—though he never envisioned and doubtless disapproved of the form it took—constituted much of the appeal of anarchism to the artistic and literary generation of the 1880s and 1890s, along with the romanticism of la propagande par le fait.

Such convictions were manifested in Picasso's art in the period from 1897 to 1914. While it is impossible to reconstruct his thinking on such complex matters, it is likely that in many ways he was unconcerned with the nuances of the more sophisticated political thought of the movement's leaders. With the mercurial, synthesizing imagination of a magpie, Picasso was quite capable of picking up and putting together elements that others argued to disjoin. The appeal of anarchism for many, and especially for a character like Picasso, was that it was more an antipolitics than a politics, more an antiparty than a party, more a badge of individualism than a pledge of allegiance to any doctrinaire program. Above all, anarchism came to represent not only revolutionary politics but revolutionary art.

Anarchism and Spain

Anarchism was particularly strong in Spain, not only in the cosmopolitan centers but in the countryside, where its themes accorded with those of a strong and politicized folk culture.[7] A brief glance at Spanish history helps explain why anarchism took such strong root in Spain from the 1860s on. In response to the central government's disregard of the welfare of the peasants, a revolutionary movement developed that was characterized by an extreme distrust of government and a lack of faith in parliamentary procedures and even universal suffrage: the *cacique* system

of rigging elections had discredited the whole notion. In 1813 feudal rights on land were abolished, and beginning in 1855 civil and ecclesiastical lands were sold on the open market.

This "economic revolution" ushered in by the liberals, who wanted to modernize "medieval" Spain, resulted in depriving the peasants of the major support for their already insecure way of life: first, the common lands on which they had traditionally grazed their animals and gathered firewood, and second, the aid of the Church, which threw its weight behind the government. Madrid's response to the revolts and food riots that characterized the rest of the century was severe, including violent suppression of the peasants involved and public execution of their leaders. A significant portion of the peasantry, from the 1860s on, was attracted to the anarchist ideas that began to circulate both through publications and word of mouth.

The shifting of the Church to unmoderated support of the central government resulted in violent anticlericalism throughout Spain, cropping up repeatedly in the form of attacks on Church property, monasteries, convents, and on individual priests and nuns. By the 1890s, despite the fact that many Spaniards still considered themselves Catholics, reportedly ninety to ninety-seven percent of the population of Madrid did not attend mass. Barcelona had a reputation for being "more irreligious than Madrid."[8] During the "Tragic Week" of 1909, an uprising in protest against the conscription of the city's workingmen for a discredited military adventure in Morocco, the first and most violent acts were directed against the Church.[9] This revolutionary anti-intellectual, anticlerical, anti-authoritarian, anti-property, and violently anti-Church attitude developed before, and alongside, the anarchism imported from France and Russia and, after a point, need not and cannot be distinguished from it. Anarchism articulated feelings well honed by historical experience in nineteenth-century Spain (socialism in that era is the story of a comparatively small dedicated group working in isolation from the majority of the Spanish Left). The other side of this distrust and hatred of government and Church was a faith in the possibility of a harmonious life without them, an arcadian vision of society left to the primitive and spontaneous instincts of the people. The Spanish peasants' vision of life without authoritarian evils was notably similar to the anarchist vision.

Barcelona was anarchism's best and last stronghold in Europe, playing a critical part in the Spanish Civil War of 1936–1939.[10] As the capital of the ancient province of Catalonia, Barcelona was traditionally oriented more toward Europe than toward Madrid and became the major industrial center of Spain, which further linked it to the north. In the 1880s the rich industrialists of Barcelona began to express their fervent Catalan nationalism, and the Catalan language, customs, and artistic traditions were energetically revived.[11] Mingling with this *catalanisme* was a working-class movement that was more purely anarchist. The two move-

ments shared many attitudes, foremost among them a settled hatred of the Madrid government. Barcelona was the most politically agitated city in Spain and the witness of increasing violence around the turn of the century. The artistic and literary movement was an intrinsic part of this politically charged atmosphere in Barcelona in the 1890s.

Modernisme: the Barcelona Avant-Garde

As several recent studies and an exhibition have shown, the café Els Quatre Gats played a significant role from 1897 to 1903 in focusing the modernist movement and providing a center for the avant-garde artists and radical writers of several generations.[12] In such a city, at such a time, it would have been next to impossible, had one so desired, to remain impervious to poverty, labor unrest, and government oppression. The artists and writers of Barcelona, and especially Picasso and his circle, did not wish to ignore the social realities; on the contrary, they paid particular attention to them, and inevitably this experience colored their view of the world and the art they made.

A large and politically avid audience supported an enormous volume of anarchist publications during the years Picasso lived in Barcelona (1895–1904). There were anarchist daily newspapers, no fewer than eleven anarchist periodicals publishing weekly or monthly, and art journals with openly anarchist sympathies such as *Joventut* and *Catalunya*. All these periodicals published discussions and translations of European and American anarchists and writers whom they saw as allied to the movement, including Proudhon, Bakunin, Kropotkin, Tolstoy, Nietzsche, Wagner, and Mallarmé. And of course the list of Spanish literary anarchist and radical writers is long: based in Madrid, Pío Baroja, Azorín (J. Martínez Ruiz), and Miguel de Unamuno; and based in Barcelona, Alfred Opisso, Pompeu Gener, Joan Maragall, Jaume Brossa, Alexandre Cortada, and others. Picasso knew most of the Spanish figures, and Opisso, Brossa, and Gener were especially well known to him.[13]

Many of the political and literary figures familiar from the anarchist press appeared in the numerous art journals published in Barcelona during the same period; most of these journals explicitly or implicitly supported catalanisme, and many further espoused *anarquisme*, despite the periodic danger of fines and imprisonment.[14] *Joventut*, for example, had a separatist editorial policy and extensively published the anarchist criticism of Picasso's friend Gener, who introduced the writings of Nietzsche to Barcelona. Many articles appeared in *Joventut* attacking the idea of art for art's sake as a "perilous 'Dilettantism' " lacking social consciousness.[15] Picasso's first published drawings appeared in *Joventut*, including his symboliste illustration for Joan Oliva Bridgman's poem *El Clam de las verges* (July 12, 1900).[16] Journals such as *Els Quatre Gats*, *Pèl & Ploma*, and *Catalunya Artística* were

more cautious, announcing their radicalism and support of catalanisme largely through publishing socially critical drawings by Catalan artists.

Even the older modernistes Santiago Rusiñol and Ramon Casas—whose Catalanist politics were relatively conservative—were assimilated into the anarchist camp. For example, Opisso, in *La Ilustración Iberica* of June 2, 1894, declared that Rusiñol, Casas, and Zuloaga—a Valencian peasant painter—represented "without doubt, the Bakunin, the Nietzsche, the Kropotkin of the Spanish section."[17] Opisso (father of Picasso's friend Ricard Opisso), far from being alone in making his Catalanist and leftist views part of his art criticism, is typical of this politically charged artistic milieu. Miquel Utrillo, Angel Guimerá, Narcís Oller, Jaume Brossa, Pompeu Gener, Massó y Torrents, and Joan Maragall, who represent the entire range of catalanisme, all wrote highly politicized art and literary criticism for Barcelona's periodicals and moved in Picasso's circle.

Lluís Graner, among the older generation of painters, rejected the Spanish tradition of moralizing genre. His paintings concentrated not on peasants but on the most deprived classes of the poor. Works such as *Tavern Interior*[18] and his depictions of beggars and ragpickers influenced the entire younger generation of socially concerned artists—including Picasso—who looked beyond a sentimental glorification of the peasants to an unsentimental depiction of their new urban realities.[19]

Many of these younger artists met at La Llotja, the art academy in Barcelona. Isidre Nonell, Ricard Canals, Ricard Opisso, Ramon Pichot, and Joaquim Mir left the academy to paint "real life" in the outskirts and poor districts of Barcelona. Known as the Colla Sant Martí (Sant Martí Group) after one of these areas, they were the painters with whom Picasso later became associated, though by then they had disbanded as a group. All of these artists concerned themselves with social themes, none more explosively than Nonell in his antiwar and antigovernment series of drawings of the abandoned soldier/beggars from the "Cuban War" (Spanish-American War) of 1898, "España después de la guerra" ("Spain after the War"). In the 1890s Canals concentrated on working-class entertainments and gypsies. Mir sketched scenes of life in the poor districts, as in his "Bosquejos Barceloneses" of 1899 and his covers for *Hispania*. Opisso made numerous sketches of peasants at work, but also recorded the pathetic plight of "urban peasants" in drawings such as *Soup Line*, 1899. He also published overtly political works such as *En Ravachol petit* (*The Little Ravachol*), 1904, which depicts a group of workingmen riveted by the sight of a young worker writing "Montjuich"—Barcelona's infamous prison—on a wall.[20] Picasso pursued similar themes. The large majority of images of these artists through the turn of the century directly concerned social themes and constituted a collective outcry against the social system responsible for the conditions they recorded. Further, many of the works were lowly drawings, intended

for publications aimed at a larger audience than exhibitions of oil paintings commanded.

This radical subject matter was part of the larger experimentalism of artists who were stylistically Spain's most innovative to date in investigating expressive color, line, and form. Nonell was the most experimental among them and had a special influence on Picasso's early work, to be discussed below. Far from desiring to constitute an isolated modernist elite devoted to art for art's sake, these artists searched out a subject and style that would at once reject academic rules and appeal to the masses with whom they identified. Thirty-five years before Socialist Realism (proclaimed by the Union of Soviet Writers in 1932), this seemed no contradiction and needed no defense. And it seemed the proper and perhaps inevitable response to an extraordinarily wide and deep popular movement toward social consciousness and political agitation, a movement to which Picasso's circle was especially committed.

Picasso's Barcelona Period, 1895–1904

Picasso emerged from this milieu as the anarchist artist-hero who adopted these themes and carried them into the twentieth century. Despite the large number of studies of his early work, the evidence of his evolving social consciousness has yet to be pointed out. In Picasso's earliest work of the late 1890s and early 1900s, he painted savagely satirical works of bourgeois comfort and decadence and, at the same time, drew many records of the impoverishment and anger of the lower classes. In the Blue Period, from 1901 to 1904, he openly sympathized with the wretched, urban poor, their hunger, broken family ties, and alienation from the earth. In contrasting works, he depicted peace and harmony in the lives of rural peasants. Such subjects directly reflect Picasso's youthful criticism of society. At this time the expressiveness and formal invention of his art specifically served to point up the social and material conditions in which his figures lived—the savage distortions of his "Lautrec" phase, the wavering lines of his beggars of c. 1900, the monochrome and absence of settings of his Blue Period. To miss this aspect of Picasso's early work is to miss a thread of continuity in the first ten years of his art.

Before considering the subject and style of Picasso's art in his Barcelona years, however, we should look at the literary evidence. His early attitudes and convictions are documented both by the avant-garde journal *Arte Joven*, which he and Francisco Asis de Soler founded and edited in Madrid during the months from January to April 1901 when Picasso lived there, and by his signature on a manifesto published on the front page of *La Publicidad* in December 1900, which demanded both the release of political prisoners held in Montjuich since the agitations of 1898 and amnesty for those who had fled into exile.

Arte Joven reliably confirms Picasso's self-consciously political postures in this

period and constitutes an important record of his sympathies and prejudices. Leading figures of the literary and artistic avant-garde of Madrid and Barcelona lent work to the new journal, especially those sympathetic to and associated with the anarchist movement: poems by Miguel de Unamuno and Alberto Lozano, stories by Pío Baroja and Rusiñol, articles by and about Pompeu Gener and J. Martínez Ruiz (Azorín), drawings by Nonell and Baroja, translations from Catalan and a "Letter from Barcelona, to the intellectuals of Madrid" by Picasso's friend Ramon Reventós, which attempted to establish political and artistic links between the two cities. The advertisements to support the magazine were few but, for our purposes, very telling: for the café Els Quatre Gats; *Arte Joven* and *Madrid* (a journal projected by Picasso and Asis de Soler but never realized); and a list of translations published by Rodriguez Serra, including Kropotkin's *Memoirs of a Revolutionist* and *The Conquest of Bread*; Ruskin's *Of Queen's Gardens*, a powerful tract criticizing the economic and industrial system; and Nietzsche's *The Birth of Tragedy* and *The Twilight of the Gods*—a menu of the most frequently reprinted and discussed books of the Spanish artistic and political avant-garde.[21]

General themes of the Spanish Symbolist movement—primitivism, faith in natural instinct, exaltation of childhood—accompanied concretely political ones, making *Arte Joven* even more anarchist than its Catalan models. Picasso and Asis de Soler's introductory statement in the *número preliminar*, following a cover drawing of poor peasants, announced their idealistic aims in highly politicized language:

> It is not our intent to destroy anything: our mission is more elevated. We come to construct. The old, the decrepit, the worm-eaten will sooner or later fall down by itself, the powerful breath of civilization is enough and will take care of pulling down that which obstructs us. . . .
>
> We come to the struggle with much enthusiasm, with much energy, with a tenacity that will never be able to spare the old.
>
> Come, then, to the struggle, ours that will triumph if we fight with faith. Come and you will not forget that *to struggle is to succeed.*[22]

In the same issue, Lozano's poem "Drops of Ink" began, "I am a mystic in Art who appears an atheist, because I arrogantly deny all authority, and scoff at theories, ancient and modern."[23]

Such anarchist rhetoric was also put to less metaphorical uses. For example, in the third issue Picasso and Asis de Soler published a passionate article by Martínez Ruiz declaring war on what he, not alone, considered to be the farce of Spain's electoral system:

> The State is evil; the State is authority and authority is the tax that impoverishes the peasant, the hardship that kills in the factory, the one-fifth duty that decimates the villages and leaves the countryside exhausted, the inadequate

wages, the humiliating alms, the law, in short, that controls everything and tyrannizes over everything. . . . We do not wish to impose laws nor that laws impose on us; we do not wish to be governors nor that anyone govern us. Monarchists or republicans, reactionaries or progressives, all are at bottom authoritarians. Let us be inert to the invitation to politics. Democracy is an iniquitous lie. To vote is to fortify the age-old injustice of the State.[24]

After this purely Proudhonian analysis—the socialists were unpopular in Spain because they consented to work within the system, viewed as irreparably corrupted and corrupting—Martínez Ruiz presented the alternative offered by the artists, who considered themselves to be the leading cadres of the revolution: "We will hasten this end: We will work for this dawn of peace and right. Art is free and spontaneous. Let us make life artistic. Propellers and generators of life, artists would not want laws or borders. As for our free bohemia, our aspiration is that it become the bohemia of all humankind." According to an article of 1901 in *Pèl & Ploma* promoting the new journal, Picasso was the real force behind the venture.[25] As Pool has suggested, it is telling that the only periodical over which Picasso had control should express social and political commitment so flamboyantly.[26] Most significantly, the ideas expressed in this journal affirm that many of his early drawings and paintings were informed by the peculiarly Spanish marriage of art and politics.

On his first trip to Paris, Picasso went so far as to sign, along with his friends Francisco Asis de Soler, Carles Casagemas, Josep Cardona, and eighty others, a "Manifesto of the Spanish colony Resident in Paris," which appeared on December 29, 1900, on the front page of *La Publicidad*. This broadly left-wing Barcelona daily was published in Spanish and therefore addressed to a larger audience than any journal in Catalan. Inasmuch as Picasso was only visiting Paris, this gesture was one of solidarity with the genuine political exiles. The manifesto demanded both the release of the political prisoners—mostly anarchists—who were still being held in Montjuich following the antimilitarist agitations of 1898 and amnesty for the exiles who had fled to France to avoid military service. Comprising three sections, the first, "La Amnistía se impone," is a large front-page editorial, which reads in part:

Twenty-thousand Spaniards—the flower of our youth—who travel over foreign lands asking for bread and work, twenty-thousand of our compatriots necessary to national production, deserters and fugitive victims of the infamy of the military service of wretches, have madly cried for oblivion, for reconciliation and for amnesty. . . .

El País has called for full and complete amnesty—befitting the beginning of a new century and of a happier age: the amnesty of the anarchists of Jerez, innocent like those of Montjuich; the amnesty of the deserters and fearless

fugitives of the fatherland from an evil law of privilege for some and of death and ruin for the majority; the generous amnesty of the Carlists, solicited by their implacable enemies, the same democrats and republicans. . . .

All the circumstances impose amnesty: the profit of the State; the interest of the Government, which involves the presence of thousands of desperate men at the border, who if they supplicate today, conspire, menace tomorrow; the commencement of a new century, with its hunger for regeneration, for concord and for a happier and more fruitful life. . . .

If we were monarchists, if we performed as loyal counsellors of the royalty, already we would have had a place at the sensible, transcendental and patriotic signing by the Regent of the full amnesty.

But while the Government hesitates and deliberates, we are pursuing the second campaign in every place where there is a provisional home, wretched and poor, of one of our compatriots.[27]

Then come the protests and pleas from Perpignan and, with Picasso's signature, the "Manifiesto de la colonia española residente en París":

Comrades! Right is on our side. . . .

We have faith and perseverance, not doubting we will achieve the just request that it is necessary to demand of the governors.

Our desertion was motivated by the horror that was inspired by the spectacle of the war, carried out for the sake of paltry aims. . . . reason dictated to us that the war was not where we ought to go.

We respect he who fights for his liberty, who struggles for his life, and before being factors of a social injustice, we prefer to flee to foreign lands carrying in us the painful grief of abandoning the lives which are more dear to us.

Calling upon the fact that we are men and partisans of universal well-being, we protest against the immensity of proceeding with the establishment. If around our corpses and the lamenting of the despairing elderly the cannibals gather to engorge themselves, we will say to he who desires war that it mocks him, since we want peace and harmony between the peoples of the earth.[28]

In fact, from 1897 until his death in 1908, Picasso's uncle paid the modest military exemption fee for his nephew,[29] who could therefore travel in and out of Spain with impunity. Furthermore, Picasso had already returned to Spain from his first trip to Paris—he and Casagemas departed on December 20, 1900, for Barcelona and Málaga—by the time the manifesto appeared on the 29th. Given that no such amnesty had yet been seriously considered by the government, it was brave and even confrontational for Picasso and others to count themselves among the exiles in order to add their voices to the protest. Asis de Soler continued to be active in

this vein and signed a letter that appeared in *Le Libertaire* in Paris in August 1904 outlining the tortures still ongoing in Montjuich.[30] Not until the Spanish Civil War of 1936–1939 did Picasso again engage in this kind of political activism. These activities demonstrate the extent of his early commitment to anarchist causes, which manifested itself in constantly changing form in his work over two decades.

Picasso's first works after his family moved to Barcelona in 1895 consisted mostly of landscapes, domestic scenes, and portraits, though a number of paintings and drawings suggest an interest in peasants, including an awareness of the difficulty of their lives. Already in Coruña in 1895 he had painted *Portrait of an Old Man* (Fig. 1), a very direct and sympathetic portrait of a peasant broken down by years of hard labor, his age and pain penetratingly expressed. *Beggar with a Tin* and *Girl with Bare Feet*, both 1895, evidence a similar sensitivity to the poor.[31] Other works from his earliest period prefigure an important motif to run through Picasso's entire career: idealized views of peasants in a rural setting. *Fisherman with Children*, 1896 (Fig. 2), depicts such a pastoral theme, common to much Spanish art and literature of this period.

Recent scholarship has demonstrated Picasso's involvement with the moderniste movement in Barcelona and the impact of its art on his work after he moved there in 1895. As early as April 1896 he saw the work of Santiago Rusiñol, Ramon Casas, Isidre Nonell, and Joaquim Mir in the same exhibition in which he showed *The First Communion*, 1895–1896.[32] The many portrait drawings of 1899–1901, which imitate Casas, attest to Picasso's friendship with members of the group, including Rusiñol, Casas, the "social" artists Mir, Ricard Opisso, and Ramon Pichot, and such anarchist intellectuals as Pompeu Gener (Fig. 3).[33] Picasso appears with his friends in a drawing made at Els Quatre Gats by Opisso about 1900, which also includes Nonell, Ricard Canals, Vidal i Ventosa, and others.[34] He was probably introduced by Manuel Pallarés about 1897 into the anarchist atmosphere of the circle of artists, writers, and activists who gathered at Els Quatre Gats.[35]

Among those at the café whom the young Picasso would have most admired, Casas and Rusiñol were more conservatively Catalanist than the next generation. Nevertheless, Casas painted a number of works that deal directly with political subjects. *Garrote vil (Vile Garroting)*, 1894 (Fig. 4), depicts the public strangling of Santiago Salvador, who bombed the Teatro Lyceo, killing twenty-two and wounding fifty in the worst anarchist atrocity of the century. Yet Casas has directed his outrage against state-sanctioned atrocity, as his title makes clear. His specific attitude is less apparent in *The Procession of Corpus Christi Leaving Santa Maria del Mar*, 1898, which depicts the procession of Church and army officials and communicants moments before an anarchist bomb exploded. Aimed at the officials, it killed eleven and wounded forty of the common people, resulting in such infamous tortures in the swollen prison cells of Montjuich that protests were raised throughout Europe.[36] Picasso's friend Pío Baroja expressed a widespread belief—one now

thought likely to be true—when he put the following speech into the mouth of a libertarian in his novel *Aurora roja* (*Red Dawn*):

> They execute Salvador, and then occurs a stupendous event; the bomb on the Calle de Cambios Nuevos, which is thrown from a window at the end of a procession. It isn't thrown when the priests or the bishop are parading by, nor when the government troops are passing, nor into the midst of the bourgeoisie; it falls right among the common people. Who threw it? Nobody knows; but certainly it couldn't have been the Anarchists; if it was to anybody's interest at that time to push violence to extremes, it was to the government's, not the reactionaries' [revolutionaries] . . . I'd place my hand in the fire and swear that the fellow who committed that crime had some connection with the police.[37]

La Carga (*The Charge*), 1899, shows the mounted *guardia civil* charging a crowd of unarmed strikers during the first tentative experiments with the general strike in Barcelona.[38] Such works not only evidence Casas's close following of these political events but represent the extraordinary conviction that they are worthy subjects for art—contemporary history painting with a vengeance: gruesome, antiheroic, and inglorious in the extreme.

Rusiñol was not only an influential painter but also an important journalist, poet, and dramatist. Although today his works may seem to express little social protest, this was not so to his contemporaries. Miguel Utrillo reviewed Rusiñol's exhibition in Barcelona in 1890; for him these paintings spoke eloquently of the particular flavor of Spanish poverty: "[interiors] deprived of all refinements, floors worn out by a hundred generations of boors, fields sterile from too many harvests . . . [and] finally the desolation of misery, the nudity of poverty, and dense cape of mildew which covers the sordidness of miserable things."[39] The numerous *jardins abandonats*, which Rusiñol painted after 1893, inspired highly political interpretations after 1898. These repeated gardens-gone-to-seed became symbolic of the Desastre Nacional, the glory that was the Spanish Empire fallen into ruin and decay. For example, Azorín, in an edition of Rusiñol's "gardens" published in 1900, wrote: "All that old world, lonely gardens . . . has disappeared without giving us descendants. Oh! Abominated fathers who leave no inheritance!"[40] These are the images that Picasso asked to reproduce in *Arte Joven* when he wrote to "Friend Utrillo," saying, "We're doing a magazine and we want to dedicate almost all of the second issue to Rusiñol."[41]

In 1897 Rusiñol published the first indigenous prose poems in Spain, *Oracions*, a collection of mystical meditations on nature written in Catalan. His plays, beginning in 1899, included social satires and serious works about the change in social values in Catalonia in the 1880s and 1890s.[42] His play *L'Héroe*, his most overtly political work in any medium, exposed the plight of the Catalan textile workers,

suggesting that Rusiñol had been somewhat radicalized in the course of his career. The year 1902 saw an enormous increase in social disorder and official repression. That *L'Héroe* had to be closed down following fighting that broke out in the audience on opening night shows the degree to which these artists were inescapably engaged in the political situation. They did not work in that spirit of detachment possible in more politically stable countries.

The Colla Sant Martí, including Nonell, Canals, Opisso, Mir, and Picasso, nevertheless preferred the works of Graner for their depiction of the Catalan lower classes and socially critical consciousness. Furthermore, the overwhelmingly political milieu in which they were immersed, with anarchist activists fully participating in their artistic circle, prepared them to respond to an example such as Graner's. The outlying districts of Sant Martí, Pekin, and Antuñez, where reportedly one of the children's games was rat-chasing,[43] spoke for themselves to these young artists self-consciously nursing their compassion and outrage.

At this time the subjects of Picasso's work coincided with those of the Colla Sant Martí, recording the street life of Barcelona's poor suburbs, the destitute mothers with children, beggars, and laborers. In a number of related drawings,[44] a violinist, a woman with a baby, and a little girl with her hand out all beg on a street corner. The number of variations on this theme suggests that Picasso was working out a composition, possibly for a journal. In one drawing (Fig. 5), a workingman in his smock, cap, and narrow trousers gives a donation to the child; above, Picasso has written "Caridad" ("Charity"). In addition to the tree trunk (or streetlight) next to which the group stands, little trees form a background, with a contrastingly elegant carriage on the right. In a related drawing, the same worker gives money to a similar group, now without the violinist.[45] Again "Caridad" is written above. In another variation on this composition, *The Street Violinist*, c. 1899 (Fig. 6), a violinist, little girl, and small dog stand next to a tree trunk on the left, while the carriage, now parallel to the picture plane, passes behind a number of pedestrians and a cyclist—symbol of the modern era. This drawing has a line around two-thirds of its perimeter, suggesting that Picasso intended it for a periodical. Other sketches of beggars seem to record observed vignettes from life rather than worked-out ideas.[46]

Another group of studies from around 1900 more clearly demonstrates Picasso's political awareness of such subjects. A series of compositions for a poster of 1900 promotes the Caja de Previción y Socorros (Social Security) as "primera en España." Two of the compositions represent a symbolic protective mother, an embodiment of the hoped-for state beneficence; the other three depict a bereaved mother with child, cast in darkness and threatened with poverty (Fig. 7).[47]

Such a threat was no mere fancy of a leftist sensibility. The situation of the working classes was desperate following Spain's loss of Cuba in 1898. At the end of the century, despite steep rises in the price of food, wages had not risen since

1850. Working conditions in the factories were among the worst in Europe, and virtually no reforms were effected until well into the twentieth century.[48] Yet if working conditions were dehumanizing, affording only marginal subsistence, not working was infinitely worse. Seasonal and chronic unemployment was unprecedentedly high at this time, and there was little choice for such unfortunates but to starve, beg, or steal. Members of this class on the outermost fringe of society were also among the major concerns of the group of writers Picasso met in Madrid— the Generation of '98, or *noventayochistas*, all of whom were politically engaged writers dedicated to a closely observed realism—and parallel to the writers and artists of Barcelona.

These marginally employed and unemployed people figure centrally in the novels of Pío Baroja, one of the most influential of the Generation of '98, whose methods and themes can help us explore the compass of Spanish avant-garde concerns. He is of particular importance because Picasso, when he lived in Madrid in 1901, knew Baroja, did at least one drawing of him,[49] and published his fiction in Picasso's own self-proclaimed anarchist journal, *Arte Joven*. Openly allying himself with the anarchists in his life and work, Baroja studied the effects of industrialization in his trilogy, *La lucha por la vida* (*The Struggle for Life*). In the first novel, *La busca* (*The Search*), the main character, Manuel, struggles to find a place for himself in society, but, in a sense, there is no longer any such thing. In the preindustrial world, a man's place and his skill were part of his identity. Now men have neither, as Baroja explains: "The slumhouse was a microcosm . . . there were men who were everything and who were nothing; part geniuses, part smiths, part carpenters, part masons, part merchants, part thieves . . . uncentered people who lived in perpetual dismay . . . many changed their occupations as a reptile sheds its skin."[50] One need only note Proudhon's statement that "work is the first attribute, the essential characteristic of man"[51] to see how perverted this world has become for Baroja. Bakunin and Kropotkin also embraced this fundamental principle of anarchism; for Kropotkin, work was "a physiological necessity, a necessity of spending accumulated energy, a necessity which is health and life itself."[52] Eventually Manuel finds a place helping out in a junkyard, which "seemed to Manuel a place fit for him, who was himself a discarded residue of urban life."[53]

In *Mala hierba* (*Weeds*), Baroja continued his study of social breakdown in the slums, where we see people dehumanized by their environment and depraved by their living conditions. Manuel himself has become a vagabond after having failed as a printer's assistant. He falls in with two other vagabonds, one of whom sums up the attitude of the authorities toward these thousands of homeless people in his own eloquent tale: "A few nights ago I went out staggering, famished, and made my way to an Emergency Hospital. 'What's the matter with you?' I was asked by an attendant. 'Hunger.' 'That's not a disease,' he replied."[54] Inevitably Manuel descends into a criminal world—not, even now, out of vengeance but out of passivity

and helplessness. Here the degradation is even more advanced, for society has crushed not only the physical and mental lives of these *desposeidos* but also their moral and spiritual lives.[55]

Mala hierba ends with Manuel revolting within himself against this spiritual bankruptcy, and he is ready to be shown the anarchist vision by his friend Jesús:

> No more hatred, no more rancour. No more judges, nor policemen, nor soldiers, nor authority, nor fatherland. In the vast prairies of the world, free men laboured in the sunlight. The law of love has supplanted the law of duty, and the horizon of humanity becomes ever wider, ever a softer blue. . . .
>
> And Jesús continued speaking of a vague ideal of love and justice, of industry and piety. These words of his, chaotic, incoherent as they were, fell like a solacing balm upon Manuel's lacerated heart.[56]

In the third book of the trilogy, *Aurora roja*, we witness the growth and workings of the anarchist movement, for Baroja the only hope out of the inhuman and intolerable condition in which he found Spain.

A large number of Picasso's subjects in his early works coincide with those of Baroja and the Spanish avant-garde in general. A drawing for *Joventut* of about 1900 shows a poor woman carrying a baby through an industrial landscape (Fig. 8). Although the sketch is rough, it is recognizably set in a Barcelona suburb, a word that has very different connotations for Americans than it did for Europeans at the turn of the century. Barcelona, Madrid, and Paris all had their factories on the outskirts of the city, in the *afueras*, *banlieu*, or "zone." The most miserable workers, as well as the unemployed and the utterly destitute, lived there in an area that had neither the natural beauties of the countryside nor the civilized beauties of the metropolis. The first book of Baroja's trilogy is set there; as *La busca* makes clear, it is not a place that anyone is *from*—all are far from their homes. These are the "suburbs" the Colla Sant Martí haunted. Nonell set his *Annunciation in the Slums (Gloria in Excelsis)*, c.1892 (Fig. 9), in such suburbs, shown by a combination of smokestacks and distant hills similar to those in Picasso's *Joventut* drawing. Other works by Picasso repeat the subject of slum life in the suburbs.[57]

Of the group of "social" artists, Nonell was certainly the most important for Picasso, not only because of the power of his example but because he particularly befriended the younger artist, letting him use his studio in Barcelona in 1899 and again in Paris in 1900. Pool has demonstrated the crucial confluence of subject and style in their oeuvres in this period.[58] Before 1900, Nonell made numerous trips to Paris, where he spent his time with the Spanish colony, which Picasso was later to join, including fellow "social" artists Canals and Joaquim Sunyer and Catalan anarchists Jaume Brossa and Alexandre Cortada. Both of the latter had been connected with the radical journal *L' Avenç* and were in exile to escape the Montjuich tortures and reprisals following the antimilitarist agitations of the Cuban War pe-

riod and the Corpus Christi bombing of 1896. It seems probable that Nonell knew Camille Pissarro, an avowed anarchist, at this time.[59]

In addition to his frequent exhibitions in Barcelona, at the offices of *La Vanguardia*, Els Quatre Gats, and Sala Parés, Nonell exhibited numerous times in Paris, including at Vollard's in 1899 and at the Salon des Indépendants from 1900 until his death in 1911.[60] He was held in high esteem by his peers, although his works of the 1890s never gained wide or popular recognition. Nonell published numerous drawings in *La Vanguardia* and in art journals such as *Catalunya Artística, Joventut, Luz,* and *Pèl & Ploma,* journals whose most political gestures were the publication of such biting social criticism as Nonell's drawings represented.[61] This gesture, however, held its dangers for the editors—Utrillo and Casas edited *Pèl & Ploma*—as well as for Nonell, since laws had been passed in 1897 decreeing life imprisonment for those advocating violence through speeches, articles, or pictures—laws applied, as was usual in Barcelona, capriciously.[62]

Nonell's first published works, in 1894 and 1896, included his series of drawings "Tipos Populares Barceloneses." Rather than the detached and romanticized genresque images associated with such a title, Nonell's politicized *tipos populares* were truly typical of the Barcelona slums: poverty-stricken men and women either idle or begging or the poor women known as "factory bugs."[63] Then in October 1896, coinciding with an exhibition at *La Vanguardia*'s offices, Nonell published a series of drawings of a population of cretins in the mountain village of Caldas de Bohí and created an uproar. It was a purposely tasteless subject, treated in a mercilessly caricatural manner—a style rather brilliantly mastered by his closest follower, and Picasso's closest friend, Carles Casagemas.[64] Nonell nonetheless described a full humanity for this obviously closely knit community of inbred simpletons. For example, one drawing shows a group of cretins gathered around a deathbed (Fig. 10), mourning one of their old men. Despite its lack of sentimentality, the drawing is touching in its affirmation that even the most dreadfully outcast express the most deeply human thoughts and emotions, and we are shown this without being able, or asked, to identify with the figures. Picasso's family groups of *miserables* and his "Mother with Child" series from the Blue Period are comparable.

Related to Nonell's cretin series is his important drawing of c. 1892, published in *La Vanguardia* in 1897, *Annunciation in the Slums (Gloria in Excelsis)* (Fig. 9). The angel of the Annunciation appears to a cretinous group of slum dwellers who fail to respond to the angel's message and imperative: "Gloria in excelsis Deo!" Such displaced, overworked, hungry, and useless creatures, living in a tent city on the outskirts of an industrial wasteland, have earned the right to their apathy and disaffection from a religion that condoned the system producing their pathetic condition. Nonell, like Picasso later in Paris, was compared in the press to Goya for his ruthlessly violent depiction of the degraded and depraved.[65]

A third series of drawings by Nonell, constituting a major part of his exhibition at Els Quatre Gats in December 1898, was called "España después de la guerra" ("Spain after the War"). It dealt directly with the devastation wrought on the Spanish soldiers of the "Cuban War"—the Desastre Nacional—who were brought back to the port of Barcelona after the defeat and abandoned there without pay. Enric Jardí, in his book on the artist, has described what Nonell saw on his return from Paris in autumn 1898:

> the sad spectacle of the Spanish soldiers disembarking in the port, the majority of them wounded and sick, who constituted in the eyes of the people of Barcelona the most poignant testimony of the disaster which had put an end to the short-lived Spanish-American War. . . . Many of these "repatriates," who still wore their light tropical uniforms of thin cotton duck, and who had no money to pay for transport to their native places, spent the autumn and winter of 1898 begging in the streets of Barcelona, either playing musical instruments or spreading on the ground—to collect such coins as the compassionate passers-by might throw their way—the bicoloured flag which had now been lowered forever more in the last of the Spanish colonies.[66]

Numbers of these drawings show wounded and wasted soldiers, called *repatriados*, a subject repeated by numerous modernistes including Casas. His *Repatriados*, 1899 (Fig. 11), shows men in tropical uniforms and hats disembarking from a ship, several of them with crutches and bandages. Nonell usually concentrated on one figure, as in "*If I'd Only Known*" (Fig. 12), published in *Pèl & Ploma*, January 1902, an issue devoted entirely to the artist. Other examples include *Repatriado* and *The Veteran*.[67]

These drawings depict men who were taken from their farms and jobs and sent to an extremely unpopular war. They saw thousands of their fellow soldiers die in the malarial swamps of Cuba; they saw inefficiency, carelessness, and disregard for life on the part of the aristocratic officers; and they knew that for a pittance unavailable to them the entire middle and upper classes of Spain had bought their way out of service. The emphasis in such works is clearly on the waste of human lives and the callousness of the authorities now that the usefulness of these men is past.

Barcelona in particular, but also Spain in general, was traditionally hard to mobilize in war; the populace resisted a patriotism that asked for sacrifices only from the poorest class of people. The question of military service constitutes yet another area where traditional Spanish popular opinion, in this case antimilitarism, usefully coincided with anarchist ideas. The use of the poor and laboring classes as "cannon fodder" in wars frankly fought for the profit of the middle and upper classes was nowhere more nakedly acted out than in nineteenth-century Spain. The sympathy of the modernistes with these discarded soldiers is evident in

the choice to depict the subject and in the unrelenting exposure of them as a new class of beggars. Many of Nonell's "blind beggars" or "crippled beggars" represent repatriados, which is made clear by the dialogue often printed with them in *Pèl & Ploma* or *Catalunya Artística*: "If I'd Only Known" and "They've stopped giving alms to the 'poor soldier home from the war.' "[68]

Baroja's *Mala hierba* also dwelled on the theme of the abandoned soldier. In Manuel's wanderings as a beggar, he meets a repatriado:

> Manuel went off by the Calle de Ciudad Rodrigo to take shelter in the arches of the Plaza Mayor, and as he was weary, he sat down upon a door step. He was about to doze off when a man who looked like a professional beggar took a seat beside him. The fellow said he was a soldier back from Cuba,—that he could find no employment and, as far as that was concerned, was no good for work any more, as he had got used to living in constant flight.
>
> "After all," continued the returned soldier, "I've got my luck with me. If I haven't died this winter, I'll never die."[69]

Baroja's description of this ex-soldier, who clearly finds sheltering on the streets of Barcelona more grueling than fighting in Cuba, emphasizes his peasant origins and affirms the accuracy of Nonell's drawings: "The soldier was a common sort; his nose was thick, his face wide, his moustaches blond. He wore a pointed hat, clothes covered with patches, an old muffler rolled around his throat, and in his hand, a stick." The repatriado then talks about his experiences, in terms that seriously indict the government:

> The returned soldier recounted some anecdotes of the campaign in Cuba. He spoke in a violent fashion, and when anger or indignation mastered him, he grew terribly pale.
>
> He talked of life on that island,—a horrible life forever marching and marching, barefoot, legs sunk into swampy soil and the air clouded with mosquitoes whose bites left welts on your skin. He recalled a dingy little village theatre that had been converted into a hospital, its stage cluttered with sick and wounded. . . . Then the war of extermination decreed by [General] Weyler, the burning mills, the green slopes that in a moment were left without a bush, the exploding cane, and, in the towns, the famished populace, the women and children crying: "Don Lieutenant, Don Sergeant, we're hungry!" Besides this, the executions, the cold slaughter of one by the other with the machetes. . . .

And, after the horror of the war, the homecoming:

> And after all this, their return to Spain, almost sadder than the life in Cuba; the whole ship loaded with men dressed in striped cotton duck; a ship laden

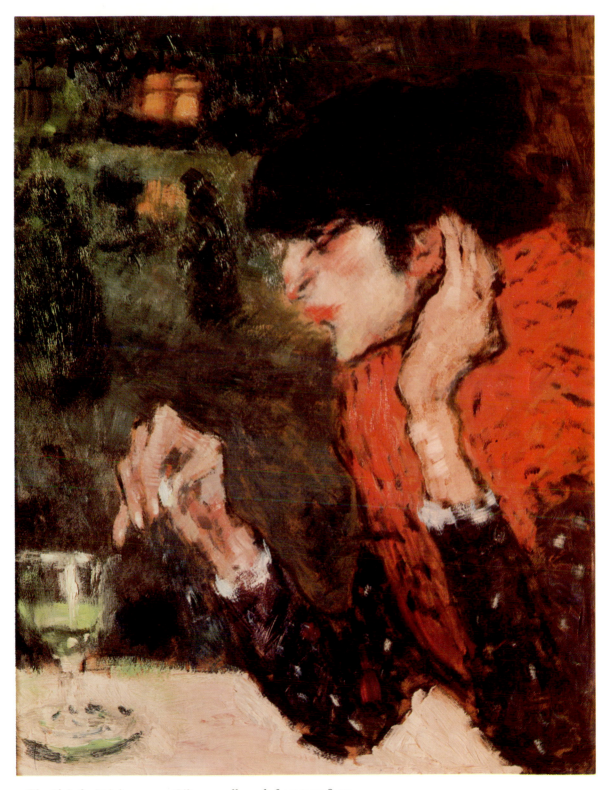

1. *The Absinthe Drinker*, 1901. Oil on cardboard, 65.5 x 50.8 cm.

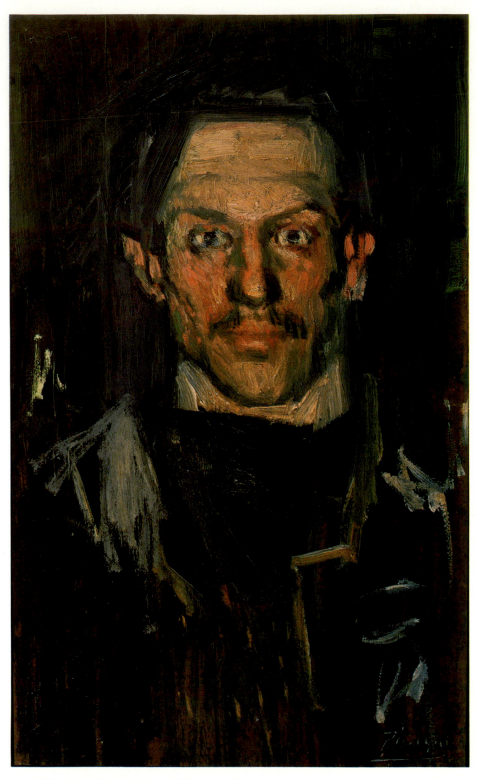

II. *Self-Portrait*, Summer 1901. Oil on cardboard mounted on wood, 51.4 x 36.8 cm.

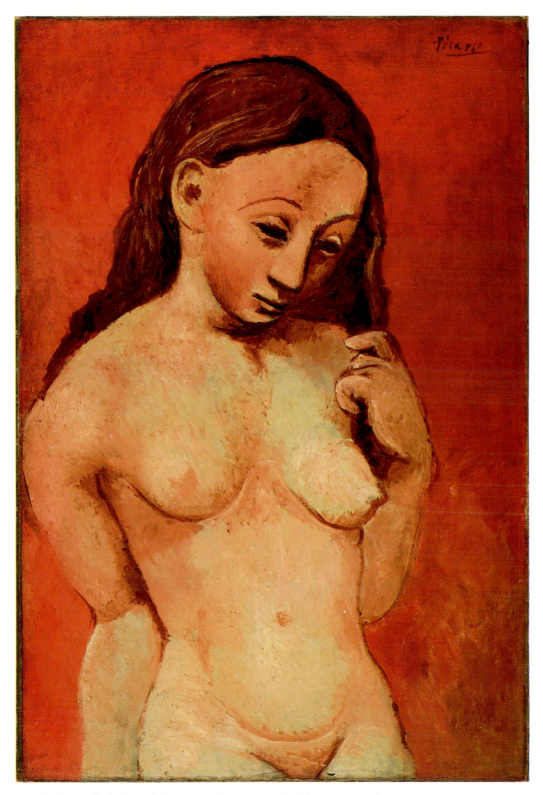

III. *Nude on a Red Ground*, Summer-Autumn 1906. Oil on canvas, 81 x 54 cm.

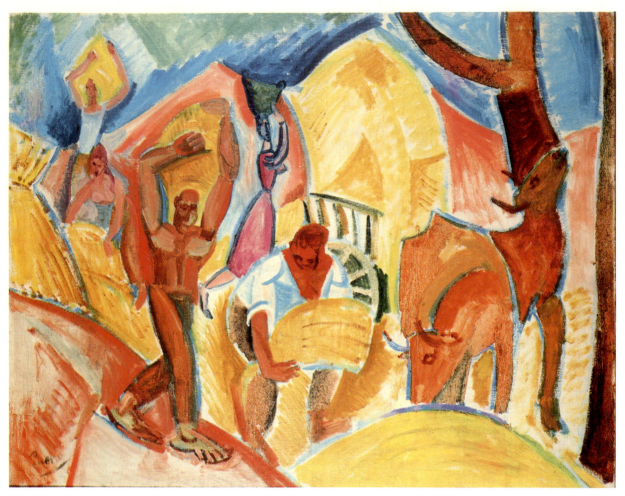

IV. *The Harvesters*, Spring 1907. Oil on canvas, 65 x 81.3 cm.

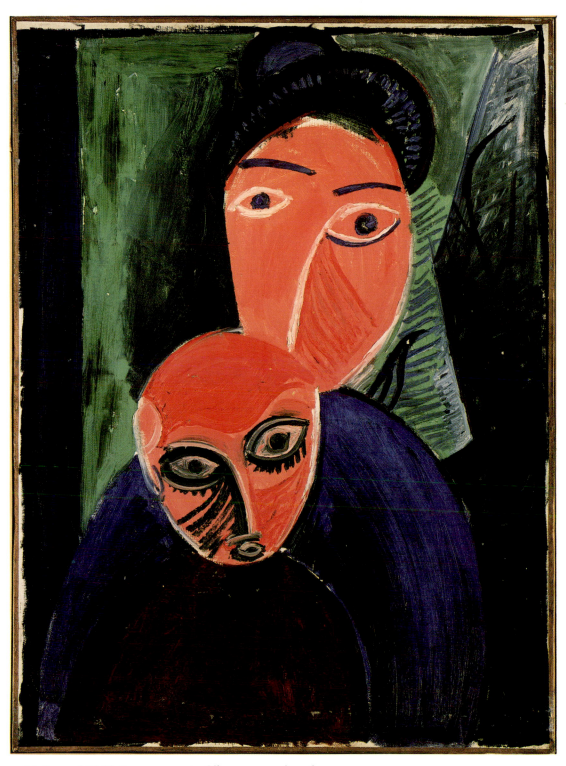

v. *Mother and Child*, Summer 1907. Oil on canvas, 81 x 60 cm.

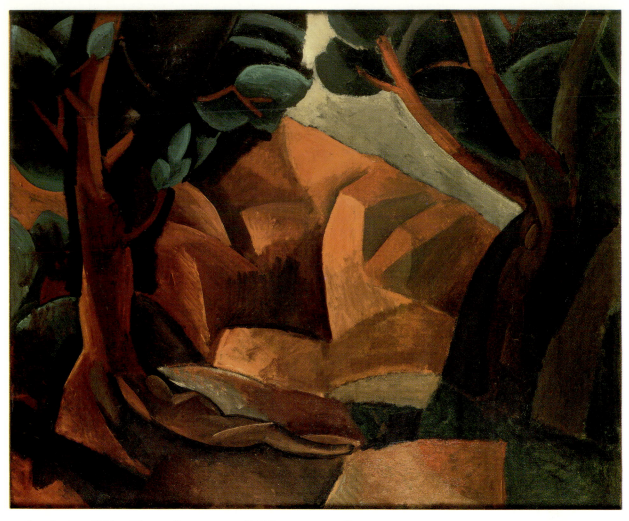

VI. *Landscape with Two Figures*, Summer 1908. Oil on canvas, 58 x 72 cm.

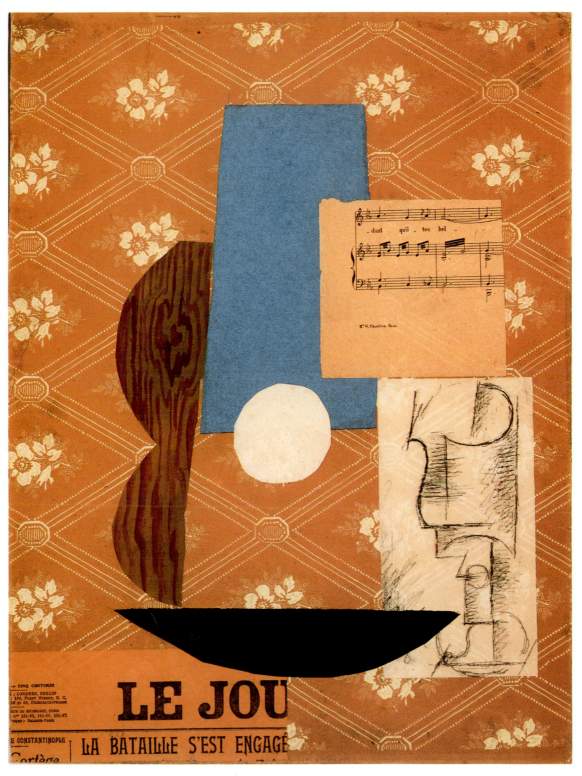

VII. *Guitar, Sheet-Music and Wineglass*, November 1912. Pasted papers, gouache, and charcoal on paper, 48 x 36.5 cm.

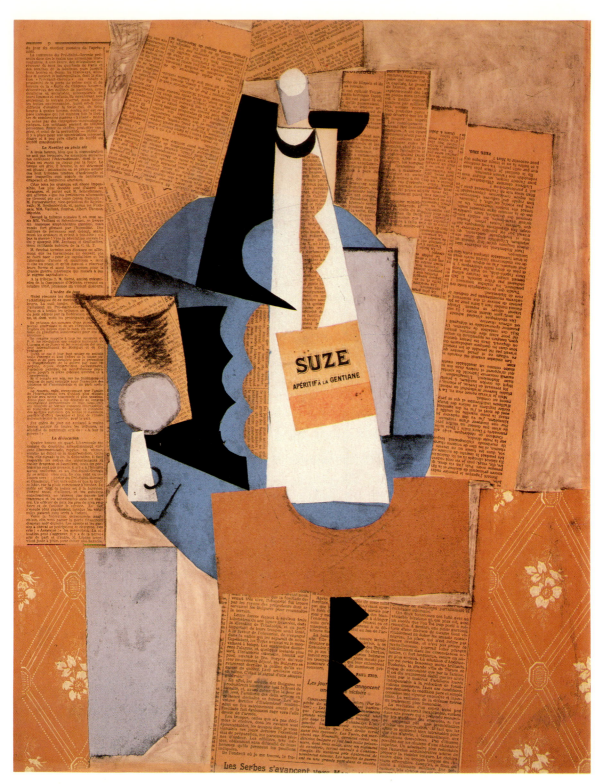

VIII. *Bottle of Suze*, November 1912. Pasted papers, gouache, and charcoal on paper, 64.5 x 50 cm.

with skeletons, and every day five, six or seven who died and were cast into the waves.

"And the arrival in Barcelona! Hell! What a disillusion!" he concluded. "A fellow would be waiting for some sort of reward for having served his country,—hoping for a little affection. Eh? Not a thing. Lord! Everybody looked at you as you went by without paying the slightest attention. We disembark in port as if we're so many bales of cotton. On the ship we had said to ourselves, 'We'll be swamped with questions when we get back to Spain.' Nothing like it. Nobody was in the least interested in what I had gone through in the Cuban thickets. . . . Go and defend your country, ha? Let the papal Nuncio go and defend it! So that he can afterward die of hunger and cold, and have somebody say to him: 'If you had any guts, the island wouldn't have been lost.' It's too damned much, I say! Too much!"

For Baroja, Nonell, and others to dwell on this theme was unavoidably to criticize the central government. Viewers of Nonell's "España después de la guerra" in December 1898 would have been inescapably confronted with identical figures on their way home from the gallery, and many doubtless sympathized with Nonell's implied outrage. They could not have missed the political point of such a subject in such an antiacademic style at such a time.

Beginning about 1900, Nonell adopted gypsies as his main subject (Fig. 13). Cervera notes that these gypsies from the Barcelona slums are not the romantic, alluring figures of popular fiction but rather the deadened, passive, morose figures of real life sunk in permanent dejection.[70] Frequently the original titles of these works confirm this, for example, *Les desgraciades* or *Misèria* (*In Distress* or *Poverty*), 1904. These are the figures referred to in the poem "La Terrestre Comèdia" ("The Earthly Comedy") by Rafael Nogueras Oller, whose portrait Picasso painted in *Interior of Els Quatre Gats* of 1899.[71] In the poem, Nogueras imagines a conversation between Nonell's gypsies on the walls of the Sala Parés, the major Barcelona gallery, and the well-dressed bourgeois visitors: "the lamentations of the disinherited" and the uneasy consciences of the well-to-do. Nogueras depicts a rather more open and sensitive response from potential picture-buyers than the angry and indignant one Nonell actually received. The middle classes knew very well the political implications in Nonell's—and the Colla Sant Martí's—drawings and paintings. But the poet very likely expressed Nonell's hopes for such an exchange between the subjects of his works and their viewers.

Carles Junyer Vidal in *El Liberal* and Alfred Opisso in *La Vanguardia* also wrote appreciative criticism of Nonell's social consciousness in his shows and published drawings, further exhibiting the firmly political response of Nonell's contemporaries.[72] Opisso in particular knew Nonell from Els Quatre Gats and from Nonell's close friendship with his son Ricard, and he would have been acquainted

with Nonell's views and artistic intentions. It is difficult to believe Opisso would have knowingly misrepresented the artist in order to advertise a political bias differing substantially from his friend's. Such contemporary responses argue strongly for Nonell's conscious and purposeful intent to make political statements in his works, an interpretation consistently denied in current discussions of Nonell.[73] One familiar with and sympathetic to the plight of the poor and with anarchist analyses of its causes and cure could not innocently choose such subjects for their purely "visual" interest. To draw attention insistently to the existence of such outcasts, their despair and hopelessness, is to draw attention equally to those who stood for ending such misery and to elicit sympathy with their cause.

While McCully and Jardí are correct in pointing to the important and innovative use of line and color in Nonell's work of this period, a sensitivity to style should not obscure for us the primary meaning of works by such artists as Nonell and Picasso, who clearly mean us to understand the socially critical barb of their subjects and treatment. The boldly innovative style of Nonell's work specifically served its subjects—formless, shattered creatures outside the pale of Spanish society—and emphasized his calculated distance from artistic rules of form *and* content. Nonell's commitment to a commercially unsuccessful radical style depicting politically charged subjects offered a powerful example, which Picasso followed. Many works of Picasso's Blue Period share this larger project with Nonell, in addition to strong similarities in composition and treatment of color, form, and paint surface, illustrated by any number of Nonell's gypsies and Picasso's crouching women or his *Two Women at a Bar*, 1902.[74]

When Picasso went to Paris, he found a similar environment and recorded it in his art. He was immediately drawn to Montmartre and the zone, or poor outskirts of Paris, paralleling his work in Barcelona. Montmartre was described by Salmon in his novel, *La Négresse du Sacré-Coeur*, in which he depicted the life of his and Picasso's close circle in these early years of the century:

> [Montmartre] with all its luxurious establishments where lobsters are sold for three francs a claw under blazing chandeliers whose floods of electricity wash the pavement of Rue Lepic, foremost boulevard of the natural bastion formed by the Butte . . . : Montmartre nevertheless belongs to the poor whom no one will ever succeed in driving out.
>
> Workers without work; cripples fuddled with cheap wine; housewives beaten unmercifully; beggars of Sacré Coeur; child vagabonds; poets dead from cold: they reign over Montmartre, they possess it, they the poor nourish the imperishable blood of martyrs within their veins. Insurrection itself reaches up there from the river banks when the reddest blood must be shed.[75]

Scène de rue (Vieillard, femme et enfant dans la rue), 1900 (Fig. 14), while it might at first seem an impressionistic view of modern city life, was read more accurately by

Picasso's contemporaries. When this work was included in Picasso's show at Berthe Weill's gallery in 1904, Maurice Le Sieutre wrote in the preface to the catalogue, "One senses the painter is interested in the tone which modern misery strikes in the suburbs of Paris. Here on the crowded ramparts are vulgar couples; at the crossroads of crowded streets there are idlers, workers, women, all unfortunates, abject and weary, rough, indistinct, worn down, tossed by life like pebbles by the sea."[76] *The Mother*, 1901,[77] shows a poor woman with a child and infant walking in a suburban landscape; Paris appears in the background. Later, in works of his Blue and Rose periods, the backgrounds become less specifically industrial and suburban than simply barren and lifeless, but Picasso continued to study the same social class.

To see the beggars of the Blue Period as continuous in theme with his earlier works supports Daix's assertion, which he later strangely contradicts, that Picasso's poverty in these years, especially when in Paris, "was not so much the cause of the Blue Period, as is often said, as the result of it. We must not forget that Picasso knew very well what was pleasing in his earlier work. . . . If Picasso returned to the study of misfortune he did it deliberately and not as a simple reflection of his own despondency."[78]

In the years 1902 to 1904 Picasso concentrated increasingly on the personal experience of poverty and alienation and its effect on small family groups. Numerous works depict broken families, with particular emphasis on the image of a woman with an infant wandering by the sea. Although they now have neutrally descriptive auction-house titles like *Woman and Child on the Shore* or more obviously formalist titles like *Mother and Child in Profile*, such works were originally exhibited at Berthe Weill's in late 1902 with titles like *La Misère: Mère et enfant*,[79] more clearly pointing to their primary content. *Figures by the Sea (Les Misérables au bord de la mer)*, 1903 (Fig. 15), depicts a family that has managed to stay together, but in such misery and hopelessness, so physically degenerated by hunger and cold, as to be utterly without a future. Their unity is heartbreaking and tenuous rather than edifying. These are among the works that André Salmon saw on his first visit to Picasso's studio in 1904. Picasso held up a candle—the light by which he worked— "when he humanely introduced me to the superhuman world of his starving, his cripples, his mothers without milk, the supra-real world of *Blue Poverty*."[80]

A madman—Picasso called him *el loco*—who lived in Barcelona was painted and drawn by Picasso several times in 1903 and 1904 (Fig. 16).[81] Such an outcast had no place anywhere in this urban society and compares tellingly both to Nonell's closely knit community of idiots in Caldas de Bohí and to Picasso's *El tonto (The Idiot)*, 1903,[82] a village idiot who was cared for within the traditional rural social structure and was neither ragged nor hungry. Picasso not only recorded this pathetic urban outcast but pointed up the exaggerated imbalance of wealth in Spanish society in a work ironically titled *Caridad (Charity)*, 1903 (Fig. 17), which

shows a grotesquely fat bourgeois giving a coin to *el loco* as he sits grimly in the street with his emaciated little dog. Even more pointed in this regard is Picasso's illustration for a play by Suriñach Sentiés, published in *Catalunya Artística* in 1900, which depicts *La boja* (Fig. 18), a widow driven mad by a lord who has pulled down her cottage to build himself a castle.[83] But Death has his revenge on them all in *The End of the Road*, c. 1899 (Fig. 19); he waits menacingly above, a parody of Christianity's heaven, while, as Picasso unnecessarily clarified, "the rich mount in carriages, and the poor on foot" to equal fates.[84] Although the rich are not individualized, the poor include mothers with infants and emaciated children and a bandaged old man on crutches.

The blind, like the mad, have been cast out into poverty and beggary in Picasso's work. Crushed and degraded, they nevertheless maintain an inner vision, revealed in the quiet dignity of the figure in *The Blind Man's Meal*, 1903 (Fig. 20), or *The Old Guitarist*, 1903 (Fig. 21), absorbed in his music.[85] The symbolic importance of the blindness of these inward-looking figures, which has been frequently discussed in Picasso literature, plays a necessary part in our understanding of these works.[86] But we should remember that, first, these are depictions of actual types abundant in the streets of Barcelona and, in fact, appear no more frequently in Picasso's oeuvre than madmen or other kinds of beggars. While Picasso does increasingly identify the artist with such social outcasts—an idea central to the anarchists' view of a bourgeois society that discards what it cannot co-opt—like the images of the *modernistes*, his represent political statements as much as symbolic identifications.

Women constituted a separate category of outcasts for Picasso, more devastating in its spiritual degradation. If a man could not find work, eventually his options were begging and crime. Women turned to prostitution and, to numb their pain and humiliation, often to alcohol and absinthe. One of his earliest paintings, *Streetwalker*, 1898–1899 (Fig. 22), depicts a prostitute on a street corner, one hand holding her crotch in a brutally frank advertising gesture, without pretense that love or companionship is being offered. Showing her on the street gives the painting a social context less evident in, for example, Toulouse-Lautrec's scenes in brothels, where illusions—by design—are more easily maintained. Nevertheless, Lautrec's work constituted an important model for Picasso. In *Harlot with Hand on Her Shoulder*, 1901 (Fig. 23), a prostitute looks boldly at the viewer—her potential purchaser—with disturbing frankness, her feline visage emerging from the ironic pseudogaiety of Picasso's pointillism. This work, according to Daix, was probably shown as *La Morphinomane* in the Vollard exhibition of June 1901, which would make it part of a series of prostitutes with addictions and link it thematically with a number of paintings by Rusiñol.[87]

A work also probably in the Vollard show, *The Absinthe Drinker*, 1901 (Pl. 1) (neutralized by Zervos to *Drinker Resting Her Elbows*),[88] goes much further in de-

scribing the mental and physical degeneration that is the inevitable result of this kind of life. The telltale yellow-green fluid sits in front of a woman with a depraved face, a wounded red mouth, and crippled-looking hands. She sits in an open café, watching other women loitering in the street. A similar work, depicting a woman with crude and vulgar features sitting in a café with a glass of absinthe, confirms the low social setting by showing couples dancing lasciviously in the background.[89] The body of the woman in *The Absinthe Drinker (Girl with Folded Arms)*, 1901 (Fig. 24), speaks a wholly different language. Instead of predatory alertness, this figure has a dulled heaviness to her features as she sits slumped in apathetic semiconsciousness, dulled by the many uses to which her grotesque and swollen body has been put. In *Aurora roja*, Baroja described the same sort of prostitute, with a comparable sympathy:

> Her complexion was withered; her gestures, timorous. There was a certain dignity about her, which indicated that she was not one of those who are born with the vocation for their sorry business. In her black eyes, in her prematurely wrinkled face, one could read weariness, sleeplessness, dejection—all this covered by a veil of indifference and insensibility.[90]

Yet another drinker, in *Two Women*, 1901 (Fig. 25), uses alcohol to achieve a state of gay carelessness, shown by her drunken deshabille; but this gaiety is belied by her distorted hands and features and by the unhappy solemnity of her companion. Another figure in this series, *Dozing Absinthe Drinker*, 1902 (Fig. 26),[91] appears to be happiest of all: for a brief time she has lost consciousness of her condition altogether.

But this is not the only fate that befalls women in such circumstances; jail and venereal disease also attend the life of the poor prostitute. Baroja again powerfully recreates the world of such figures:

> Just as [Manuel] was turning into the Calle del Arenal, he came upon a beggar in a doorway. She was huddled in a tattered old white cloak; her head was swathed in a kerchief, her skirt was ragged, and she clutched a stick.
> Manuel drew near to look at her. It was Violeta.
> "Charity, sir, I'm a sick woman, sir," she stammered in a voice that came like a bleat. . . .
> As she spoke, two street-women came along, one of them a bulky wench with moustaches.
> "And how did you get this way?" Manuel went on.
> "From a cold."
> "Don't you believe a word she says," interjected the woman with the moustaches, in a raucous voice. "What she had was the 'syph.' "
> "And all my teeth have come out," added the beggar, showing her gums. "And I'm half blind."

"It was a terrible case," added she of the moustaches.

"You can see for yourself, kind sir, what's become of me. I fall at every step. And I'm no more than thirty-five. . . ."

Manuel, horrified, gave her all he had in his pocket; two or three pesetas. She got up, trembling in every limb, and leaning heavily upon the stick, began to walk, dragging her feet after her and supporting herself against the walls. The paralytic made her way down the Calle de Preciados, then into the Calle de Tetuán, where she went into a tavern.[92]

Picasso depicted just such a scene in *Alms*, 1899 (Fig. 27), a small color sketch that includes a tall young man giving coins to a huddled old woman in the street, while behind him a group of prostitutes, their breasts exposed, jeer and wave their glasses aloft; farther to the rear a man and woman approach a staircase in an indecorously close embrace.

The series culminating in *The Two Sisters*, or *The Meeting*, 1902, representing either a nun and a prostitute or, more likely, two prostitutes, resulted from Picasso's visits over several weeks to the Saint-Lazare prison hospital for venereal diseases.[93] According to Sabartés, *Seated Woman with a Fichu*, 1902, depicts a woman in a prison cell, cold and shivering in the moonlight.[94]

Picasso expresses a great deal of sympathy for the women depicted in this group of works. Biographers agree that he himself wavered between periods of visits to prostitutes and regret accompanied by hypochondria. Often the physical degeneration of these women illustrates the disease most of them carried and that Picasso may have contracted.[95] But such physical crippling also expresses the moral degradation that accompanied this path, which led not out of, but deeper into, the inescapable poverty of their class. Such sympathy contrasts sharply with his satirical paintings of women who are bourgeois or can pretend so. *Woman in Blue*, 1901 (Fig. 28), roughly contemporary with *The Absinthe Drinker* (Pl. 1), represents either a high-class prostitute or a genuinely bourgeois imitation. From an anticapitalist and antibourgeois point of view, there may be no difference. Overdressed, her head and body dwarfed by the sumptuous materials of her fabulously expensive outfit, this woman gives every appearance of having clawed her way to the top. She looks ahead with burning eyes, her garish lips pressed in an iron resolve and her arm firmly planted on her parasol, immovable from her position on the social ladder.

Beginning in 1897, Picasso made many drawings of street scenes, interesting in their emphasis on work. *A Carter*, 1897–1898 (Fig. 29), similar in style to numerous others, walks along beside his harnessed horse, wearing the characteristic Catalan long smock and cap.[96] *A Porter*, 1897–1899 (Fig. 30), dressed identically, walks bent over with the weight of his bundles. These drawings, and many related ones, are executed in a flowing curvilinear style with repeated lines, strikingly

Daumieresque both in the quality of line and the bulkiness of the figures and in the concentration on images of the common people.[97] By this time Picasso would have seen Daumier drawings in the numerous art journals available in Barcelona and, after 1897, at Els Quatre Gats. Many of these workers, and probably some beggars, too, can be seen eagerly educating themselves in the struggle to better their condition. The ability to read was a rare privilege among the working classes of Spain at this time, even in enlightened Barcelona. The workingman in *Two Men Reading*, c. 1900, who, like his elegantly dressed neighbor, can read to himself, is far luckier than the workingmen and women in *Onlookers*, 1897–1899 (Fig. 31), and its study, *A Group Reading*.[98] In *Onlookers*, two women, one with a baby, and two men look over the shoulder of a bourgeois with a newspaper as they listen to him read. Not only was this habit a common one among the working classes of Spain, it was crucial to the spread of anarchist and progressive ideas.[99]

Coinciding with both the degradation of poverty and the articulate exchange of such inflammatory news and ideas as the city offered, violence was a very real presence and danger. A group of drawings related stylistically in these early works concerns a kind of street violence almost daily acted out in Barcelona in the years following the Montjuich tortures and the unprecedented and unexpected growth of the anarchist movement. Madrid had its own share of such troubles when Picasso lived there in 1897–1898. At least twelve drawings in the Museu Picasso in Barcelona, all dating from 1897–1899, depict violent street fights and confrontations. Assailants, victims, and horrified onlookers act out knifings, assassinations, and mob scenes in both cities. Five drawings, all in pen on squared paper, done in Madrid in 1897–1898, seem to attempt to work out a composition, never completed, involving a workingman with a knife in his right hand, one and possibly two fallen figures, and a well-dressed man gesturing theatrically in horror and recrimination with several others behind him.[100] Another drawing (Fig. 32) depicts an interior scene with a man holding a knife, held back from another on the floor by a pair behind him. Furniture has been knocked over, and a pregnant woman with a small child clinging to her legs gestures in horrified despair. Two related sketches study the four central characters of this drama from different viewpoints.[101] A further sketch, done about the same time, graphically depicts an attack, with one man on his back on a pavement, the other kneeling over him with his hand drawn back ready to strike.[102] These drawings recall the published graphics of Steinlen, whose work was known to Picasso by this time and who depicted the brutalized condition of the poor, including such phenomena as wife-beating and mistreatment of children, and their violent confrontations with the police and army.[103]

A further group of four drawings, two related compositionally, show a street assassination or murder. In the first two (Fig. 33),[104] a man holds out his arm to keep back those running up to view the victim, huddled over by two men. The

other drawing (Fig. 34), not directly related, depicts a different moment in a similar scene. This time, with two victims lying in the street, one clutching his stomach, a group of men turns and hurries away. Whether the attackers are among them, or they are merely a crowd who cannot afford to get involved, remains unclear. The fourth related sketch depicts two groups of armed men confronting each other on a street.[105] Another drawing in this group, *Street Fight*, 1897–1898 (Fig. 35), shows an angry mob led by a man holding a knife, stopped by an imposing figure protecting the inert body of a man behind him. All the figures appear to be workers; given the political climate in Spain in the late 1890s, this drawing may depict some form of workers' protest. The latest in this series is one of two studies of 1900–1902 for a poster for *El Liberal* (Fig. 36), a left-wing newspaper published by Picasso's friend Carles Junyer Vidal, depicting a demonstration of poor men and women yelling angrily from beneath the inflammatory masthead.

These drawings demonstrate that Picasso responded directly to the social and political violence of the time rather than merely hearing about it at Els Quatre Gats. He observed such events in the city streets and was absorbed in working out a composition on the theme, possibly for publication. Given the interest in, and dedication to, the social and political realities of Spain on the part of Picasso and his circle, it is fair to deduce from these repeated and highly politically charged subjects that Picasso intended his work to be seen as political art. His themes accumulate subjects of specific concern to the anarchist milieu of which he was a member, and his treatment of them expresses a sympathy with the *marginación social* and represents much more than solipsistic projection. They counter the idea that Picasso's Blue Period represents merely sentimentalism or autobiographical projection rather than, as Sabartés is virtually alone in maintaining in later years, primarily a "testimony of conscience,"[106] with all the sophisticated allusion and conscious intention that implies.

The uncompromising look at actual conditions of society by modern Spanish writers and artists was accompanied by a faith in the old Spanish way of life and the unsophisticated peasant. Art, to be vital, must locate and express the spirit of this life. Lily Litvak, in her study of arcadianism among these writers, notes that Baroja, Azorín, and Unamuno all exhibited a mistrust of the modern, industrialized world and looked back longingly to a primitive Spanish Arcadia.[107] Just as industrialization destroys the old life, capitalism destroys the balance between art and life. Vanguard critics decried this in numerous articles at the turn of the century, for example, José Deleito Piñuela in 1904: "But no longer is this popular mass—as it was in the infancy of the modern peoples—the quarry from which artistic inspiration springs forth, anonymous and spontaneous. . . . Now art is the patrimony of a minority, and by becoming aristocratic it has become too intellectual."[108]

Rusiñol had sounded his call to the past in a lecture at the Ateneo Barcelonés in the early 1880s:

> The trend of *Modernisme* in art is to drink in the primitive springs, where the water [that is] pure and free from all mannerism abounds. Music derives its inspiration from the popular song; from the inspiration of the people, poetry; from the primitive painters, the most modern painting; and if we want to have our own decorative style, it is necessary to get our inspiration from the style of our heritage, from this residue of the past.[109]

This arcadianism reflects a core anarchist idea, drawn into the realm of esthetics but by no means depoliticized. Many socialist and anarchist writers, in fact, were brought to bear witness in such esthetic discussions in Spanish journals, including Proudhon, Bakunin, Kropotkin, William Morris, and Tolstoy, all of whom wrote on this subject. Kropotkin—a highly respected scientist and, in early expeditions, the first to understand the geological structure of Siberia—developed the idea most thoroughly and scientifically in *Mutual Aid*.[110] Using Darwin as his base, he opposed T. H. Huxley's interpretation of Darwin's researches, where competition and struggle were seen as the dominant factors in the survival of a species.[111] Kropotkin cited a compelling array of observations of mutual aid in animal groups; his most famous proof of the "natural law of cooperation" was Darwin's own example of a blind pelican supplied with fish by other members of its flock. And borrowing a page from John Ruskin and William Morris, Kropotkin further saw this natural law at work in tribal cultures, in the Greek city-states, and in medieval cities. The influence of Rousseau can be seen here in the profound conviction that "primitive" societies—and "primitive" arts—are tapped into truer, more natural, and therefore better modes.

For the anarchists, unlike the Marxists, the role of art in society was a central issue, both in its reflection of the current state of culture and, in the future, as an expression of a harmonious society. Proudhon felt that art must serve a moral and social purpose and should force people to look at the realities of the life of the poor, promoting a desire for social change. In his *Du principe de l'art* he analyzed the debauchery of contemporary art: "Society divides itself from art; it puts it outside of real life; it makes of it a means of pleasure and amusement, a pastime, but one which means nothing; it is a superfluity, a luxury, a vanity, a debauchery, an illusion; it is anything you like. It is no longer a faculty or a function, a form of life, an integral part and constituent of existence."[112] Bakunin also felt disgust with contemporary art, which he held partly responsible for the awe he saw the poor feel for the trappings of power: "Artists have become the natural servants of priestcraft and despotism against the liberty of peoples. Ministers of corruption, professors of voluptuousness, prostitutes' pimps, it is they who have taught the masses to bear their indignity and their indigence."[113]

While Proudhon called for an art of pure agitational propaganda, Kropotkin, who based his study of esthetics on Proudhon, Tolstoy, Wagner, Ruskin, and Morris,[114] looked to an earlier time when art was unified with life and could therefore express a true cultural spirit. He discussed his ideas on art at greatest length in *The Conquest of Bread*, widely and popularly read in Spain.

> When a Greek sculptor chiselled his marble he endeavored to express the spirit and heart of the city. All its passions, all its traditions of glory, were to live again in the work. But today the *united* city has ceased to exist; there is no more communion of ideas. The town is a chance agglomeration of people who do not know one another, who have no common interest. . . . What fatherland can the international banker and the ragpicker have in common? Only when cities, territories, nations, or groups of nations, will have renewed their harmonious life, will art be able to draw its inspiration from *ideals held in common*.[115]

The only way, according to Kropotkin in "Paroles d'un révolté," that artists can now help is to join in labor with the workers and so unite in experience with them:

> And remember, if you do come, that you come not as masters, but as comrades in the struggle; that you come not to govern but to gain strength for yourselves in a new life which sweeps upwards to the conquest of the future: that you come less to teach than to grasp the aspiration of the many; to divine them, to give them shape, and then to work, without rest and without haste, with all the fire of youth and all the judgment of age, to realize them in actual life. Then and then only, will you lead a complete, a noble, a rational existence.[116]

The Neo-Impressionists rejected these directives, whose authors and close followers imagined a conservative rather than avant-garde art in response.[117] Both Signac and Pissarro, for example, rejected any obligation to subjects with a social message in favor of a truly "revolutionary" art of form, color, and line that was true to the artist's sense of beauty. But, despite these very major differences of viewpoint, the artists embraced what they saw as the heart of these ideas, evident in Signac's Kropotkinian line: "Justice en sociologie, harmonie en art: même chose."[118] And although Picasso's generation saw its task as moving beyond the now old-fashioned painting and poetry of the late nineteenth century, they directly inherited these ideas and arguments, going further in the directions already laid out before them. Pierre Quillard, a close friend of Alfred Jarry's and an influential anarchist writer, articulated this position:

> The fact alone of bringing forth a beautiful work, in the full sovereignty of one's spirit, constitutes an act of revolt and denies all social fictions. . . . It seems to me . . . that good literature is an outstanding form of propaganda by

the deed. . . . Whoever communicates to his brothers in suffering the secret splendor of his dreams acts upon the surrounding society in the manner of a solvent and makes of all those who understand him, often without their realization, outlaws and rebels.[119]

Among the many European writers translated and excerpted in Spanish political and literary journals at this time, John Ruskin and William Morris are important for their role in the development of anarchist ideas on esthetics. Unamuno discussed Ruskin in letters after 1895 and in articles such as "La dignidad humana" and "Sobre el cultivo de la demótica."[120] General discussions of Ruskin's work became frequent after 1900. Beginning in 1897, both Spanish and Catalan translations appeared. *A Joy For Ever* was translated and published in 1897, *The Seven Lamps of Architecture* in 1900, and *Of Queens' Gardens* in 1901, a powerful tract criticizing the economic and industrial system. Collections of Ruskin's economic, social, and esthetic essays and lectures were compiled in 1901 and 1903 in Spanish and Catalan.[121]

Although Ruskin's fame was based on his art criticism, after 1860 his writing turned increasingly to political economy and social criticism. Ruskin came to feel that modern civilization, with its "reckless luxury, the deforming mechanism, and the squalid misery of modern cities," makes great art impossible.[122] His *Stones of Venice* had been praised by Carlyle for its analysis of the way architecture reflects a society's morality and religion,[123] an idea closely embraced by his anarchist contemporaries and already put forward by Proudhon. Ruskin furthered such ideas in lectures, for example, "The Relation of National Ethics to National Art," delivered at Cambridge in 1867. These ideas affirmed convictions later held by the Spanish avant-garde. And just as Ruskin lectured to the Working Men's College in London, Adolfo Posada lectured on Ruskin to Spanish workers, and attempts were made to popularize his ideas for their benefit.[124] Generally emphasis was put on Ruskin's hatred of industrialization. Joan Maragall, Catalonia's major poet, discussed Ruskin in terms of the Spanish vision in an article of 1900: "He fights mechanization in industry for being the enemy of beauty in work and for brutalizing the worker . . . he wants to achieve a new social life, founded in the aesthetic ecstasy in life unfolding in an atmosphere of peace and beauty."[125]

William Morris and his socialist medievalism was also translated and discussed in the same period. His play *The Tables Turned* was translated by Fermin Salvoechea, an anarchist, and serialized in the anarchist journal *La Revista Blanca* in Madrid in 1901 when Picasso lived there. Morris's utopian novel *News from Nowhere* was translated and published in Barcelona in 1903.[126] *News from Nowhere* envisages a future England where the inhabitants have abolished private property, and all share work equally; everyone engages in all kinds of work from road-mending to wood carving, that is, from the menial to the artistic; all are equal, no government

directs them, and the concept of "nation," and therefore war, has become inconceivable.[127] Morris's pacifism appealed strongly to the progressive circles in Madrid and Barcelona, already antinationalist and antimilitarist. His utopian vision, as far as it goes, coincided with the anarchist views favored in Spain. It was politically useful as well as morally edifying to receive such support from the "North."

Utopian ideas appear in many of Picasso's works, as his early studies of peasants give way to a self-consciously idyllic pastoralism. From June 1898 to February 1899, convalescing from the scarlet fever he had contracted in Madrid, Picasso lived in a tiny Catalan village called Horta de Ebro (after 1919 Horta de San Juan) with the family of his friend Manuel Pallarés. Picasso himself attached great importance to this visit, the first time in his life that he had lived outside a city. "All that I know, I learned in Pallarés' village," he said later.[128] A new realism appears in the drawings and paintings done during and immediately following his visit to Horta de Ebro; but more significantly, he saw for the first time the simple life of the Spanish village, its seasonal rhythms, its relationship with the land, and its sense of community. Kropotkin, raised in Moscow, had a similar experience in his youth, which contributed to the formation of his ideas on "natural" and "spontaneous" communities.[129] From Picasso's trip to Horta come numerous sketches of men and women working, for example, *Landscape with a Peasant*, 1898–1899 (Fig. 37).[130] This peasant seems almost contained by the land he works, so harmoniously does his shape and presence conform to the natural shapes of the cultivated land. The same could be said of the peasant working in an orchard depicted in another sketch of this period, although in a heavier style.[131]

When Picasso returned to Barcelona and began making trips to Paris the following year, his work concentrated on the decadent night life of those cities, the street life, beggars, and *marginación social*. His *Portrait of Manuel Pallarés*, 1899 (Fig. 38), dressed in a suit and seen against a background of smoking industrial chimneys, contrasts with images of the friend with whom he had camped out in the mountains of Tarragona.[132] But in 1902, and again in 1903, Picasso returned to the themes of rural life, this time exaggeratedly idealizing the peasants after the manner of Puvis de Chavannes's arcadian works. In *Man with a Sack on his Back*, 1902, an idealized, classical nude man walks, bent over by the weight of his sack; but his strength and beauty suggest that he was born for the burden, that it does not degrade him, that instead it represents his natural function.[133] *Pastoral Scene*, c. 1902 (Fig. 39), depicts the same idealized nude figure, now holding a lamb, in conversation with a nude woman (except for her Aragonese head covering) with a baby. A figure behind them reaches to the ground near a grazing flock of sheep. This scene takes place in Arcadia, that idyllic place in early history when men and women lived in complete harmony with nature, before—according to the anarchists—power structures and corrupting governments arose to exploit human la-

bor and interfere with relations and processes that were themselves expressions of nature. At the same time, it represents a world to come, since, as Signac wrote to Henri-Edmond Cross, quoting Malato in *La Revue Anarchiste*, "The age of gold is not in the past, it is in the future!"[134]

For the anarchists the last surviving expression of this ideal time lost in humankind's infancy was to be found in the rural peasantry, still engaged in the same primitive chores and with the same simple relationship to the land and its products. In 1903 Picasso executed a series of pastoral works based on his memories of Horta four years earlier, which suggests the appeal for him of this aspect of anarchist thought. Having already shown "the people how hideous is their actual life" in the slums and alleys of Barcelona and Paris, he now began to explore "what a rational life would be," that double-sided ax that Kropotkin had exhorted artists to wield.[135] *Family at Dinner (Evocation of Horta de Ebro)*, 1903 (Fig. 40), captures the traditional, even ritual, quality of peasant family life, as the mother serves food to her husband and child from an ancient hearth. The simplification of form and calm faces bespeak an enviable tranquillity that seems the inevitable fruit of this simple and natural life. Other works of this series depict Catalan peasants dancing or listening to a guitarist,[136] whose wholesomeness and expression of community with his fellow villagers contrasts powerfully with the isolated urban misery of *The Old Guitarist* of the same period (Fig. 21).

Such pastoralism, contemporary with Picasso's most extreme and heartrending depictions of those same peasants, now urbanized and deprived of their traditional life tied to the land, voices the anarchists' answer to the corrupt and decadent system that authored such misery. As we have seen, Kropotkin, in *Mutual Aid* and *The Conquest of Bread*, wrote at great length developing his ideas on the spontaneous and natural instincts of "primitive" people and societies; such ideas were familiar to and embraced by the modernistes and the Generation of '98. These articles of faith gripped Picasso's imagination—and played a renewed role in his work at the end of that decade—and were inseparable from his generation's Nietzschean convictions regarding the importance of the "natural" spontaneity of the "true" artist. On this issue, social and esthetic theory could become one for those more concerned with pursuing their radical art than with recognizing the contradictions between Kropotkin and Nietzsche. Sabartés recalled of this early period (using the historical present):

> I am aware that something still remains to be said about Picasso's ideas at the beginning of the "blue period," judging from conversations with him at the time.
>
> Picasso believes that art emanates from sadness and pain. With this we agree. . . . We are passing through a period of uncertainty which everyone considers from the point of view of his own wretchedness. . . .

At the same time we maintain—and quite eagerly, since this idea derives from Picasso—that the true artist must ignore everything, that knowledge is a hindrance, because it blurs the visions and impedes expression by depriving it of spontaneity. . . . We affirm that expression can be pure only when it issues directly from the artist . . . In the works of the primitive painters can be discerned all the principles of our doctrine, for they speak an innocence uncontaminated by artifice.

If we demand sincerity of the artist, we must remember that sincerity is not to be found outside the realm of grief, which can be divined in all the pictures Picasso painted in 1901.

Picasso expounds his opinions but rarely, but whatever he withholds may be discovered in his work. Because of the sincerity of his new expression, we prefer these childlike stammerings to academic rhetoric and boisterous eloquence.[137]

Such anti-intellectualism and faith in the pure, direct expression of the artist, attributed by Sabartés to Picasso, were common themes in the artistic circles of Madrid and Barcelona, as well as all the European capitals at this time. The idea that art should be a spontaneous act, unmediated by intellect, comes not from an art-for-art's-sake attitude but, rather naively and grandly, from its opposite. Nietzsche's insistence on untrammeled self-expression played an important role in reinforcing this attitude, especially in Spain where his influence was enormous.[138] Picasso was a friend of Nietzsche's great popularizer in Barcelona, Pompeu Gener, and drew his portrait in 1899–1900 (Fig. 3). Jaume Brossa, also a popularizer of Nietzsche and an active anarchist frequently in trouble with the authorities, was a friend of Picasso's for many years. He, too, brought the cult of extreme individualism and personal liberation home to Picasso in the 1890s:

Man, carried away by a just and iconoclastic pride, the result of the psychological atmosphere created in his intelligence, will no longer tolerate the slightest barrier to his free-ranging mind; and this exaltation of the individual means that not a single myth, not a single idol, not a single entity, human or divine, will remain to stand in the way of the total liberation of individuality. Some people may say that these theories imply a general dissolution; but as well as a negative they possess a positive spirit, one that renews and builds up lost powers and forces.[139]

One of the most important aspects of Nietzsche's influence in Spain was his exaltation of genius, embodied for the Spanish avant-garde in the concept of the *"Yo,"* the "I" or ego. In Spain this became a catchword for Nietzscheanism, adopted by pro and con alike. Hostile critics referred to Nietzsche's "hipertrofía del yo" ("hypertrophy of the ego") and its implied "exaltation of genius and the irrational process."[140] The writer Clarín criticized the anarchist Gener for introducing the

nefarious idea of the *Superhombre* into Spain, "the human manifestation ('la apari-
ción sensible humana') of the Fichtean *yo absoluto*, the latter being determined by
the exigency to 'be(come) what you are.' "[141] For Gener, "the philosophy of
Nietzsche is solely the exteriorization of his ego" ("sólo la exteriorización de su
Yo").[142] Such ideas, popularized by discussion in the *tertulias*, justified to the artists
and writers an extreme bohemianism and, among the younger generation, helped
rationalize outrageous departures from traditional artistic styles in the name of
self-expression.

Picasso, in particular, embraced the idea of the natural outpouring of his ge-
nius in Nietzschean terms. In two self-portraits of 1901, the word "Yo" accompa-
nies a highly self-dramatizing image of the artist. In the first of the two, tradition-
ally known as *Self-Portrait: Yo Picasso*, spring 1901 (Fig. 41), Picasso presents
himself as an exaggeratedly 1890s bohemian, with clean white shirt, enormous
foppish orange tie, and long hair. The large palette and brilliant colors match the
boldness of the crude, energetic strokes of paint, much like van Gogh's. Dramati-
cally emerging thus from an otherwise incongruously dark background, the inten-
sity of the artist's gaze, the manifestation of the direct outpouring of his untram-
meled genius from the dark night of the soul, is affirmed and explained by the
large printed word "yo" in the upper left-hand corner of the canvas. A dash fol-
lows the "yo," distinctly separating it from the much smaller, cursive signature be-
low. The dash and the difference in their appearance show that these two words
do not constitute a sentence, "Yo Picasso" ("I am Picasso"), which would manifest
an as yet undeserved and egotistical proclamation of achievements and at the same
time represent a humor inappropriate to the drama of the image. Rather, the
"yo——" above Picasso's signature announces the fact of his genius, its potential,
and his intention to allow its voice to flow through him unhindered: an act not of
hubris but of genuine bravery in his social and artistic setting.

The second work, *Self-Portrait*, summer 1901 (Pl. II), exhibits the toll his brav-
ery has taken. We confront directly the genius of the artist, whose trappings have
now become irrelevant but whose older face and hypnotic gaze express an almost
unbearable intensity of thought and feeling. This time all but the face of the figure
is plunged into darkness, with strange bright marks of color placed heedless of
form, and the "Yo——" in the upper left-hand corner stands alone. Picasso's sig-
nature, very small as if to deny any possible accusations of narrowly personal ego-
ism, occupies the lower right-hand corner of the work. On a sheet of sketches, of
c. 1902–1903, in a flurry of signatures, he also wrote "Yo el Rey" and "Yo," fol-
lowed below by another signature.[143]

Picasso meant these references to the Nietzschean Superman-artist seriously.
It took a great deal of courage for an artist to brave public censure and to deny his
past training, which for Picasso also meant denying his father and family tradi-
tions.[144] The burning self-portraits were painted on the cusp of his colorful, salable

style and the unmarketable Blue Period. As such they declare his conscious choice, *au très grand sérieux*, of the hard and honest path to the unknown in himself, at the edge of artistic experiment. This idea is crucial, and for many of the artists and writers in the political bohemias of both Barcelona and Paris, Nietzscheanism combined with anarchist notions of the role of the artist in furthering progressive consciousness. As Jean Grave wrote, echoing Oscar Wilde, "art is the supreme manifestation of individualism."[145]

The period from 1901 to 1904, the years in which Picasso moved back and forth between Barcelona and Paris, saw increased unemployment and deteriorating conditions for workers and the poor in Spain's inflated and crippled economy—nowhere more tellingly reflected than in Picasso's contemporary work of the Blue Period. In Barcelona, increasing numbers of strikes and riots were followed by waves of repression and hunting down of "subversives."[146] Catalanisme was under attack by the Madrid government, and many of the modernistes left Barcelona during the agitations. No wonder that Picasso wished to leave. But there were also many positive reasons to move to Paris from the provincial artistic capital of Spain. The north, for the modernistes, stood not only for artistic freedom but also for moral and political freedom. These three aspects of libertarian philosophy were inextricably intertwined. All this held true for Picasso, who affirmed it in a conversation with Maurice Raynal: "Convinced that in Spain he would not be able to express freely the tormented work he had inside him, Picasso came to Paris. Suddenly he was breathing the air of liberty which had been missing. Later he said to me: 'If Cézanne had worked in Spain, they would have burned him alive.' "[147]

The reference to authoritarian intrusion into the very mind of the artist and the image of the Inquisition are not accidental. Paris meant being free of the political repression always threatening in Barcelona; it meant a kind of sexual freedom often imagined but less frequently acted out in Spain; and it even meant a decreasing obsession with these very themes in his work. Picasso could now look beyond the tormented narrative and open himself to the modernist revolution in painting and poetry that Paris offered. Politically he was one with his milieu in the avant-garde circles of Madrid and Barcelona; artistically he took their outrageous theories more to heart and pursued an increasing boldness and antiacademicism in his style that finally went beyond that of his Spanish peers. But he not only maintained a strong adherence to the anarchist esthetic as he pushed his art in Paris to increasingly revolutionary stages over the next ten years, he also continued to deal, both metaphorically and concretely, with political issues that were central to the concerns of the anarchist artists with whom he had matured in Spain. Only this shared anarchist esthetic posture made possible such vast claims as the following—for a penniless artist still at the very beginning of his career—written by his friend Carles Junyer Vidal and published in *El Liberal* at the time of Picasso's move to Paris in 1904:

Picasso is still young; he has not lived a long life yet, but his work is rooted in tradition. It is old and it is modern: old in the impulsive strength which gives his work the completeness of the idea of Art; and modern in its insatiable appetite for the new, an appetite to destroy outmoded prejudices and to overcome former trends which have still survived, though as brittle as glass. . . .

Picasso is more, infinitely more than what many think—even those who seem to know him. He is the beginning of an end.[148]

2. Earthly Salvation

Anarchism and the French Avant-Garde, 1900-1914

Is not the salvation of the soul on earth to be found in a completely new art?
—André Salmon, *La jeune peinture française*, 1912

PARIS, THE intellectual home of anarchism, mothered strong anarchist and social-ist movements.[1] Both groups influenced the course of events in late nineteenth-century France, but it was the anarchist movement that, almost exclusively, won the adherence of the left wing of the literary and artistic avant-garde.[2] With ideas formed among Barcelona's radicals, Picasso moved to Paris in 1904 and almost immediately found his way into an artistic circle, still strongly redolent of symbol-isme, with a history of anarchist thinking and activity. Most significantly for Pi-casso, these anarchist esthetic attitudes were manifested in the life and works of his new friends Guillaume Apollinaire, Alfred Jarry, and André Salmon, who es-pecially influenced the young Spaniard at this time. Such a milieu paralleled his Barcelona experience while encouraging greater artistic radicalism. Anarchist views of the role and importance of the artist provided a serious rationale for styles of art and behavior that looked to the uninstructed like outrageousness for its own sake. Exasperated critics were not wrong to call such self-conscious bohemianism "anarchist," as they frequently did.[3] In this setting, from this moment until the war, Picasso's work passed rapidly from narrative socially critical painting through an experimental primitivism almost unimaginably violent—*Les Demoiselles d'Avignon* is Picasso's la propagande par le fait—to the most daring collaborative artistic revo-lution of the twentieth century: Cubism and the collages. The development of Pi-casso's work will be considered in Chapters 3 through 5. This chapter considers the French background to his work, with special focus on Apollinaire, Jarry, and Salmon.

Paris, 1904

The first thirty-five years of the Third Republic, which was proclaimed on Septem-ber 4, 1870, saw a succession of crises and scandals that destabilized and threat-ened the very success of the republican form of government in France. The Bou-langer crisis in 1887–1889 almost became a military coup and was supported by popular discontent to left and right; the Panama scandal in 1892–1893 exposed

corruption at high levels of government; and the Dreyfus Affair, dragging on for years after 1894, dangerously polarized the entire country. L'Affaire Dreyfus brought France by 1899 to the verge of civil war and ended by discrediting the army, the Church—which had vigorously supported the anti-Dreyfusard position—and a rapid succession of governments all dedicated to covering up the culpability of the army hierarchy. Dreyfus was not finally reinstated in the army until 1906, after a serious and permanent governmental swing to the left and the effective dissolution of the political power of the Church with its official separation from the state in 1905.[4]

Throughout the period from 1896 to 1914, economic prosperity increased for the middle and upper classes but not for those at the bottom. La Belle Epoque saw unprecedented strikes and social unrest. Increasing industrialization paralleled a growing class of urban poor for whom there were no labor laws to limit working hours or to secure safe working conditions and no system of social security when they became too sick or too old to work.[5] Widespread poverty led logically, for some, to the series of anarchist bombings that periodically crippled the social routines of Paris in the 1890s. As in Barcelona, repressive laws were passed that included restrictions on the freedom of the press: up to five years' imprisonment for the crime of provocation, even if the "provocation" did not result in theft, murder, incendiarism, or subversion.[6] Such laws were also used by the French police to harass and control the rapidly growing anarchist movement, though with nothing like the arbitrariness and ruthlessness of its Spanish counterpart; French law was not as easily bent to suit the whims of those in power. France and "the North," while offering a familiar social landscape, also offered Picasso a world of genuinely greater political, sexual, and artistic freedom.

Eugenia Herbert has given us an excellent account of the political side to French avant-gardism at the end of the nineteenth century, its kaleidoscopic variations and passionate arguments. With the exception of Georges Seurat, of whom too little is known, we know that virtually all the associates of the Neo-Impressionist movement were actively involved in social reform on various levels, and that, in France, their views were anarchist rather than socialist.[7] Camille and Lucien Pissarro, Paul Signac, Henri-Edmond Cross, Maximilien Luce, Charles Angrand, Théo van Rysselberghe, and the critic Félix Fénéon, to name the major figures, all took their anarchism extremely seriously. Many aspects of their art were intended to serve a political purpose—the modern, sometimes industrial subjects, the awareness of class differences, possibly even the scientific basis, paralleling Kropotkin's, of their procedures—though above all they were dedicated to expressing their individuality and "sense of beauty."

A large spectrum of political, literary, and artistic attitudes coexisted in the Symbolist movement, one end of which was mildly to flamboyantly anarchist. Thus many Symbolist artistic and literary figures, including Stéphane Mallarmé, Gustave

Kahn, Adolphe Retté, Laurent Tailhade, Paul Adam, and Alfred Jarry, made a public show of sympathy with the anarchists and acceptance of their ideas, especially embracing the radically individualist and subjective side of the movement. Passions ran high on issues of terrorism, syndicalism, "social" art, and art for art's sake, and the 1890s saw a constant stream of argumentative theorizing in the anarchist press and little reviews.[8] Many anarchist leaders and theorists called for an art that the masses could understand and with which they could identify, while those radical individualists, closer to Nietzsche and Stirner than to Kropotkin, fiercely justified their solipsistic and elitist preoccupations in terms of the freedom of the artist and the liberation of the imagination. Though much Symbolist art and literature is extraordinarily elusive in subject and tone, it nevertheless developed in a setting of social criticism and political engagement. Other important Symbolists, such as Emile Verhaeren and Stuart Merrill, were radical socialists rather than anarchists but nevertheless worked closely, in both the artistic and political spheres, with the others.

Other modernists concretely involved with the anarchist movement included Octave Mirbeau, Théophile Steinlen, and Félix Vallotton.[9] Most of these figures and others, including Alphonse Daudet, Anatole France, Pierre Loti, Leconte de Lisle, Mallarmé, Signac, Luce, and Pissarro, subscribed to *La Révolte*. The subscription list of this journal, founded by Kropotkin and edited by Jean Grave, was seized by the police in 1894.[10] Fénéon was sufficiently suspected by the French government as a militant—he was, in fact, found with a hand grenade—to be included in the trial of the "Thirty" following President Carnot's assassination in 1894, along with Grave, the libertarian philosopher Sébastien Faure, and a group of professional "anarchist" burglars.[11] It is a testament to the liberality of the French legal system that all but the burglars were acquitted.

The Pissarros, Signac, Steinlen, Kees Van Dongen, Vallotton, and van Rysselberghe contributed drawings to *La Révolte*, its successor, *Les Temps Nouveaux*, and other anarchist papers and periodicals. Writers contributing to *Les Temps Nouveaux* and *Le Père Peinard* included Mirbeau, Tailhade, and Adam, while Camille Pissarro—who could ill afford it—and Stuart Merrill helped out occasionally with needed financial assistance. In the early 1890s the two leading anarchist journals in Paris, *La Révolte* and *Le Père Peinard*, together circulated over ten thousand copies weekly.[12] By 1905 there were 452 separate anarchist publications appearing in France.[13]

La Révolte and *Les Temps Nouveaux* addressed themselves to the arts as well as to social issues, for reasons as philosophic as propagandistic. Art was an issue central to the anarchists' criticism of contemporary society and to their view of a harmonious future. Proudhon, Bakunin, and Kropotkin all wrote on the subject of art and revolution, exhorting artists to reject the bourgeois system of rewards and boldly to show the world as it was.[14] Kropotkin believed that true artists are the

avant-garde of the future, playing an important role in changing human consciousness and moving it forward. Apollinaire expressed many of these ideas, transformed by the needs of a younger generation, in his poetry and criticism, and Picasso did so in his art.

The leading artistic and literary journals also published anarchist views: *Les Entretiens politiques et littéraires*, *La Revue Blanche*, one of whose editors was Fénéon, *Le Mercure de France*, edited after 1885 by Rémy de Gourmont, *La Plume*, and *Le Coq Rouge*. These journals published current criticism and reviews by Paul Valéry, Henri de Régnier, de Gourmont, Mallarmé, Tailhade, Verhaeren, Merrill, Kahn, René Ghil, Adam, Fénéon, Charles Morice, and others.[15] Of these, Herbert mentions Verhaeren, Adam, Fénéon, Ghil, Merrill, Tailhade, and Kahn as self-professed social radicals. But the others, less committed, were nonetheless sympathetic in their support of the activists. As in Barcelona, such reviews were published alongside translations and excerpts from anarchists and others co-opted by the movement: Jean Grave—the leading French anarchist—Wagner, Nietzsche, Kropotkin, Marx, Bakunin, Elie and Elisée Reclus, Emile Vandervelde, Max Stirner, William Morris, and others. The Symbolist milieu was thus saturated with politics, and writers and artists publicly took positions in response to political events as well as debated how art could best serve the revolution. Picasso arrived in the latter heyday of this bohemia, as a younger generation contemplated its partial escape to the future.

During Picasso's first trips to Paris between 1900 and 1904, he spent his time with the Spanish colony, a shifting group of artists, writers, and radicals. He had known many of them well in Barcelona: Ricard Canals, Ramon Pichot, and Isidre Nonell (all of the Colla Sant Martí with which Picasso had been associated there), Hermen Anglada, Paco Durio, Manolo Hugué, Joaquim Sunyer, Carles Casagemas, Jaime Andreu Bonsons, Jaime Sabartés, Mateu Fernández de Soto, Sebastià Junyer Vidal, and anarchist activists Jaume Brossa and Alexandre Cortada, whom Picasso caricatured in a letter to Ramon Reventós in 1900: "El Señor Cortada, jefe del comité separatista."[16]

The French police have left a telling image of artistic/political life in this period in their surveillance reports of meetings of artists and anarchists: on January 11, 1900, "Les Iconoclastes" (a group of artists who met regularly, and were regularly under surveillance, from at least 1900 to 1904) met at the Café des Artistes, 11, rue Lepic (Montmartre) to hear Bariol, with leading anarchists Sébastien Faure, Malatesta, Charles Malato, and "Libertad" (the latter two were Spanish) in attendance; on March 14, 1900, "an anarchist read the brochure of Peter Kropotkin, 'La Morale anarchiste.' "[17] Such meetings were typical, in both Paris and Barcelona, of the way knowledge of the ideas of Kropotkin and others became communal intellectual property. Picasso continued to see his old Spanish friends

throughout his years in Paris, but he also began to meet French avant-garde poets and artists.[18]

When he moved to Paris permanently in 1904, Picasso found himself in a very familiar social and political climate. He made his way into the French Symbolist/ anarchist circle with remarkable rapidity. Taking over the studio of Paco Durio— friend and follower of Gauguin—in the Bateau-Lavoir in April, he soon met Guillaume Apollinaire and André Salmon.[19] By the autumn of 1904 Picasso and Max Jacob, whom he had met in 1901, were accompanying Salmon and Apollinaire to the various soirées of the older Symbolists, including the gatherings sponsored by the journals *La Plume* and *Vers et Prose*. Here Picasso met Alfred Jarry, Paul Fort, Fénéon, Tailhade, Kahn, Verhaeren, Merrill, Signac, Sérusier, Jean Moréas, Charles Morice, and a host of lesser figures, including socialist poet and journalist Alexandre Mercereau and anarchist Mécislas Golberg, who about that time was writing *La Morale des lignes*.[20] Although the entire world of the French artistic and political bohemia confirmed in Picasso the anarchist esthetics he had already absorbed in Barcelona, Apollinaire, Jarry, and Salmon were especially important since they became his closest friends and strongest influences and had their own histories of interest in anarchist ideas. Their relation to the anarchist movement and that of their work to anarchist ideas and attitudes are the subject of this chapter.

As a reminder, however, of Picasso's familiarity and absorption with issues of an anarchist art at the time he met these writers, we can look briefly at a little book of poems by Félicien Fagus—art critic for *La Revue Blanche*—which Picasso eagerly pressed into Salmon's hands the first night of their meeting[21] (a small vignette that incidentally contradicts Picasso's later posture of anti-intellectualism and indifference to books). Fagus's *Testament de ma vie première* is a collection of anarchist poems by one fervently loyal to the movement and its themes. It includes a poem that may well have especially appealed to the young artist, "Variation autre sur le vieux thème," which is addressed to "le Printemps" ("Spring"), the God who "made Impressionism," and includes the following lines:

> You make rain on the baskets / Of the little flower-sellers, / Such lovable horrors / That the bourgeois takes colic / Thinks he is seeing the heretical splendors / Of Van Gogh and Pissarro, / And commends with terror, / Passing before the stalls / Of the little flower-merchants, / His poor soul to Our Lord, / To Our Lord Bouguereau![22]

Bouguereau, the arch-academic painter, here serves for the bourgeois as a narcotic against the shocks of reality. There are also numerous antiwar poems, including a marching song, "Chanson de route," dedicated all too accurately "To My Future Brothers-in-Arms," which we are asked to sing in the café-concert, obviously with a great show of mockery, to the tune of "La Marseillaise." It begins:

We are being led to the butchery;
Why? No one has said . . .
It appears that it's *la Patrie*
That needs us to be dead!
 March! march! it's *la Patrie*,
 March! march! that we serve!

And concludes:

But our mission is big,
If we kill, if we die,
It's for the wealthy pig
Asleep in his money-sty!
 March! march! it's *la Patrie*,
 March! march! that we serve![23]

Though our taste for this sort of poetry may have dimmed in the intervening years, its sounding of anarchist themes is loud and clear: ridicule the bourgeoisie, mock the notion of loyalty to the state, pour scorn on the rich, refuse to fight in any war, and embrace the newest and most outrageous art, which can be recognized by the vehemence of its rejection by the bourgeoisie. Picasso had done, and would do again, all these things. But they were only possible, as publicly proclaimed positions, when the bohemia in which he moved was also proclaiming them.

Anarchism and Apollinaire

Apollinaire was of that generation of artists drawn to the Symbolists out of admiration for their great poets, their rejection of bourgeois values, and their politicization of this stand, though he was apt to ridicule the Symbolists' hyperesthetic poses and delicate mysteries. As a schoolboy in Nice in the mid-1890s, Apollinaire copied the poetry of Verlaine, Mallarmé, and Rimbaud and imitated their allusive styles in his own poetry.[24] In 1897 he produced an anarcho-Symbolist "newspaper," *Le Vengeur*, with poems and articles by himself ("Guillaume Macabre") and his friend Toussaint-Luca.[25]

Attracted to anarchism for its affirmation of individualism and its stand against bourgeois society, Apollinaire would have found anarchism inseparable from the artist's struggle in a money-grubbing culture of boors and philistines. A messianic character in Apollinaire's youthful novel of 1900, *Que faire?*, expresses, in his characteristic absurdist mode, the anarchist's credo that man is not intrinsically evil but corrupted and that all men and women are redeemable once the oppressive fictions of history and religion stand exposed. Dr. Cornelius Hans Peter announces: "On my arrival on earth I found humanity on its last legs, devoted to

fetishes, bigoted, barely capable of distinguishing good from evil—and I shall leave it intelligent, enlightened, regenerated, knowing there is neither good nor evil nor God nor devil nor spirit nor matter in distinct separateness."[26]

Settling permanently in Paris in 1902, Apollinaire soon met important figures in the anarchist/Symbolist movement. Fénéon introduced him at *La Revue Blanche*, which published a few of Apollinaire's poems, stories, and articles. He also published in 1902–1903 in *L'Européen*, a pacifist journal, columns of which he was inordinately proud, according to Salmon's memory.[27] In 1903 the avant-garde review *La Plume* published Apollinaire's "Avenir," a poem, as Adéma notes, "still strongly marked by his youthful anarchism."[28] At the wild soirées of *La Plume*, famous in the 1890s and reinstated in April 1903, Apollinaire met Stuart Merrill, Paul Fort, Jean Moréas, André Billy, André Salmon, and, most significantly for his future work, Alfred Jarry.[29] In his address book, preserved at the Bibliothèque Nationale in Paris, he recorded the addresses of all these and of Paul Adam, Henri Barbusse, Georges Darien, Gustave Geffroy, Gustave Kahn, Octave Mirbeau, J. H. Rosny, elder and younger, and Laurent Tailhade, all writers and all devoted to the anarchist cause.[30]

Later that same year Apollinaire and Salmon started their own review, *Le Festin d'Esope, Revue des belles lettres*, "une société d'esprit libertaire,"[31] which published nine issues from November 1903 to August 1904. Arne Hammer, an editor of the pacifist *L'Européen*, was associated with the new review, and Jarry contributed poetry and advice.[32] *Le Festin d'Esope* included stories and poems by Apollinaire; poems by Salmon and Jarry; an article by their friend Polish anarchist Mécislas Golberg, entitled "Lettre à Alexis sur la Passivité"; "Chronique," a column probably by Apollinaire, discussing a radical-socialist group; political commentary by Apollinaire's friend the Albanian revolutionary "Thrank-Spirobeg" (Faïk bég Konitza)[33]; and a translation from Czech, "Lettre d'un condamné à son défenseur," by Otakar Theer. Such a combination of politics and art was typical of avant-garde reviews of the period—its closest model was *La Plume*—though *Le Festin*, like Picasso's *Arte Joven*, flirted with anarchist outrageousness somewhat more flamboyantly. Readers interested in politics and social movements were referred to various European journals such as *L'Européen*, *Die Zukunft* of Berlin, *Die Zeit* of Vienna, and *Albania* of London. Various "forthcoming" books and plays were announced, including a "social theater" with a humanitarian and pacifist message, to be advertised by Salmon and introduced by Apollinaire, though it apparently never materialized.[34]

After *Le Festin d'Esope* folded for lack of funds, Apollinaire concentrated until 1910 on contributing to other less radical but more solvent journals, publishing social criticism, art criticism, poems, and stories in such periodicals as *La Plume*, *Le Temps*, *La Grande France*, *La Revue d'art dramatique*, *La Phalange*, *Poésie*, *La Revue Blanche*, *Vers et Prose*, *Tabarin*, *La Revue des Lettres et des Arts*, *Paris-Journal*, *Je dis tout*,

Arts et Spectacles, and *Les Marches de l'Est*.[35] Around 1909–1910 Apollinaire regularly contributed political columns to *La Démocratie sociale*—a militant republican journal dedicated to social reform—both under his own name and as "Polyglotte," a speaker of many tongues reviewing items and concerns in foreign journals.[36] The column Apollinaire signed with his own name discussed mostly literature and social gossip; *in propria persona* he was more frequently political.

Although the majority of journals Apollinaire reviewed were German, he also—as a genuine polyglot, though he doubtless received help—reviewed periodicals published in the United States, Great Britain, Italy, Poland, Spain, Switzerland, Greece, Hungary, Russia, and Belgium.[37] The subjects that attracted him—he seems to have had complete freedom in the choice of content and its treatment—concern exactly those areas of interest to the left-wing intellectual. Here is a sampling from a three-month period in 1910: French imperialism in Abyssinia, prison reform, German socialism, Spain's economic future and its fight against the workers' movement, the history of organized labor in the mines of Sweden, the movement to improve conditions for Italian soldiers, organized labor in America's shoe factories, the role of French capital in foreign countries, white workers in the tropics, *Memoirs of a Socialist* by Lily Braun of Munich, railroad strikes in America, Prussian electoral reform, the Bosnia-Herzegovina constitution, Nietzsche and Hungary's great poet Petoefi, the "Finland Question" regarding Russian rule, poverty in London, social politics in Switzerland, and the "Jewish Question" in Poland, an issue gathering force at the turn of the century.[38]

Apollinaire continually returned to issues of anarcho-syndicalism, anticolonialism, and antimilitarism in these small journalistic pieces. In a review of a book on "Militarisme aérien" in *La Démocratie sociale*, No. 12, March 19, 1910, he wrote of optimism and faith in a future world of universal peace, though not perhaps without a trace of irony: "Aerial militarism, according to the German author, will render war, so to speak, impossible. According to him, the deadly machines will acquire, because of the freedom with which they will manoeuver in the air, an unheard-of power, and universal peace will have been born out of the high value of this weapon and above all out of its destructive precision."[39] This idea is interestingly paralleled in Picasso's doubtless equally ironic allusion, in a series of paintings of 1912, to a French pamphlet propagandizing the military use of the airplane, discussed in Chapter 5. Caizergues, in his valuable article, "Apollinaire journaliste," notes:

> It is with these words that the new column, "la vie anecdotique," opens: "I love people, not for what unites them, but for what divides them; and hearts—I want above all to know what torments their hearts." The approach of the anecdotist consists therefore, essentially, in a sharp consciousness of flaws, of lacerations marked as much on an individual level as on a social level, which

conducts him quite naturally to an interest in minorities ethnic, sexual, political, artistic, in all those on the fringe, in all those not counted, that the journalist thus brings out of the darkness, or the ghetto where they are usually relegated.[40]

Such, exactly, are the subjects of Apollinaire's voluminous prose in these journalistic columns.

Apollinaire continued to manifest such political concerns not only at the beginning of his journalistic and editorial career but throughout the prewar period. When he again found himself editor of *Les Soirées de Paris* (1912–1914), the mix of art and politics familiar from *Le Festin d'Esope* strongly characterized the journal, following in the footsteps of the most overtly political of the established literary reviews, *La Plume*. In addition to art criticism and poetry, including his own, Apollinaire's journal published dispatches from the Balkan Wars; followed the arrest and trial of the "last" gang of anarchist bandits, *la bande à Bonnot*; presented lengthy discussions of such earlier anarchiste-symboliste poets as Paul Adam and Laurent Tailhade, specifically including their politics, and of purely political figures such as Victor Barrucand and anarchist leader Zo d'Axa; and printed a memoir of the Commune of 1871.[41] A piece by Salmon in *Les Soirées* amusingly meditated on the changing relations of poetry to political radicalism:

> Until I was twenty life was beautiful. . . . Everything was easier. The free-verse poets were revolutionaries and the regular poets were republicans. Magre or Vielé-Griffin, one could choose. It was very convenient. Today everything is more complicated, one is utterly confused. One no longer even knows who is a *vers libriste*; the republicans are revolutionaries and each is classic. It is too difficult, I renounce it.[42]

Les Soirées also published antimilitarist pieces, including a satire on military pomp by Jarry and a body of his unpublished letters, as well as artworks, including two of Jarry's *Ubu roi* marionettes and Picasso's collage-constructions. Thus Apollinaire's mixture of art, real-world politics, and political satire represented the perfect mingling for him, and for his circle, of all that should concern the true modernist.

In 1910 Apollinaire took over Salmon's post as the regular art critic for *L'Intransigeant* ("La vie artistique"), and in 1911 he began contributing a regular column, "La vie anecdotique," to *Le Mercure de France*, setting himself up as the leading critic of avant-garde art in Paris in established vehicles of avant-gardism for the previous, Symbolist, generation. He did not leave his political sympathies behind in his art criticism. For example, in 1908 he discussed the political nature of Kees Van Dongen's work, an interpretive notion that would seem questionable if not for the artist's open anarchist affiliations and the fact that Apollinaire—through Picasso—knew him at his home in the Bateau-Lavoir:

M. Van Dongen aggressively manifests some formidable appetites. He feels at home in the midst of turmoil and seems to be exhibiting his political opinions. This is not the bitterness of a Multatuli, but rather the violence of a Domela Nieuwenhuis [two Dutch political figures, the first a reformer, the second a militant socialist].

M. Van Dongen transports us among giants who resolve social questions shamelessly. He always leaves us with a painful impression. He prostitutes his noblest and most beautiful colors to these urban humiliations, which he notes with the eye of a foreigner.[43]

In an article of 1910, Apollinaire praised an otherwise arrière-garde work by Father Van Hollebeke because it commemorated the recent legal separation of Church and state in France in 1905, still a fiery issue at that time.

More significantly, in these columns Apollinaire can be fairly characterized as sallying forth, on a virtually daily basis, to defend the rights of modern artists, praise their "sublimity," and above all explicate over and over again the obligation of the artist—and by implication the art critic—to be the voice of the future and the herald of the new. Numerous critics have noted Apollinaire's growing preoccupation with novelty and innovation in the early years of his friendship with Jarry and Picasso.[44] His determination to promote always the newest and most outrageous works of art seemed to come from his belief in their importance as manifestations of modernism rather than their significance as individual works, to which he would rarely devote more than half a line. Salmon in his memoirs took some pains to distinguish this aspect of Apollinaire's art criticism from his own:

> I did not need to be in accord on all points with Guillaume [who was] floating from Picasso to Matisse, turning with a little inquietude around Derain, and, I think, awakened to the taste for the new art by Vlaminck, [whom he] met in the train from Chatou. . . . I loved the art of painting; I placed several painters above others; Guillaume Apollinaire preoccupied himself above all with valuing all that aided him in the affirmation of this *Esprit nouveau*.[45]

Apollinaire's value for historians of modern art has long been debated. To what extent his writing faithfully represents, for example, Picasso's thought is indeed arguable, though recent scholarship has tended to temper the devaluation of Apollinaire as a reliable source.[46] He perhaps too frequently made claims with little knowledge or understanding of those he defended and often enough created rows in the press and made enemies of those he meant to praise.[47] But there is no doubt that Apollinaire meant his critical endeavors to parallel the artistic efforts of his painter-brothers, and he knew well, from Jarry and Picasso if from no one else, where to recognize audacity and outrageousness. Here is Apollinaire's childhood friend James Onimus:

In 1905 or 1906 I saw him again in Paris. He took one of my friends and me to the Louvre, to the gallery of antiquities. He spoke with great verve against the *Antinoüs*; it wasn't that he was trying to destroy classical sculpture but rather that in his love for a new art, for the need to surpass all that was known in art, he was attacking the foundations, impeccable in themselves, but the consequences of which lead to the academic style.[48]

More than just defending any and all manifestations of modernism, Apollinaire in his defenses expressed many of those optimistic faiths of the anarchist estheticians. Thus the new art is not merely different from that of the past but heralds a new beauty and a new era with wholly changed attitudes toward humanity.

I personally am a great admirer of the modern school of painting, because it seems to me the most audacious school that ever existed. It has raised the question of what beauty is in itself.

The modern painters want to represent beauty detached from the pleasure that man finds in man—and that is something that no European artist, from the beginning of recorded time, had ever dared to do. The new artists are searching for an ideal beauty that will no longer be merely the prideful expression of the species.

And, Apollinaire continues, art further plays a social role in expressing this new spirit:

One could give the following definition of art: creation of new illusions. Indeed, everything we feel is only illusion, and the function of the artist is to modify the illusions of the public in accordance with his own creation. . . . It is the function of Art, its social role, to create this illusion . . . [which] seems quite natural to me, since works of art are the most dynamic products of a period from a plastic point of view. This dynamism imposes itself on human beings and becomes, through them, the plastic standard of a period. Thus, those who ridicule the new painters are ridiculing their own faces, for the humanity of the future will form its image of the humanity of today on the basis of the representations that the most vital, that is, the newest, artists will have left of it.[49]

As with Kropotkin's idea that the art of ancient Athens expressed the deepest truths of the whole culture, at every social, political, and philosophical level, so with Apollinaire's contemporaries in the modern era. In this light, Apollinaire criticized the army of fellow critics who rejected the new art, carefully pointing out their oft-reiterated allegiance to authority:

The cubists, whatever individual tendency they belong to, are considered by all those who are concerned about the future of art to be the most serious and most interesting artists of our time.

And to those who would seek to deny a truth so manifest, we reply simply that if these painters have no talent and if their art deserves no admiration, then those whose job it is to guide the taste of the public should not talk about them.

Why so much anger, honored censors?
The cubists don't interest you? Then don't be interested in them. But instead, we have indignant cries, gnashing of teeth, and appeals to the government.

Such a venomous spirit in our art critics, such violence, such lamentations, all prove the vitality of the new painters; their works will be admired for centuries to come, while the wretched detractors of contemporary French art will soon be forgotten.[50]

In a complete inversion of traditional proofs of excellence in art, Apollinaire here avowed that it was these critics' very rejection and horror of the new art that *proved* its certain value. He concluded: "We must not forget that people fired at Victor Hugo. His glory was not diminished by that fact. On the contrary." If the outrageousness of one's art, or one's critical posture, provokes a negative reaction, it must have hit a real chord. What could seem a mere defensive reaction is based instead on a faith that these artists are paving the way for a new social and psychic order, which the old order deeply recognizes and resists. For Apollinaire, as for Jarry and Picasso, outrageousness sufficed in its own right to push the frontiers of art forward into that unknown—but unquestionably better—future envisioned by the anarchist prophets. The path they were to follow was laid out by Kropotkin and, not contradictorily to them, by Nietzsche and was already familiar to Picasso, Apollinaire, and Jarry in the 1890s: to love genius, to trust that inspiration speaks with a true voice, to reject and rise above the mediocrity of the bourgeois society which is death to art, and above all to embrace freedom—artistically, morally, politically.

Apollinaire repeatedly sounded these themes in his art criticism. In *Les Peintres cubistes: méditations esthétiques*, published in 1913 but written between 1905 and 1912, he wrote of Picasso: "A new man, the world is his new representation. He enumerates the elements, the details, with a brutality which is also able to be gracious. New-born, he orders the universe in accordance with his personal requirements, and so as to facilitate his relations with his fellows. The enumeration has epic grandeur, and, when ordered, will burst into a drama."[51] In 1912 he announced in *Les Marches de Provence*: "Picasso ranks among those of whom Michelangelo said that they deserve the name of eagles, because they surpass all others and pierce through the clouds until they reach the sunlight."[52] Meditating on the nature of the critic in 1914, he envisioned for himself a similarly exalted role: "The critic must be as accurate as posterity; he must speak in the present in the words of the future."[53] And in 1918, in the preface to the *Catalogue de l'Exposition Matisse-*

Picasso at the Paul Guillaume Gallery—in one of his highest flights of prose—Apollinaire pictured Picasso as a Zarathustrian *Übermensch* making unprecedented forays into the unknown:

> Picasso is the heir of all the great artists of the past. Having suddenly awakened to life, he is heading in a direction that no one has taken before.
>
> He changes direction, retraces his steps, starts out again with a surer, ever-larger step; he gains strength from his contact with the mysteries of nature or from comparisons with his peers of the past. . . .
>
> In Picasso, talent is augmented by will and patience. The aim of all his experiments is to free art from its shackles.
>
> Is his not the greatest aesthetic effort we have ever witnessed? He has greatly extended the frontiers of art, and in the most unexpected directions.[54]

Apollinaire sees his "new" men re-ordering the universe; what they write and paint will be fully intelligible only to the future because art—and therefore the mind—will be freed from its shackles and will live in the sunlight. Such utopian ideas are estheticized images borrowed from social theory, and they directly reflect the anarchist dreams Apollinaire, Picasso, and a whole generation grew up on.

Sexual freedom was no minor subject to the Parisian anarchists or to Apollinaire, Jarry, and Picasso. Since his early years in Paris, Apollinaire had written pornographic novels for a living, increasingly out of the conviction (or rationalization) that it constituted an act of moral freedom.[55] Where Kropotkin and his generation created a moral system in their anarchist view of the world, the later generation of anarchist artists often rejected the very idea of a moral system, outraging "bourgeois" moral values for the sake of breaking taboos. When Apollinaire founded his second, short-lived journal in 1905, he called it *La Revue immoraliste*. But that this took on a new moral tone is evident in the seriousness with which he approached his scholarly editions—translated, annotated, and with bibliographies—of earlier pornography, including de Sade, Baudelaire, and John Cleland's *Memoirs of Fanny Hill*.[56] He also undertook, with Fernand Fleuret and Louis Perceau, a bibliography of all such holdings in the Bibliothèque Nationale, compiled in secret and remaining the standard reference to this day.[57]

The key to such thought is the idea of individual liberty, which remained a serious note in all of Apollinaire's art criticism. His last lecture, delivered a year before his death in November 1918, concluded: "We can hope, then, in regard to what constitutes the material and manner of art, for a freedom of unimaginable opulence. Today poets are serving their apprenticeship to this encyclopedic liberty."[58] It is important to note here that for the modernists art is inseparable from life—and in this sense artistic freedom takes a genuinely political stand against a restrictive and moribund society. Apollinaire brooded in this vein on society as

much as on art, at times sounding almost as pessimistic as the author of *1984*. At the beginning of the war, he wrote in *Le Mercure de France*:

> By destroying liberty, this war which the Germans made inevitable arouses our curiosity about people in earlier ages who could live as they liked. The conditions which such an existence requires have never been met as in the eighteenth century. We can well fear that, after the peace, these conditions may never return, and that regimented men sealed off inside their nationalities, races, professional and political groups, men organized in docile herds, may never again dream that there was a time when one could do what one wanted.[59]

Such freedom had to be flaunted to be exercised at all. Apollinaire's favorite word for good, progressive, and important art was "audacity."[60]

A brief look at Apollinaire's own poetry shows that he followed a path similar to Picasso's, from an early Symbolism through an awareness and criticism of the society around him to a modernist idiom. This new language of modernism, in its surprising juxtapositions, recreates aspects of "modern" experience and combines art and reality through the honest pursuit of esthetic adventure on the part of the artist; as Apollinaire styled himself in "La Jolie Rousse," "fighting always in the front lines / Of the limitless and of the future."[61]

In his earliest works of c. 1900, Apollinaire played with symboliste imagery and paid homage to such poets as Verlaine and, especially, Mallarmé, with their delicate harmonies, suggestive floral symbols, and obscure, allusive figures. In "Le Larron" of c. 1900, a magician represents the poet, rejected by the solid folk who own the trees from which he has stolen fruit. "Maraudeur étranger malheureux malhabile" ("marauder foreigner wretch derelict"), they call him; but then they say, "Il pleure, il est barbare et bon" ("He is crying, he is barbaric and good").[62] Such themes of the social/artistic outcast, the sensitive and therefore "barbarian" and primitive soul, and the mysterious stranger mix ivory-tower symbolism with a political sensibility increasingly evident during the years of L'Affaire Dreyfus. In 1898 Apollinaire declared himself a Dreyfusard and expressed his sympathies with the anarchist movement.[63] Breunig has discussed one of Apollinaire's unpublished poems from this period, "Au Prolétaire":

> It is frankly bad . . . largely because of the clash between the subject matter and a highly precious vocabulary: the smoke from the ugly factories is blown by the "aquilon," the proletarian seamen who have drowned are lulled by "nenias" or Greek funeral dirges. Yet for all its awkwardness the poem reveals that Apollinaire was becoming attuned to a new source of inspiration, the modern industrial city, and like the Belgian poet Verhaeren was trying to combine the urban themes of naturalism with the techniques of symbolism.[64]

These works also parallel paintings of Picasso's Blue and Rose periods, and though the two artists did not meet until 1904, they quickly recognized their shared view of society and their artistic purpose in it.

In the landmark poems of 1907–1909, "Le Brasier," "Les Fiançailles"—dedicated to Picasso—and "Vendémiaire," Apollinaire played with his new modernist style of juxtaposition, ambiguity, and secret, unexplained allusions. This style developed, not unexpectedly, in relation to the art he saw emerging during his years as a critic. Shattuck characterizes the complexity of this art in both media:

> The formal techniques of juxtaposition, with the components of play, nonsense, and the absurd, provide the most apt vehicle for the mood and content of the arts in the Banquet Years. The child-man who travels in a world of incipient humor, dreams, and multiple meanings, must so dispose the elements of his mind that they represent both his reason and his unreason.
>
> Inevitably the two categories of juxtaposition entail a set of characteristics often criticized in modern art—obscurity, illogicality, inept style, abruptness. "Abruptness," in fact, means, precisely, lack of transition. Apollinaire dubbed it *surprise* and singled it out as one of the fundamental traits of our era.[65]

This is an important aspect of Picasso's work of the same period, where primitivism, muffled allusion, irrationality, and lack of transition constitute surprise indeed. Breunig has called "Les Fiançailles" Apollinaire's *Demoiselles d'Avignon*.[66] But more than a group of techniques or associated themes, the poem represents a more important shift in Apollinaire's esthetic. Steegmuller and Décaudin have argued that "Les Fiançailles"—and its dedication to Picasso—testifies to the role played by Picasso and other artists in opening Apollinaire to ways of fusing art with life and the necessity of this new fusion in revitalizing art and poetry.[67] The nature of this shift is all-important and should seem strikingly familiar from anarchist tracts. Their contents, well known to Picasso and other "anarchist artists," had long viewed painters and poets as marching toward the future in advance of the rest of mankind by virtue of their artistic boldness and their unique ability to reveal the truth, unhampered by tradition. Art, for the true modernist, was connected to everything: one's life, one's morality and politics were an inseparable part of one's art. Salmon, in a letter (undated but after World War I) to Jean de Pierrefeu (in which he casts doubt on Francis Carco's memoirs—"I esteem him very much, but he was not in our soviet"), affirms this central idea from the time that he, Apollinaire, Jacob, Pierre MacOrlan, Picasso, and Derain were "jeune par principe": "the people of 1895 impelled me to take a manifesto: Do not put life into art but restore art in life. Apollinaire, himself, dreamt well of something identical. . . ."[68]

Style alone, however, was no more Apollinaire's exclusive concern than Picasso's, and his greatest contribution is usually considered to be the introduction of

modern, urban subjects in his poetry. "Zone," the opening poem of *Alcools* though one of the last written (1912), and "Vendémiaire," the closing poem (1909), record Apollinaire's meditative walks through Paris. The "zone" refers to the slums on the outskirts, which Apollinaire frequently seeks out in the poem: "I love the grace of this industrial street."[69] Although "Zone" is a profoundly sad poem, it nevertheless celebrates aspects of modern life, ones that are strongly reminiscent of Picasso's contemporary collages, both in specific content (see Chapter 5) and in their abrupt intrusion into Apollinaire's other thoughts: "You read the handbills, catalogues, posters that sing out loud and clear—/That's the morning's poetry, and for prose there are the newspapers,/There are tabloids lurid with police reports,/Portraits of the great and a thousand assorted stories."

The opening of "Vendémiaire" locates Apollinaire's meditations in time by exhorting "Men of the time to come, remember/Me, I lived when the kings were finishing," referring to recent assassinations and attempted assassinations[70] as well as to the aspirations of the whole epoch. And, more than merely finding a new subject for poetry, Apollinaire felt it an obligation to record and respond to the modern world. His *calligrammes*, discussed in relation to Picasso's Cubism in Chapter 4, not only take *vers libre* beyond the breaking point in form but centrally incorporate the experience of such inventions as the telegraph, with its resulting miraculous (and yet reduced) communication, and the Eiffel Tower, whose aerial view forms the shape of the poem and whose radio tower at the top received and transmitted the telegraphic messages.[71]

Such poetry apparently was only possible at that one small moment in time, according to Apollinaire, who wrote to André Billy: "As for the *Calligrammes*, they are an idealization of free-verse poetry and typographical exactness at a time when typography is brilliantly finishing its career, at the dawn of new modes of reproduction which are the cinema and the phonograph."[72] These aspects of his poetry reflect the concerns of the whole group, *la bande à Picasso*, and, though Apollinaire's work—like that of his companions—is too frequently treated by scholars as apolitical, his poetry cannot be understood in artificial isolation from the social matrix and high-flown political rhetoric that inspired him.[73]

Anarchism and Jarry

If life and art became inseparable expressions for Apollinaire and Picasso, this was all the truer for Alfred Jarry, who encouraged both artists to hurry in directions they were already headed. Most observers agreed that Jarry was the artist whose life was his major work; as Salmon put it, "Père Ubu slipped two pistols in Alfred Jarry's belt."[74] Jarry's invariable mode of transportation (bicycle), dress (bicyclist), weapon (pistol), talk (nonsense), voice (monotone), lodgings (absurdist), and behavior (outrageous) are all continuous with his art in the most fundamental way.

They express a view of the world that is antitraditional, bourgeois-baiting, destructive, and resolutely "modern."

Despite the apparent anarchism of Jarry's whole act, often noted as such by literary and art historians,[75] the political component of this anarchism—one would think its most salient feature—is continually overlooked. Jarry's anarchism was not a metaphor for his artistic revolt; his artistic revolt, along with his dress, behavior, etc., was part of his anarchism. He rejected contemporary society on every level as an irrelevant shrine to the past, deriving its power from the cynical perpetuation of a political and social status quo. The very titles of his Ubu productions tell us that he saw life around him as stagnant rather than dynamic—*Ubu roi, Ubu colonial*—presenting anachronistic political arrangements as static, verbless, intransitive. Since society should be dynamic rather than stagnant, Jarry's self-appointed role was that of prod, a prod whose political point was unmistakable to his contemporaries.

In *Ubu colonial*, a section of *Almanach illustré du Père Ubu* published in 1901,[76] Father Ubu meets Dr. Gasbag on his return from "the disastrous voyage of colonial exploration undertaken by us at the expense of the French government"; like the bloated, self-satisfied bourgeois that Ubu represents, seeking profits for himself at the public's expense, he brags of his adventures:

> Our first difficulty in those distant parts consisted in the impossibility of procuring slaves for ourself, slavery having unfortunately been abolished; we were reduced to entering into diplomatic relations with armed Negroes who were on bad terms with other Negroes lacking means of defense; and when the former had captured the latter, we marched the whole lot off as free workers. We did it, of course, out of pure philanthropy, to prevent the victors eating the defeated, and in imitation of the methods practiced in the factories of Paris. Desirous of making them all happy and of ensuring their general welfare, we promised them that if they were very good we should grant them forthwith—after ten years of free labor in our service, and upon the establishment of a favorable report by our galley sergeant—the right to vote and to produce their own children themselves.[77]

"In imitation of the methods practiced in the factories of Paris" brings home the parallel between the exploitation of poor workers at home and the search for even cheaper labor abroad. In a chilling exhibition of doublethink, Ubu adds, "In order to assure their security, we reorganized the police force; that is to say, we suppressed the police inspectors, who had not yet been appointed in any case, and substituted for them a sleepwalking clairvoyant who denounced malefactors to us."

This anticolonial theme, already familiar to us in Apollinaire, is repeated a number of times in the Jarry canon. Later in *Ubu colonial*, Ubu brags about a successful scam, notably reminiscent of the Panama Scandal of the early 1890s, in

which he raised subscription money to build an "inland port." In "Connaissances utiles et inventions nouvelles" ("Useful Knowledge and New Inventions"), Ubu invents a giant umbrella, to be carried at the four corners by "four Negro slaves":

> But since the Negroes might have yielded to the temptation of taking some advantage of the shelter reserved to our own strumpot, which would have been irreverent; and since the passers-by, seeing Negroes meticulously preserved from all humidity, would have found it difficult to believe that these were genuine dyed-in-the-wool Negroes, a supposition which would have lessened the sumptuousness of our progress and made us prone to the charge of stinginess; and since, though totally innocent of this last vice, we should be very reluctant to acquire full color or even washed out Negroes; we finally resolved to suppress the very idea of Negroes, or at least to keep it in reserve.[78]

Inverting what he saw as the fiction of Western cultural and racial superiority to "primitive" peoples, Jarry tells us that a Negro fled from a bar in Paris without paying for his drinks; in Jarry's account he asserts that, not at all a criminal, the man must have been an explorer from Africa investigating European civilization and caught without "native" currency.[79]

Jarry's not-so-light-handed play with the theme of anticolonialism is the other side of his primitivism: the worship of instinct, puppets, violence. By giving a political consciousness to the African figures in such works as these, he refuses to sentimentalize the image of the noble savage. Instead he modernizes it, acknowledging in his treatment of the theme the political realities that have brought the Oceanic and African "fetishes" into the view of the avant-garde and overturns the romanticism of his admired Gauguin and the Symbolists.[80] This is first-rate and unrelenting political satire not only of contemporary politics but also of the Symbolist avant-garde itself.

The related theme of antimilitarism is treated several times in Jarry's work. In 1897 at the height of the Dreyfus Affair, he wrote the novel *Les Jours et les nuits, Roman d'un déserteur*, whose central subject is the systematic dehumanization on which, he implies, the army is based. The main character is the sensitive Sengle, who is inducted into the army, subjected to its irrational and total need for perfect conformity, and finally forced to submit to the annihilation of his character. The novel makes no Bakuninesque arguments against international wars; rather, Jarry focuses on the loss of individuality and freedom in Sengle, who is so alienated by his experience that he has no idea whether others are reacting similarly. Falling asleep, Sengle looks out the doors of his quarters: "Through these openings he, who was so afraid of mirrors, saw himself reflected in other soldiers."[81] After having been summoned by the major in the middle of the night to help solve a newspaper word puzzle, "Sengle went back upstairs, to his unit's sleeping quarters, or to some reasonable facsimile among the innumerable identical doors and landings,

and in several such rooms he saw bodies just like his own, hardly raising the flat surface of the beds, and was convinced that each bed was the one he had just left."[82]

Blind adherence to the idea of freedom Jarry found equally absurd. Counting among his friends and intimates many anarchists and anarchist sympathizers—Kahn, Mallarmé, de Régnier, Tailhade, Fénéon, A. F. Hérold, Mauclair, and Quillard[83]—Jarry did not fail to ridicule optimistic, simplistic, or utopian ideas in the movement, despite much poker-faced quoting of such famous bomb-throwers as Emile Henry and Auguste Vaillant, whose acts had caused furious argument among the various anarchist factions.[84] In scene two of *Ubu enchaîné*, Ubu meets a small army of "free" men on the Champ-de-Mars:

> THE THREE FREE MEN: We are free men, and here is our corporal—long live freedom, freedom, freedom! We are free.—Let's not forget our duty, it's to be free. Slow down, we will arrive on time. Freedom, that is to never arrive on time—never, never! for our freedom drills. Disobey all together. . . . No! not together: one, two, three! the first time by ones, the second by twos, the third by threes. There's all the difference. Devise a different move, though it is very tiring. Disobey individually—the corporal of free men!
>
> THE CORPORAL: Fall in!
>
> *They scatter.*[85]

Even when trying to be free, the bourgeois mind takes a deterministic model: exhausting all the ways, scientifically, of disobeying "though it is very tiring." The mathematical precision of this approach—reemerging later in Samuel Beckett's novels, for example, Watt with his elaborately precise methods of sucking each of his sixteen stones daily—determines only the enslaved condition of the mind and the impossibility of freedom. It was precisely this aspect of the play that Picasso took in and recounted years later to Hélène Parmelin.[86] Even in art, Jarry saw this model worked out; his own life and work frequently proceeded in perfect inversions: an anarchist drill team, an inland port. When the French government outlawed the Breton language, Jarry sat down and mastered it.[87] His continual reversal of expectations virtually became a formula, a modus operandi (one that is also discernible from this time onward in Picasso's work and, tellingly, in his statements on art).

If all the avant-garde struggled to create high art, Jarry struggled to create low. But at the same time he accused his friends of using a familiar formula: what else is *vers libre*, or *libre pensée*, but a new form of obligation, creating a new academy of like-minded artist/revolutionaries? Even this new "edifice," including his own earlier work *Ubu roi*, must be destroyed: "FATHER UBU: Hornsocket! we will not have demolished everything if we don't demolish even the ruins!"[88] His method, of course, was satire—"ingeniously absurd," in Salmon's words. Any seri-

ousness was to be countered immediately and unrelentingly, even in his closest friends. Salmon recounts an episode in Jarry's library, with Jarry waxing mock-enthusiastic over military memoirs:

"I have a strong taste for military stories. *They are the only true things in our literature. . . .*" Jarry particularly savoured the astonishment that he caused in others; it was his true joy and one will see how he killed himself, with a heroic, a glorious naïveté, for this joy of astonishing. He resumed: "I passionately love the army." My surprise was growing. "They call me antimilitarist because I wrote *Les Jours et les nuits, Roman d'un déserteur*, but this isn't true."

"This isn't true" he said in his Père Ubu voice [a loud, cadenced monotone] . . . : "Let the bugle sound in Our own rue Cassette in Our good City of Paris and you will see Us, instantaneously, and with great dispatch, seize Our mighty rod, shit-pot and noble's staff and, standing erect in Our little phynance car, place Us in good view, at the head of Our troops of Our French Republic."[89]

Jarry also goes on in his epigraph to *Ubu enchaîné* to subvert the idea of mere destruction, of his proposed "demolished ruins," with a Nietzschean assertion of the power of new art to undermine the past and its hold over us: "Now I see no other way than to balance them with beautiful, well-ordered edifices."[90] "Beautiful, well-ordered edifices" hardly describes Jarry's plays from the hapless spectator's vantage, but constitutes a rather good bird's-eye view of his whole project. If he can expose all the folly, vanity, and cupidity that perpetuate the old order, and if, in exposing it, he behaves as if the revolution has already taken place, then, according to Kropotkin, a new *édifice social* will rise up to supplant the old. We would do well to regard with suspicion any thought that Jarry too naively believed such utopianism, but there was more than mere destruction behind his life and work. As Shattuck concludes: "A single facet of his work does not represent Jarry as an author and fails to show his desperate effort to renovate human sensibility. His method of hallucination constitutes an attempt to destroy and create simultaneously: to transform."[91]

No one behaved more actively as if the revolution were taking place than Jarry. When Picasso met him in 1904, it was at first Jarry's behavior that he emulated. One of Jarry's personal symbols was a pair of pistols he carried openly—to thwart the law against carrying concealed weapons—and frequently used. He was an excellent shot; purposely irresponsible, he liked to shoot bullets as frighteningly literal metaphors of his social role. Salmon remembers that "if a passerby asked his way, Père Ubu indicated the route to the gentleman, the arm extended by the length of the pistol. And if it was a light [*du feu*, fire] that the nocturnalist asked of Père Ubu, then would be the boundless joy of Alfred Jarry,"[92] who would unhesitatingly fire his gun before the terrified petitioner.

Early in their friendship, Jarry gave Picasso a Browning automatic which Picasso, in turn, similarly carried and used; Penrose loyally suggests that this was in order to "express his high spirits."[93] Picasso was known to fire it in the air when asked by insistent admirers to explain his "theory of aesthetics": they no doubt got his point.[94] Another such incident took place in the rural backwater of Horta de Ebro in 1909, when Picasso fired the gun into the air from his balcony in answer to loud accusations from village women in the street below that sinful sexual scenes were going on between Picasso and his foreign *compañera*.[95]

According to Max Jacob, Picasso's closest friend in these years, Jarry's gift of the revolver represented not the mere offering of a coveted object but the ritual passing on of a sacred symbol:

> At the end of a supper, Alfred Jarry gave up his revolver to Picasso and made a gift of it to him. . . . At that time it was recognized:
>
> 1. that the tiara of the psychic Pope Jarry was loaded in the revolver, the new distinguishing mark of the papacy;
> 2. that the gift of this emblem was the enthronement of the new psychic Picasso;
> 3. that the revolver sought its natural owner;
> 4. that the revolver was really the harbinger comet of the century.[96]

Picasso understood the meaning of the transfer; he was ready to move on to a more revolutionary artistic position, pushing himself on from the meditative, privatistic, and still narrative paintings of 1904–1905 to the more formal abstractions of 1905 and 1906. These were the years when Jacob would look at Picasso's latest painting and cry, to Apollinaire's delight, "Encore trop symboliste!"[97] The religious metaphor in Jacob's account of the passing down of the gun is relevant, too: Jarry played pope and lived in his "Grande Chasublerie" in order to blaspheme but also to demonstrate that the anarchist artist lived out his role on every level of experience. More than a set of political beliefs, anarchism was a way of viewing the past, present, and future of the spiritual and social world; insisting on disbelief in God (see Bakunin's *Dieu et l'État*), anarchism supplanted religion. The difference between Jarry and someone like Bakunin or Jean Grave is that Jarry did not notably replace religion with faith in a future harmony of man, hence the more nihilistic cast of his art and life. His vision of man was unredeemed, closer to such later writers as Kafka and Beckett. Unlike Picasso, Jarry had no pastoral vision to counter his rejection of contemporary society, which accounts for much of his appeal in the later twentieth century.

Despite this important difference, Jarry was important for Picasso in a number of ways. In *Les Demoiselles d'Avignon* (Fig. 59), discussed in the next chapter, Picasso worked out in his own terms the destructiveness symbolized by the gun and representing the anarchist attitude toward society. LeMaitre and others have

noted that, in the eyes of his contemporaries, Jarry represented, above all, destruction and revolt, and that his influence was greatest on those very poets—Apollinaire, Jacob, Salmon ("J'ai vu Jarry, je l'ai écouté, je l'ai suivi")[98]—closest to Picasso, who was famous for spending more of his time with poets than with fellow painters. "We influence each other in turn," Picasso told Salmon and tacked a sign on his Bateau-Lavoir studio, "Au rendez-vous des Poètes!"[99]

Anarchism and Salmon

André Salmon, self-styled "child of Symbolism, of Boulangism, of [the] Panama [Scandal] and of the Dreyfus Affair,"[100] in his smaller way also confirmed Picasso's anarchism on his entry into French artistic culture. Sympathetic since adolescence to the symboliste/anarchiste milieu, Salmon was an equal founder with Apollinaire of *Le Festin d'Esope*. As much a follower of Jarry as Apollinaire and Picasso, he was responsible for organizing the wild soirées of *Vers et Prose* at the Closerie des Lilas. In the spirit of the mocking humor common to the group, he performed his share of disreputable antics; the most famous among them involved a display of foaming-at-the-mouth delirium tremens with Maurice Cremnitz at the banquet honoring Henri Rousseau in Picasso's studio in 1908.[101] Gertrude Stein (possibly for reasons of her own) claimed that their condition had been real rather than fictional, prompting Salmon to remark that she "understood little of the tendency we all had, Apollinaire, Max Jacob, myself and the others, frequently to play a rather burlesque role. We made continual fun of everything."[102]

It is doubtful that this humor was appreciated by Matisse, who made discreet inquiries as to the hand or hands who wrote on the walls and fences of Montmartre: "Matisse is mad!" "Matisse is more dangerous than alcohol." "Matisse has done worse than war!"[103] But the joking, as with Jarry, was also serious. As Salmon recalled, "There was a joking and studio wit from 1903 on at the Bateau-Lavoir, where, at the same time, modernism, Orphism, cubism, were being seriously prepared," and, he insists, encompassing both the light and serious sides is essential to understanding the period.[104] In fact, he extends this observation to include the quality of political life as well, asserting: "One found oneself in an epoch with a spirit that was revolutionary but relatively gay. One then knew syndicalists, resolute but to tell the truth also prankish [*rigolos*]. I can find no other adequate expression. Some socialists more or less nuanced with anarchy."[105]

As Salmon proceeded in his poetic and journalistic career in Paris from 1903 on, he became acquainted with most of the significant political and literary men of both his and the previous generations. In his memoirs, he notes most of the political, literary, and artistic events of the prewar period of which he was a witness. In regular attendance at the soirées of the highly political *La Plume* and *Vers et Prose*, Salmon also went, for example, to the Théâtre Civique in 1903 to hear a lecture

by Gustave Kahn, whom he proclaimed "polémiste ardent." Another time he went there to hear the flamboyantly anarchist Laurent Tailhade read his revolutionary ballads, including his famous *Ballade Solness*: "Anarchie, ô porteuse de flambeaux!" And at the Théâtre Civique one could always hope to see such admired anarchist literary figures as Félix Fénéon; Rémy de Gourmont, "le plus intelligent des radicaux-socialistes"; or Octave Mirbeau, whom he described as the "old anarchist with the gang, collaborator of brave men, little short-lived journals, from *Père Peinard* to *l'En-dehors*; . . . each epoch having its 'convulsionaries,' Octave Mirbeau was loved for his generous ideas."[106]

Salmon spent as much time as possible with the older generation of anarcho-Symbolists, delighted, for example, to be invited to Tailhade's banquet honoring Mirbeau in 1904. He became friendly with Pierre Quillard, Jarry's close friend, who passionately fought for libertarianism; Félicien Fagus, anarchist poet whose book, *La Testament de ma vie première*, was eagerly recommended to Salmon by Picasso the night they met; Henri de Régnier, recounter to Salmon of many tales of the Symbolists, who "voluntarily flaunted their sympathy for the methods of militant anarchy"; and Stuart Merrill, activist poet, who "would never declare himself more than revolutionary socialist."[107] But best was the "daily banquet of the rue de Seine," where Salmon ate with his closest friends: Apollinaire, Jarry, Mécislas Golberg, and the pacifist editor of *L'Européen*, Arne Hammer (who in 1914 cried when he saw Salmon and Apollinaire in uniform).[108] Picasso's old friend Manolo was also there, and doubtless Picasso, too, though Salmon has systematically omitted Picasso from most of his memoirs (by request?), except to remark from time to time that he is a great artist, or that he did not attend the soirées that, in fact, he did attend. (For example, Salmon recounts the sorry tale of Apollinaire's arrest for the "affair of the Phoenician statuettes" without so much as mentioning Picasso, who was their owner; it was Picasso's denial to the police that he even knew Apollinaire—such was his own terror of arrest and deportation to Spain, where, after 1909, he was wanted for draft dodging—that played no small role in Apollinaire's subsequent emotional disturbance).[109] At these early, happy, banquets, "One shared poems. One discussed doctrines. . . . One played the fool, but all that sort of thing is necessary to constitute a new poetic universe."[110]

Salmon was a friend of many prominent activist revolutionary figures in Paris, including Victor Méric—editor of the radical socialist *Les Hommes du Jour* and *Le Barricade*—who coolly introduced him, at a café in the Boulevard Saint-Michel, to the "most wanted" anarchist outlaw of the day, Bonnot; Miguel Almereyda, Spanish anarchist activist in exile; Emile Pouget, editor of the period's most extreme anarchist journal, *Le Père Peinard*; and Victor Barrucand, theoretician of *Pain gratuit*. Salmon witnessed many strikes—sometimes, but not always, as a paid journalist[111]—with their attacks on the crowd by mounted police, and executions of well-known anarchists. At the guillotining of Liabeuf, who killed several police-

men and whom Salmon represents as a lone, pathetic, and harassed street urchin pushed past the limits of human endurance, he met Léon Werth (supporter of Cubism), Almereyda, de Régnier, and Paul Adam, "just as in the days of Ravachol and others," as well as numbers of (unnamed) writers and artists among his friends. The police delayed the public execution a day because of the immense and agitated crowd, which nevertheless turned up in force again the second night for the "veillée macabre"; they duly killed young Liabeuf, whom Salmon calls "murderer, not vulgur assassin, one instance of a neighborhood hero from a time sufficiently anarchist," and concludes, "Ah! these stories from before the First War. They are no longer always understood very well, now."[112]

If such liaisons among writers, artists, and political activists have been played down since this period, they were, at the time, taken seriously enough by the police. The Préfecture de Police still houses files of surveillance reports on Quillard, Almereyda, Méric, Pouget, and numerous other revolutionaries with whom the artists and writers of la bande à Picasso were acquainted. Among their reports we learn that police agents: followed on December 14, 1903, several "compagnons" to a Steinlen exhibition in the Place Saint-Georges; noted on February 21, 1904, that the anarchist Zanetta lived next to Jarry at no. 6 (Jarry lived at 7, rue Casette, near the Jardin Luxembourg); attended lectures by Tailhade; and, beginning in the spring of 1904, followed the Spanish anarchists closely, rightly anticipating trouble during the forthcoming visit by King Alfonso XIII of Spain in 1905. A police infiltrator known as "Gilles" seems to have succeeded in getting close to Francisco Ferrer, Ferrer's son-in-law (and Picasso's friend from Barcelona) Jaume Brossa, Anselmo Lorenzo, Almereyda, "Libertad," Malato, and others.[113] There is even a file on "Pablo Ruiz dit [alias] Picasso," whose title temptingly suggests it may have been started before he *was* Pablo Picasso (though French law frustratingly prevents perusal of the file before the third millennium, A.D. 2033), and a mention of the highly suspect Pedro Mañach, Picasso's patron of 1900–1901.[114]

Leftist art critics also came under suspicion in these years, as evidenced by the reports on Urbain Gohier, Félix Fénéon, and Fernand Pelloutier, author of *L'Art et la révolution*. The police themselves, however, had a more balanced idea of the constellation of the anarchist milieu than this account may indicate, sensibly rejecting a number of anonymous turnings-in of neighbors by "friends of order and morality" and properly distinguishing among "intellectuels, libertaires, 'suiveurs.' " But they were quite capable nonetheless of harassing the compagnons at 13, rue Ravignan (the Bateau-Lavoir). Salmon, in his memoirs of the mid-1950s, typically downplayed any genuinely political motives in the art or behavior of his circle, yet he nevertheless returned frequently to the subject of their political attitudes, revealing many telling events:

During this time, Zo d'Axa, Roinard and the writers of *L'En Dehors* smoked their pipes, prophesying terrible upheavals to young hangers-on, many of

whom [later] attained power. Because hard-up friends could bum a portion of a modest feast, one called oneself "*partageux*" [literally "sharer," a period code word for those holding that all property should be communal]; because one didn't bear a grudge against a friend negligent in returning a frock coat, borrowed in order to recite poetry in society, one loudly denounced property. At the same time, Ravachol the vagabond and the polytechnician Emile Henry [anarchist bomb-throwers] demonstrated the danger of explosives, comparable indeed, on another plane, to police bayonets, when they're trying to be clever. The police swooped down on the trapper's cabin [the Bateau-Lavoir], asylum of the dream. In vain did they search for bombs and weapons. The tenants of 13 put on a fine and fatalistic show of being persecuted. Several moved out.[115]

After the war, Salmon wrote a novel, *Le Drapeau noir* (1927), referring to the black flag of anarchism, which constitutes an apologia for his movement away from prewar anarchism. The main character, a young poet, and an old anarchist from the streets discuss—passionately but rather hopelessly—issues of poverty, war, and the possibilities of political change. Thirty years later Salmon wrote a history of the libertarian movement from 1871, entitled *La Terreur noire*, which combines history with memoir. A large section recounts the deeds of Ravachol, that much romanticized propagandist of the deed defended more by artists and poets—including Adam, Mirbeau, Fénéon, Quillard, Verhaeren, and Pissarro—than by political figures like Kropotkin and Grave.[116] This book addressed the important issue of how Salmon and his generation were, though antimilitarists, led into fighting in World War I. Although in all these works he coolly pretends to have watched from the sidelines as the political events and passions that he describes manifested themselves (and pretends, too, that Picasso was never by his side), left-wing politics remain the subtext of his memory of the period. Salmon's memoirs, as a result, leave an oddly ambiguous impression, with narrative frequently contradicting tone: even while he sneers at the naïveté and essential nonseriousness of his group's attitudes to public life, and assures us of their safely ivory-tower preoccupations, politics figure again and again as the central fact of life, quite clearly seen, for the prewar avant-garde.

Others who figured in Picasso's life during this period and crowded his studio, while perhaps less influential, nevertheless affirmed in him anarchist ideas and attitudes. Kees Van Dongen, who lived in the Bateau-Lavoir from 1906 to 1907, was very close to Picasso and Fernande.[117] In Van Dongen's own words: "I had the good fortune to meet Félix Fénéon, who, like myself, frequented the group of anarchists."[118] Vlaminck, whom Picasso probably met through Apollinaire in 1904 or 1905, had been immersed in the Parisian group of anarchists since before 1900. While doing his obligatory military service (1897–1900), he met anarchist Fernand

Sernada, who introduced him to the leaders: Sébastien Faure, Malato, "Libertad," Amereyda, Zo d'Axa, and Tailhade. Vlaminck became passionate over the Dreyfus Affair and, while still in the army, attended the famous retrial. He was a convinced antimilitarist, contributing drawings and donating paintings to such anarchist journals as *Fin de Siècle*, *L'Anarchie*, and *Le Libertaire*. Vlaminck also articulated anarchist esthetic ideas, with all his faith in spontaneity, instinct, violence, and the potential power of art as a revolutionary—rather than a merely propagandistic—tool:

> I wanted to revolutionize habits and contemporary life, to liberate nature, to free it from the authority of old theories and classicism, which I hated as much as I had hated the General or the Colonel of my regiment. . . . I felt a tremendous urge to recreate a new world seen through my own eyes, a world which was entirely mine. . . . I was a tender barbarian, filled with violence. I translated what I saw instinctively, without any method and conveyed it truly, not so much artistically as humanely.[119]

Interestingly, Vlaminck's anarchism and Picasso's share revolutionary attitudes toward their art, but the analogy does not extend to the images themselves. Both proceeded with unprecedented violence, but while Vlaminck remained essentially an expressionist, Picasso realized the greater impact of an attack on the forms and genres of traditional art. Salmon recalled a crowded evening in Picasso's studio, talking and looking at the paintings, and Vlaminck's response: "No joke? And I, who came to shock you!"[120]

3. La Propagande par le fait

Picasso's Early Paris Period, 1904-1907

Innovate violently!
—Guillaume Apollinaire, c. 1907 (in Salmon, *Souvenirs sans fin*)

THE EFFECT on Picasso of joining the Parisian avant-garde, and falling under the powerful influence of such figures as Alfred Jarry and Guillaume Apollinaire, was both to confirm his dedication to the idea of being a revolutionary in art and to encourage the greater formal experimentalism characteristic of the French capital. Yet, for several more years, the main impulse of his art remained narrative. The hungry and the beggars who people the works of Picasso's Blue Period, in its last phase when he moved to Paris in 1904, and the poor and socially outcast *saltim-banques* of his Rose Period of 1905 all make their way on the fringes of a society that has no use for them. Although born out of visibly political concerns in Picasso's work, the saltimbanques soon took on a timeless character, a version of pastoral—or anarchist utopia—and this continued to be the direction of his art throughout 1906. At the same time, Picasso began to manifest his interest in "primitive art," most significantly Iberian—the ideal childhood of Spain—and African, with its more complicated and tormented associations. As his art became more outrageously abstracted in form, Picasso returned in some highly significant works to a narrative base and closed his first Parisian phase with an explosive act—and seen as such by his contemporaries—of la propagande par le fait: *Les Demoiselles d'Avignon* (Fig. 59). The tale of the development of this art is primarily French, but it is also important to keep in mind the degree to which Picasso remained a Spanish artist and the quantity of influential friendships and contacts that he maintained with Catalan artists, writers, and political activists throughout the prewar period.

Picasso's Catalan Ties

After Picasso moved to Paris in 1904, he visited Catalonia—where he excitedly spoke Catalan "almost all the time"[1]—six out of the following nine years: the summers of 1906 (Barcelona and Gósol), 1909 (Barcelona and Horta de Ebro), 1910 (Cadaqués), 1911 (Céret), 1912 (Céret), and 1913 (Céret and Barcelona). A seventh trip was planned for 1908 but canceled.[2] On the three trips back to Barcelona in 1906, 1909, and 1913, he visited old friends, many of whom he had seen in

Paris in the interval. In 1906, though staying in Barcelona only a few days, Picasso and Fernande Olivier visited El Guayaba, a "private club" in the studio of Joan Vidal i Ventosa and Joaquim Borraleres, where Picasso and his circle had frequently gathered since 1902.[3] Vidal i Ventosa took the well-known photograph of Picasso and Olivier with Ramon Reventós at this time.[4] In 1909 on their way to Horta, Picasso and Olivier again visited El Guayaba—now moved into the studio Picasso had originally shared with the ill-starred Casagemas. At that time he also visited Pallarés.[5] Picasso's trip to Barcelona from Céret in April 1913 to bury his father was short, but he returned in 1917 and stayed from June to November, stopping at all his old haunts and meeting friends, who honored him with a banquet on July 12. During this entire period, he never lost touch with the avant-garde, or the Spain, of his youth, as his regular trips to Catalonia testify. His friend the Catalan sculptor Julio Gonzales later noted:

> I have known Picasso more than thirty years. And every time I have seen and talked to him—which is often—we spoke about Catalan people. I have heard his nostalgic words about Barcelona and Perpignan [close to Céret in French Catalonia]. He conjured up the holidays, the fairs, the public displays and events of all kinds. And he did it with vigorous details. Everything over there interests him. He is one of us.[6]

Olivier mentions that one of the reasons Picasso worked at night when she met him in 1904 was that during the day he was visited in Paris by "a constant stream of Spaniards." She mentions Durio, Echevaria, Sunyer, Anglada, Zuloaga, Pichot, Canals, Nonell, Manolo, and Fabiano the Guitarist.[7] All these early years in Paris, during the first visits in 1900–1904 and after his permanent move until the war, Picasso also frequently saw Sabartés, Itturino, Gener, and any other of the old Barcelona gang who passed through. The Barcelona anarchists Jaume Brossa and Alexandre Cortada were among them, still dedicated to promoting the revolution on all fronts.[8] It was Brossa—implicated by the police in the clandestine activities of Francisco Ferrer—who arranged Casagemas's papers, notified the family of his death, and attended the funeral in Paris following Casagemas's suicide in 1901.[9] Daix mentions an early collector of Picasso's work in the Bateau-Lavoir days, Olivier Sainsère, a state councillor: "He had aided Picasso greatly since his first visits to Paris. He not only bought his works . . . but also, Picasso recalls, he provided a sort of legal protection against the police, who suspected virtually all the rather Bohemian young Spaniards of anarchism."[10]

Such "suspicions" may be less surprising if we recall Fernande Olivier's description of the behavior of Picasso's group, who "would come back at night frequently drunk, shouting, abusing one another, singing and declaiming in the little square, which had, no doubt, witnessed similar scenes countless times. They would

wake up the neighbours with revolver shots: Picasso had a mania for this. He always carried a Browning."[11] And our surprise will be less still if we remember that Brossa and Cortada were sometimes among them. Picasso's affiliations with anarchist activists, out of whatever romantic allegiances, were very real. So apparently notorious were the Spaniards for their anarchist connections and behavior, and so sympathetic to this were their French friends, that when the hapless Juan Gris told Max Jacob of his arrest by the French police, who had mistaken him for Octave Garnier (a much wanted anarchist bomb-thrower), Jacob misunderstood and offered to hide him.[12] During this whole period, from Picasso's youth to his maturity, a network between Paris and Barcelona was kept up by the Barcelona modernistes. Picasso may have later become their greatest success, but at this time he was only one among many Spaniards in Paris, pushing at the frontiers of art and keeping up contacts with home.

Primitivism and Propaganda: Paris, 1904–1907

When Picasso moved to Paris in April 1904, he was in the last, "mannerist," phase of the Blue Period. Fernande Olivier, who met him that fall, remembers his working on an etching whose themes are continuous with his work since the 1890s. *The Frugal Repast*, 1904 (Fig. 42), revealed "the most intense feeling of poverty and alcoholism and a startling realism in the figures of this wretched, starving couple."[13] Before long this overtly socially critical work gave way to the harlequins and saltimbanques of the Rose Period. According to Barr, this "relaxation of his subject matter in 1905 may have been a reflection of his improving circumstances."[14] Daix goes further and draws a direct line between Picasso's themes and the fullness of his pockets: "Harlequins and circus people replace the beggars and the down-and-out, and the melancholy of the last period retreated before an optimism that grew in proportion as Picasso's living conditions improved."[15]

Such an ungenerous assumption treats Picasso as a victim of his economic circumstances and psychological outlook on the world, denies his legitimate and shared interest in the actual beggars that swarmed the cities at that time, and makes it difficult for us to perceive his conscious intentions or political motives. Such a view also tends to deny that the early saltimbanques are not only thin but despairing, homeless, and hungry, as we can see, for example, in *Mother and Child (Saltimbanques)*, 1905,[16] and *Acrobat and Young Harlequin*, 1905 (Fig. 43). Picasso, in identifying with the saltimbanques, identified the artist in general, not just himself in particular as is usually argued, with these wandering acrobats and entertainers, rejected and misunderstood by a culture undeserving of their innocence or their art—a theme frequent in *modernistes* Rusiñol and Opisso.[17] That Picasso identified precisely with the saltimbanques' survival and persistence on society's edges does

not make them mere symbols of the artist's struggle nor mitigate the political component of their plight as actual representatives of their kind.

Many of the images of saltimbanques in 1905 are placed in generalized, non-specific settings—such as *Boy with a Dog*,[18] with its blue, barely modulated background, and, best known, the large *Family of Saltimbanques* in Washington (Fig. 44). This symbolic, empty landscape predominates as the series progresses. The earlier works more clearly stated the social conditions of the traveling entertainers. For example, a series of studies for a work presumed lost but described by Olivier depicted a group of saltimbanques living out of a caravan, having stopped to make a meal.[19] In *Family of Saltimbanques (Study)* (Fig. 45), the figures stand grouped on a neutral ground as in the final version, but behind them lies a setting with a racecourse: one sees hints of top hats and elegant shawls in the crowd of spectators watching a race in progress and a hapless jockey going down with his horse—a possible emblem of the risks at stake in providing pleasures for the bourgeoisie and idle rich. The saltimbanques do not watch the race; they are itinerant and on the move and as such are reminiscent of Daumier's similar depictions of the outlawed saltimbanques of the 1850s.[20]

Harlequin, easily recognizable here as a self-portrait of Picasso, wears an overcoat and carries a suitcase. Whereas in the final work the young acrobat carries a drum or stand, in this study he carries a soft duffel bag, apparently filled with his few belongings. The fat clown still carries his sack, which seems put to a parallel use in light of these other details. As Palau i Fabre has pointed out, they seem more vagrant than the earlier groups, being without even a caravan.[21] The seated "Majorcan" woman of the final version, whose appearance reinforces its empty, discontinuous, and therefore timeless and symbolic landscape, is absent in this study, with its emphasis on the social context and realism of the figures. Picasso at the time of the study was, in fact, very like such figures. Recent studies have addressed the artist's comparison and identification of himself with the main figure in the painting.[22] This identification can be seen to work on the social as well as on numerous other levels: an emigrant artist from a picturesque country, dirt poor, with an artistic vision to offer to an unappreciative bourgeois culture that represented the very end of an exploitative civilization. The difference is that whereas the saltimbanques were passive and resigned to their fate, Picasso was subversive and intended to fight.

The year 1905 saw the transformation of the harlequin/saltimbanque theme into an arcadian vision, serene and ideal. *Petits Gueux (Little Beggars)*, 1904 (Fig. 46),[23] done in the first months after Picasso's arrival in Paris, depicts three children, barefoot and in rags; two of these figures soon changed their clothes for Harlequin and acrobat—still gaunt and destitute—in *Two Acrobats with a Dog*, 1905 (Fig. 47);[24] after less pathos-inspiring transmutations of body, costume, and pose,[25] they reemerged, nude and idealized, at Gósol in 1906 in the series culminating in

The Two Brothers (Fig. 48).[26] A close comparison clearly reveals the early beggars to be the source of the overall series. Interestingly, as Picasso distanced the mood of the work and treatment of color and form from the depressed and starving harlequins, he returned to the original motif of the young child on his brother's back, emphasizing the total dependence of the child on the youth who is all his society. In the later work we are right to feel secure in assuming that the child can be cared for, a security that the face of the older brother denies in the original drawings of 1904. The later figures express, in their idealized nudity and serenity, the harmony of man with nature that was Picasso's main theme in his Catalonian retreat.

This returning arcadianism did not first reappear in Gósol, however. A series of drawings and gouaches of 1905,[27] based probably on Picasso's weekly visits to the Cirque Médrano in Paris, depicts a young equestrienne, who was joined, in a gouache of early 1906, by a boy in blue (Fig. 49); this young male figure soon reappeared alone with the horse, then shed his clothes and emerged as the central figure in Picasso's major work of this pre-Gósol period, *The Watering Place* (Fig. 50),[28] which was never realized on a large scale. André Salmon in 1912 gave us the original identity of the boy in blue, who first appeared in the seated *Boy with a Pipe*, 1905, and its study: "Picasso had painted the very pure and simple image, without a model, of a young Parisian worker; beardless and dressed in blue cloth—close to the appearance of the artist himself during working hours."[29]

The same figure, dressed identically, reappeared standing in *Juggler with Still-Life* and *Blue Boy*, both 1905.[30] In early 1906 he appears standing next to the horse with the equestrienne in the gouache noted above and, in a closely related gouache, he stands next to the now riderless horse. Two more studies depict the figures of the horse and nude boy, hand on hip, before a neutral landscape, culminating in the large canvas *Boy Leading a Horse*, 1906 (Fig. 51). Traditionally the unbridled horse has symbolized untamed sexual passion, but here the horse's docility and willingness to be led without a halter suggest the unity of horse and boy; both, in their nudity, are natural creatures in harmony with each other and with nature. This arcadian theme, familiar to us from Picasso's earlier work—for example, *Pastoral Scene*, c. 1902 (Fig. 39)—fits logically into the studies for the unrealized *Watering Place*,[31] where nude boys lead and ride unbridled horses to a pond in a generalized landscape similar to that of the *Family of Saltimbanques* of the previous year. Both groups of works illustrate an evolution from youthful, innocent beggar or worker to member in an idyllic, harmonious world of rank-free equality and unity of man and nature. Such, at least, is the traditional vision of arcadia, before even Proudhon or Kropotkin won the hearts of the avant-garde with their politicized version of it.

The form of "naturalness" most cherished by the turn-of-the-century avant-garde was "primitive" art.[32] For the previous generation, children's art had reigned as higher and purer than the "primitive" arts of Cambodia, Egypt, and the Middle

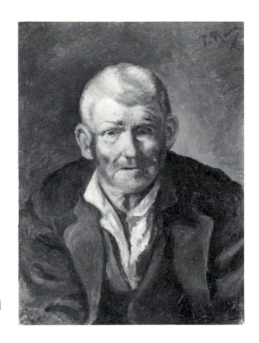

1. *Portrait of an Old Man*, 1895. Oil on canvas, 58.5 x 42.8 cm.

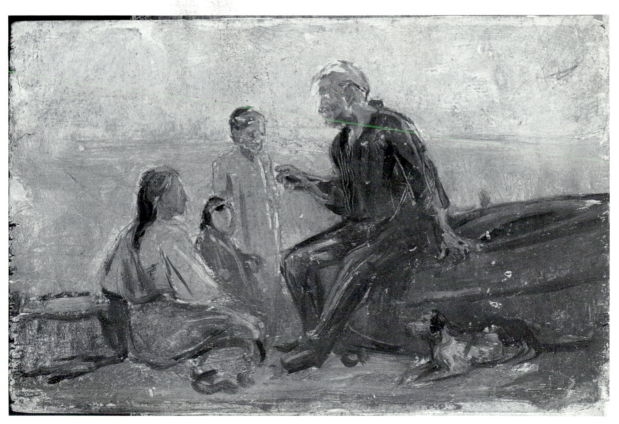

2. *Fisherman with Children*, 1896. Oil on wood, 10 x 15.7 cm.

3. *Portrait of Pompeu Gener*, 1899–1900. Pen and wash on paper, 8.4 x 7.8 cm.

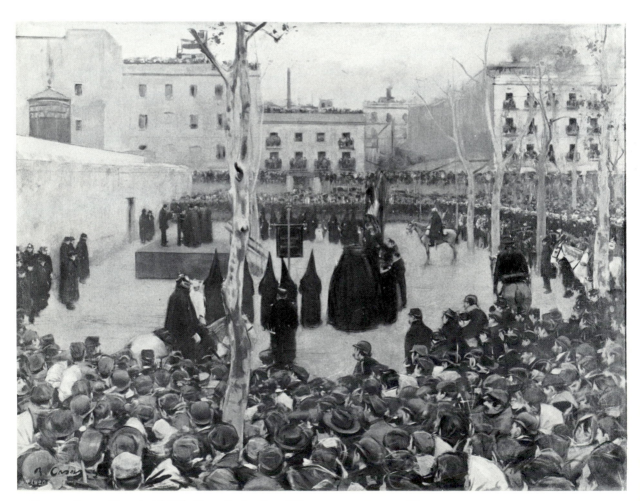

4. Ramon Casas, *Garrote vil (Vile Garroting)*, 1894. Oil on canvas, 127 x 166.2 cm.

5. *Caridad (Charity)*, c. 1899. Conté crayon on paper, 23.2 x 33.8 cm.

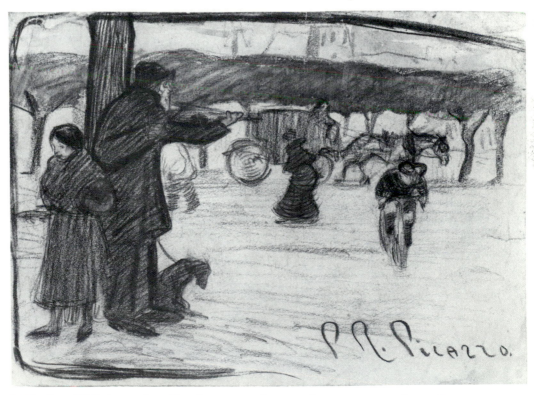

6. *The Street Violinist*, c. 1899. Conté crayon and watercolor on paper, 23.6 x 33.6 cm.

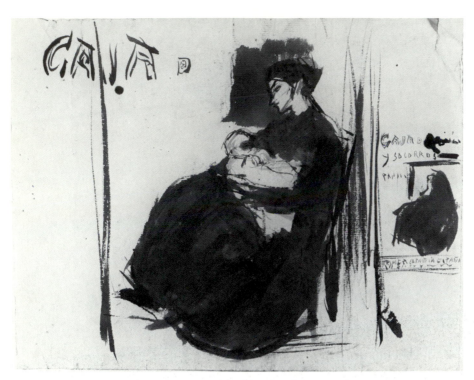

7. Poster for *Caja de Previción y Socorros*, 1900. Watercolor on paper, 23.8 x 31 cm.

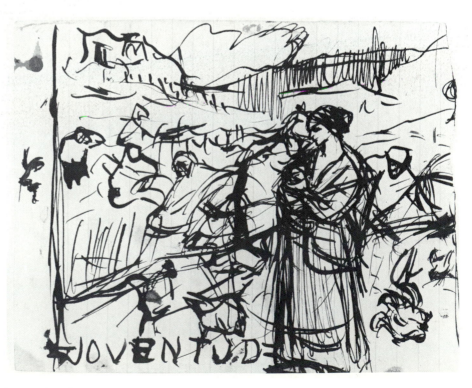

8. Drawing for *Joventut*, c. 1900. Ink on paper, 13.4 x 17.4 cm.

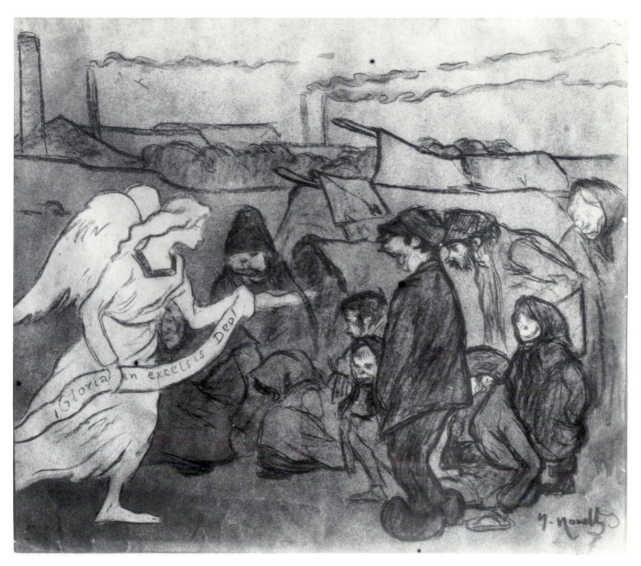

9. Isidre Nonell, *Annunciation in the Slums (Gloria in Excelsis)*, c. 1892. Conté crayon and charcoal on paper, 32 x 35.5 cm., published in *La Vanguardia*, 1897.

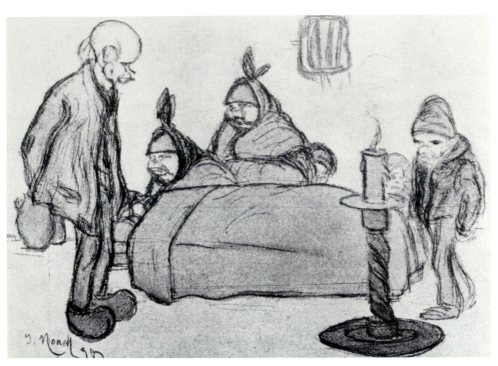

10. Isidre Nonell, *Cretins*, 1896. Conté crayon, color, and powder on paper, 25 x 36 cm.

11. Ramon Casas, *Repatriados*, 1899. Charcoal on paper, published in *Pèl & Ploma*, February 3, 1900.

12. Isidre Nonell, *"If I'd Only Known,"* from the series "España después de la guerra," 1898, published in *Pèl & Ploma*, January 1902.

13. Isidre Nonell, *Les desgraciades* o *Misèria (In Distress* or *Poverty)*, 1904. Oil on canvas, 75 x 100 cm.

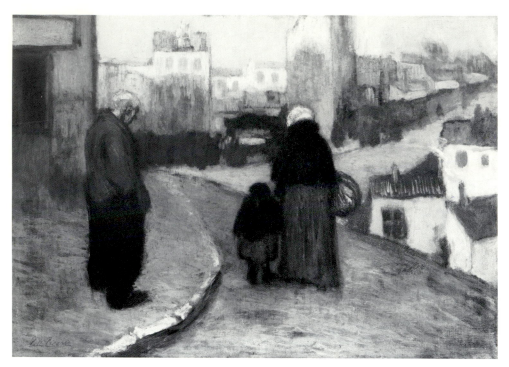

14. *Scène de rue (Vieillard, femme et enfant dans la rue)*, 1900. Oil on canvas, 44.5 x 62.3 cm.

15. *Figures by the Sea (Les Misérables au bord de la mer)*, 1903. Oil on canvas, 61.6 x 50.5 cm.

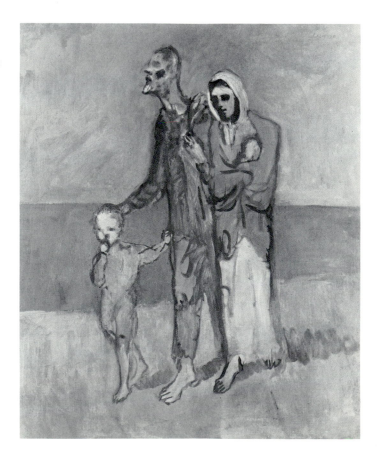

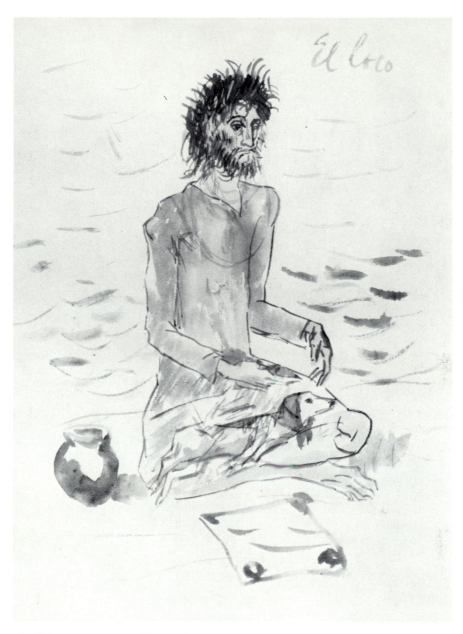

16. *El loco*, 1903–1904. Watercolor on paper, 29.2 x 21 cm.

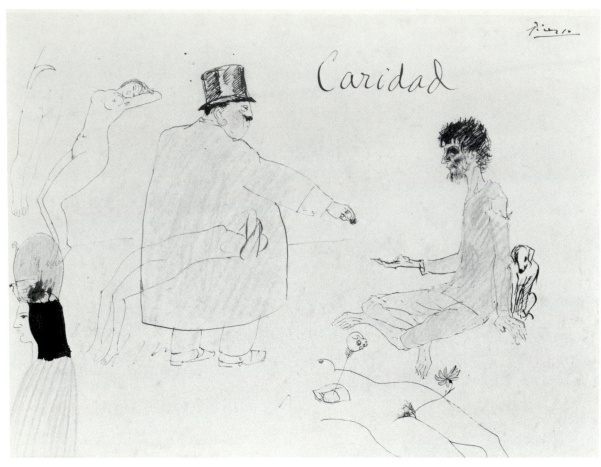

17. *Caridad (Charity)*, 1903. India ink and
colored crayons on paper, 26 x 36 cm.

18. *La boja (The Madwoman)*, 1900. Ink,
watercolor, and gouache on paper,
13.5 x 9.5 cm., published in *Catalunya
Artística*, September 6, 1900.

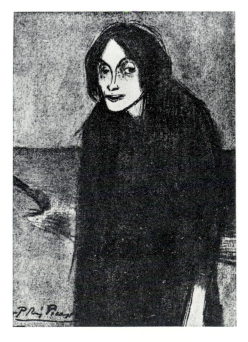

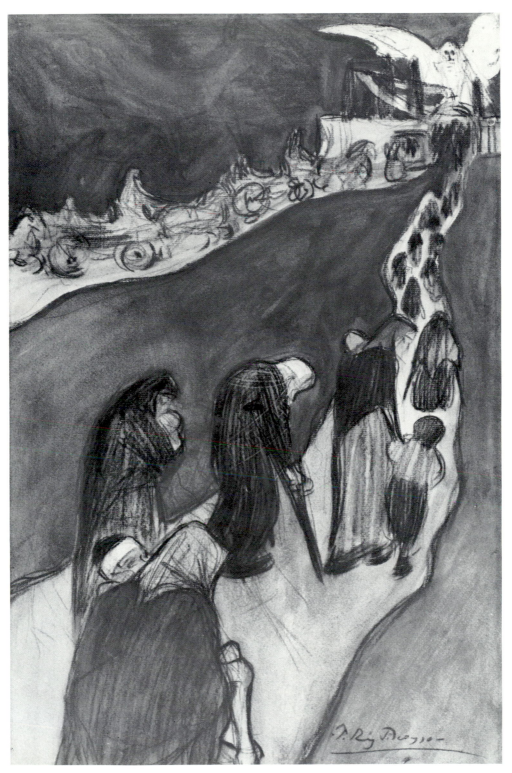

19. *The End of the Road*, c. 1899. Oil wash (?) and conté crayon on paper, 45.5 x 29.8 cm.

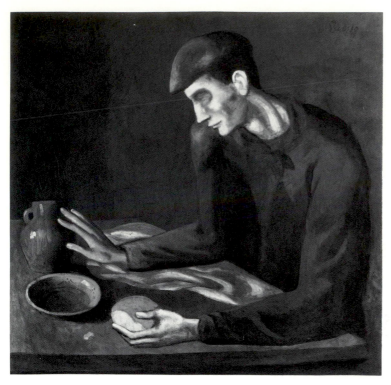

20. *The Blind Man's Meal*, 1903. Oil on
canvas, 95.3 x 94.5 cm.

21. *The Old Guitarist*, 1903. Oil on panel,
122.9 x 82.6 cm. Helen Birch Bartlett
Memorial Collection, 1926.253 © 1987
The Art Institute of Chicago. All rights
reserved.

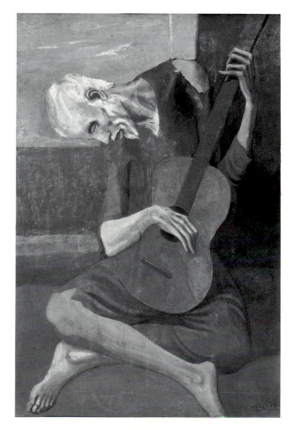

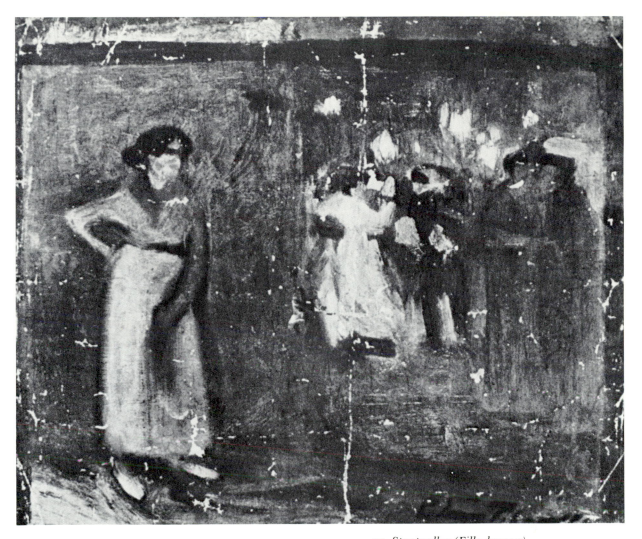

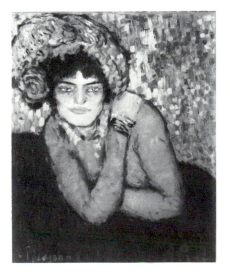

22. *Streetwalker (Fille des rues)*, 1898–1899. Oil on canvas, 46 x 55 cm.

23. *Harlot with Hand on Her Shoulder*, 1901. Oil on cardboard, 69.5 x 57 cm.

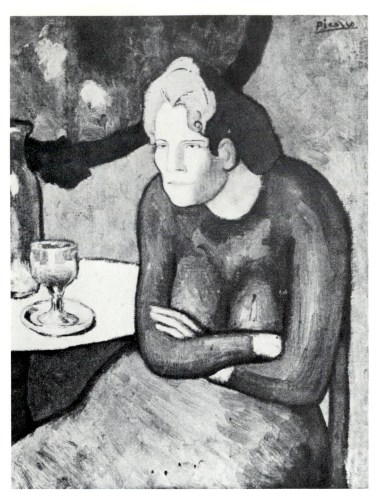

24. *The Absinthe Drinker (Girl with Folded Arms)*, 1901. Oil on canvas, 77 x 61 cm.

25. *Two Women*, 1901. Watercolor and ink on paper, 13.4 x 20.3 cm.

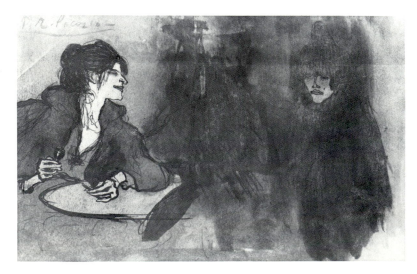

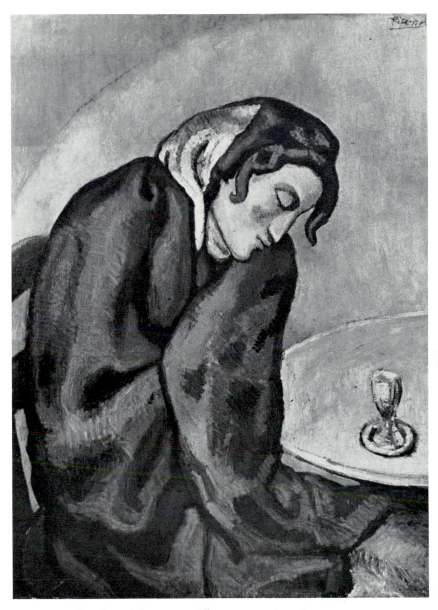

26. *Dozing Absinthe Drinker*, 1902. Oil on canvas, 80 x 62 cm.

27. *Alms*, 1899. Charcoal, pencil, and colors with turpentine, 47 x 32 cm.

28. *Woman in Blue*, 1901. Oil on canvas, 133.5 x 101 cm.

29. *A Carter*, 1897–1898. Conté crayon
on paper, 18.5 x 13 cm.

30. *A Porter*, 1897–1899. Conté crayon
on paper, 32 x 22.2 cm.

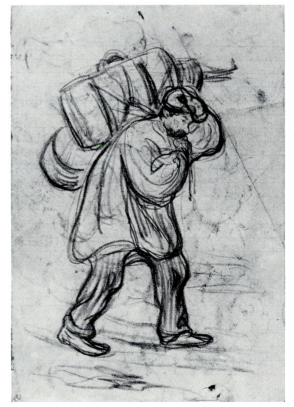

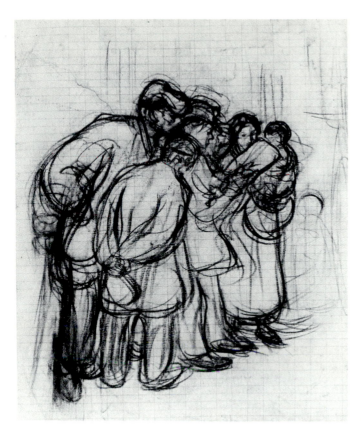

31. *Onlookers*, 1897–1899. Conté crayon
on paper, 21 x 16.8 cm.

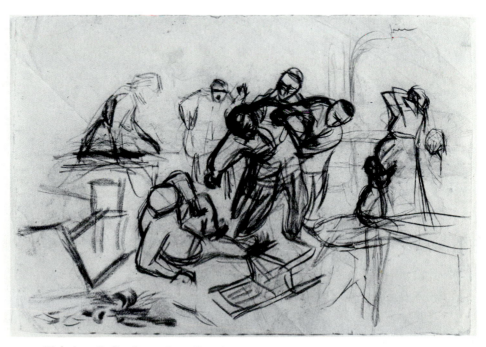

32. *Fight in a Café*, 1897–1899. Conté crayon on paper, 22.9 x 33.5 cm.

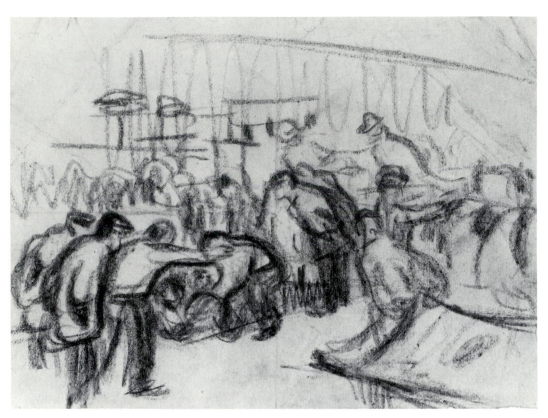

33. *Street Scene*, 1897. Conté crayon on paper, 15.6 x 21.3 cm.

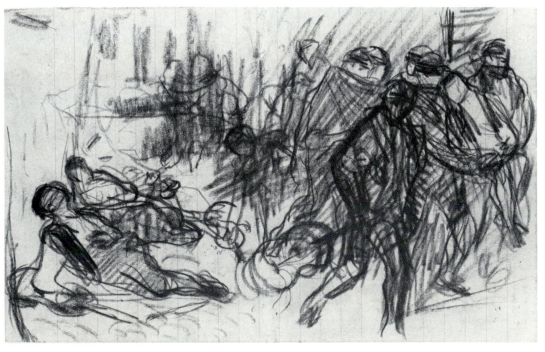

34. *A Crowd of Men (After the Fight)*, 1897–1898. Conté crayon on paper, 13 x 21 cm.

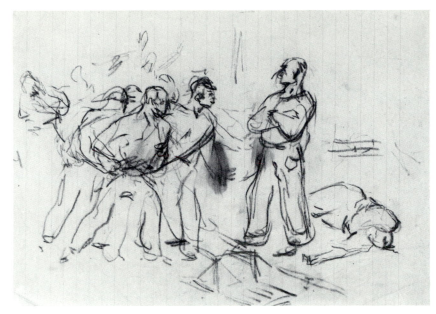

35. *Street Fight*, 1897–1898. Conté crayon on paper, 20.1 x 26.2 cm.

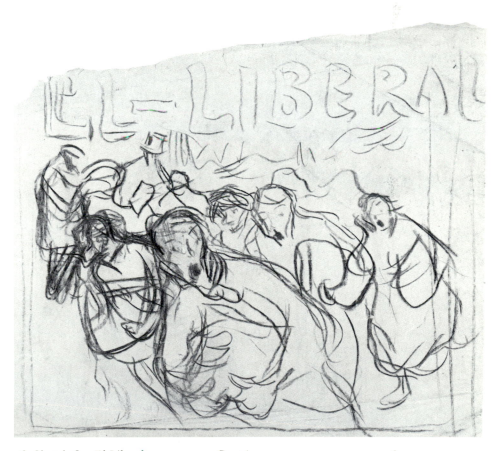

36. Sketch for *El Liberal*, 1900–1902. Conté crayon on paper, 33.7 x 36.3 cm.

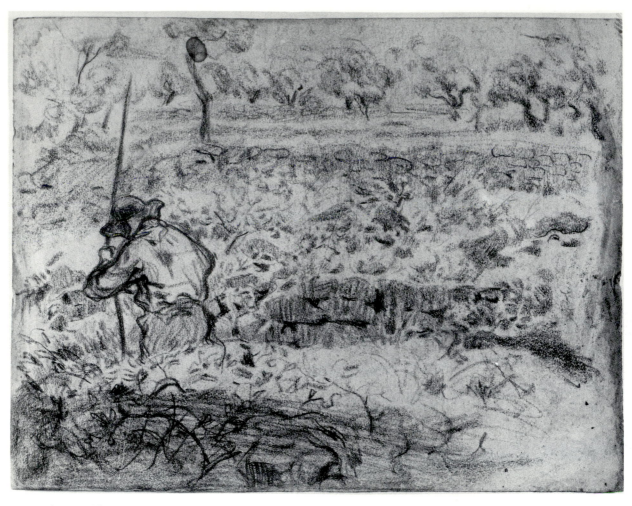

37. *Landscape with a Peasant*, 1898–
1899. Conté crayon on paper, 24.2
x 31.8 cm.

38. *Portrait of Manuel Pallarés*,
1899. Charcoal and color wash on
paper.

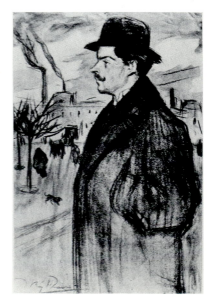

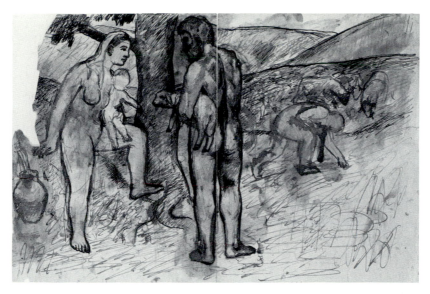

39. *Pastoral Scene*, c. 1902. Pen and wash on paper, 26.1 x 40 cm.

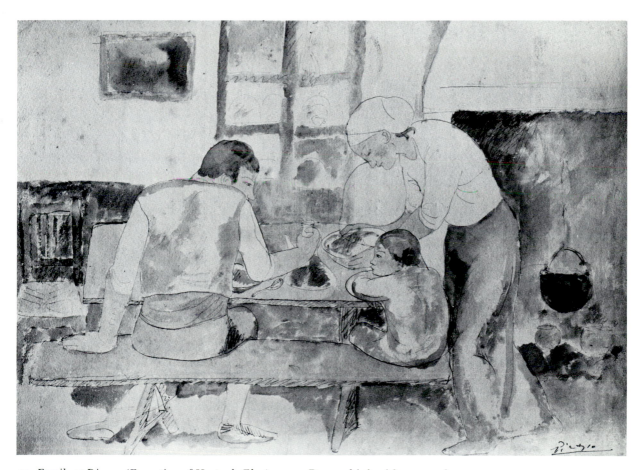

40. *Family at Dinner (Evocation of Horta de Ebro)*, 1903. Pen and ink with watercolor on paper, 31.7 x 43.2 cm.

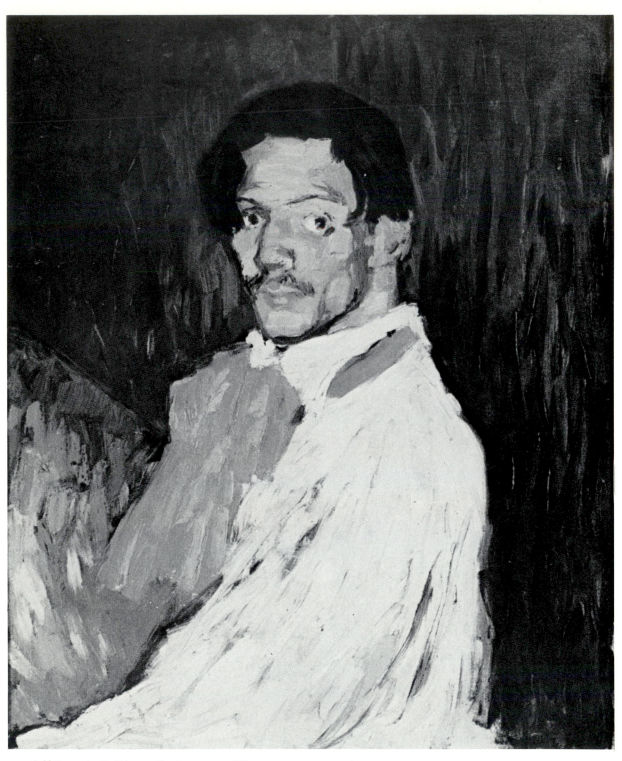

41. *Self-Portrait: Yo Picasso*, Spring 1901. Oil on canvas, 73.5 x 60.5 cm.

Ages, and as more accessible to the artist. Gauguin pointed the way for the following, Cubist, generation. While they closely embraced the idea of childlike purity and spontaneity, they no longer looked to the civilized cultures of the Middle and Far East, but to the "barbarian" cultures of Oceania, Africa, and the Americas, and, in Picasso's case, to Spain.[33] Although much of Picasso's possible access to Iberian art c. 1903–1906 has been documented, it is little recognized that in his early years in Barcelona he would almost certainly have seen images of Iberian statuary in the Catalan art journals, readily accessible at Els Quatre Gats.[34] *Hispania* and *La Ilustració Llevantina* published illustrated articles on the indigenous art of Catalonia during the Catalan Renaissance, including Iberian and Romanesque. Picasso may even have seen a copy of E. Hübner's *La arqueología de España*, published in Barcelona in 1888, since the whole issue of indigenous art, and its primitive expression of a "pure" spirit, was given a good deal of attention in Picasso's circle around 1900. The important excavations at La Alcudia de Elche in 1897, which produced the stunning *Lady of Elche*, brought attention to Iberian art and led to the excavations at Osuna and Cerro de los Santos.[35]

James Johnson Sweeney has closely documented the discoveries and publications of Iberian art in Spain and France prior to the *Demoiselles*, though he misses the Catalan periodicals and notes mostly professional archaeological journals that Picasso was much less likely to have seen.[36] To be sure, Sweeney argues only for a "coincidence of dates which would tend to support the likelihood of a recently-awakened curiosity and interest on Picasso's part": Picasso had recently told Zervos (in 1939) that he had not seen any African art until just after painting the *Demoiselles*, but that he had been inspired instead by Iberian sculpture.[37] Sweeney also documents the Louvre acquisitions prior to 1907—as early as 1897 the museum had displayed the *Lady of Elche*—and emphasizes that "it was in the spring of 1906 that Iberian art had received its widest publicity in Paris thanks to the installation of the Osuna sculptures [excavated in 1903] in the Louvre."[38] He goes so far as to suggest briefly that "the fact that these expressions were a part of Picasso's racial or national heritage had a further importance,"[39] but neither investigates nor speculates further. Most subsequent critics have been content to trace the stylistic relationships.[40]

Yet more than providing mere models of simplified form, the Iberian images offered expressions of the earliest, most "primitive" Spanish people about whom anything was known. Thought to have come to the peninsula from Africa beginning in about 3000 B.C., they were described by Roman writers as typically dark-complexioned, small-framed, hardy, wiry, alert, and savage.[41] (If Picasso was aware of this description, he would probably not have been displeased with its similarity to his own physical appearance.) Up to about the fourth century B.C., the Iberians were settled in the southeast corner of Spain, centering in Andalusia and Murcia, but by the third century B.C., their culture had shifted in part to the valley of the

Ebro River (corruption of Iberus), encompassing the lower part of Aragon and Catalonia. Thus Catalonia could claim ancestry back to the original Iberians, whose art expressed the purest "Spanish" or "Catalonian" spirit before the corruption of modern times. Such ideas served to promote the general importance of primitivism in the Catalan *renaixença*; the reproductions of Iberian art no less than the puppet plays at Els Quatre Gats justified the extreme simplification of artistic means in the work of the 1890s of such artists as Casas, Mir, Canals, and Nonell, as well as Picasso.

The excavations at Osuna begun in 1903 were first published in Paris in 1906,[42] and the Osuna bas-reliefs were put on prominent display on the main floor of the Louvre in the spring of the same year and widely publicized. Picasso may have known that Osuna lay less than fifty miles from his birthplace in Andalusia. Golding rightly points out that the earliest forms of Iberian influence in Picasso's art of 1906 closely resemble the Greek-influenced Osuna reliefs, whereas the two central figures in *Les Demoiselles d'Avignon* relate closely to the extremely crude sculptures from the excavation at Cerro de los Santos,[43] which were on view in the Louvre after 1903 in the Salle des Antiquités Ibériques (Fig. 52).

This basement room is the one from which they were stolen in March 1907 by Apollinaire's ex-"secretary" Géry-Piéret, who sold them to Picasso, initiating the "affair of the Phoenician statuettes." This culminated, not at all amusingly, in Apollinaire's arrest and incarceration for four days in the Santé prison for harboring, as the police thought, the thief of the Mona Lisa.[44] Picasso certainly knew the two heads were stolen since he kept them hidden in his house while he owned them, became terrified when the police discovered Géry-Piéret's name following the theft of the Mona Lisa, and instantly set about trying unsuccessfully to throw them in the Seine.[45] And he was not above breaking the law in other matters, such as carrying a concealed weapon.[46]

Could these have been "commissioned" thefts? Salmon, contemplating Apollinaire's role (and, as usual, obscuring Picasso's) in the affair, disingenuously wondered: "Who knows whether Guillaume did not, like myself, unsympathetic with the police even to antistatism, hear this fool Gery-Pieret, for one moment a witty man, say to the charming Marie Laurencin: 'Mlle Marie, I'm going to the Louvre. . . . Is there nothing you need?' "[47] It seems an otherwise extraordinary coincidence that Apollinaire's friend would have found a virtually hidden basement room, stolen such obscure and heavy objects—each weighed above fourteen pounds—and then fortuitously discovered that Picasso would buy them during the period of the *Demoiselles'* first phase. Such an outlaw attitude on Picasso's part would not be inconsistent with his sense of his rights as an artistic appropriator, with a unique and compelling relationship to little-valued expressions of Spanish barbarism.

That Picasso used the actual forms of the Iberian sculpture in his work in a

new way in 1906 and 1907 does not necessarily argue that it was his first awareness of them. The idea of expressing the primitive in oneself, in emulation of this pre-historic manifestation of the childhood of Spain, was new neither to Picasso nor to the Barcelona *modernistes*. But it was a particularly apposite moment in his art and in his relations to French culture to appropriate these sculptures to his work. As we will see in Picasso's later, more abstract, works, as he distanced himself from narrative painting he found ways of bringing content back into his art. With the allusion to prehistoric Spain embodied in the radically simplified forms of his "Ibe-rian" figures, Picasso announced his origins and sympathies as outside the Euro-pean tradition. This is nowhere more evident than in his *Self-Portrait with a Palette*, autumn 1906 (Fig. 53), with its exaggeratedly Iberian features: large staring eyes with hard linear rims, geometric arcs of eyebrow, simplified helmet of hair, and oversized ear on a simplified, elongated oval head.

Considering the special importance Picasso gave to his self-portraits of 1901, with their affirmation of the Nietzschean "Yo," we can expect this self-portrait of 1906 to be conflated with Iberian forms in order to make a particular statement.[48] By identifying himself with Iberian art as the primitive expression of a provincial culture largely outside the mainstream of European art—any emigré Spaniard must have rankled at the romanticization of picturesque Spain and the *fantaisies espagnoles* of the nineteenth century—Picasso strikes an adversary pose. And by making his own art in the image of this Spanish primitivism, he embraced its more "genuine" forms and feelings as a challenge to the outworn decadence of the still-powerful academic tradition. The secrets of the sculptures, Picasso assured Apol-linaire, were "at once ancient and barbarian."[49]

Picasso introduced this important idea in his work by "quoting" the sculptures. At the same time, by incorporating the Iberian forms into the arcadian works of summer 1906, he associated Iberian culture with the simple, harmonious golden age that was the anarchist pastoral vision, "ancient and barbarian." *Nude with a Pitcher*, summer 1906 (Fig. 54), while retaining some of the features—the eyes, for example—of earlier works such as *Boy Leading a Horse*, additionally exhibits new characteristics: the blockier body, the sculpturesque modeling of the face, the long, straight, substantial nose, the perfectly arched brows, the look of quiet, self-con-tained concentration. Other figures in the same series even more strongly evidence the new Iberian influence, for example, *Head of a Woman*, summer 1906, and *Standing Female Nude*, summer 1906.[50]

Many of the works from 1906 also bespeak the classical Mediterranean world alongside or intermingled with the Iberian. Palau i Fabre has discussed the impor-tance of the neo-Greek style in Barcelona when Picasso and Olivier passed through on their way to Gósol in May;[51] he quotes Eugenio d'Ors in his call for the "Medi-terraneanization" of Catalan art, to ally it with the traditions of the north and east rather than with the Castilian plateau—and the authoritarian and centralized

Madrid government—to the west. Picasso, however, had already spent two years at the Closerie des Lilas listening to Jean Moréas's call for classicism, so the message in Barcelona would have reinforced rather than introduced such thoughts. Either way, Picasso consistently used classicizing forms in the service of the pastoralism begun in 1905, though he was never interested in the mere "devotion to Beauty" advocated by d'Ors. Nevertheless, it is worthy of note that d'Ors made his appeal on moral, and by implication political, grounds when he wrote:

> For too long now has ugliness darkened the works of artists. They must be won back to an unclouded devotion to Beauty. They must aspire once more to produce sublime examples of formal perfection. . . . Beautiful forms are glorified once again. And everything we do along these lines will give us significance in history tomorrow; a significance morally demanded by the conditions in which nature has placed us. For I believe that our position as Mediterraneans not only gives us rights but also imposes duties on us.[52]

After Picasso returned from Gósol, he embarked on a series of works that specifically undermine the classicizing beauty of those done in Gósol. Both shocking in their crudity and subtly horrifying in their image of humanity, they have shifted only slightly from the pastoral images of the summer. In paintings like *Nude on a Red Ground*, summer–autumn 1906 (Pl. III), and *Nude Combing Her Hair*, autumn 1906,[53] the timelessly elegant gestures of the Gósol nudes are aped by increasingly grotesque figures who gaze eyelessly in a parody of gentle wistfulness. In the first, the earthy colors of the background and figure are overlayered by a sickly green tint on the chest, belly, and thighs, which thoroughly alters the effect of the work. The major paintings of the late summer and autumn, *Two Nudes* (Fig. 55) and its studies, the series of self-portraits (Fig. 53),[54] and *Seated Female Nude* (Fig. 56),[55] deliberately affront our sensibilities—especially after the gentle vision of the summer—embracing instead the violence of the primitive, its power to subvert traditional images, and its resulting threat to the old civilization.[56]

These blank masks and blocky geometricized bodies undermine the traditional canons of female beauty in a new way in Picasso's work. He had rarely—apart from the immediately preceding summer—concentrated on women as objects of harmonious beauty and physical health. From the grotesquely self-satisfied women of the Madrid period (see Fig. 28) and the degraded, swollen prostitutes and starving scarecrow mothers of the Blue Period (see Fig. 15 and Pl. I) to the elongated, skeletal laundresses and companions of the early Rose Period (see Fig. 42), Picasso had consistently distorted the female form for expressive and metaphorical purposes. Yet nearly always they had been depicted in a social context of some kind—bourgeois comfort, urban poverty, circus life—and as such remained purposely outside the academic tradition and in the line of nineteenth-century avant-gardism. But the new work of late 1906–early 1907, by depicting the "idyllic"

nude and suppressing all other content, attacked the traditional image of nude female beauty on its own ground. Such works challenged the very concept of the old order and announced its demise in the face of a full-scale revolt—a revolt in the name of those powerful, primitive forces of natural being that civilization, according to the anarchists, had corrupted and suppressed for so long. "In shattering a fragment of the artistic façade," Gustave Kahn had written in 1897, the artist "touches the social façade."[57] Picasso continued in this direction through 1907, increasing the violence of his departure from traditional canons and ending with the explosion that is *Les Demoiselles d'Avignon*.

The increasing antinaturalism of Picasso's style in this period continued to serve the polarities of his earlier work: an attack on the bourgeois complacency represented by the classical tradition and an affirmative vision of a timeless rural anarchist harmony. The monumental crudity and obtrusive sexuality of such figures as *Seated Female Nude* speak as if from the darkest past of human consciousness or the deepest level of unmediated inspiration—for Picasso it would amount to the same thing. And he applied the same developing techniques of linear and geometric simplification to pastoral themes. In Gósol he had made a number of studies for *Composition: The Peasants*, executed in Paris in August 1906 (Fig. 57). What is probably the earliest sketch—both more naturalistic and most unlike the others—represents a young girl leading, at a walk, a blind flower seller (Fig. 58). Subsequent drawings and gouaches[58] depict the couple at a run, the flower vendor now younger and sighted, moving the image from observed realism in a social context to an idyllic scene of joyous work in harmony with nature. This anarchist pastoral vision is completed in the final version with the inclusion of a pair of sweet-faced oxen who run along unburdened at their side.[59]

Picasso began in this picture to distort form in a new way. Taking cues from El Greco—he had probably just seen his friend Miguel Utrillo's book on the artist when he passed through Barcelona[60]—he elongated the figures in an uneven and inconsistent manner, so that they seem extraordinarily disproportionate, and began to break up the form, at least of the draperies. What Picasso discovered here was a way of treating arcadian themes in an exaggeratedly anticlassical style. He pursued this avenue, it seems amazing to realize, into 1907 and the Cubist period. In *The Harvesters*, spring 1907 (Pl. IV), a pair of oxen graze in the foreground while five robust men and women carry on the harvest.[61] This image again speaks of healthy labor, in tune with the seasons of nature. The unusual colors—the joyous golden yellow of wheat, clear turquoise blue and pale green of sky above, and brilliant mauve of the central woman's dress—combine with the earthy red-brown and medium rose of the soil, trees, oxen, and harvesters' bodies—colors that are familiar from Picasso's work of 1905 and 1906.

Unlike contemporary Fauvist paintings, to which this work is usually compared,[62] the colors are not arbitrary. Closer to Van Gogh's paintings, the colors are

taken from nature and heightened as an expression of the intense vitality of natural forces. The brilliant yellow wheat here is harvested by men and women the same color as the soil, trees, and beasts, forming another image in Picasso's oeuvre of the laboring peasant's unity with nature. To reduce this painting to the formulation that, as Daix writes, "Picasso tested out colour effects, using a theme he had noted at Gósol,"[63] is to ignore Picasso's earlier work and the importance of subject matter to his larger artistic career; and it treats his work beginning in 1906 or 1907 as a march toward Cubism, long viewed as the most purely formal and contentless of Picasso's styles. It further ignores the fact that this theme "Picasso noted at Gósol" was not new either to Picasso or to the Western tradition. Picasso precisely wanted to pursue a formal radicalism without abandoning allusion and subject matter, as *The Harvesters* and *Les Demoiselles d'Avignon* prove. The style itself constitutes part of the subject matter that he was exploring: his allusion to crudely "primitive" ancient Spanish art in the very forms of these "Iberian" figures performing an ancient ritual promotes an entirely different reading of this subject than would a classicizing version and imports several calculated acts of rebellion into the work.

It has often been noted that Picasso's work leading to *Les Demoiselles d'Avignon* responds to and competes with the large figural compositions of Matisse and Derain. All, of course, stem from the important example of Cézanne's *baigneuses*.[64] Matisse's *Joy of Life*, 1905–1906, appeared at the Salon des Indépendants in spring 1906 (and was bought by the Steins), and his *Blue Nude*, 1907, and Derain's *Bathers*, 1907, were shown a year later.[65] The *Demoiselles* acknowledges the Cézanne, Matisse, and Derain paintings in its radical, "modernist," large-scale composition of nude female figures. That the overall tone of the work differs so greatly is part of Picasso's point, discussed below. Here it is important to note that *The Harvesters* also carries on a dialogue with the *Joy of Life*: where Matisse's arcadia represents a classical vision, with nude figures luxuriously idle in an ideal landscape, Picasso's represents something closer to the Spanish anarchist vision, where an ideal harmony grows out of mutual aid and working the soil. When Picasso, who had always preferred the concrete, responded to Matisse and Derain with a large composition of female nudes in *Les Demoiselles d'Avignon*, he showed a roomful of prostitutes, much like Manet with his shocking *Olympia* in 1863, which unacceptably depicted a prostitute in the posture of a reclining Venus.

Traditionally *Les Demoiselles d'Avignon* (Fig. 59) has been seen as "the first Cubist picture,"[66] a view focusing on its formal innovations. But studies in the last fifteen years have shed new light on various aspects of the picture's content and cast doubt on the work's similarity, in aim and effect, to the supposedly content-neutral Cubist period that followed. For example, Steinberg considered Picasso's treatment of sexual themes; Rosenblum investigated the relationship of the work to such earlier artists as Ingres, Goya, Delacroix, and Manet; Johnson has addressed the influence of Nietzsche, Jarry, and the theater on the *Demoiselles*; and Gedo has inter-

preted the painting as an allegory of Picasso's inner psychological drama.[67] All these readings of the *Demoiselles* have contributed to our understanding not only of the work's preoccupations but of its historical place and time. Without displacing any of these interpretations—in fact, in many ways confirming the self-conscious radicalism these critics identify in the painting—I would argue that Picasso's earlier anarchism also visibly plays a role in all phases of its composition.

As several of these historians have pointed out, the revelation of a sketchbook, released to Zervos shortly before Picasso's death in 1973, sheds new light on the early stages of the composition, especially the two male figures—"sailor" and "student" with book and skull—who were later omitted.[68] The original conception was far more narrative than the final painting. The sailor sits in the center of the composition, next to a table with fruit and a *porrón* of wine (Fig. 60). One woman sits next to him; in two sketches she appears to sit on his lap.[69] The other four women display themselves for the benefit of the man holding a book who has just entered—a "medical student," Picasso later insisted, possibly to defuse obvious interpretations of the skull.[70] In several sheets of studies this figure holds a skull, in some a book; in one he holds both (Fig. 61).[71] Steinberg has attempted to explain the carrying of the skull and book into this whorehouse as heralding "the deadening approach of analysis." But most scholars agree that the skull is a memento mori,[72] and indeed it seems impossible to imagine this ritualistic figure—with primitivist features in rigid profile, presenting his death's-head to the prostitutes—divested of such meaning. The student presents the skull to the sailor and prostitutes with its traditional associations: to remind them of death and the spiritual "wages of sin," which Cabanne claims was Picasso's original title.[73]

Given Picasso's anticlerical attitudes and alienation from the Church, however, the "wages of sin" in this study speak more of the private hell of the prostitute, a recurrent and dominant theme in his work from 1898 to 1904. When the student exchanges the skull for a book, he raises his left arm in a rhetorical gesture, and the prostitutes at the right seem to look at him in surprise (Fig. 62). With his increasingly hieratic, Iberian features[74] and the book of wisdom he carries, he attempts to bring a liberating message to what Picasso had depicted in the Blue Period as the absolutely lowest, most exploited members of the social order. When this figure—whose features originated in Picasso's own self-portrait[75]—is transformed into the female figure who similarly enters from the left in the final version, as can clearly be seen in the intermediate sketches, the raised left arm with its rhetorical gesture of announcement never varies in a single study.[76] This figure, now a prostitute herself, also continues to look at the roomful of prostitutes in the final version, though the others all turn outward, directly facing the spectator, who thereby becomes the customer. In at least nineteen sketches, Picasso played with the idea of including, at the feet of the "student," a bitch suckling puppies (Fig. 63),[77] an image of overpowering naturalness of sexuality, especially in contrast

with the kind of sex purveyed in a whorehouse. In Figure 61, the bitch leaps joyfully at the figure's feet, as if allying herself with him.

Speculations on the evolution of the *Demoiselles* such as these and others (for example, whether Picasso identified with one or both of the male figures, or later merged his identity into the left-hand female figure)[78] offer provocative suggestions. Nevertheless, we must distinguish between primary and secondary content, between the content accessible—even obvious—to a contemporary viewer and content personal to Picasso, accessible only through drawings that he kept hidden for over sixty-five years. In the final work we have only the five women. Yet Picasso, while rejecting the narrative quality of the early studies with their laden symbolism of skull and suckling bitch, incorporated some of this allusive content into the forms of the female figures. As with the earlier *Nude on a Red Ground* (Pl. iii) or the contemporary *Harvesters* (Pl. iv), the Iberian faces of the two central figures and their crudely simplified forms ally them with that idyllic moment of Spain's prehistoric past. But in the context of the brothel, such visions become inappropriate and point up painfully the prostitutes' loss of freedom and harmony with nature. At the same time, the exaggeration of their sexual display threatens the spectator/customer, now that they have turned their attention from the "student" to the world beyond the frame. Their primitive power and hypnotic gaze are anything but alluring; yet they pale in comparison with the violence of the two right-hand figures, based on African rather than Iberian models, whose presences considerably increase the horrific voltage of this work.

The date of Picasso's first encounter with African sculpture has been much debated by scholars; the crux of the question is whether he was aware of African art before he finished painting the *Demoiselles*. Vlaminck remembered that Picasso first saw samples in Derain's studio about 1905; Matisse, that he showed Picasso a piece he had just acquired in the fall of 1906 in the apartment of Gertrude Stein, who confirms the story; Salmon, that Picasso was already collecting African masks of his own in 1906.[79] Picasso himself said nothing about it for almost thirty years except for his facetious remark in 1920, "L'art nègre? Connais pas!"[80] Then in 1942 Zervos announced in oddly legalistic terms:

> The artist has formally certified to me that at the time he painted the *Demoiselles d'Avignon*, he knew nothing of the art of black Africa. It's some time later that he had the revelation. One day while leaving the Museum of Comparative Sculpture which then occupied the left wing of the Palais du Trocadéro, he became curious to push the door opposite, which gave access to the rooms of the old Museum of Ethnography. To this day, more than thirty-three years later and in spite of current events that torment him profoundly, Picasso speaks with profound emotion of the shock he received that day, at the sight of African sculpture.[81]

The visit, the emotional shock, certainly have the ring of truth. But was this his very first knowledge of its existence? Typically Picasso, while all Paris excitedly discussed and collected African sculptures, remained oblivious until one day—like the charming innocent he often pretended to be—he accidentally discovered it for himself by being curious about a door. If the overwhelming visual evidence of the two right-hand figures in the *Demoiselles* still had not quite convinced one—and it has convinced most scholars[82]—the fictional qualities of this "formal certification" (à la Jarry) should. Two years earlier Picasso had given a far more lengthy and compelling account of this trip to the Musée d'Ethnographie to André Malraux, who did not publish it until after Picasso's death, though he made detailed notes at the time that are worth quoting at length:

Everybody always talks about the influences that the Negroes had on me. What can I do? We all of us loved fetishes. Van Gogh once said, "Japanese art—we all had that in common." For us it's the Negroes. Their forms had no more influence on me than they had on Matisse. Or on Derain. But for them the masks were just like any other pieces of sculpture. When Matisse showed me his first Negro head, he talked to me about Egyptian art.

When I went to the old Trocadero, it was disgusting. The Flea Market. The smell. I was all alone. I wanted to get away. But I didn't leave. I stayed. I stayed. I understood that it was very important: something was happening to me, right?

The masks weren't just like any other pieces of sculpture. Not at all. They were magic things. But why weren't the Egyptian pieces or the Chaldean? We hadn't realized it. Those were primitives, not magic things. The Negro pieces were *intercesseurs*, mediators; ever since then I've known the word in French. They were against everything—against unknown, threatening spirits. I always looked at fetishes. I understood; I too am against everything. I too believe that everything is unknown, that everything is an enemy! Everything! Not the details—women, children, babies, tobacco, playing—but the whole of it! I understood what the Negroes used their sculpture for. Why sculpt like that and not some other way? After all, they weren't Cubists! Since Cubism didn't exist. It was clear that some guys had invented the models, and others had imitated them, right? Isn't that what we call tradition? But all the fetishes were used for the same thing. They were weapons. To help people avoid coming under the influence of spirits again, to help them become independent. They're tools. If we give spirits a form, we become independent. Spirits, the unconscious (people still weren't talking about that very much), emotion—they're all the same thing. I understood why I was a painter. All alone in that awful museum, with masks, dolls made by the redskins, dusty manikins. *Les Demoiselles d'Avignon* must have come to me that very day, but not at all because of the forms; because it was my first exorcism-painting—yes absolutely![83]

The interpretation Picasso gives here has quite obviously been filtered through the experience of Surrealism and the 1930s—he repeated related ideas to Zervos in 1942 and to his friend, Surrealist poet Paul Eluard, who echoed them in an essay in *Cahiers d'Art* in 1936[84]—but the confession, given only to Malraux, rings true: "*Les Demoiselles d'Avignon* must have come to me that very day."

The reasons for looking to African art as a model closely resembled Picasso's attraction to Iberian art. Firstly, though other artists may have admired it, collected it, and even shown it to Picasso, none had yet incorporated its forms into their art. Thus it was new. But, more important, African sculpture offered a model of conceptualizing simplification based on folk traditions that go back into the mists of time, representing to Picasso bona-fide "primitive" expressions of thought and feeling.[85] Salmon records, in *La jeune peinture française* (1912), Picasso's interest in Oceanic and African images as "raisonnables," or conceptual; in the first half of the century this was generally cited as Picasso's whole relationship to "primitive" art.[86] But Salmon goes on to say in a later section of the same chapter that, "in choosing savage artists as guides," Picasso "was not unaware of their barbarity." He was "the apprentice sorcerer always consulting the Oceanic and African enchanters." Abandoned by friends who did not understand his new art, "a bit deserted, Picasso found his true self in the society of the African augurs."[87]

Africa, as imported into Picasso's painting, represents not an idyllic, pre-European society but the very opposite of civilized Europe and as such a threat to it. The radical treatment of the traditional idealized nude female—now literally "idealized" in terms of African conceptualization, antirational no matter how *raisonnable*—announces the end of the old world of art with a new, staggering violence. The violence comes not only from the savage treatment of the faces and forms of the two right-hand figures based on African art, but from the very allusion to the "dark continent" unavoidably carried with it. The tremendous powers of primitive spirituality—"African soothsayers"—overwhelm the decadent European tradition in an undeniable act of moral rebellion. The comparatively passive "Iberian" women in the middle, prostitutes on sexual display, are overwhelmed by, and their psychic presence supplanted by, the "African" women on the right, who mock such display and aggressively challenge the "bankrupt" Western artistic tradition. Braque, expressing a similar attitude (for which Picasso later wished to deny him credit), said in 1954 that "the negro masks also opened a new horizon to me. They permitted me to make contact with instinctive things, direct [emotional] manifestations which went against the false tradition."[88] Not only are these spirits unsympathetic to the life of Europe, they are its enemy.

This work, painted by Picasso—Jarry's friend and disciple—while Jarry lay dying,[89] cannot avoid a relationship to those anticolonial satires on black Africa that populate Jarry's oeuvre. The raw sexuality of his black characters, their perverseness, stand against the world of their rulers; and behind it all lies the exploi-

tation and the brittle and absurd cultural superiority that Jarry ridiculed. Appropriately, colonial Europe brought home with it the elements of its own symbolic destruction: without colonials carrying barbaric curiosities back for display in Paris, no Trocadéro could have offered its horrific treasures to Picasso's eyes. Picasso himself was conscious of Africa's tribal and colonial setting. A drawing in a sketchbook of 1905 (Fig. 64), contemporary with studies for the *Family of Saltimbanques*, shows an African native in front of a grass hut, two palm trees, and a river with a tiny figure in a canoe. The African is emaciated, mere skin and bone, with an overlarge and crudely simplified head, his arms on his hips forming a diamond shape.[90] Since Picasso was probably not yet aware of African tribal art, this drawing may reflect a more general interest in Africa, à la Jarry and Apollinaire, as a place both culturally fascinating and politically oppressed, whose oppression was caused by French colonialism.[91]

On one hand then, the alliance of black Africa, with its brutal colonial history, and these prostitutes, in Picasso's oeuvre among the most cruelly exploited and spiritually damaged groups in European society, represents not only the end of the old artistic order but also of the old moral and political order as well. And in terms of the anarchist view of things, where *The Harvesters* bespoke an ideal time of past and—after the revolution—of future, *Les Demoiselles d'Avignon* constitutes an act of la propagande par le fait—that horrifying method of drawing attention to the oppression of the present and sparking revolt. Picasso made a particular point to Pierre Daix that these two works developed side by side: "He was quite definite that this [*The Harvesters*] was painted at the same time as *Les Demoiselles d'Avignon*."[92]

If the masks of the individual demoiselles are horrifying, the painting as a whole is more so. Although prostitutes usually wish to please, Picasso's fetishes terrify and repel the spectator; likewise, the painting itself mocks and challenges the time-honored status of the easel painting as commodity. It is noteworthy here that Picasso refused to exhibit his work or to participate in the traditional Salon system of judgment and official reward. After he moved to Paris, he never submitted to any Salon. And after his group show at the Galeries Serrurier in February–March 1905, the only current work he publicly exhibited in Paris seems to have been in May 1910 at the Galerie Notre-Dame-des-Champs and possibly another in late 1910.[93] Otherwise, to see his work, one had to make an appointment at Kahnweiler's—his gallery was not open to the public—or know Picasso himself, which was not difficult for interested buyers or fellow artists.

A number of critics have described *Les Demoiselles d'Avignon* as a bombshell or the like, and Palau i Fabre compared it to the bombs of Catalan anarchists, though for reasons he sees as solely relating to the Barcelona art world.[94] Critics of the time conceived of Picasso and the literary and artistic avant-garde as "anarchists in art," as the journalism of the day abundantly demonstrates.[95] His own circle was

horrified, and several eyewitness accounts give us a sense of the seriousness of Picasso's departure from his earlier work. Salmon, after relating the charming story of the *Boy with a Pipe* and its crown of roses, wrote:

> Picasso was able to live and work in this way, happy, justifiably satisfied with himself. He had no ground for hoping that some different effort would bring him more praise or make his fortune sooner, for his canvases were beginning to be competed for.
>
> And yet Picasso felt uneasy. He turned his pictures to the wall and threw down his brushes. . . .
>
> Never was labour less paid with joys, and it was with none of his former juvenile enthusiasm that Picasso set to work on a major picture [*Les Demoiselles d'Avignon*] which was intended to be the first application of his researches. . . . The results of the initial researches were disconcerting. No concern for grace; taste repudiated as an inadequate standard!
>
> Nudes came into being, whose deformation caused little surprise—we had been prepared for it by Picasso himself, by Matisse, Derain, Braque, Van Dongen, and even earlier by Cézanne and Gauguin. It was the ugliness of the faces that froze with horror the half-converted.[96]

Gertrude Stein was silent; Leo Stein laughed; Matisse angrily swore revenge on what he saw as a mockery of his own modernism. Derain told Kahnweiler that "one day we shall find Pablo has hanged himself behind his great canvas,"[97] rather bitterly alluding to Zola's famous failed artist in *L'Oeuvre*. Even Apollinaire was taken aback and worried that Picasso might destroy the reputations they had both worked hard to establish; he muttered only one word, "révolution."[98] Kahnweiler, in relating his first visit to the Bateau-Lavoir, has given us the best description of Picasso's position at this time:

> Nobody could imagine the poverty, the abject misery of those studios in the rue Ravignan. . . . In parts the wallpaper hung off the planks forming the walls. The drawings were covered in dust, as was the tattered material of the divan, which was torn open. By the stove the ashes were piled in a mountain of lava. It was frightful. Here it was that he lived with a very beautiful woman, Fernande, and a huge dog, Fricka. There, too, was the large painting Uhde had told me of, that great painting which since then has been named "Les Demoiselles d'Avignon," and which represents the starting point of Cubism. What I'd like to make you realize at once is the incredible heroism of a man like Picasso, whose moral loneliness was, at that time, quite horrifying, for none of his painter friends had followed him. Everyone found that picture crazy or monstrous.[99]

Kahnweiler goes on to relate the oft-repeated but always varied story of Braque's reaction to the *Demoiselles*: it made him "feel as if someone were drinking

gasoline and spitting fire."[100] The original version of this story appears in Salmon's "Montmartre, 1906–1920": "C'est comme si tu buvais du pétrole en mangeant de l'étoupe enflammée!" ("It's as if you drank gasoline while eating flaming wick!")[101] In Olivier's memory the version is somewhat different; she remembers that at the beginning of his friendship with Braque, Picasso offered reasonable and clear arguments defending the work, but Braque refused to be convinced: " 'Mais,' finit-il par répondre, 'malgré tes explications, ta peinture c'est comme si tu voulais nous faire manger de l'étoupe ou boire du pétrole.' " (" 'But,' he ended by answering, 'in spite of your explanations, you paint as if you wanted to make us eat wick or drink gasoline.' ")[102]

There are also many varied translations of "l'étoupe" in the telling of this story: "tow," "rope," "cotton waste"; all dance around an idea that makes little apparent sense. Penrose's paraphrase typically misses the point by transforming Braque's statement into horror at Picasso's assault on French taste (aristocratic and specifically associated with Matisse): "All [Braque] could say as his first comment was, 'It is as though we are supposed to exchange our usual diet for one of tow and paraffin.' "[103] But "l'étoupe" means not "rope," but "tow" in the sense of "fuse" or "wick," which with gasoline constitutes a Molotov cocktail, an anarchist bomb, affirmed by the common phrase "mettre le feu aux étoupes" ("to light the fuses"). This reading of Braque's statement is the only one that makes sense of the combination of these two particular ingredients. And it pointedly indicates the aspect of the *Demoiselles* that Braque—who was in many ways prepared to understand much of the stylistic radicalism of the painting[104]—could not accept: the sheer destructive desire of Picasso to outrage and offend. And if, as now seems likely following the recent revelation of Braque's address in one of Picasso's sketchbooks from the spring of 1907,[105] Braque actually saw the work develop, then the statement would not be the result of surprise. Rubin suggests, compellingly, that it is his "suspicion that the remark was repeated by Picasso and that he was largely responsible for its dissemination."[106] If so—and the rumorlike variations argue in its favor—it stands not only as part of Picasso's campaign, waged vigorously in the 1920s, to devalue Braque's contribution to the development of Cubism but as a testament to Picasso's own view of the *Demoiselles* and its desired impact.

To argue whether the *Demoiselles d'Avignon* did spark the beginning of the Cubist movement or to discuss its well-known stylistic innovations is not my purpose here, but to note that with other levels of meaning newly considered in the last decade Picasso's anarchist background also played a part, one only confirmed by his contact with such other influences as Jarry, Apollinaire, Salmon, Van Dongen, Vlaminck, and the avant-garde circles in Paris. *Les Demoiselles d'Avignon* was the most outrageous artistic act conceivable at that time, and it held many implications for Picasso and others in days to come.

Picasso's overall impulse in *Les Demoiselles d'Avignon* was negative not only in

its violent re-ordering of artistic form but in its preoccupation with the past. It was an attack on traditional ideals and artistic formulas.[107] Most of his work of 1907 also looked back, undertaking a careful and considered subversion of the major art-historical genres. Picasso, at the time he worked on the *Demoiselles* and in the period immediately following, applied his increasingly violent style—with its allusions to black Africa—to the most traditional subjects in Western art. Madonna and Child, Sleeping Venus, self-portrait, still-life, landscape, the *Spinario*, Picasso transformed them all with destructive wildness throughout 1907. In each genre he carefully established those formulas that would make them still recognizable, then subverted their inherited conventions through violent distortions of color, form, and space.

Picasso placed *Mother and Child*, summer 1907 (Pl. v),[108] in a formulaic Madonna and Child composition, with the child on his mother's lap, his silhouette contained within hers. The mother is robed in the Madonna's traditional blue, and the unusual treatment of her hair can be read as a halo—radiating strokes graduating from black to blue as they expand out to form a circle around her head. Picasso developed the imagery just far enough for us to make the association. Yet, while the composition is familiar, the appalling faces are not. Openly based on such African artifacts as Babangi masks from the French Congo (Fig. 65) and copied almost outright in works like *Head with Scarification*, summer 1907, these faces stare at us with challenging intensity.[109] The comforting universality of such Christian and pagan combinations as Gauguin's Tahitian Madonna and Child, *Ia Orana Maria*, 1891, is rendered demonic in this African Madonna and Child, which suggests a feeling of possession by horrifying and hostile spirits that convey no message of maternal love or spiritual redemption for mankind. Their heads contain frightening details: enormous skewed and lidless eyes through which they stare, scarified cheeks, and tiny uncommunicative mouths (the mother's is hidden by the edge of the child's red skull). Whether their "magical" quality is attributable to Picasso's psychological need for catharsis, as Rubin has argued, or Picasso co-opted their apotropaic power in order to horrify the onlooker, the final appearance of the work constitutes a rather vicious attack on the Church and on the structures of inherited artistic conventions for religious art.

Picasso also executed a self-portrait in this African style, *Head of a Man*, spring 1907 (Fig. 66), recognizable by his characteristic forelock, which is far more radical than his better-known *Self-Portrait*, spring 1907, in Prague.[110] The flat oval face, pointed chin, tiny mouth, wedge nose with cross-hatching, and blank eyes all relate it to Picasso's adoption of the African mask, conflated here with the Iberian features of large eyes and ear as in the *Mother and Child*. And just as his *Self-Portrait with a Palette*, 1906 (Fig. 53), announced his allegiance to Iberian art, this work allies Picasso himself with a non-Western tradition specifically associated with Africa, with all its threat and challenge to Europe.

Female Nude on a Bed (Fig. 67) and its study *Reclining Nude*,[111] both summer 1907, descend from the theme of the recumbent Venus, whose most famous treatments include Giorgione's *Sleeping Venus*, c. 1510 (Fig. 68); Titian's *Venus of Urbino*, 1538; Ingres's Louvre *Odalisque*, 1814; Goya's *Maja Nude*, c. 1800; Manet's *Olympia*, 1863, also in the Louvre and accessible to Picasso; and, of course, Matisse's *Blue Nude (Souvenir of Biskra)*, 1907, shown that spring in the Salon des Indépendants. Picasso's contemporary watercolor sketch of Ingres's *Odalisque* suggests his consciousness of working in this tradition at the time (Fig. 69).

In Picasso's *Female Nude on a Bed* the position of the nude—extended from left to right on her back with her right arm behind her head, elbow pointing up, and right leg crossed under the left—is identical to Giorgione's *Venus*, which Picasso would have known from reproductions. The position varies only in the more exaggerated crossing of the legs—which provocatively turns the lower half of the body toward us even more than Titian had done in his version—and in the absence of the left arm with which Giorgione, Titian, and later Manet had drawn attention to the figure's sexuality. The hatched lines that surround the nude, while as abstract as anything Picasso had painted to date, derive from the traditional bed clothing and background curtain. The three lines at the bottom of the canvas that converge on the nude's right hip resemble the cloth similarly folded under Venus's right hip in the Giorgione. Picasso's cloth with its schematized folds, which hangs behind the nude, is less exactly derived from any single work but alludes collectively to the Titian, whose drapery hangs on the left side revealing an opening on the right; to the Ingres, whose hanging drapery and more shallow opening are reversed; and to the Manet, whose drapery covers the right side and whose partition covers the left side. Picasso has avoided dealing with the space behind the curtain on the right of his painting by filling it in with flat hatching. As in the *Demoiselles* and earlier works—for example, *Two Nudes*, 1906 (Fig. 55), and *The Harlequin's Family*, Paris, spring 1905[112]—Picasso has used drapery to restrict problems of depth and to tie the figure formally to a shallow surrounding space.

He succeeds in this more completely in *Nude with Drapery*, summer 1907 (Fig. 70), whose figural constellation grows out of the composition of the reclining nude and in which—despite the title—the drapery is hardly discernible. As in the *Demoiselles*, the folds of hanging drapery have readily lent themselves to a simplified abstraction; that this was Picasso's starting point can be seen clearly in an early study.[113] In the final version he has retained the verticality of the cloth but altered its angles and folds so as to echo the angles and forms of the nude. The line of the right forearm extends across the top of the cloth, and the arc of the buttock is repeated in an arc immediately to the left, like the curve of the back of the figure's left leg and right foot. Picasso has carefully changed the background color and direction of the hatching in those spaces between figural forms that normally reassure us of spatial continuity, for example, between the left arm and body and

between the knees and ankles. This method of creating surrounding forms that repeat those of the figure and tie it to the same plane as the background was more simply and less successfully attempted by Braque in his *Large Nude*, winter 1907–1908, which is as indebted to this work as to the *Demoiselles*.[114] Such a work as *Nude with Drapery* reveals Picasso's formal interests at this time and the brilliant solution that takes the first step toward the merger of form and space.

To return to my original argument, the contemporary *Female Nude on a Bed* fails in this respect because other motives took precedence in its conception. Picasso wanted this work to exhibit the recumbent Venus formulas in order to radically redefine a traditional image. But the bed and hanging drapery, necessary for its ready identification, create readings in depth that undermine the denial of three-dimensional space which constituted one of his tools of redefinition. Thematic concerns in this case outweighed Picasso's formal ones: turning from the comparatively modern theme of the brothel (*Les Demoiselles d'Avignon*), he saluted the works that best represented the tradition he was leaving behind. In a long series of paintings in this period, he used this image of a female nude with her arm behind her head, elbow pointing up, as shorthand for the traditional image of female beauty, for example, the second figure from the left in the *Demoiselles*; *Nude with Drapery*; *Standing Nude*, early 1908; *Nudes in a Forest*, spring 1908 (Fig. 71); *Three Women*, spring–autumn (?) 1908; *The Offering*, spring 1908; and *Landscape with Two Figures*, summer 1908 (Pl. VI).[115]

Picasso also radically reappraised the traditional still life in this period; for example, the *Vase of Flowers*, summer or autumn 1907,[116] with its strangely violated flower shapes, displays an overall treatment similar to *Nude with Drapery*. More tellingly in terms of his larger subversive project, the violently colored *Composition with Skull* incorporates a traditional memento mori iconography, which has encouraged Reff to redate it to spring 1908, following the suicide of the German painter Wiegels in the Bateau-Lavoir.[117] Even the *Spinario*—instantly recognizable as the image of the nude boy withdrawing a thorn from his foot—is subjected to Picasso's transformations in *Petit nu assis*, summer 1907 (Fig. 72). Here Picasso has not only treated the traditional image in his tortured style but has twisted the legs of the figure into an equally painfully tormented position just beyond the limits of human capacity. The *Spinario* "reconsidered" has lost all the grace and idealism of the Greek original.

In all these works, traditional motifs are treated in a violent, experimental manner that challenges their survival: the Madonna and Child, the vanitas still life, and images of idealized female beauty all represent obsolete formulas whose time-honored meanings Picasso attacked and transformed. Apollinaire's recommendation at this time—"Innovate violently!"[118]—was surely nowhere taken so seriously as by Picasso in these contemporary works. In a sense, this violent reevaluation of the history of art was the last of Picasso's preoccupation with specifically traditional

images for many years. Yet the development of his Cubist style cannot be entirely understood without also grasping the power of its revolt against traditional ways of seeing and painting. To view the parade of Analytical Cubist still lifes as a series of "classical" meditations on form and space is utterly to turn our backs on both the context of these immediately preceding works and the responses of a broad spectrum of contemporary viewers, an issue considered in the next chapter.

Apollinaire later applied quite powerful language to Picasso's Cubist works: Picasso carried out an "assassination" of anatomy; his incorporation of oilcloth, painted paper, and newspapers reminded Apollinaire that "there is mention of an Italian artist who painted with excrement; during the French revolution blood served somebody as paint." These images are redolent of purposeful offense, of violent politics, and of revolution—a word Apollinaire frequently used for Picasso's "great revolution of the arts, which he achieved almost unaided."[119] This revolution did not happen overnight, but was the result of Picasso's methodical overturning of tradition, beginning in his works of these earlier periods. His subsequent Cubism is continuous with these paintings of 1907 in their pointed and ingenious violation of artistic norms.

4. The Style of Revolution

Anarchism and Cubism, 1907-1912

A picture used to be a sum of additions.
In my case a picture is a sum of destructions.
—Pablo Picasso, interview with Christian Zervos, 1935

THE YEAR following his violent reevaluations of art-historical tradition, Picasso began to work closely with Georges Braque, moving toward a radically new style. Following the watershed marked by *Les Demoiselles d'Avignon*, Picasso rapidly and steadily moved toward an increasingly abstract mode, which would place him and Braque in the forefront of a new generation of avant-garde artists. Picasso and Braque's Cubism was based rather loosely and unscientifically on various ideas that seemed particularly forward-looking and characteristic of the new century—for example, Bergson's philosophy and Princet's mathematics[1]—and fulfilled the anarchist esthetic dictum (echoing Baudelaire) that art must express its own time. The Cubist project was conducted, as its apologists universally asserted, with the high seriousness of a search for "reality" even while the visible world receded from their canvases. From the vantage of 1909, the most radical direction in which Picasso could push remained formal abstraction, which he and Braque pursued steadily until the war. The stylistic features of their adventurous new style were apparent to critics from the very beginning: the increasing difficulty of identifying the hermetic image, with its fragmentation of form, ambiguous treatment of space, suppression of color, and its oblique and conceptual relationship to the material world. Picasso's drive to be artistically radical, which helped push the development of Cubism at its frenzied pace from *Factory at Horta de Ebro*, summer 1909 (Fig. 74), to *Bottle of Suze*, November 1912 (Pl. VIII), in only four years, was impelled not—as some critics seem to think—by the *Kunstwollen* of the style alone, but also by his dedication to the *idea* of the revolutionary in art: "a sum of destructions" not only of form and space but of every material and thematic tradition Picasso could think to violate.

This precisely was Picasso's "political act," an assertion later made by Picasso himself. When he joined the French Communist party in 1944, immediately following the liberation of Paris, he made statements that have generally been understood as metaphorical (or delusional), but which I believe he intended literally. His horror at the German occupation and his serious commitment to the Parti Com-

96

muniste Français (PCF) at this time obliged his conscience to tell the truth straight-forwardly. As one can see from his earlier statements, discussed below, Picasso's utterances are usually oblique and ironic. But in the extreme emotional climate of the liberation, he declared with rare candor and thoroughness his lifelong commitment to artistic revolutionism as a political act. In his first explanatory statement, an interview with Pol Gaillard in October 1944, Picasso said:

> My joining the Communist party is the logical outcome of my whole life, my whole work. Because, I'm proud to say, I have never considered painting as an art of simple pleasure, of diversion; I have wanted, through drawing and through color, since those were my weapons, to penetrate always more deeply into knowledge of the world and of men, in order that this knowledge liberate us all more each day; I have tried to say, in my own way, that which I held to be the most true, the most just, the best, and that was naturally always the most beautiful, as the greatest artists well know.
>
> Yes, I am conscious of having always struggled by means of my painting, as a true revolutionary. But I have understood now that even that does not suffice; these years of terrible oppression have demonstrated to me that I must fight with not only my art, but my whole self.[2]

The next spring, following much heated debate in the press, some of which expressly accused him of insincerity and of having stated that art and politics had nothing in common, Picasso composed an official written statement to counter such unsubstantiated rumors:

> What do you think an artist is? An imbecile who has only his eyes if he's a painter, or ears if he's a musician, or a lyre at every level of his heart if he's a poet, or even, if he's a boxer, just his muscles? On the contrary, he's at the same time a political being, constantly alive to heart-rending, fiery or happy events, to which he responds in every way. How would it be possible to feel no interest in other people and by virtue of an ivory indifference to detach yourself from the life which they so copiously bring you? No, painting is not done to decorate apartments. It is an instrument of war for attack and defense against the enemy.[3]

As Picasso most succinctly summed up in a less passionate and more characteristically aphoristic way: "It is not necessary to paint a man with a gun. An apple can be just as revolutionary."[4] These statements are rare indications of Picasso's allegiance to the political ideas of his youth, which had become for him, as for most of the world, inadequate to the horrors of World War II. Though he quite evidently adhered to these ideas inconsistently even in his early years, his conviction of their importance for him and his work is manifest in these statements, and the work itself supports the view that he had of it. Indeed, during its public life from

1908 until after the war, the Cubist movement never escaped charges that it was purposely attacking society in violating artistic traditions, a charge that is worth investigating. This background is critical to an understanding of the relation of the Cubist movement to the society it rejected, and therefore precedes a consideration of the development of Picasso's Cubism.

Cubism and Its Critics

Conditioned by the symboliste rhetoric regarding art and revolution, art critics in the left-, centrist, and especially right-wing press often discussed modern art in terms of radical politics. Their assumption that every work of art functions in relation to the desire to preserve or change the status quo reveals the high degree to which French culture at the turn of the century was politicized, for Picasso's audience as much as for Picasso himself. Our exclusive familiarity with the apologias of the supporters of the Cubist movement has meant that we have completely lost the flavor of the more widespread response to its undeniable outrage on tradition. Apollinaire, Salmon, and other critics wished to emphasize the positive, scientistic, and even visionary aspects of Cubism; but we can understand neither the Cubist movement nor the prose of its defenders except against the background of its more general reception by critics in the French press, who repeatedly equated Cubism with anarchism, revolutionism, and willful destruction of the past. There is no reason to assume that these critics were entirely wrong.

For example, Maurice Robin, in Victor Méric's radical socialist *Les Hommes du jour* in 1909, called the new art—by which he was referring to Fauvism as well as Cubism—"l'art ultra-révolutionnaire." Henri Guilbeaux, two years later in the same journal, specifically accused Picasso—who had gone beyond this critic's taste for revolutionary art—of having produced "grotesque results, ridiculous, only made, it seems, in order to shock the bourgeoisie." Camille Mauclair, onetime anarchist intellectual moving visibly to the right in these immediately prewar years, equated the avant-garde with the "failed anarchist"; and Sâr Péladan, now an extreme opponent of modernism, rabidly pronounced the new art "anarchy . . . wishing to find a way to proclaim the immortal principles of '89, in esthetics."[5] Coriolès, in a showily fair-minded article in the leftist *Le Gaulois*, opposed the faithful Beaux-Arts students to the avant-garde who exhibited a "willfully revolutionary spirit, nay, anarchic tendencies"; and J. d'Aoust in the literary *Livres et art* tried to soften the universal reaction by asking, "In order to be 'of one's time' is it not necessary always to be a little 'revolutionary,' in art principally?" (but also, by implication, in life).[6] Urbain Gohier, an old compagnon of Jean Grave but no supporter of the newest art, mockingly paraphrased Apollinaire in the republican mass-circulation daily *Le Journal*, in the voices of the Cubist painters:

It's not our fault if life was [earlier] magnificent . . . while life today is mean, cramped, shabby. . . .

The scenes and personages in our pictures do not come from our imagination, but are taken from life, from a humanity neurasthenic, hysterical, epileptic, alcoholic, ether-, opium- and morphine-addicted, fed with poisons, watered with poisons, injected with poisons, addicted to all the causes of breakdown, and without the vigor to resist it.

So, these bizarre anatomies, these deformations, these contortions, these colorless or crazy faces, they are ours. Our painting is faithful. . . . our descendants will have an exact idea of the people, the society, the life of today in looking at our canvases.[7]

Such widespread responses to the Cubist exhibitions share assumptions not only about the ugliness of the new style but about its challenge—for good or ill—to existing French culture. Among the shrill notes raised in reaction to Cubism, patriotism rose above all others, which gives us a telling view of the patriotic fever rising as the Great War approached. Gabriel Mourey, also in the relatively moderate pages of *Le Journal*, found the Cubists to be "les plus déplorables, les plus répréhensibles, les plus dangereuses," and above all, mostly foreigners; he concluded: "We are pursuing at this very moment the syndicates of teachers who propagate in youth the hatred of patriotism; what a pity that there exists no law permitting a judiciary action against the painters who propagate in the public the hatred of beauty!"[8]

Mourey's article so inspired Monsieur Lampué, of the Conseil municipal, that he wrote a letter to the sous-secrétaire d'Etat des beaux-arts, pointing an accusatory finger at the Cubists, whom he termed "a gang of malefactors who comport themselves in the world of the arts like apaches in ordinary life" (both images redolent of anarchist street violence); he further asked how the dignity of the government could seem to protect such scandalous works by allowing them to be exhibited in the national palaces.[9] Far from being dismissed as an absurd politicization of neutrally esthetic experimentation, Lampué's cry was soon taken up in the Chambre des Députés on December 3, 1912, in the debate on whether to censor the style as an abominable, "antinational," and "foreign" influence on French art, or at the least to refuse to allow it to be exhibited in the national palaces—a move that, had it succeeded, would have kept Cubist paintings out of the annual Salon d'Automne at the Grand Palais.

The *Journal officiel de la Chambre des Députés* records the exchange, which took place after a heated discussion of the resolution "to give to the police commissioner the right to prohibit any theatrical piece or any café-concert song that defends the crime of antipatriotism."[10] Such was the atmosphere in which the following debate occurred:

M. JULES-LOUIS BRETON: For several years, under the pretext of renovating art, of modernizing its methods, of creating new forms, original formulas, certain exploiters of public credulousness have surrendered themselves to the most insane competition in extravagances and eccentricities.

I dream not at all of contesting their unfortunate right, but I cannot allow our administration of the fine arts to lend itself to these jokes in very bad taste and graciously to deliver our national palaces for these manifestations which risk compromising our marvelous artistic patrimony. (*Very good! Very good! from diverse benches.*)

And this more especially as it is for the most part foreigners who come thus among us, in our national palaces, to throw discredit consciously or unconsciously on French art. . . .

I do not ask either of the undersecretary of state [of the fine arts] that he himself exercise a direct control, absolutely impossible to realize, on the exhibited works.

But I ask him quite simply to demand from the concessionary societies [the Salon d'Automne] obligatory guarantees, especially concerning the establishment of the jury of admission, and to forewarn them that if, in future, the scandal of this year is renewed, we would have the obvious obligation to refuse them the concession of the Grand Palais.

It is in effect, gentlemen, absolutely inadmissible that our national palaces serve demonstrations of a character so plainly antiartistic and antinational. (*Applause.*)[11]

Only, it seems, the persistent and witty rebuttal of the deputy from Montmartre, a personal friend of Matisse and well known to all the modernists, convinced the undersecretary of state to take no serious action:

M. MARCEL SEMBAT: . . . The Salon d'Automne had, this year, the honor, always perilous and flattering, to be an object of scandal. It is to the Cubist painters that this was due.

I am very happy that in response to these vehement campaigns, the Salon d'Automne was found in favor with the undersecretary of state [of the fine arts] and in favor with all those who know it well and interest themselves in . . . a movement which has exercised so profound and so happy an influence on modern art. . . .

M. Breton has not gone so far as to propose the reestablishment of censorship. I thank him. . . . When M. Lampué wrote his famous letter, it was very much this end that he pursued. The undersecretary of state was called upon to close the national palaces for us. This was a method of reestablishing censorship, the most villainous and the most brutal of all, I believe! . . .

Who then will dispute, even in the milieus the most quickly alarmed by

revolutionary tendencies, the worth of the [judges] and the security of their taste? And then I ask M. Breton how it comes to be that people of taste so sure and of talent so proven . . . have opened the door to innovators that he judges so dangerous? . . .

That is why I repeat that it is necessary to take into consideration the future when viewing an artistic endeavor . . .

M. JULES-LOUIS BRETON: You cannot call that which the Cubists make an artistic endeavor!

M. MARCEL SEMBAT: . . . when viewing an artistic endeavor that scandalizes you. . . .

M. CHARLES BEAUQUIER: One does not encourage filth! There is filth in the arts as elsewhere. . . .

M. MARCEL SEMBAT: My dear friend, when a picture seems to you bad, you have an uncontestable right: it is not to look at it, to go to look at others; but one doesn't call the police![12]

Interestingly, while virtually all the newspapers carried accounts of the debate and the undersecretary's response—"Je suis, en art, partisan d'une politique de moindre intervention"[13]—only the column in *Paris-Journal*, almost certainly written by Salmon, emphasized that Monsieur Bérard, le sous-secrétaire d'Etat des beaux-arts, did indeed request the president of the Salon d'Automne henceforward to let in fewer foreigners and to exercise some control over the Cubists.[14]

This exchange reflects a very serious aspect of the birth of modernism in Paris, in a climate of political passions to which art spoke directly. To imagine that artists were oblivious to the dialogue their work inspired is to blind ourselves to the realities of their world. And it is but a small step to realize that they were abundantly aware of the possibilities before ever putting brush to canvas. As for Picasso, the idea of art-as-provocation had animated his work ever since the 1890s, and it found fresh incitements in Paris in his friendships with Salmon, Apollinaire, and Jarry.

Although the contemporary supporters of the Cubist movement traded less frequently in political imagery, their discussions dealt with a set of assumptions about the aims and meanings of the new art with which we have also lost touch. The needs of the post-World War I period to drain meaning from what had come to serve as the rock bed of formalist art and criticism have significantly deformed our image of Picasso's aims and interests. During the Cubist movement, critics and supporters never questioned the assumption that art has content. Whether we would still agree with their individual assertions, they never shied away from making associations and connections regarding meaning in the work. Charles Morice wrote of Braque's show at Kahnweiler's in 1908 that "the artist has seen simply the geometrical harmonies which convey to him everything in nature."[15] Nature, in

1908, still attempted to convey something to artists. In the following remarks, quoted from an interview of 1908 with Gelett Burgess, Braque himself—while emphasizing the formal properties of his work—introduced motivations of emotion, beauty, and "the Absolute" into his discussion. He told Burgess that he "looks at Nature in order to possess it emotionally," and continued:

> I couldn't portray a woman in all her natural loveliness. . . . I haven't the skill. No one has. I must, therefore, create a new sort of beauty, the beauty that appears to me in terms of volume, of line, of mass, of weight, and through that beauty interpret my subjective impression. Nature is a mere pretext for a decorative composition, plus sentiment. It suggests emotion, and I translate that emotion into art. I want to expose the Absolute, and not merely the factitious woman.[16]

In 1910 Metzinger also affirmed emotion, idea, realism in his understanding of the Cubism of Picasso and Braque:

> Picasso does not deny the object, he illuminates it with his intelligence and feeling. With visual perceptions he combines tactile perceptions. He tests, understands, organizes: the picture is not to be a transposition or a diagram, in it we are to contemplate the sensible and living equivalent of an idea, the total image. Thesis, antithesis, synthesis—the old formula undergoes an energetic inter-inversion of its first two terms: Picasso confesses himself a realist. Cézanne showed us forms living in the reality of light, Picasso brings us a material account of their real life in the mind—he lays out a free, mobile perspective, from which that ingenious mathematician Maurice Princet has deduced a whole geometry.[17]

Long discussions of the importance of the relativity of knowledge (Olivier-Hourcade), Kant's philosophy and "the essence of things" (Raynal), conceptual apprehension and "primitive" art (Salmon), mathematics and the "Fourth Dimension" (Apollinaire), "scientific" research into the nature of reality, Euclidean space, and Riemann's theorems (Gleizes and Metzinger), etc.—however misunderstood or exaggerated in their importance—all point to the conscious content and passionate discussion frequently alluded to in Picasso's circle.[18] Despite the formal properties of the new style that all such discussions attempt to elucidate, one assumption underlies all the supporting critics' writings in this period: that Cubism is the newest step in the world-historical drive to understand the nature of reality. None of these writers doubt that all the formal experimentation ultimately, and indeed seminally, serves this purpose. Raynal, the driest of the early critics of Cubism, the least given to such flights of fancy and symbolisme in his prose as Salmon or Apollinaire exhibits, makes this prejudice clear in his "Qu'est-ce que . . . le 'Cubisme'?"of 1913: "The cubists, not having the mysticism of the Primitives as a motive for painting,

took from their own age a kind of mysticism of logic, of science and reason, and this they have obeyed like the restless spirits and seekers after truth that they are."[19]

This is the basis that drops out of discussions of Cubism after the First World War: the assumption of meaning in human endeavors that the experience of the war shattered. As early as 1917, Paul Reverdy—in "Sur le cubisme"—discussed the movement in purely formal terms. Cubism has already become an art dependent solely on its abstract elements, the "means of constructing a picture by taking the object as a pictorial element only, quite apart from the anecdotal standpoint." Such notions as "the artist's vision"—crucial to the prewar understanding of the Cubist impulse—have become "obsolete": "We are at a period of artistic creation in which people no longer tell stories more or less agreeably, but create works of art that, in detaching themselves from life, find their way back into it, because they have an existence of their own apart from the evocation or reproduction of the things of life."[20]

Kahnweiler, despite the influence of the German philosophy he was reading during the composition of *Der Weg zum Kubismus* in 1914–1916, essentially avoided the issues raised by earlier criticism in his close technical reading of the step-by-step development of the style's formal elements. Waldemar George in 1921 pointedly refuted the prewar view of Cubism, adamantly discussing the movement in purely stylistic terms. "Cubism," he wrote, "is an end in itself, a constructive synthesis, an artistic fact, a formal architecture independent of external contingencies, an autonomous language and not a means of representation."[21] One need only quote the extreme formalism of Ozenfant and Jeanneret of 1920 to conclude this argument:

> What has a still-life to say to us other than what we make it say? Yet by its means artists accustom themselves to appreciate works whose only value is their poetical content, a poetry derived from the relation of forms and colours independent of what is imitated. The lesson thus taught largely determined the Cézannian emancipation and, following on it, the Cubist.
>
> The subject matters so little in a still-life that a trifling shock was to prove sufficient to inaugurate an attempt to dispense with it entirely.
>
> Cubism therefore, in my opinion, can be considered as the "still-life" entirely liberated from the subject. . . .
>
> One definition would be: "Cubism is painting conceived as related forms which are not determined by any reality external to those related forms."[22]

These philosophical idealists were speaking out of a postwar disillusionment. The motivating ideas behind Cubism dropped away in their writing, and they were left with what they called its "scaffolding," a word first coined for Cubism by that antirationalist Jean Cocteau.[23] In many ways those who had lived through the war,

and especially the younger generation, had lost a grip on those assumptions of meaning, order, and reason that were so unquestioned a part of daily experience before the catastrophe of the war. In fact, disillusionment was widespread as early as 1916 following the almost incredible bloodbaths at Verdun and the Somme: well over a million Frenchmen were killed between August 1914 and April 1916.[24] Such losses in the tragically stalemated war led in 1917 to mutinies in the French army. At the same time corruption and even collaboration with the enemy were exposed at the deputy and ministerial levels of the French government. The unprecedented trench war resulted in destruction on both sides on such a colossal scale as to make its continuation seem irrational and even suicidal. And the fanatical patriotism of the reconstruction period did little to comfort the rationalist: with two and three-quarter million military and civilian dead, three-quarters of a million permanently injured, and the entire northeast section of France an utter wasteland, it is not surprising that the prewar assumptions about the workings of the human mind, the impulses of the human breast, and the fruits of a civilization that could produce such a destructive cataclysm underwent a crisis of faith. As Kenneth Silver has demonstrated, the purism and formalism of the 1920s developed under the powerful impulse to deny the chaotic and horrifying realities of postwar France.[25] What is not recognized is that in addition to establishing a "purely formal" art and an accompanying dialogue, the artists and critics rewrote the history of the Cubist movement and established an obfuscatory model of Cubism whose influence we still feel, though diminishingly, today.

The only voices after the Great War to counter the continuously prevailing view of Cubism as an art exclusively preoccupied with form were the Dadaists and Surrealists, whose interpretations of Picasso's Cubism have been universally ignored, doubtless because they hold to well-known convictions about the importance of content in art—and to political views—of their own. Here is Huelsenbeck in 1920, sounding very much like the prewar supporters of the movement—"Picasso" rather than "Cubism" is the conscious motivator of the style—but with a thoroughly political cast:

> Consequently [Picasso] restricted his painting to the foreground, he abandoned depth, freed himself from the morality of a plastic philosophy, recognized the conditionality of optical laws, which governed his eye in a particular country at a particular time. . . . He wanted to paint no more men, women, donkeys and high-school students, since they partook of the whole system of deception, the theatre and the *blague* of existence—and at the same time he felt that painting with oil was a very definite symbol of a very definite culture and morality. He invented the new medium. He began to stick sand, hair, post-office forms and pieces of newspaper onto his pictures, to give them the value of a direct reality, removed from everything traditional.[26]

Louis Aragon on the collages in *La peinture au défi* in 1930: "There is the grandeur of Cubism at this time: anything, without preoccupying themselves whether it was perishable, served these painters to express themselves, and so much the better if it had no value, if it disgusted the world."[27] And Tzara in 1931: "*Papier collé*, in all its different aspects, marks in the evolution of painting, the most poetic moment, the most revolutionary, the touching flight toward the most viable hypotheses, a greater intimacy with daily truths, the insurmountable affirmation of the temporary, and of temporal themes, the supremacy of the idea."[28]

Certainly the aims and motivations of the Dadaists and Surrealists were to make use of Picasso's work for their own rhetoric, but they also pay homage to one they saw as a real predecessor. And their image of him rings true, once he is seen—as they must have seen him—against the social and political backdrop of the pre-war period: Picasso is viewed here as a self-conscious revolutionary and antitraditionalist, desiring to disgust the world and reject the culture and morality represented by the medium of oil on canvas in order to approach "intimacy with daily truths." Their witness serves as an unheeded and refreshing counterpoint to such contemporary statements as Reverdy's, whose assertions—"works of art . . . in detaching themselves from life, find their way back into it, because they have an existence of their own apart from the evocation or reproduction of the things of life"—have not been recognized as at least as self-serving and remarkably farther from the truth.

Thus since the 1920s, scholars have considered early and Analytical Cubism as contentless, without an iconography, works whose revolutionary meaning lay precisely in their distance from "outmoded" humanist Weltanschauungen. While it is entirely true that the revolutionary nature of the Cubist movement is expressed in its style, the style and its uses are not without a "content" of their own. And, at the same time, it is not recognized that Picasso often applied this stylistic "content" to allusive figures and images consistent with much of his earlier work, images that are much more than mere pretexts for an analysis of form. As *Les Demoiselles d'Avignon* indicated, Picasso, in reevaluating his role as a revolutionary artist, shifted the emphasis of his work from subject matter to style; yet he continued—like Apollinaire—to articulate ideas and themes in his art. In Chapter 5, we will see how the collages reflect in surprisingly direct ways the political theories in which Picasso was immersed during his early days in Barcelona and Paris. The significance of this political content, which was incorporated into works long seen as among his most abstract and therefore most "modern," suggests a needed expansion of our critical vision, not only to the sorts of ideas Picasso was able to manipulate in the collages themselves but to the general and continued importance of concrete subject matter in the early and Analytical Cubist works.

Not too long ago *Les Demoiselles d'Avignon* was seen as a purely formal experi-

ment. William Rubin noted in 1977 the gradual separation of the *Demoiselles* from Cubism proper in the critical literature of the previous decade and an emerging understanding of the picture as "not yet Cubist." He concluded:

> One of the results of the tendency to disengage the *Demoiselles* somewhat from its traditional place in the teleology of Cubism has been the encouragement of fresh research, both in relation to the picture's place in Picasso's individual development and in regard to its sources in other art. Thus the last few years have seen important new approaches to the painting by Leo Steinberg and Robert Rosenblum. The former showed how our tendency to view the *Demoiselles* from the Cubist perspective has blinded us to many aspects of the picture's meaning and has significantly deformed our image of Picasso's aims and interests in 1907. Steinberg found that the most important consideration suppressed in prevailing views of the *Demoiselles* is the picture's specific sexual content; Rosenblum's text built upon this aspect of the work and unlocked hitherto unexplored sources of it in Goya, Ingres, Delacroix, and Manet. Now that the new, non-Cubist perspectives on the *Demoiselles* have permitted us to see the picture as a richer, more complex work in itself, they must also, I believe, open the way for us to reevaluate the picture's place in the early history of Cubism.[29]

Certainly the *Demoiselles* is an enormous distance from Cubism in its formal preoccupations, but its recent reevaluation, rather than separating it from the Cubist period as "richer, more complex," may suggest that Cubism itself is richer and more complex than we have come to think, and in very much the same way as the *Demoiselles*.[30]

If we dismantle the traditionally accepted discourse and look closely at the early and Analytical Cubist periods, Picasso's continuing preoccupation with and development of some of the recurrent themes in his earlier (and later) work becomes apparent, specifically his reevaluation of such themes in the context of an increasingly radical style. The experimental appearance of the style, its utter newness as well as its lack of immediately recognizable objects, served to outrage and subvert the forms of traditional subjects—nudes, portraits, landscapes—and to convey the artist's distance not only from ordinary vision but also from bourgeois society. Picasso's Cubist period differs from the rest of his career in its suppression of image in favor of a forbidding abstraction, an abstraction based on many forward-looking ideas including the radical reconstitution of vision, perceptual and conceptual. But to divorce style from meaning was, demonstrably, never his purpose; understood more fully, Picasso's Cubist period can be reunited with the rest of his oeuvre.

Rebellious Art: Picasso's Early Cubism

During the Cubist period, though Picasso and Braque worked toward an increasing abstraction of form, their subject matter—portrait, landscape, still life—remained basically the same. Consequently most critics, with the notable exceptions of Meyer Schapiro, Theodore Reff, and Anne Edgerton, have considered this subject matter to be merely a neutral vehicle for their formal experiments.[31] This raises the important question of whether a subject gains or loses meaning through repetition. In the body of Picasso's work as a whole, critics agree that repetition of a subject indicates a preoccupation or idea on the artist's part, a theme we may consider, on whose meaning we may speculate. The same, then, presumably should hold true for Picasso's Cubist period, where, despite the largely formal considerations of the style's development and the larger meaning of that project, recurrence of his earlier themes and subtle play with innovative subjects cannot uniquely suggest their irrelevance. In fact, they offer much suggestive material for consideration.

Picasso's major works of the following year—the figure compositions from the winter of 1907–1908 to the summer of 1908—seem oddly idyllic after the aggressive brutality of *Les Demoiselles d'Avignon* and allied works of 1907. *Friendship*, winter 1907–1908, depicts two intertwined female figures. The three interrelated canvases—*Standing Nude*, early 1908; *Three Women*, summer 1908 (reworked winter 1908–1909); and *Nudes in a Forest*, spring 1908 (Fig. 71)—all represent an image of Venus on sexual display, passive and so simplified as to be depersonalized.[32] The scarification lines, so self-consciously ugly, brutal, and threatening in the works of 1907, are gone, to the spectator's relief.

Even more soothingly, the natural setting of *Nudes in a Forest* recalls the pastoralism familiar from Picasso's earlier work and at the same time again challenges Cézanne's late "Bather" series.[33] The pastoral element suggested by Picasso's use of nudes in a landscape is confirmed by the *Landscape with Two Figures*, summer 1908 (Pl. vi).[34] Here the figure of sleeping Venus, arm behind her head, lies at the base of a tree, her body nestled into the contour of the landscape and colored with the hues of the exposed earth. Another nude figure, possibly male, leans against a tree whose trunk is obscured by green bushes, making the figure seem almost a part of the tree's form. Arching back at an angle, this figure is painted in the colors of the trunk, while the left arm is extended unanatomically to conform with the shape and direction of the branch above. Picasso represents these figures as, literally, part of the landscape and exaggeratedly "natural." Such, in unchanged conformity with Spanish and anarchist images of rural harmony, is Picasso's vision of the unity of humanity and nature. Possibly this image made too emphatically literal and naive a utopian statement—Picasso, Apollinaire, and Jarry strongly advocated sexual freedom and its naturalness—since Picasso kept it in his own collection his

entire life. This aspect of his interest also manifests itself in the integration of land-scape and figure forms in such works as *Bathers in a Forest, The Dryad*, autumn 1908, and *Bathers*, summer 1908, and in the theme's continuation in 1909 with *Woman Bathing, Bathers* (clearly of a man and woman together), and *Bathers in a Landscape*, all early 1909 and all retained by Picasso in his own collection.[35] In all these works the figures are increasingly incorporated into the natural forms surrounding them.

The year 1909 also witnessed a decrease in symbolic subjects in Picasso's work, evident in the transformation of *Carnival at the Bistro* into a still life.[36] Picasso largely concentrated on formal problems in the work of this period, moving from the earlier ambitious nude figure compositions often in imaginary settings or con-flated with landscape studies from La Rue des Bois to tangible objects in his im-mediate environment—single figures, still lifes, and, in the summer at Horta de Ebro, landscapes. Yet despite the intense formal investigation of the visual world evidenced by these landscapes of Horta de Ebro of the summer of 1909, a number of elements in the works belie the notion of Picasso's exclusive immersion in the analysis of form. Palau i Fabre has noted that the palm trees that appear in draw-ings done in Barcelona on the way to Horta, such as *Houses in Barcelona*, May 1909 (Fig. 73), reappear in *Factory at Horta de Ebro*, summer 1909 (Fig. 74), although Horta has no palm trees.[37] Both Daix and Fry have confirmed this, but only Palau notes that just as there were no palm trees in Horta, neither was there a factory.[38]

When Picasso went to Horta with Manuel Pallarés for the first time in 1898, they took a train to Tortosa and then rode a mule the remaining twenty-five miles, after which they needed several days of rest from the journey.[39] The village of Horta had changed little in ten years. Farming was the sole activity of the area, along with the pressing of olive oil in the Pallarés family's mill. Horta represented an idyllic rural life, far away from the complications and decadence of the city. Why then introduce a factory smokestack and palm trees—recognizably Barce-lonese motifs—into this rural setting? In part Picasso probably wanted vertical ele-ments to facilitate a flat structuring of the otherwise recessive sky to compensate for a lower horizon than in the other six landscapes of the series. But rather than incorporating, say, three palms, he introduced the smokestack, an image laden with those associations of human exploitation and degradation evident in his early works as well as in one like Nonell's *Annunciation in the Slums* (Fig. 9). Two views of the oil mill show a group of low buildings with two short towers, on which, it could be argued, the factory stack is based.[40] But neither tower has the same regular shape of the smokestack; and, whatever the formal basis of the stack's shape, the final image reads as a factory—not an oil mill—with attendant meanings.

The factory in combination with the palm trees is specifically reminiscent of Barcelona, which was undergoing an intense political convulsion during the sum-mer of 1909.[41] The political disturbance may explain in part why Picasso's thoughts turned to Barcelona at this time. The Spanish government was pursuing

a war in Morocco, popularly considered to be an imperialist adventure solely in the interests of the new Spanish owners of the iron mines in the Rif Mountains near Melilla. After a devastating ambush in Morocco on July 9, the government in Madrid, needing to replace lost men, called up reservists, but only in Catalonia. This was seen, probably not incorrectly, as a vindictive act directed against the actively separatist region, which had become outspokenly pacifist following the return of the starving and abandoned soldiers from the disastrous Cuban and Philippine wars. Furthermore, after 1887 only the poorest were liable to conscription; the middle and upper classes could buy their way out of military service with a modest exemption fee of fifteen hundred pesetas.[42] (As noted earlier, Picasso himself avoided military service in this way; his uncle Salvador, from 1902 until his death in 1908, paid the fee for him.[43] That for the first time he found himself in Spain unprotected may explain some of his concern over the course of events in Barcelona.) And to complicate this situation, the mines over which the fighting had begun were thought to be owned by the Jesuits, which caused many to add their hatred for the Church to their anger over the politically motivated conscription. Joll has described the consequences:

> This was too much for a population which had already had enough of inefficient and oppressive government, and for whom the disasters of the Cuban war were still fresh in their minds. Barcelona rose in revolt and for a week—the *Semana Trágica*—it looked as though a spontaneous social revolution had broken out. As the anarchist Anselmo Lorenzo wrote in a letter on 21st July: "It is amazing! The social revolution has started in Barcelona, and it has been started by something so ill defined, misunderstood and wrongly identified as that which is sometimes called the vile rabble and sometimes His Majesty the People. No one started it! No one led it! Neither liberals nor Catalan separatists, nor republicans nor socialists nor anarchists. . . . A week of intoxication, of holy rage, seeing that the fury of the masses was justified by a hundred centuries of misery, oppression and endurance."[44]

This antigovernmental, antimilitary, anticlerical uprising was severely repressed by Madrid: 175 workmen were shot in the streets and 2,000 arrests were made, of which 1,725 were brought to trial.[45] At the end of Red Week, or la Semana Trágica, approximately 2,000 people fled to France from Catalonia, some because of complicity and many to avoid the punitive army conscription.[46] The government, eager for scapegoats, executed five men. One of these was Francisco Ferrer, founder of the coeducational Escuela Moderna in Barcelona, a school based on anarchist principles of spontaneity, free love, and anticlericalism. When Ferrer, who had always opposed violence in his writings and had been in England during the entire episode,[47] was court-martialed and executed on October 13,

1909, an enormous cry of protest rose in the rest of Europe. With editorials denouncing "la España Inquisitorial," large demonstrations in all the major European cities protested Ferrer's death and the persecution of people for their ideas.

During this period, from the first ominous rumblings in June when the Conservative Prime Minister Miguel Maura closed the Cortes[48] through the whole summer, Picasso and Olivier were in Horta, following events as best they could. In letters to Gertrude Stein preserved at Yale, both record their awareness and fear of the first thrilling, then terrible, events in Barcelona. "My dear friends," wrote Picasso in an undated letter, "I haven't [?] written you before [?] this because it appears that we have been in Spain in full revolution and I am [?] fearful that my [?] letters will not arrive at your [?] [.] Today the [?] newspapers are beginning to arrive here and they say that it is finished."[49] After discussing a proposed trip to Madrid and Toledo ("I've long wanted to look again at Greco"), Picasso concluded with the hope that Stein was still planning to meet him in Barcelona. In another undated letter, probably somewhat later, Picasso asked whether Stein was still planning to come, and again wrote: "We have seen in Spain a great revolution [.] Now it is finished [.] I thought that our trip [?] in Spain was going to be finished."[50] A third undated letter announces, "We are going to Madrid and Toledo," and asks, "Are you coming to Horta??" And around the margins of Picasso's letter, Olivier has written a lengthy note of her own on the subject of the uprising:

> My dear Gertrude—I believe [myself] to have responded to your two letters. But the events which have passed throughout Spain and principally in Barcelona have isolated us from the world for about ten days and as [?] the government has hindered all external relations the letters which I sent you must not have [?] reached you for a long time after I sent them. It appears that the people have demolished the railroad bridges [?] into Barcelona. I don't know whether you are very up-to-date on this but it was very serious.[51]

In the end Gertrude Stein did not come to Spain as planned, nor did Picasso and Olivier go to Madrid and Toledo. Although their information that all of Spain had risen was incorrect, doubtless it was indeed wiser to stay in their little village. No sources I have seen mention whether Picasso returned to Paris by way of Barcelona—still in the grip of the terrible repression—or over the mountains as he had returned from Gósol in 1906. Since Horta is southwest of Barcelona, this is somewhat less likely, though the dangers of Barcelona included for him the threat of conscription. Picasso was sympathetic enough with the revolutionaries to want to march in what became the violent protests in Paris on October 13 and 17, 1909, against Ferrer's execution, consisting of as many as 500,000 and led by Jean Jaurès and the deputies Sembat, Vaillant, and others. He was deterred, however, by the quite realistic fear that if arrested he would be deported to Spain and, no longer

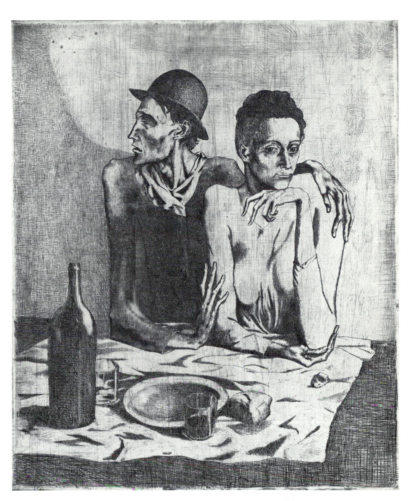

42. *The Frugal Repast*, 1904. Etching,
46.5 x 37.6 cm.

43. *Acrobat and Young Harlequin*, 1905.
Gouache on cardboard, 105 x 76 cm.

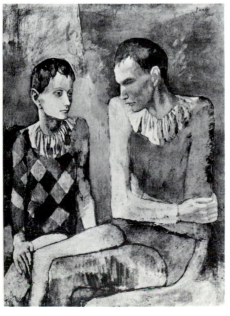

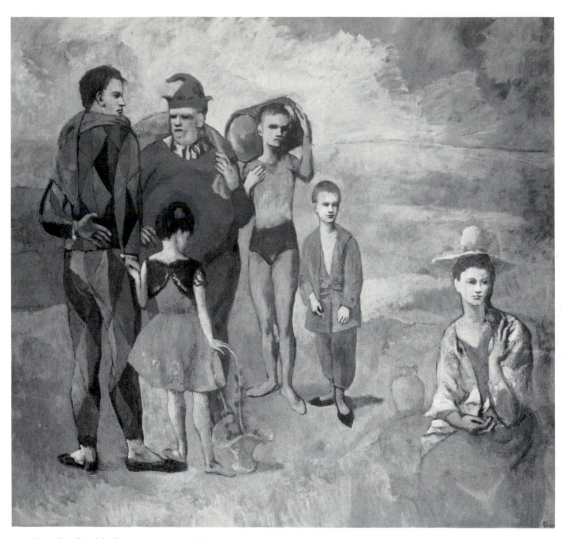

44. *Family of Saltimbanques*, 1905. Oil on canvas, 212.8 x 229.6 cm.

45. *Family of Saltimbanques (Study)*, 1905. Gouache on cardboard, 51.2 x 61.2 cm.

47. *Two Acrobats with a Dog*, 1905. Gouache on cardboard, 105.5 x 75 cm.

46. *Petits Gueux (Little Beggars)*, 1904. Watercolor and ink on paper.

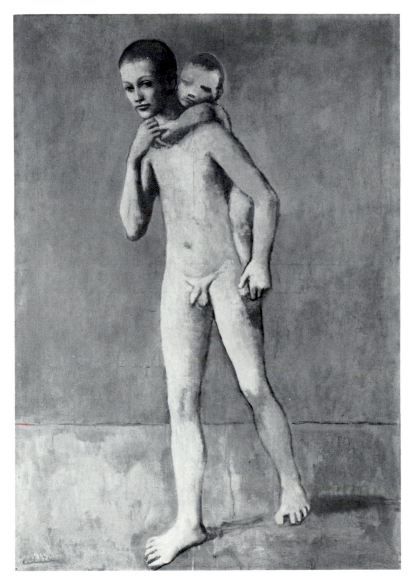

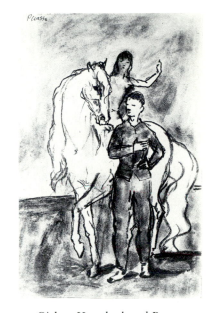

49. *Girl on Horseback and Boy*, 1905–1906. Watercolor on paper, 51 x 34.5 cm.

48. *The Two Brothers*, Summer 1906. Oil on canvas, 142 x 97 cm.

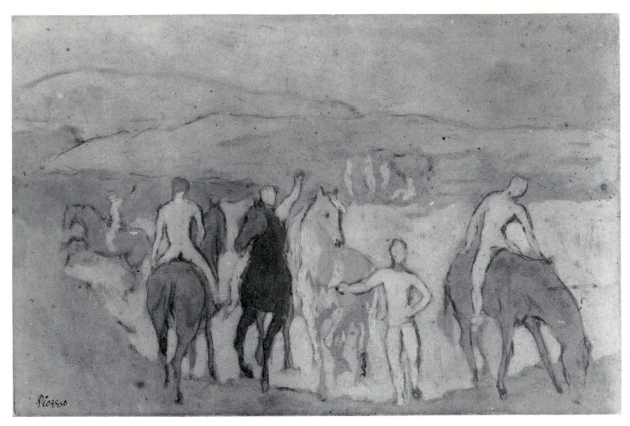

50. *The Watering Place*, early 1906. Gouache on pulp board, 37.7 x 57.9 cm.

51. *Boy Leading a Horse*, early 1906. Oil on canvas, 220.3 x 130.6 cm.

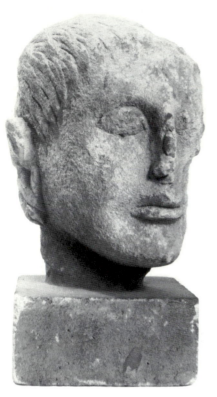

52. *Head of a Man* (Iberian),
Cerro de los Santos, 5th–3rd
century B.C. Stone, 21 cm.

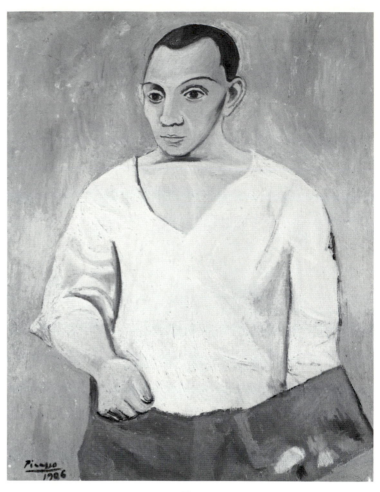

53. *Self-Portrait with a Palette*,
Autumn 1906. Oil on canvas,
92 x 73 cm.

54. *Nude with a Pitcher*, Summer
1906. Oil on canvas, 100 x 81.3
cm. Gift of Mary and Leigh B.
Block, 1981.14 © 1987 The Art
Institute of Chicago. All rights
reserved.

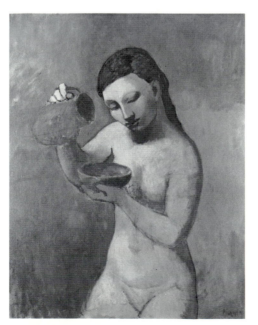

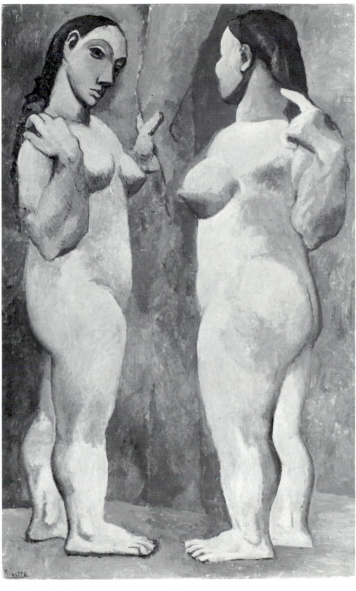

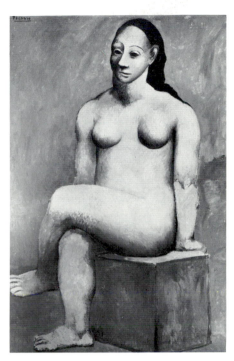

56. *Seated Female Nude*, Autumn 1906.
Oil on canvas, 151 x 100 cm.

55. *Two Nudes*, Autumn 1906. Oil on canvas, 151.3 x 93 cm.

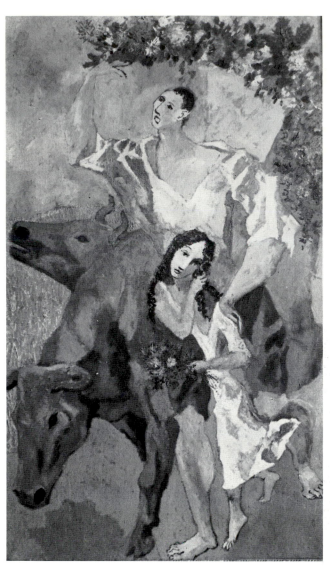

58. *The Peasants (Flower Vendors)*, Summer 1906. Watercolor and ink on paper, 62.2 x 46.7 cm.

57. *Composition: The Peasants*, August 1906. Oil on canvas, 218.5 x 129.5 cm.

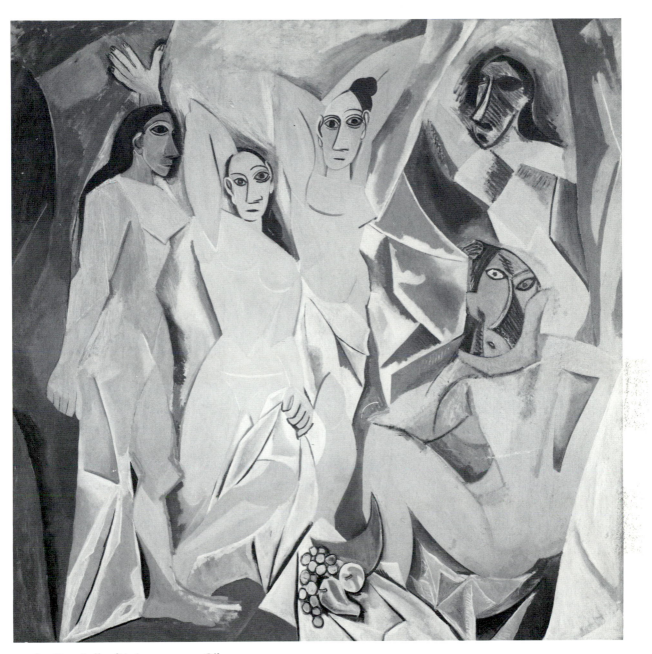

59. *Les Demoiselles d'Avignon*, 1907. Oil on canvas, 243.9 x 233.7 cm.

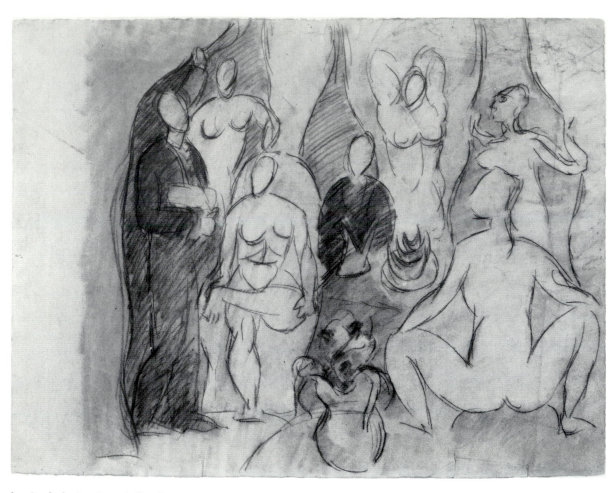

60. *Study for Les Demoiselles d'Avignon*,
Spring 1907. Charcoal and pastel on paper,
47.7 x 63.5 cm.

61. *Study for Les Demoiselles d'Avignon*
(sketchbook page), Winter-Spring 1907.
Pencil on paper, 24.5 x 19.5 cm.

62. *Study for Les Demoiselles
d'Avignon* (sketchbook page),
Spring 1907. Pencil on
paper, 19.5 x 24.5 cm.

63. *Bitch Suckling Puppies,
Four Studies* (sketchbook
No. 44), Spring 1907.
Pencil on paper, 19.5
x 24.5 cm.

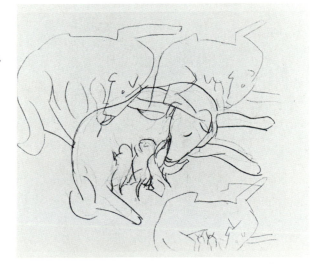

64. *African* (sketchbook No. 35), 1905. Pencil on paper, 14.5 x 9 cm.

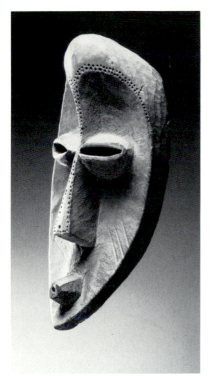

65. *Mask*, Etoumbi Region,
Congo-Brazzaville, People's
Republic of the Congo. Wood,
35.5 cm.

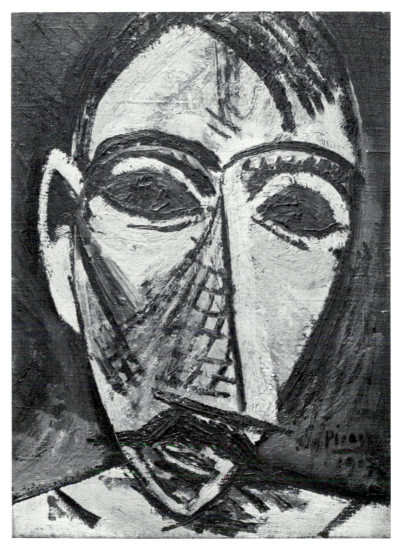

66. *Head of a Man*, Spring 1907. Oil on canvas, 33 x 24 cm.

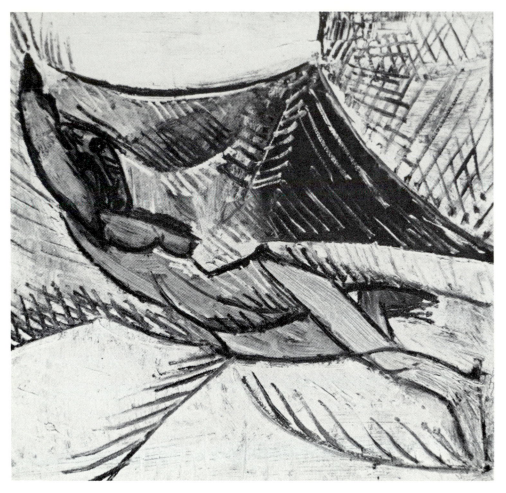

67. *Female Nude on a Bed*,
Summer 1907. Oil on panel,
36.5 x 38 cm.

68. Giorgione,
Sleeping Venus, c. 1510.
Oil on canvas, 108.6
x 175.3 cm.

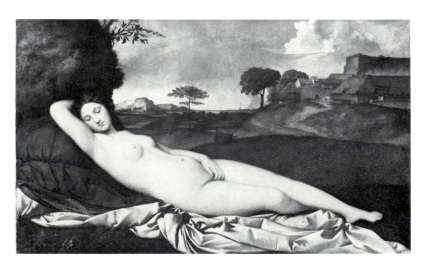

69. *Odalisque, after Ingres*, Summer 1907. Watercolor, gouache, and pencil on paper, 48 x 63 cm.

70. *Nude with Drapery*, Summer 1907. Oil on canvas, 152 x 101 cm.

71. *Nudes in a Forest*, Spring 1908. Gouache and watercolor on paper, 47.6 x 59 cm.

72. *Petit nu assis*, Summer 1907. Oil on wood, 17.5 x 15 cm.

73. *Houses in Barcelona*, May 1909. Pen and ink on paper, 17.1 x 13.3 cm.

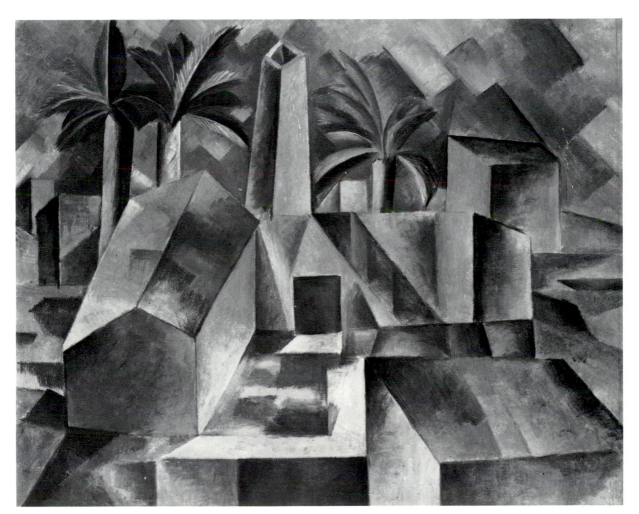

74. *Factory at Horta de Ebro*, Summer 1909. Oil on canvas, 53 x 60 cm.

75. *Study for Carnival at the Bistro*, Winter 1908–1909. Gouache, 32 x 49.5 cm.

76. *Portrait of Braque*, Winter
1909–1910. Oil on canvas, 61
x 50 cm.

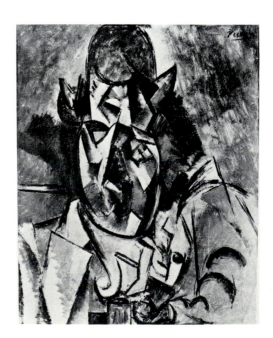

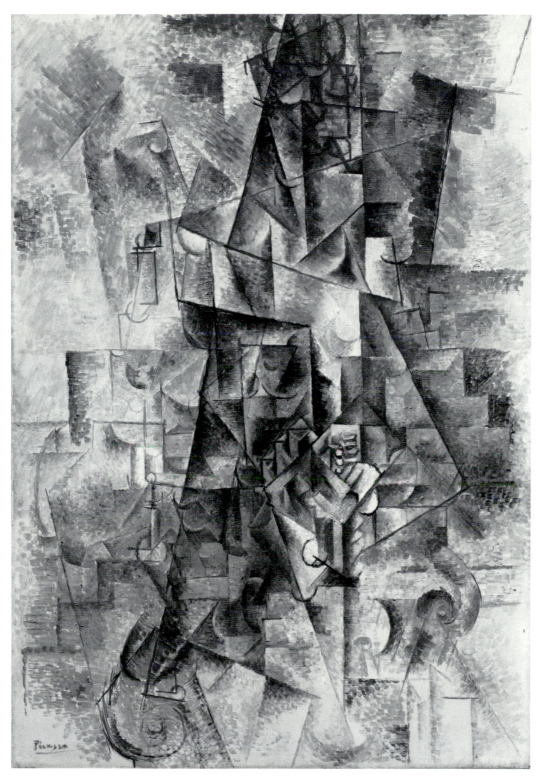

77. *The Accordionist (Pierrot)*, Summer 1911. Oil on canvas, 130.2 x 89.5 cm.

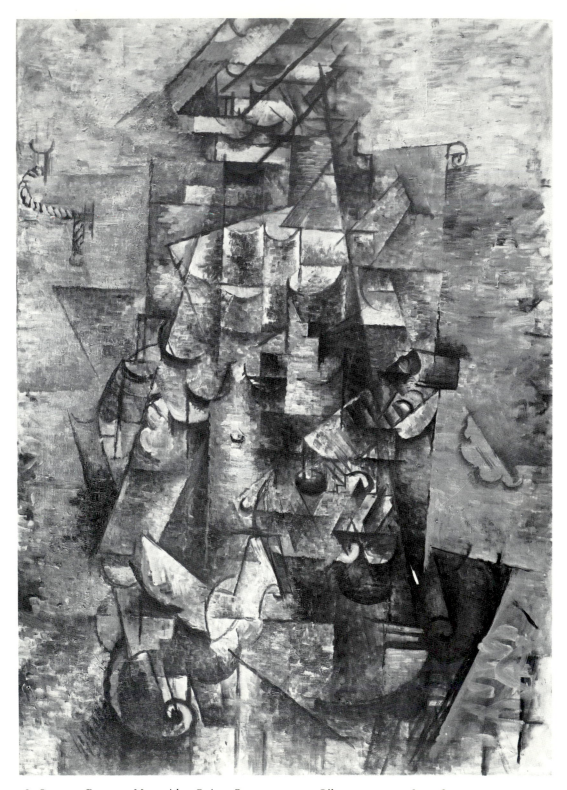

78. Georges Braque, *Man with a Guitar*, Summer 1911. Oil on canvas, 106.2 x 81 cm.

protected by his uncle, forced to serve in the Moroccan War that had sparked the uprising in Barcelona.[52]

This episode serves to establish Picasso's serious desire to avoid military service, which will become relevant again in the period immediately preceding the Great War, and his continuing political sympathy with the anarchist cause, especially as it related to Spain and Catalonia. And, to return to the *Factory at Horta de Ebro*, it is suggestive that such images of Barcelona, anomalous in the idyllic rural setting, may record Picasso's concern with the workers' uprising in that city, so emphatically verbalized in his letters to Stein: "We have been in Spain in full revolution" and "We have seen in Spain a great revolution"—the active "we" manifestly heartfelt. Such an attitude is not surprising in one who only two months earlier, while waiting in Barcelona for his Horta arrangements to be completed, was busily working to revive the anarchist art journal *Arte Joven*, which he had founded and edited in 1901 with Francisco Asis de Soler.[53] And though he did not participate further in the radical *Arte Joven*'s resuscitation, the summer of 1909 does represent an important turning point in the increasing radicalism of his art, as he pursued a direction fewer and fewer could follow.

Revolutionary Art: Picasso's Analytical Cubism

There has been much discussion recently on the general issue of politics and the avant-garde, most significantly Peter Bürger's *Theory of the Avant-Garde*, which attempts to locate a genuine but brief moment, from Cubism through the 1920s, when artists rejected "the institution of art" and stepped outside the previous (and subsequent) nexus between art and bourgeois society. Bürger's theory helps to confirm a political reading of Picasso's Cubist period, but his frank interest, like that of other Marxist critics and theorists, is professedly in a late twentieth-century political interpretation of an early twentieth-century moment. It is unconcerned with the issue of what the artists *thought* was the political matrix and content of their art. Their conscious politics, which certainly lacked the rigor and historical stamp of Bürger's, remain curiously outside the issues in this controversy, and he has been rightly criticized for his lack of subtlety in dealing with issues of avowed concern to late nineteenth- and early twentieth-century artists.[54]

Central to the issues in this theoretical discussion is an assumption that the quintessential radical act of modernism was the divorce of form and content, with form defined as "technical elements" and content as "those elements which make statements."[55] Bürger believes that late nineteenth-century Estheticism had "altogether detached itself from the praxis of life," which suits his theory but does not fit many of the artists' statements about their own work or their attachment to the anarchist and, less frequently, socialist movements. Many of the Symbolist and Neo-Impressionist artists saw their work as socially critical by virtue of its content

(e.g., Luce's industrial suburbs) and its style (e.g., Gustave Kahn's assertion that "in shattering a fragment of the artistic façade [the artist] touches the social façade").[56]

To a much larger extent than has been recognized, Picasso's Cubism followed from Symbolism in this political attachment and in the stylistic violation of norms as well as in other ways: the radical emphasis on formal elements *itself* makes a statement. As Richard Shiff elegantly phrased it, "form, or rather technique, [can] both represent and embody content."[57] Indeed, the treatment of form alone in the modernist period often constituted a self-consciously "political" act of outrage on traditional themes and styles of art, as witnessed by the larger Cubist movement and by the Futurist and Constructivist movements. Albert Gleizes, for example, saw his art as intimately tied to his socialist convictions and his desire for a harmonious collective of artists, which he and others attempted to realize at the Abbaye de Créteil.[58] To the Futurists and Constructivists, the formal outrageousness and experimentalism of their art constituted an attack on tradition in the name of revolution and liberation, as they made abundantly clear in their statements. Interestingly, at the height of his revolutionary fervor in 1920, Naum Gabo took the Cubists to task precisely for their anarchy:

> The attempts of the Cubists and the Futurists to lift the visual arts from the bogs of the past have led only to new delusions. . . .
>
> The distracted world of the Cubists, broken in shreds by their logical anarchy, cannot satisfy us who have already accomplished the Revolution or who are already constructing and building up anew.[59]

What angered contemporary critics of Cubism was, as they saw it, the representation of the world as simplified, geometric, and colorless, by artists whose apparent aims were to modernize artistic methods, mock French art, propagate the hatred of beauty, and produce grotesque results only in order to shock the bourgeoisie. They were dangerous innovators with revolutionary and anarchistic tendencies whose larger aims were, in a word, antiartistic, hence antinational. And these antiartistic images were not of people merely, but were "exact" images of society, fragmented and dehumanized.[60] Such overstatement contains the usual grain of truth, and we have missed a central feature of modernist art in overlooking its reception by a broader range of contemporary critics, who reveal much of the mind of the age in the nature of their hostility. Yet whether avant-garde artists were successful in changing society is another issue entirely, and Bürger is correct to note the impotence, finally, of the avant-garde's attack in this regard. Perhaps Mauclair was not wrong when he equated the avant-garde with the "failed anarchist."[61]

We are concerned here with what Picasso took to be his artistic politics, obeying in many ways Kropotkin's call to artists: "Place your pen, your pencil, your chisel, your ideas at the service of the revolution. . . . Show the people how hideous

is their actual life, and place your hands on the causes of its ugliness. Tell us what a rational life would be, if it did not encounter at every step the follies and the ignominies of our present social order."[62] Such a call had its effect on a whole generation of artists and writers, though, as noted above, there is no doubt either that Kropotkin envisioned a very different sort of art than that produced by the modernists or that many of those artists who embraced the anarchist view, including Picasso, Vlaminck, and Van Dongen, left Kropotkin's taste far behind. Every generation interprets its obligations differently, and the anarchist esthetics that were taken rather more literally at the start of Picasso's career were in his Cubist period transformed into a metaphor for artistic "revolution."

Such a radical alteration of the material world in Picasso's Cubist works, however, was not meant merely to shock a complacent bourgeoisie, though they easily accomplished it, largely through exhibitions of works by his followers. The negative and destructive side of anarchism, the propaganda of the deed, was an influence felt more purely in Picasso's work of 1907. The constructive side of anarchism, its followers' ardent desire to reconstruct the consciousness and society of the future—to "re-order the universe," in Apollinaire's words—also played a significant role in the development of Picasso's Cubism. Central to anarchist belief, and found in virtually all the writings on this subject by Proudhon, Bakunin, and Kropotkin, as well as numerous artists and critics throughout Europe, was faith in the power of art to alter the ways in which people thought, to support the status quo or undermine it, to change the consciousness of the age, and thus to hasten the social revolution.

Such a formula must now seem naive and hopelessly idealistic, and it is likely that this is the most alien aspect of anarchist esthetics for us to comprehend from this end of the twentieth century. Something of the sort was also felt by the very generation—including Picasso—who had embraced these ideas after the First World War seemed so cruelly to expose them. This disillusionment, as I noted earlier, played a large role in creating an unnecessarily simplified image of the Cubist movement. In recent years, scholars have come to appreciate in more and more periods of Picasso's work the extraordinary marriage of intensely personal emotion to brilliant formal invention as his contribution to the art of our century. For example, during the Rose Period he investigated the formal problems of relating a figure to its surrounding space and at the same time used these figures, the saltimbanques, to symbolize the relation of the artist to society.[63] In the 1930s Picasso's meditations on the nature of female sensuality served highly inventive discoveries of Cubist recombinations of forms.[64] Many of his best works are commonly admired for his brilliant combination of formal and thematic concerns: the painful Synthetic Cubist works of the 1920s such as *The Dance*; the "Crying Woman" and the "Minotaur" series of the late 1930s; *Guernica*, 1937; and the ruthless series of late drawings concerning Picasso's waning sexual powers.[65] Critics

agree that all these works relate to Picasso's personal experience, his emotional life, his private meditations, even when they also encompass world events, as with *Guernica.*

So familiar now is this personally revelatory artist, so confident are we of finding in his works those cues and signposts of his life, that the Cubist period seems to have been authored by another Picasso, one who, though he may be the most brilliant formal inventor of the century, is sublimely indifferent to content. This disinterested Picasso, however, was largely his own after-the-fact invention. He was notoriously unforthcoming during the Cubist years, and those who did write in support of the new style, as we have seen, elaborated their own terms in discussing it. Scholars continue to be frustrated by the lack of evidence regarding what specific ideas Picasso or Braque may have contributed to such criticism. The only contemporary "interviews" with Picasso—Gelett Burgess in 1908 (not published until 1910) and Marius de Zayas in 1911—are unfortunately both paraphrased; to what extent is, of course, conjectural.[66] Beginning in the 1920s, Picasso finally spoke directly, even "officially," about the Cubist period—his aims, his methods, his relationship to Braque—and in virtually every case he distorted, exaggerated, and misled those who faithfully repeated his "statements" as gospel.[67] Picasso's anti-intellectual posture required that he be ruled not by thoughts or ideas but by pure unmediated genius pouring through those famous black eyes. And his egotism required that Braque become a follower, "Madame Picasso."[68]

These early statements are worth examining in order to understand the myths about Cubism that we lingeringly embrace today. As early as 1912, when he was known in the press as "pince-sans-rire Pablo Picasso" ("pinch-without-laughing" or, roughly, deadpan jokester), Picasso gave misleading answers to would-be historians about such subjects as the nature of Cubism and the importance of African sculpture for his work.[69] Salmon remembers him asserting to a journalist in 1918 that "he knew nothing and wanted to know nothing of Cubism."[70] In an interview published in 1923, Picasso rejected the idea that he had been "researching" in his Cubist period, or "evolving," both terms implying conscious purpose. He promoted the idea that "Cubism . . . is an art dealing primarily with forms," and asserted that people had blinded themselves and others with theories. He specifically rejected any role in Cubism of "mathematics, trigonometry, chemistry, psychoanalysis, music, and what not"[71] (which suggests that someone had better look into the influence of chemistry on his work). Yet in a letter to the Russian periodical *Ogoniok* in 1926 he felt it important to mention that "the mathematician, Princet, . . . used to be present at our discussions on aesthetics."[72] Maurice Raynal painted a similar picture of enlightened conversation (no matter how overstated his special claim) when he remarked: "I can remember the joy of the first cubists when in the far-off days—it will soon be ten years ago—I showed them, by quotations from the philosophers, how their deductions had re-created most of these great thoughts."[73]

The fact that Picasso participated in such "discussions on aesthetics" evidences a literate awareness of intellectual issues raised by the kind of work being done, but seems increasingly phantasmagorical as the mystification of Picasso's character proceeded during the 1920s.[74] He promoted this anti-intellectual view of himself vigorously throughout his life, and as late as 1971 suggested to William Rubin that the reality in Cubism is "like a perfume," an image that is sensual, unlocatable, and not susceptible to the rational mind.[75] Some of the impulse for Picasso's obfuscation must be attributable to his Jarryesque love of the *blague* and the anarchist artist's posture of perfect spontaneity, discussed in Chapter 5. But the forces of the postwar period worked themselves on the expatriate Picasso as well as on other artists and critics, and there is no doubt that the new formalist version of Cubism served Picasso's new, and at times uncomfortable, position in postwar France extremely well. It was to be twenty years before he would admit, following the shock of the German bombardment of Guernica, to his political past. But by then the confining formalism of the postwar years was thoroughly entrenched as an intellectual model, and we were ill equipped to understand what he meant.

As we have seen, style embodied "content" in Picasso's Cubism, and in their own time and place such works hardly represented the disinterested play of line and form that he later claimed. At the same time, similar to the pattern of his earlier work, Picasso continued to explore recognizable subjects—often those with special meaning for him—in his Cubist canvases. In 1909, the same year as his Horta landscapes, he fused a number of figure studies with Harlequin and the saltimbanque theme familiar from his Barcelona, Blue and Rose periods (Fig. 75). For a long time, scholars did not deal with these obvious continuations of Picasso's earlier representational periods, and the works were not acknowledged or recognized as such. For instance, Golding, in *Cubism: A History and An Analysis, 1907–1914*, of 1959, was so deeply committed to the idea of Cubism as a purely formal art that he avoided the problematic issue of these works in his main text and only speculated in a footnote: "The rather puzzling costumes of these sitters, the fancy-dress-like quality, may perhaps be due to the fact that the paintings were executed from photographs, postcards or magazine illustrations; it is known that Picasso occasionally worked from photographs at this time."[76] Yet it seems a far stranger idea to imagine that Picasso—the same artist who painted, on the one hand, *Family of Saltimbanques* (Fig. 44) in 1905 and, on the other, *Three Musicians* in 1921—would ever use subject matter arbitrarily, as a passive recipient of photographs, postcards, or magazine illustrations. Whatever the visual source, Picasso used subject matter consciously and purposefully throughout his artistic career.

In 1973 Reff, in his article "Themes of Love and Death in Picasso's Early Work," discussed Harlequin as "an alter ego for Picasso, who in two pictures of the Rose Period gave this figure his own features, . . . the first of those imaginary characters through whom he has often expressed the themes of alienation and frater-

nity, jealousy and love that haunt his imagination."[77] To this excellent point I would only add that the alienation to which he refers is specifically social alienation. Reff goes on to speculate, though briefly, on Harlequin's reappearance in Picasso's Cubist period in, for example, *Carnival at the Bistro, Harlequin Leaning on his Elbow*, spring 1909, and the *Temptation of St. Anthony*, spring 1909.[78] And though he noted in conclusion that two Analytical Cubist works also pertain to the harlequin theme—*The Accordionist*, summer 1911 (Fig. 77) (which Reff calls by its pre-1939 title *Pierrot*), and *Harlequin*, summer 1913—he did not discuss the implications of the theme's reappearance at this late date.[79] Yet these facts can lead to a conclusion shocking in its simplicity: that Picasso in even his most austerely hermetic Cubist paintings was concerned with familiar ideas and playing with allusive thematic content to which we have been blinded by the impact of the works' formal daring.

One of these themes extends throughout this period and takes over from the earlier self-portraits and harlequins: the characteristically modernist theme of the portrait of the artist. The conflicted place of the artist in the early twentieth century, dependent on the self to give context to an artistic act, promoted an exaggerated self-consciousness of the act itself. Given Picasso's psychic investment in himself as a revolutionary in art and his continual announcement of that fact in his self-portraits of 1901, 1906, and 1907,[80] his insistence on the portrait of the artist as a subject in the period from 1909—following the temporary disappearance of Harlequin—to 1913 stands as a lengthy meditation on the transforming power of art and on the artist's role in revolutionizing and transforming modern man. His insistent use of this subject stands in a perfect relationship to Apollinaire's visionary criticism of Picasso's Cubism as "re-ordering the universe."

A number of major Cubist figure studies seem specifically to represent Georges Braque, to whom Picasso was deeply tied and with whom he was developing the most extreme avant-garde art of his time. If so, they honor Braque's role in a collaboration that was crucial for Picasso and for the development of Cubism. Several studies for *Carnival at the Bistro* (Fig. 75) include a figure in a domed hat, whom Rubin has identified as Cézanne, though this figure is at least as likely to depict Braque.[81] *The Hat*, early 1909,[82] focuses strongly on the hat itself, and during the winter following these two works, Picasso painted a male figure wearing the same domed hat, entitled *Portrait of Braque* (Fig. 76). "It was painted in the studio without a model," Picasso later told Daix. "Afterwards, with Braque we said that it was a portrait of him. He wore a hat a bit like that."[83] In *The Accordionist (Pierrot)*, painted in Céret, summer 1911 (Fig. 77),[84] the hat reappears, its arc on the right side of the figure's head abruptly truncated by a sharp horizontal. Since Braque was rather famous in Montmartre—and much beloved by Picasso—for playing the concertina, an identification of the image with Braque is strongly suggested. A figure in the same hat is depicted in *The Aficionado*, summer–autumn

1912,[85] and in the collages *Man with a Hat*, December 1912 (Fig. 102), *Man with a Violin* (Fig. 84), *Head of a Man*, and *Head of Man in Bowler Hat*, all autumn–winter 1912[86]—a period of the closest collaboration between Picasso and Braque and of the most daring achievements.

At the same time, like the image of Harlequin conflated with the accordion player in *The Accordionist (Pierrot)* (note, for instance, the ball studded with circus stars at left center as the earlier title would suggest) and those images that reappear in the summer of 1913 in *Head of Harlequin* and *Harlequin*,[87] such works are portraits of the artist and sometimes surrogate self-portraits. In *The Accordionist*, for example, Picasso's figure is shown with his eyes closed, depicting the inspired artist, eyes turned inward in a musical transport reminiscent of such earlier works as *The Old Guitarist* of 1903 (Fig. 21). The fact of a theme so powerfully redolent of symbolisme persisting into the Cubist period in such a work as *The Accordionist* tells us of the importance Picasso still placed on inspiration in this highly conscious and analytical period of his art.

Braque, too, in *Man with a Guitar*, summer 1911 (Fig. 78), depicted the musician singing with his eyes closed, which may point to a shared view of this theme. Braque, in fact, probably first introduced the musician and musical instruments in their work during this period.[88] It was not until after his meeting with Braque and after the fading of the harlequin theme in spring 1909 that Picasso began to depict figures with musical instruments. The first, *Woman with Mandolin*, spring 1909, owes to Braque the handling of the instrument itself.[89] Picasso treated the subject again in two canvases in spring 1910, *Woman with Mandolin* and the unfinished *Girl with a Mandolin (Fanny Tellier)*.[90] Like Braque at the same time, Picasso had adopted the musician by spring 1911 as one of his major subjects; in the following two years nearly half of all Picasso's oil paintings and collages, plus numerous constructions, depicted musical instruments of various kinds either in the hands of musicians or in still lifes.

For Picasso (despite his reported "tin ear"), music epitomized art and, frequently, leisure as signs of civilization. His early depictions of musicians, a rare subject for him, were never neutral: either they represented the unappreciated artist/beggar struggling on the fringes of society, as in *The Old Guitarist* of 1903 and *Hurdy-Gurdy Player* of 1905, or country folk at ease, the music an expression of their simple and harmonious lives, as in his evocations of Horta of 1903, where Catalan peasants listen quietly to a guitarist or dance the jota.[91] During the Cubist period, the representation of music in Picasso's work came to represent the power of art, its ability to express and evoke emotion, to move people with thoughts and feelings otherwise difficult of approach.

To Symbolists like Mallarmé, whose book of poems Picasso owned and read,[92] music was the most abstract of the arts, offering to the listener an unparalleled freedom in responding, for which vowels and colors were analogs. Though Picas-

so's formal vocabulary consisted of lines, planes, and tonal relationships rather than color "harmonies," he pursued an abstraction of form whose analogy with music he repeatedly asserted in his subject matter, with its musicians, musical instruments, sheet music, and song titles. As such, music represented his great project—joined now with Braque's—of exploration at the "frontiers" of art and experience. The musician is the artist, the creator of culture, the avant-garde. And, as we shall see in the collages, Picasso also used music to represent all the fragility of civilization during the Balkan Wars of 1912–1913, which posed a serious and genuine threat to the peace of Europe and ultimately led to the war that turned the tables on the anarchists'—and Picasso's—vision of the future world.

Though Picasso and Braque later stated that Apollinaire's understanding of the formal concerns of Cubist painting was misguided, his understanding of the revolutionary import of Cubism and the way it overthrew tradition was certainly correct. And to a large extent it was hindsight, with all its changed perspective, that cast Apollinaire's criticism in a negative light.[93] "Pitié pour nous qui combattons toujours aux frontières / De l'illimité et de l'avenir" ("Pity for we who fight always at the frontiers / Of the limitless and of the future"), wrote Apollinaire in "La Jolie Rousse."[94] As he had done with Braque, Picasso acknowledged his comradeship with Apollinaire in several major canvases painted in summer 1911 at Céret, *Man with a Pipe* and *The Poet* (Figs. 80 and 81).

In the first, Picasso depicted the half-length "portrait" of a man with a mustache, smoking a pipe while writing (eyes open) on a sheet of white paper visible below. The letters [JOURN]AL and [R]est[aurant] identify the location—a French café, where one may spend large amounts of time reading or writing in a congenial atmosphere. Close enough in style to be considered by Daix "a rectangular version" of *Man with a Pipe*,[95] *The Poet* also depicts a mustachioed man, *pipe à la bouche*, half-length, the white sheet of paper below, with its edges curled. And in *The Poet*, Picasso has added a detail that may also give us a location for this *écrivain à la pipe*. A pipe rack made by tacking a piece of string to the wall can be seen in the upper right with three pipes in it.[96] This kind of string pipe rack is also visible on the wall of Braque's studio, just below the violin, in a photograph taken about 1910–1911.[97] This could mean that the poet is depicted in either Braque's studio or Picasso's, who may also have had a string pipe rack. They all smoked numbers of clay pipes.

Picasso depicted Apollinaire—certainly the poet he most admired—numerous times, with his large, bottom-heavy face, mustache, and clay pipe in mouth, which, according to Olivier, he did not take out even to tell stories (Fig. 79).[98] Salmon, like most of the Picasso circle, also smoked a clay pipe and sometimes sported a mustache,[99] but Apollinaire, disciple of Jarry, was famous for a method of poetic composition to which these canvases seem to point. Notoriously "unable" to write poetry in a quiet room—though he wrote voluminous amounts of prose thus—Apollinaire affected a pose, *au très grand moderne*, of being able to write only when

walking the streets of Paris or in the middle of the most chaotic scenes: cafés, restaurants, or artists' studios.[100] At his own very bourgeois home, however, fastidiously clean and furnished by his mother,[101] Apollinaire, according to all reports, would not have tolerated so bohemian an object as a string pipe rack. Olivier even passes on the story from Laurencin that he would make love only in his armchair since he could not bear to disarray the bed, a story they all seemed to believe.[102] Such anecdotes of Apollinaire's eccentricities were so well known that he must have been rather easily recognized by those who knew how to read the paintings.

Such a "portrait" would pay homage to the strong stylistic relationship between Analytical Cubism and Apollinaire's calligrams with their revolutionary typography, obscurity, allusion, and "surprise." "Lettre-Océan," with its rotating lines and dizzying juxtapositions, appeared in *Les Soirées de Paris* in June 1914 and represented at that moment the most radical combination of fragments of everyday life with the breakdown of poetic form. The subsequent issue presented a critical discussion of the poem—so profoundly did the publisher (Apollinaire) comprehend his readers' need for excursus—which explained, "It is a revolution, with all the force of the word. But this revolution is only at its beginning."[103]

As with his "portraits" of Braque and his repetition of the theme of music, Picasso in these evocative portraits of Apollinaire makes an analogy between the Cubist painting, its innovative daring, its rejection of traditional form and vision, and Apollinaire's poetry. With it he acknowledges his friend's role in the development of a radically modernist style whose revolutionary intentions they had shared since meeting in 1904. It thus makes sense that when Picasso later helped compose a published statement rejecting Apollinaire's critical interpretations of Cubist painting, he prefaced his rejection with this *hommage*: "Picasso has never questioned, then or now, the greatness of Apollinaire the poet. On a personal plane, too, he greatly enjoyed Apollinaire's company, was stimulated by his constant flow of exciting ideas, shared many of his sentiments, and derived much encouragement from discovering the similarity of their esthetic outlook."[104]

These considerations of subject matter in the most abstract periods of Picasso's art parallel and allude to the revolutionary nature of the invention and development of the Cubist style itself, which overturned (here one cannot avoid political metaphors) inherited conventions of color, form, space, framing, image, and materials.[105] Picasso's intentions were, I would argue, to transform the mind of his age, not to obliterate it; hence, from his point of view, to arrive at complete abstraction was never the object of his revolution, but rather to "destruct" an artistic tradition powerfully identified with the social status quo. Thus Picasso criticized the classical tradition, but, rather than dismissing it, he used the devices of traditional painting as a foil against which his own work played and without which its inversions, puns, and offenses are incomprehensible. His work, ironically, takes the classical tradition seriously, one of the preconditions of modernism.[106] (Similarly,

Picasso never "overcame" his bourgeois origins, which were the foil for his bohemianism.) And while the Cubist style accomplished this destruction of traditional vision and dismantling of artistic form, the subjects to which it was frequently applied often betray that idealistic and visionary hope of fostering a new consciousness that is at the heart of the anarchist vision.

5. The Insurrectionary Painter

Anarchism and the Collages, 1912-1914

*Why can one count painters who are insurrectionary in their work
on the fingers of one hand, and not writers?*
—Pablo Picasso to Hélène Parmelin, 1963

WE HAVE SEEN that the influence of anarchist ideas is felt in various ways throughout Picasso's work of the prewar period, but it is nowhere more compelling or more revolutionary than in his early collages. His incorporation of legible pieces of newsprint, long seen as representing merely the fact of a newspaper, represents in addition his continued interest in and manipulation of anarchist themes and social critique. This extraordinary combination of politics and radical esthetics manifests Picasso's direct response to the events of the First Balkan War and the antimilitarist social critique mounted in response by the Left. Insistently reiterating anarchist themes—war, war profiteering, machinating government officials, strikebreaking, anarchist and pacifist demonstrations—these news items import contemporary political debate into self-consciously "revolutionary" works of art and are an index of specifically political motives in Picasso's revolt against tradition. Reports on the Balkan Wars and the economic and political state of Europe constitute more than half of the newsprint clippings in Picasso's collages of 1912–1914, the years in which the body of his collages were made. Another quarter introduces macabre accounts of suicide, murder, and vandalism, which accumulate to depict, with the blackest humor, a pathological bourgeois world gone mad.

Although Parisian newspapers grew increasingly obsessed with war and political events in 1913 and 1914, this fact is not reflected in Picasso's collages, as it would be if he had passively used front-page news. Instead, after the autumn and winter of 1912, he turned toward more personal subjects. These later collages, when they incorporate newsprint, largely allude to issues of health—offers of cures for tuberculosis, for example—and to the art and café world, including theater listings and advertisements for tonic wines. In very few cases is the newsprint in the collages rendered illegible by overdrawing, and few are devoid of meaning in the context of Picasso's life and oeuvre and therefore arguably "arbitrary" inclusions, as has traditionally been thought. Further, the pieces of newsprint are often wittily and tellingly tied to the Cubist images of the cafés, where arguments and discussions of these political and esthetic issues took place; the iconography of the

collages insistently sets us among the tables, bottles, liqueurs, and, indeed, newspapers of an artistic, left-wing bohemia.

The Collages and the Threat of War

In order to understand the allusions in the collages and to grasp the background to Picasso's concern with such issues, it is important to review contemporary political events briefly. In France in the years leading up to the war, frequent clashes between strikers and the state forced attention on the plight of the workers.[1] One result of the repression of the labor movement and the persecution of its leaders was the growth and increasing militancy of the anarchist movement and the Confédération Générale du Travail (CGT), the labor movement or syndicalist arm of the anarchist movement, which recorded 300,000 members in 1906, 400,000 in 1908, and 600,000 in 1912. At the same time, the more moderate socialists were gaining voters and seats in Parliament. The left-wing movements in France over a wide spectrum of opinion gained tremendously in numbers and political power during the avant-guerre.[2]

Anarchists embraced the working-class revolution and advocated the use of violence and strikes to achieve their ends. More important, however, was their utopian vision of a future society, in fighting for which they were fiercely opposed to nationalism and war. In 1905 the First Moroccan Crisis awakened France to the possibility of war with Germany.[3] The French Foreign Minister Théophile Delcassé had made a secret deal with England and Spain, agreeing on colonial spheres of influence and setting up a French protectorate in Morocco. Wilhelm II, who cherished thoughts of a German colonial empire, was furious at having been excluded from the division of the spoils. Claiming the jeopardy of Germany's economic interests, he sailed into Tangier, landing with sword symbolically drawn to announce his readiness to go to war over the issue. Negotiations went on for a year, and war seemed imminent until the Settlement of Algeciras in 1906. But even this accord was temporary, and for the next seven years Morocco was the pretext for continual tests of strength and calls of bluff between Germany and France, as both prepared for war. Despite the reputation for carefree gaiety of la Belle Epoque, an atmosphere of impending war hung over the entire period and was of active concern to the generation who knew it would be asked to fight.

The other major crisis of the years immediately prior to World War I was the First Balkan War, which is of special importance for Picasso's work. When Raymond Poincaré became France's premier and foreign minister in 1912, he rapidly began to gear up for war with Germany, which he thought would be "short but glorious."[4] One of his first moves was uncritically to support Russian designs on the Balkans. Czar Nicholas II formed the secret Balkan League with the aggrieved Serbians and Bulgarians in March 1912, assuring war with the Ottoman and

Austro-Hungarian empires, hence Germany, who was bound in treaty to Austria-Hungary. When Poincaré himself visited Russia, pledging full support for Russia's plans for war and a rapid buildup of French military strength, the stage was set for World War I. On October 15, 1912, Montenegro, Serbia, Bulgaria, and Greece declared war on Turkey. After expelling the Turks, in November Serbia laid claim to a large part of Albania in the Austro-Hungarian Empire, and Austria-Hungary mobilized. But because Russia's military preparations were incomplete, the czar failed to come in with Serbia; treaty discussions began in London and dragged on until May 1913. The Second Balkan War amounted to a few weeks' skirmish and ended in a "final" treaty in August 1913. While much blind optimism prevailed, many accurately saw the Balkan Wars as a dangerous preview of a general European war. When a year later World War I did break out, the immediate event that sparked it was the assassination of Austria-Hungary's Archduke Francis Ferdinand by a Serbian nationalist.

"The end of militarism is the mission of the nineteenth century," Proudhon had written in 1861.[5] After the Moroccan Crisis of 1905, the burning issue for both anarchists and socialists was whether the workers would or should fight in the war that already seemed inevitable. Most on the Left hoped that when called upon to shed their blood for capitalist "warmongers," workers internationally would recognize their class brotherhood, refuse to fight, and rise up to prevent war altogether. This was the course advocated by France's leading socialist, Jean Jaurès, right up to the moment of his assassination three days before France mobilized its armies. He sensibly dreaded the outbreak of war; but others, thinking that war would trigger revolution, clamored for it. In France alone in 1910 a million socialist votes encouraged the deluded hope that the workers were ready.[6]

Numerous anarchist and socialist congresses met during the avant-guerre to formulate positions against militarism and the coming war. A congress in Amsterdam in 1904 founded the Association Internationale Antimilitariste (AIA). They published an "affiche aux conscrits" that read:

> When they command you to fire your guns on your brothers in misery . . . workers, soldiers of tomorrow, you will not hesitate, you will not obey. You will fire, but not on your comrades. You will fire on the gold-braided old troopers who dare to give you such orders. . . . When they send you to the border to defend the coffers of the capitalists against other workers, abused as you are yourselves, you will not march. All war is criminal. At the mobilization order, you will answer with an immediate strike and with insurrection.[7]

Although the AIA was soon crushed by the government, its recommendations were embraced with increasing frequency. The anarcho-syndicalist union Confédération Générale du Travail (CGT) repeatedly published a *Manuel du soldat* advising desertion or the spreading of revolutionary propaganda in the barracks; at the CGT

congress in Marseilles in 1908, the delegates agreed to proclaim a general strike at any declaration of war. Desertion and absenteeism in the French army grew at an extraordinary rate in response to this powerful and widely disseminated critique of the military establishment: 5,991 in 1902; 14,067 in 1907; 12,000–13,000 in 1912.[8] And while "le loi de deux ans" of 1905, which did away with most exemptions from military service, increased the overall size of the army, the desertion rates represent a widely disproportionate increase.

Socialists likewise met to consider tactics for preventing war. From 1907 on, Jaurès became famous for his stand against imperialism and the machinery of war, traveling all over France to plead and argue for peace to hundreds of thousands who came to listen. As war approached, more and more support seemed to gather behind his arguments; for example, a speech he gave in a working-class district of Paris on May 25, 1913, organized in only two days, drew a crowd of 150,000. The anarchists and socialists organized demonstrations so huge and enthusiastically critical of the government that Premier Barthou threatened to crack down further on the labor movement.[9] In the end, the government ignored the message from the Left with impunity, and the French nation in a patriotic fever marched off to a war ultimately more destructive than any—whether "warmongers" or workers—could possibly have imagined.

It would have been nearly impossible in Paris in those years to have remained oblivious to the scope of this left-wing antiwar movement, which drew attention to the plight of workers as well as to the machinations of armaments manufacturers and government ministers. D.-H. Kahnweiler, Picasso's dealer and friend after 1907, remembers those politicized years before the war:

> As for my political ideas, I was a leftist. For example, I took part in a demonstration on the grave of Zola, who had just died [1902]. . . . I was still, you remember, a very young man, so the only way I could show my interest was to participate in demonstrations and meetings, which I did. I heard Jaurès, Pressensé, all the great socialists of the day. I took part in demonstrations. The Dreyfus case was fairly recent, and the political atmosphere was still very unsettled. The right wing was very restless, and the left wing was full of enthusiasm.[10]

Picasso, far from remaining impervious to such events, was galvanized by them. Maturing in radically anarchist and pacifist Barcelona, he was equipped to understand the machinations and jockeying for war that such events represented. According to the anarchists, war is on one level madness and on another level exploitation of workers as cannon fodder in the interests of armaments manufacturers and profiteers. While the fever of patriotism in France grew around him and the press became more and more hysterical, Picasso explored these issues through "quoting" with the newsprint he selected and through juxtaposition of

such quotations with the still-life images in his collages of 1912–1913. Such associations range from black humor to black horror and embody threats to the civilization represented by the work itself.

The subtle interaction of these elements makes Picasso's antiwar posture apparent and reveals it to be consistent with the anarchist views that frequently informed his earlier work. That he steadily stood against the war is confirmed by his refusal to be caught up in the final panicked rush to "defend civilization" that overtook all his French friends, including the antimilitarist Salmon. Even Apollinaire, who, like Picasso, was from a neutral country, changed his citizenship in order to fight on the French side.[11] It took considerable courage in the face of Kropotkin's much publicized support of the Allied cause, and doubtless loss of esteem in the eyes of a patriot like Braque, to maintain a pacifist stance at such a heady moment.

A reading of the newspaper clippings in many of Picasso's collages reveals them to be reports and accounts of events with special political meaning, constituting a journalistic diary of the period. Most were carefully cut out to preserve legibility, and sometimes whole columns of print remained intact. Where Picasso cut into the text of an article, he usually clearly retained its sense; in not a single case did he cut up the center of a column. Furthermore, the clippings did not innocently reflect front-page news; it can be observed that Picasso selected from all parts of the newspaper, including the financial pages. (In his collages, Braque demonstrated little interest in such *actualités*, though he was cutting scraps out of the same newspapers from which he and Picasso were making supposedly random selections.)[12] In fact, it seems likely that the very development of the use of newsprint in Picasso's collages—a full year before Braque's—was directly motivated by a desire to work these anarchist issues into his art. No more concrete way could be imagined of pulling Cubism back from the brink of total abstraction, a denouement steadfastly avoided by both Picasso and Braque. And no more democratic way could be found for the project of subverting the high art of oil painting than that of introducing such easily readable articles, on such universally engaging subjects. It is even possible that this was Picasso's answer to the Futurists' charge that Cubism was a politically irrelevant art; but rather than evoking political subjects, such as Umberto Boccioni's *The Raid* of 1911 or Carlo Carrà's *Funeral of the Anarchist Galli* of 1910–1911, in a modernist style, Picasso introduced the political questions themselves into the dynamic interaction of the total work.[13]

Following the recent redating by Daix and Rosselet of Picasso's Cubist works, we now know that the first time he used a scrap of newsprint in a collage was in *Guitar, Sheet-Music and Wine Glass*, November 1912 (Pl. VII), in either his first or second experiment with papier collé. Concerning the current Balkan War, this first headline, from *Le Journal* of November 18, 1912, dispatched from Constantinople, reads "La Bataille S'Est Engagé" ("The Battle Is Joined"), referring literally to the war and perhaps metaphorically to Picasso's personal struggle with the issues it

raised, as well as to the formal challenge represented by the unprecedented and outrageous use of collage in art.[14] Picasso used only part of the original headline in the paper, which reads in its entirety, "LA BATAILLE S'EST ENGAGEE FURIEUSE sur les Lignes de Tchataldja," and thus makes it seem that what is a headline from a war well under way (since October 15) is the éclat of the first battle. The fear that the Balkan War would lead to a pan-European war and the frantic (if insincere) peacemaking efforts by the other European powers were recorded in the newspapers in the following months, and in Picasso's subsequent collages. These anxieties, introduced into the setting of the still life, seem to threaten the fragile pleasures of a civilized peace: wine and music in a wallpapered room.

In the second collage in which Picasso used newsprint, *Violin*, November 1912 (Fig. 82), the article he chose describes the occupation of Saint-Jean-de-Medua by the Montenegran army and discusses the desire of the Turks to continue fighting. *Bottle of Suze*, November 1912 (Pl. VIII), the third work in which he used newsprint, contains a report, dated "16 Novembre," of the Serbian advance toward Monastir in Macedonia, including accounts of the wounded, descriptions of battle movements, and speculations on how long besieged Adrianople could hold out against famine. Picasso deepens our sense of the tragedy of war by including, alongside accounts of strategy and battle movements, gruesome descriptions of war's victims. This collage includes the following account (Fig. 83) of a cholera epidemic among the Turkish soldiers, which can be read as a pacifist statement on the part of the reporter in that the Turks, "the enemy," are seen sympathetically:

> Before long I saw the first corpse still grimacing with suffering and whose face was nearly black. Then I saw two, four, ten, twenty; then I saw a hundred corpses. They were stretched out there where they had fallen during the march of the left convoy, in the ditches or across the road, and the files of cars loaded with the almost dead everywhere stretched themselves out on the devastated route.
>
> How many cholera victims did I come upon like this? Two thousand? Three thousand? I don't dare give a precise figure. Over a distance of about twenty kilometers, I saw cadavers strewing the cursed route where a wind of death blows and I saw the dying march, ominous in the middle of troops indifferent and preparing themselves for combat.
>
> But I had seen nothing yet.[15]

These vivid descriptions of the horror and agony of war placed upside down in the still life—an image of the world turned on its head—are forced into a dialogue with a report on the other side of the collage of a mass socialist/anarchist/ pacifist meeting, forty to fifty thousand strong, with lengthy quotations from the speakers that, in effect, voice the leftist position. This article—right side up in the composition—reports that "the most listened-to speakers were at first the foreign-

ers, and among them M. Scheidemann [a leading German socialist], who affirmed 'that the German proletarians will not fire on their French brothers'. . ."; "M. Sembat [the defender of Cubism in the Chambre des Députés] ended his speech affirming that the workers ought not to seek death 'for the capitalists and the manufacturers of arms and munitions.' " And a third speaker articulated the threat inherent in all we have seen here by his opening words: "In the presence of the menace of a general [Euro]pean war. . . ."[16]

After these first three works, a cluster of collages all dating to late November–early December 1912 recorded the progress of the fighting, the preliminary negotiations for peace, and closely related subjects.[17] *Man with a Violin* (Fig. 84), for example, includes in the upper left a report on an action by the miners of the Nord and the Pas-de-Calais, and in the center left an article in which the minister of the navy defends himself in Parliament against accusations that, if war were declared, the fleet would be undersupplied in powder, munitions, and fuel. In an adjacent column a reporter in Bulgaria speculates on whether the Balkan War will escalate and whether "if a third power intervenes, Germany will throw itself into the balance." His column continues in the lower left, describing the preliminaries for peace negotiations at Tchataldja. At the bottom of the picture a partial cutting, apparently reporting a discussion in the Chamber, concerns itself with the "antimilitarist campaign" and "the extreme left."[18] Thus these articles mingle the subjects of the Balkan War with worker discontent and the pacifist/anarchist movement and allude to the threat of a larger war in which France would be involved.

In *Still-Life: Bottle and Glass on Table* of December 1912 (Figs. 85 and 86), we read that M. Millerand, once a leading socialist but now minister of war (a contradiction in terms according to the party faithful), has "blasted" the antimilitarists in the Chambre des Députés for resisting the passage of a law expediting the French military buildup. In the series to which this work belongs stylistically, including *Bottle and Wineglass* (Fig. 87) and *Table with Bottle and Guitar*, both of December 1912 and both containing dispatches concerning the unstable armistice signed on December 3, 1912,[19] the newsprint is circumscribed by the outline of the bottle, suggesting its role as the bottle's liquid and, by extension, the stuff on which French culture is temporarily drunk.

It is worth noting that the iconography of these collages from autumn to winter 1912 centers more strictly on the Paris café than do the later collages of 1913 and 1914, in which a larger percentage of the incorporated newspaper items suggest other, less serious, themes (discussed below). For example, the background of *Bottle on a Table* of December 1912 (Fig. 88) consists of a single sheet from the December 3 *Le Journal* turned upside down—the financial page—which almost entirely discusses the impact on European economies of the shaky armistice of the First Balkan War. Stock markets plunge as representatives of the great powers meet in London to settle boundaries and reparations and attempt to balance the

interests contending in the Balkan peninsula; while some profit from war, others suffer disastrously. Thus this collage affirms the direct link between war and the economic health of nations. That the isolated bottle seems to rest on a table formed by the newspaper itself suggests that the economic structure making café life possible rests on the uncertain and despotic whimsy of uncontrollable world events, a suggestion tragically borne out two years later in 1914 when the world was indeed turned upside down. Picasso and his generation, through their early immersion in the anarchist view of the world and of war, were well equipped to foresee this. The diaristic quality of the series would be incomplete without the actual announcement of peace in the First Balkan War, and it appears, cut from *Le Journal* of December 4, 1912, in *Bottle and Wineglass* (Fig. 87): "Les Alliés signent l'Armistice / La Grèce s'abstient."

Picasso continued to refer to the approach of war in his later collages, but much less frequently. For example, during the bitter debates in 1913 on the proposed increase of military service from two to three years, which lasted from March until the government's proposal was enacted on August 7, Picasso noted the storm of controversy in *Violin*, 1913.[20] Through an ink drawing on a piece of newspaper that forms the ground, we can easily read:

> The French government has understood the extent and urgency of its duty in light of the formidable war preparations of the German Empire. It recognizes the need to make up as fast as possible and at any cost the shortcomings of our military organization. To improve materiel, it is asking for extraordinary sums—many hundreds of millions—and in order to build up the effective active-duty army, it will go, if necessary, it is rumored, so far as to propose the reinstatement of the three-year term of service.[21]

During 1912 and 1913 Picasso made approximately eighty collages, of which fifty-two contain newspaper text; of these, at least half deal with the Balkan Wars and the economic and political state of Europe.[22] Most of the latter were produced in the autumn and winter of 1912, when their production virtually supplanted the activity of painting in Picasso's oeuvre, so absorbed was he in these new issues of form and content. Of all two-dimensional works executed in the autumn and winter of 1912, thirty-nine were collages while only twelve were paintings, including oil, watercolor, and gouache. Further, of these twelve paintings, three consistently explored the vertical format and formal elements of *Guitar, Sheet-Music and Wine Glass* (Pl. VII), while five more played with its horizontal version, *Guitar and Sheet of Music*.[23] These facts illustrate Picasso's discovery of the several layers of exploration possible with the medium of collage, his attempt to translate this to painting, and his subsequent decision to pursue collage virtually exclusively in this short and crucial period. In 1913 he executed an equal number of paintings and collages, forty each, and by the end of the year he had returned almost exclusively to paint-

ing. Picasso continued to make collages in 1914 but lost interest in dealing with the real-world events of newsprint, which appeared in only four of the approximately forty-six made that year.

The collages offered an extraordinary arena for the exploration of these politicized themes as Picasso's absorption with the medium in this period confirms. He had earlier that year registered a contemporary controversy about possible future wars in three paintings of spring 1912, all known as "Notre Avenir est dans l'Air" ("Our Future is in the Air"). Each records the title and cover design of a pamphlet propagandizing military aviation.[24] Apollinaire had earlier noted, in *La Démocratie sociale* in 1910, the naive faith held by some that the airplane, as the ultimate weapon, would make future war impossible, a fond hope from which he exhibited a certain ironic distance,[25] as Picasso is doubtless also doing.

Why does Picasso have this pamphlet? Perhaps he was interested only in the juxtaposition of the title—with its analogy to his and Braque's work (they were known to call each other "Orville" and "Wilbur")—with the tricolor; just as likely, he was also interested in the questions raised inside the pamphlet. He notes the idea of military aviation as controversial by placing the pamphlet in each case next to a daily paper—*Le Matin* and *Le Journal*—in which it would have been criticized and discussed. This is the first intrusion of a concretely political subject into Picasso's Cubist works and is roughly contemporary with his first essays in collage—*The Letter*, early 1912, and *Still-Life with Chair Caning*, spring 1912[26]—but he soon abandoned the painted allusion for the literal incorporation of news.

Even Picasso's constructions often incorporate newsprint relevant to his political concerns (which, incidentally, helps in locating more exact dates for some of these works). For example, the cardboard construction *Guitar*, dated by Daix to "autumn (?) 1912," includes on the inside—and is not visible in any photograph I have seen—a dispatch from the Balkan War on Greece's refusal to sign the armistice (which locates it on or after December 3, 1912). *Guitar and Bottle of Bass* includes a clipping discussing the international finances of various essential services and corporations, including banks and railroads: "Banques étrangères également plus faibles." (Since the date "23 avr 1913" appears on this clipping, Daix's date of autumn 1913—for which he does not give a reason apart from the terminus ad quem of its November 15, 1913, publication in *Les Soirées de Paris*—should probably be changed to spring 1913.)[27] *Construction: Violin*, December 1913 (Fig. 89), cleverly comments on all such content in the collages, on all that Picasso was bombarded with from the world around him and all that he encompassed in his avant-gardism, by announcing rather prominently that *something*—the subject of this sentence is unambiguously cut off by a piece of *faux-bois*—"arrive en tête de tous les jour[s]."

How do these cuttings from *Le Journal* make sense in the context of works traditionally considered among the artist's most highly abstract? Picasso, who had

embraced a political view that despised the diplomatic maneuvering of these years and rejected patriotic jingoism, would have been drawn into discussions with his French friends about their expected roles in the coming war. Like Picasso, many of them, including Salmon, Vlaminck, and Signac, had grown up in the intellectual atmosphere of anarchism/symbolism and certainly voiced their pacifism at this time.[28] Others, like Braque, expected to answer the call of la patrie. In the end, virtually the entire avant-garde marched off to war, including the virulent antimilitarists. Kropotkin amazed everyone by publicizing his fears of a German "threat to civilization" and encouraging participation in the war. As noted above, even Apollinaire changed his citizenship from Polish to French so that he could fight with his French brothers to "defend civilization."[29] Picasso, though from a neutral country, still would have had to justify his noncombatant position, given the passionate rhetoric aroused by the threat of a general European war.

With such ominous events and promises of hostility as the clippings in these collages record, the discussions and arguments grew intense in cafés all over Paris, nowhere more violently than at the artists' own La Rotonde in Montparnasse.[30] With their settings of bottles, glasses, café tables, and newspapers, these works not only depict the physical setting of the artistic bohemia, where political arguments were part of the daily fare, but also suggest the contents of such arguments by selectively importing the news itself into that heady atmosphere. Picasso juxtaposed readable columns of newsprint whose authors insistently reiterated subjects of specific concern to left-wing radicals: war, war profiteers, machinating politicians, ministerial abuses of power, strikes and strike-breaking, anarchist and pacifist antiwar demonstrations. The news items accumulate to project an image of French politics as venal, power-mongering, and posing a crazy threat to all those values of humanity and civilization that Picasso's work had always, in various ways, embraced.

The articles can be seen as addressed to an audience of *Le Journal* readers, that is, those who constituted Picasso's immediate society and whom he expected to read, as well as to contemplate, his collages (this would explain why he incorporated so few Spanish newspapers in the collages as a group and none in late 1912).[31] *Le Journal*, a mass-circulation Republican daily, which touched "le grand public," according to Salmon, published a million copies of each issue[32] and encouraged in its reporters a somewhat disrespectable emphasis on the prurient and the gory. It was the ideal vehicle for importing into the café settings of the collages the widely publicized war news, descriptive "walks on the battlefield," and those macabre "human-interest" stories of murder, suicide, and vandalism that make up another quarter of the newsprint items used in 1912–1914. Picasso never employed anarchist or radical newspapers, which would have replaced description with polemic.

His use of the traditional still life as an arena for his Spanish radicalism iron-

ically acknowledges Picasso's anomalous position in French artistic culture, in which, in so many ways, he refused to participate. An anarchist would have said "refused to legitimate." For example, he publicly exhibited in France only two or three Cubist canvases during the entire life of the Cubist movement and none at the independent Salons.[33] It is true that this is not the typical strategy for avant-garde artists supporting the anarchist cause. Pissarro and Signac, for example, gave money and donated prints and paintings to help support Jean Grave's *Les Temps Nouveaux*.[34] Not only did Picasso not follow suit, he also made a point of refusing to sell drawings to left-wing satirical magazines, such as *L'Assiette au beurre*, which offered him an entire issue.[35] This journal frequently featured artists and friends whom Picasso certainly admired, including Steinlen and Van Dongen, and remained a (small) source of income and publicity for Picasso's generation, including Juan Gris, Jacques Villon, Louis Marcoussis, and Franz Kupka. On the other hand, Hippolyte Petitjean and Louis Hayet, among the Neo-Impressionists, also refused to donate or sell illustrations although both were committed anarchists.[36] Without knowing Picasso's thoughts on this subject, however, one can only note that he never fully participated in the French art world on its own terms. And while he readily sold works to interested buyers—he was dependent, as were all but the financially independent (like Signac),[37] on the bourgeois art market—he had twice earlier abandoned salable styles in order to pursue, first, his Blue Period work, and later his "African" style and proto-Cubism. Certainly collages are less salable than the traditional and more permanent oils on canvas.[38]

Although Picasso did not follow Signac and others in acting out the previous generation's idea of the bona fide anarchist artist, he nevertheless followed in his own way Signac's directive: "The anarchist painter is not he who depicts anarchist scenes, but he who, without care for lucre, without desire for recompense, struggles with all his individuality against the bourgeois and official conventions through personal action."[39]

Such doubtless were Picasso's thoughts, however self-serving they may seem in retrospect. The incorporation of the columns of newsprint for their associational values remains as radical an introduction of the real world into an otherwise illusionistic context as the incorporation of those letters, signs, and headline fragments to whose meanings we are already alert.[40] But at the same time they extend the revolutionary nature of such intrusions by representing through their selection literally revolutionary viewpoints. And, perhaps more significantly, such news items firmly orient the outrage on traditions of image and craft in the political philosophy that justified the systematic attack. The columns of newsprint, more than any other of the collage elements, suggest Apollinaire's meaning in his explication of the appearance of "actual objects" in the collages: "new in art," he wrote in *Les Peintres cubistes*, "they are already soaked with humanity."[41]

The fact that there is no contemporary art criticism that articulates this read-

ing of Picasso's collages—apart from the general critical view of Cubism as the saboteur of the past—is not surprising when we recollect that he never exhibited them at the time. Perhaps best equipped to understand the depth of what Picasso was doing in these collages, Apollinaire referred only rarely to specific works in his art criticism and, even then, never gave an individual painting more than a line or two. He preferred high-flown generalizations, which almost exclusively characterize this genre of his writing, though he frequently cast such generalizations in politicized language that was more than merely metaphorical.[42] Further, the monthly journal that Apollinaire edited in 1912–1914, *Les Soirées de Paris*, was highly political in tone and followed the events of the Balkan Wars almost as closely as did Picasso's collages.[43] For a while he published eyewitness accounts from his foreign correspondent, André Tudesq, who was the journal's managing director in 1912 and happened also to be *chef des informations* for *Paris-Midi*, doubtless the journal footing the bill.[44]

Yet the most telling response to the political aspect of Picasso's collages comes from neither journalists nor art critics but from parallel works of art by Blaise Cendrars and Juan Gris, members of Picasso's circle at this time. Cendrars wrote the following poem, "Journal" (which means both "newspaper" and "diary"), in August 1913 and published it in Apollinaire's *Les Soirées de Paris* in April 1914.[45] The fifth and sixth stanzas read like *Bottle of Suze* (Pl. VIII), and the poem as a whole stands as another testament to the painful side of intellectual life in Paris during the progress of the Balkan Wars, under the threat of the larger war to come:

Journal

Christ
It's been more than a year since I've thought of You
Since I wrote Easter my poem before last
My life has changed greatly since
But I am still the same
I even wanted to become a painter
Here are the paintings I've done and which this evening hang on my walls
They open strange vistas in me and make me think of You.

Christ
Life
That's what I've ransacked

My paintings hurt me
I am too intense
Everything is bright orange.

I've spent a sad day thinking of my friends
And reading the newspaper

Christ
Life crucified in the opened newspaper I'm holding my arms outstretched
Wingspread
Rockets
Effervescence
Cries.
You would say it's an airplane falling.
It's me.

Passion
Fire
Continued story
Newspaper
It's useless not to want to speak of oneself
You must cry out sometimes

I am the other
Too sensitive August 1913.

Gris, after a period of making a living by selling socially critical and political cartoons to such journals as *L'Assiette au beurre*, developed a unique and brilliant Cubist style, following the artistic maneuvers of his Spanish compatriot at several removes (in style and time) but with attentive absorption.[46] Gris's use of newsprint in his collages differs from that of the other Cubists; for example, he cut out and combined letters to create false headlines, leaving room for none of the doubts regarding conscious intention that Picasso and Braque's collages can still inspire. Picasso's ground-breaking use of newsprint in his collages of the Balkan War period, before Gris was making papiers-collés of any kind, did not pass Gris unnoticed; but not until 1914, in the first year of his concentrated exploration of the medium of collage, did political and military events inspire him to make similar use of newspaper headlines and texts to manifest his political consciousness. For example, *The Package of Coffee*, 1914, contains a battle map of Ulm; *Still-Life, Glasses and Newspaper*, 1914, shows the folded front page of the May 3 edition of *Le Journal*, exhibiting an illustration and article about a dirigible explosion at Verdun; and *The Checked Tablecloth*, 1915, contains an illusionistic copy of *Le Journal* with only one legible headline: "COMMUNIQUES OFFICIELS," suggesting a life taken over by and obsessed with the war, as, in fact, Gris was at the time.[47] Other works of this period contain articles about the conduct of the war itself and mastheads of newspapers, including *Le Matin*, *Le Figaro*, and *Le Journal*, representing a variety of political attitudes toward events.[48]

It is notable that it was Gris, a Spaniard, who most honored Picasso's incorporation of news events and political issues in his art; but more significantly, Gris's

work of 1914 and 1915 affirms the ease with which a contemporary perceived and imitated Picasso's incorporation of political subjects. Likewise, the anarchist Dadaists developed this aspect of collage, and they especially admired Picasso's Cubism, reproductions of which decorated the walls of the Café Voltaire in Zurich in 1916.[49] Kurt Schwitters, for example, incorporated into his early collages of 1918 to 1920 newsprint relating to contemporary electrical and metal workers' strikes, with which he was in sympathy, and allusions to the difficulties of international alliances.[50]

Picasso's "newsprint" collages, then, record the prewar days in Paris; they are a meditation on the public issues that invaded private lives; in them, Picasso attempted to work out his relationship to the impending war. (The word *journal*, so prominently featured in many of the collages, also means "diary.") The articles incorporated into these works reflect his awareness not only of the forces making war inevitable but the opposition's arguments against participation. They articulate the reasons to refuse to fight or to have anything to do with the madness of nationalism and war. This was the course Picasso himself chose.

The Collages and Social Criticism

The Balkan Wars, while certainly the most dramatic, were not the only symptoms of the moribund society Picasso and his generation criticized in their art. Those of Picasso's collages of the same period not explicitly concerned with battlefield news and antimilitarist demonstrations often exhibit a sardonic black humor and a relish for the macabre. Other clippings from the sensationalistic daily *Le Journal*, equally meticulously cut and pasted for legibility and representing another quarter of the newsprint items imported into his collages, subvert the quotidian still life by incorporating accounts of murders, assassinations, suicides, vandalism, poisonings, and acts of senseless and often absurd violence. These collages, whose settings again suggest the cafés and studios where Picasso and his friends read newspapers over their aperitifs and discussed the evident madness of the modern world, exhibit a consistent and more than formalistic attitude to the world beyond the picture frame, an attitude that Picasso's profound if unsystematic attachment to Barcelona anarchism permits us to call "political." Such black humor and subversive comic posturing recall similar strategies of social criticism and personal rebellion in Apollinaire and Jarry and represent another continuum in Picasso's Cubist period with his more radically anarchist past.

Apollinaire's poetry and criticism honored and paralleled Picasso's efforts in painting and the collages, as discussed in Chapters 2 and 4. In addition to the passionate seriousness of his criticism, Apollinaire frequently applied the tools of ridicule and mockery in his championing of a "liberated" art and life. He concentrated much satiric energy on the theme of the "freedom of art." In the Brussels

periodical *Le Passant* in November 1911 he wrote a chronicle of the first meeting of a "Committee for Freedom of Art," whose proceedings he professes to have overheard while hiding in the room. All the members of the committee are men who support freedom in principle, but not in action, and who exhibit political prejudices on all sides. The meeting opens with M. Aching Waterlily, man of letters:

> M. WATERLILY: Naturally, I am in favor of Freedom of Art. Nevertheless—and I believe that I am expressing the sentiments of all the citizens here present—I request (it goes without saying) that Jews, foreigners, Protestants, and free thinkers should not be allowed to invoke this freedom in order to spread their abominable doctrines.

Several other members speak (including Urbain Gohier, a self-professed anarchist and friend of Jean Grave, but notably conservative in his art criticism and a thorn in Apollinaire's side), declaring themselves *for* "freedom of art," but *against* educational, sexual, political, and . . . artistic freedom:

> M. URBAIN GOHIER: I too am certainly in favor of Freedom of Art, but we must not go too far in that direction. I demand that we take action against the cubists, whose paintings I find extremely offensive.
> VICE-PRESIDENT PAUL REBOUX: I demand that action be taken against all those who write in free verse and, in general, against all those whose books I don't quite understand. . . .
> M. SUCH-AND-SUCH, a family man, asks that the freedom of writers not extend so far as to inform children of what they will find out one day. "I mean the sexual act, gentlemen. Let us think about it always, but speak about it never!"
> M. IMPOTENT (member of several academies): I propose, moreover that we prosecute the sexual act. Modern thought is sufficient unto itself. Let us free ourselves of all bestial habits.

The president concludes "that we are here for Freedom of Art and that we will not leave here before starting to take action against all those who compromise that freedom by making use of it."[51]

For Jarry, unlike Apollinaire, satire was the dominant form of his attack on art and society and not merely an adjunct. But it served the same high purpose of debunking the past, ruthlessly exposing the venality of the political present, and opening possibilities for a future art. In a piece of vicious "nonsense" in the conclusion of *Ubu colonial*, Ubu in his disingenuous way attacks Dr. Gasbag for failing to appreciate the Negro as a completely different animal from the Frenchman:

> PA UBU: had been rash enough to put up a notice outside our house saying: No dumping; and since the Negro takes pleasure only in disobedience, they came running from every corner of the town. I remember a little pickaninny who arrived each day from a distant part of town just to empty a lady's cham-

ber pot under the windows of our dining room, presenting the contents for our inspection with the remark:

> Hey you folks look heah: me black me make yellow crap, ma mistress she white she make black crap.

GASBAG: This would merely prove that the white man is simply a Negro turned inside out like a glove.

PA UBU: Sir, I am astonished that you should have discovered that all on your own. You have clearly profited from our discourse and deserve advancement. Possibly, when turned inside out in the manner you have described, you may suitably replace the specimen of black slave.[52]

A significant aspect of Jarry's influence on Picasso was his sense of humor, with humor itself as a creative/destructive mode of which the firing of guns and misleading of critics was a part. When asked about his writing, Jarry answered, "It doesn't resemble anything"[53]—an answer purposely unsatisfactory because exaggeratedly comforting for those who suspected they saw something of themselves and their world in the figures of Ubu and Faustroll. Central to this humor is the lie. Memoirists and scholars have frequently pointed out that, increasingly, Jarry's adoption of Ubu's persona was "a falsity vital to survival," articulated perfectly by Emmanuel Dieu in *L'amour absolu*: "Since he is certain that, in order to be understood he must lie, every falsehood is indifferent to him. It is a way of reaching people."[54]

It is well known to those who study Picasso's statements—"official" and unofficial—that they are full of contradictions. "In my opinion to search means nothing in painting. To find, is the thing," he said in 1923 in a fierce denial of any "spirit of research" in his work.[55] But in 1935, talking to Christian Zervos, he referred to young would-be Cubist painters as "taking up our researches."[56] And later he said, "I never do a painting as a work of art. All of them are researches."[57] He continued in this same statement to assert that "I search incessantly and there is a logical sequence in all this research," further contradicting an earlier insistence that "the several manners I have used in my art must not be considered as an evolution."[58] Such inconsistencies express not confusion in Picasso's mind, but the desire to counter perceived *idées fixes* in the audience of critics with whom he is speaking. Often enough Picasso rejects completely the right of the questioner to know if he has to ask. Fernande Olivier made the point several times in her memoir that "he was always irritated by people who insisted on making him explain his intentions in words." We see the same figure in her description of Picasso at the Steins':

> Matisse could always talk lucidly and with intelligence and he had an absolute determination to convince his hearers.
>
> Picasso rarely took such trouble. He was always pretty sardonic, and I believe he rather despised anybody who was not prepared to understand him.

During these evenings at the Steins', which were by no means disagreeable, Picasso would remain morose and dejected for the greater part of the time. He was bored by everyone, people were always trying to make him explain his position, which he found difficult to do, especially in French; and anyway he couldn't explain what he felt needed no explanation.

He would come away exasperated and furious.[59]

Even when the questioner was a close friend, Picasso would prevaricate; Sabartés recalls the early days in Paris when he enthusiastically wrote an article on Picasso's new "blue" paintings and submitted it to him:

"What do you say?" I asked him.

" 'In the hands one sees the hands,' my father used to say."

As is his way, Picasso refuses to give his opinion when asked for one; he hates to be interviewed.[60]

And when some English admirers from *Studio* came around the same evening asking for explanations, Picasso, "as if he recognized a life raft," insisted that Sabartés read his article, in Spanish; they listened politely without comprehending a word, thanked them, and left, whereupon Picasso burst out: "You see, if it hadn't been for that we'd never have gotten rid of them! And you! Telling me they wouldn't understand!"[61] This unhelpful posture remained one of Picasso's most enduring characteristics; Malraux recalled asking him about the "monster" paintings of World War II and earlier:

"What do they mean?"

Every time he got that naive expression on his face—his miller-straight-out-of-a-comedy look, Braque used to call it—an expression he was particularly fond of when he wanted to mystify people who questioned him, he was apt to reply with questions. . . .[62]

Such an attitude expresses Picasso's aggressive anti-intellectualism. In contradicting himself, in refusing to speak, he denied having an esthetic theory at all—an idea he frequently verbalized, rather than merely acted out, after the war.

But he also deliberately misled would-be critics about his history and ideas, sometimes so exaggeratedly as virtually to signify the blague in the telling. Asked in 1920 about the influence of African art on Cubism, Picasso barked, "Negro art? Never heard of it!"[63]—a canard he repeated in relation to *Les Demoiselles d'Avignon* to the end of his life, and which his most loyal expositors naively repeated until quite recently. Another absurdist piece of "history" Picasso later invented—passed on with sober credulousness by the adoring Sabartés—illustrates his deliberate inversion of the truth: "Do you know that when I painted my first guitars I had never had one in my hands? With the first money they gave me I bought one, and after that I never painted another" (see Fig. 21 and Pl. VII).[64] These two (or any other)

guitars, which appear consistently in Picasso's work from 1898 to 1972, illustrate the absurdity of his statement. This bit of self-mythologizing (which plays wittily on romanticized notions of "Spanishness") not only denies common sense and the easily reconstructible facts but asserts a relationship between objects and Cubist paintings of them belied by, for instance, the innumerable hours Kahnweiler, Vollard, and Fanny Tellier sat for their portraits in 1909 and 1910.[65] But we cannot fault Picasso for this: in his famous—and "authorized"—interview with Zervos, he called for a revolution against common sense!

Such outright and hilarious falsehoods are more easily detected than his more subtly obfuscatory statements about the nature of art. In this same interview he put on a disingenuous display of innocence when faced with the public's desire to understand the products of the artist. In 1923 he told Florent Fels, "We all know that Art is not truth. Art is a lie that makes us realize truth. . . . Through art we express our conception of what nature is not,"[66] representing the artist (quite properly) as a conscious manipulator. But in 1935, under different circumstances, he complained that no one understands that the artist is just another unconscious aspect of nature: "Everyone wants to understand art. Why not try to understand the songs of a bird?"[67] Picasso's statements also are not "truth"; they're lies manipulated to separate the credulous from the knowing. He is certain that in order to be understood he must not substitute words for his pictures: he must lie—a conviction confirmed and exemplified by the prototypical anarchist artist, Jarry. Picasso revealed this attitude frankly in his "Letter on Art," which he signed and published in the Russian journal *Ogoniok* in 1926 but later appropriately denied having authored:

> Inquisitive journalists and art lovers come to see us with the idea of extracting dogmatic verities from us or definitions which would explain our art to them, putting its pedagogical value—a value that I deny categorically—in relief. We are painters. Do they want us to be coiners of verities and maxims, watching over the market, as well[?]
>
> It is true that anthologies of the thoughts of Ingres and Delacroix are published. It makes one shiver. What thought of Delacroix could compare with his *Sardanapalus*:
>
> What is art?
> If I knew I should take care not to reveal it.[68]

As we have seen, Picasso paid homage to the esthetic that paralleled his own in the work of his revolutionary friends. Further, the incorporation of newsprint into such collages as *Guitar, Sheet-Music and Wineglass*, November 1912 (Pl. VII), expresses and may indeed have been first motivated by a desire to deal artistically with intractably "real world" newspaper events, the realities of war, international power politics, and the socialist and anarchist response to them, with which we may

assume Picasso was in sympathy. He analogously incorporated newspaper clippings into other collages that report not world-political events but the sort of comic-awful "human-interest" stories that are the stuff of feature journalism and the very hallmark of that great daily, *Le Journal*.

Seen with a Jarryesque eye as Picasso would have seen them, and as he would have expected viewers of his collages to see and read them, these stories become small parables of the absurd and the incongruous and thus appear as evidence of a bourgeois society in terminal stages of pathology. Picasso's incorporation of them into the ideal medium of the collages, sometimes juxtaposed with the more public madness of the war news, takes on a socially critical cast that is unmistakable. For example, *Head*, spring 1913 (Fig. 90)—one of his rare uses of an out-of-date newspaper—presents an absurdist view of the excesses of absolute power with its description of Czar Alexander III's pompous and anachronistic coronation in 1883. The journalist's statement acknowledges that it was "the most majestic ceremony one could imagine. . . . in the tradition of other centuries."[69] That Picasso has placed the mouth over part of the newsprint suggests that we are being given the journalist's view of what he saw and underscores the republican bias informing this eyewitness account. It also demonstrates again that the way Picasso used such content complements the formal complexity of his work. Likewise *Violin*, November 1912 (Fig. 91), with its dry discussion of the mechanical production of artists' colors in terms of tonnage and annual profits, points to an ironic view of the industrialization of art and its procedures.

Like Jarry and Apollinaire (whose alias in his youth was "Guillaume Macabre"), Picasso had often played with black humor and the macabre in his work in ways that frequently underscored his adversary relationship to bourgeois culture. Early examples include *Raven Perforating the Skull of an Eminent Citizen*, 1903 (Fig. 92); *Homuncule Attacking an Overdressed Old Man*, 1903 (Fig. 93); *Head of a Cretinous Old Man*, 1903, gouty and rich; *Bourgeois Being Cajoled*, 1903; *The Christ of Montmartre*, 1904, a suicide; and *The Strangler*, 1905, a study for a poster, as well as caricatural drawings too numerous to mention and most too scurrilous to be well known.[70] One of the most telling of these is his *Self-Caricature and Other Sketches*, 1903 (Fig. 94), where Picasso reveals himself to us as a devil armed with pen and brush: a bestial, mocking destroyer of complacent bourgeois society. And it is worth noting that a certain macabre and fetishistic aspect of the African sculptures so admired by Picasso and his friends is an obvious point of their appeal. "I am haunted. Haunted," the character of Sorgue, based on Picasso, repeats when confronted with "Dahomeyan" sculpture in Salmon's novel depicting these years, *La Négresse du Sacré-Coeur*.[71]

The newsprint in many of the collages suggests Picasso's continued playing with such themes, deliberately outraging the "classicism" of the still-life subject. In *Newspaper and Violin*, December 1912 (Fig. 95),[72] a small headline informs us that

"Chauffeur Kills Wife," in this first macabre symptom of a world gone mad. The paper itself emphasizes the absurd by noting the murderer's profession as if it were somehow relevant. *Le Journal*, from which Picasso took the overwhelming majority of clippings for the collages, is, as I have noted, a sensationalistic daily, which suggests his deliberate seeking out this sort of story to place next to his wine and cigarettes. As elsewhere, he plays with the relationship between the clipping and the drawing by dividing the headline with a brutal and knifelike stroke, so that one actually reads:

> UN CHA/slash/FEUR
> TUE/slash/FEMME

Above the headline the letters JOU, the root of *jouer* and *jouir*, usher in ironic notions: to play, to trick, to act, and to enjoy. A *joujou* is a toy, a plaything. And over these letters hovers a double curve in *faux-bois*, Picasso's shorthand for the violin's silhouette, which in the setting takes on the double role of shorthand for the murdered woman.

The same arena where we can see, in *Bottle of Suze* (Pl. VIII), twenty thousand corpses in a walk on the battlefield is also an arena where a sexagenarian, in *Table with Bottle and Wineglass*, autumn 1912,[73] is beaten senseless by a burglar and left for dead, and where a soldier, in *Bottle and Wineglass*, December 1912 (Fig. 87) (which also records the signing of the armistice for the First Balkan War), spits out a bullet he received in the head twenty-six years earlier, indubitably in a colonial skirmish. Nazin Pasha is assassinated in *Still-Life "Au Bon Marché,"* early 1913.[74] Public and private madness have become interchangeable and inseparable aspects of French culture as it appeared, at least, in the newspapers, whose own weird juxtapositions Picasso often recorded. We can read in *Bottle of Vieux Marc, Glass and Newspaper*, spring 1913 (Fig. 96), and in *Man with a Violin*, December 1912 (Fig. 84), which already mingles articles on war, strikes, and pacifist demonstrations, of an *artiste* who poisoned her lover and a singer who committed suicide following a performance. In *Bottle and Wineglass*, December 1912 (Figs. 97 and 98), a vagabond accuses himself ("s'accuse") of murder. And *Bottle, Cup and Newspaper*, autumn 1912,[75] describes to our indignant outrage the vandalizing of public monuments by *la bande noire* (not entirely unrelated, as Salmon affirmed, to la bande à Picasso).[76]

The sickness of this world preparing itself for war with hypocritical indignation and secret eagerness is evident in the decay at every level. Like Jarry and Apollinaire, Picasso used black humor in his work as a form of political satire. (When in 1907 Pablo Gargallo wanted to decorate the modernist facade of the Teatre Bosc in Barcelona, he made four portraits: Gargallo represented drama; Ramon Reventós, tragedy; Nonell, comedy; and Picasso, farce.)[77] In his earliest works Picasso had found ways of showing the effects of an unhappy, unequal society, and he found ways of reaffirming this on the eve of war for those who gath-

ered in cafés drinking wine, listening to guitars, and reading grotesque items such as these in their newspapers. Picasso is not obliged to offer solutions as he offers criticism. As with his esthetic statements, the world, like the murder or suicide of M. Chardon in *Table with Bottle and Violin*, December 1912 (Fig. 99), "reste plein de mystère."

Braque, as in *Still-Life with Guitar* (Fig. 100) and *Bottle, Glass and Pipe*,[78] both 1914, only infrequently used newsprint in his collages compared with Picasso—in only seventeen out of a small total production of fifty-seven—and his first incorporation of a piece of newsprint was not until 1913. Few of his collages could be called political, but most are similarly used for their amusing, macabre, or allusive content, including an article on Bergson, a notice that Victor Hugo's molar has gone on display—"La dent de l'immortel poète"[79]—and an item on the "Parricide of Montrenil," whose father died following an argument: "mort"—Braque is certainly enjoying the irony—"d'émotion" ("died of emotion"). Braque made a point of making ragged edges to his newsprint, pointing to a desire for an appearance of arbitrariness.

Gris, who began his career as a political cartoonist, also used newsprint as a consciously allusive element in his collages. Some, as I discussed above, make a political point in relation to the current war, but others play a more lighthearted role, as when he painstakingly created a false headline with his own last name in *Breakfast*, 1914,[80] or announced in *The Man at the Café*, 1914 (Fig. 101), a work with an elaborate series of false shadows and textures, "There will be no more faking of works of art."[81] But such uses of newsprint in the work of Gris, and more so in that of Braque, while certainly conscious and highly witty, seem isolated and do not accumulate and reiterate themes with the insistence of Picasso's. The presence of these themes in Picasso's art must be seen against a backdrop of social unrest and political upheaval, which leftist intellectuals at the time feared or hoped were the death throes of a bankrupt bourgeois society. Picasso's inclusion of newsprint reporting instances of social pathology, whether absurd or truly terrifying, sustains an expression that is as "revolutionary" politically as artistically.

And what of those collages containing newsprint that alludes neither to the crazy decadence of French society nor to political events? Although Picasso subsequently moved away from the predominantly political preoccupations of autumn–winter 1912, he continued to use instances of newsprint incorporated into the collages to play with themes and ideas that had personal meaning for him. The fact that the press grew increasingly hysterical throughout 1913 and 1914 as the Great War approached is nowhere innocently reflected in Picasso's collages, as would be true if the choice of newsprint were truly (or at all) arbitrary. Instead there is an increased incidence of themes of societal madness (only slightly less socially critical than the war news) and the more personal themes of the arts and health, especially advertisements for tonic wines and cures for both the syphilis Picasso so feared contracting and the tuberculosis of which his beloved Eva Gouel was slowly dying.

For example, Vieux Marc—a pressing of the grapes considered healthful—appeared in at least five collages of spring 1913, including Figure 99, and in two further works, one a collage and the other a painting, of spring 1914.[82] *Still-Life: Bottle and Glass on Table*, autumn–winter 1912, advertises "Vin Désiles" and, humorously, a purchasable FORCE VIRILE.[83] *Man with a Hat*, December 1912 (Fig. 102), includes a short fictional piece, of the sort frequently found in *Le Journal*, about two lovers, which is juxtaposed to a medical article on tuberculosis. *Head of a Man*, autumn–winter 1912, contains a clipping, forming the face of the figure, reporting on the debates in the Chambers in the first week of December, which included the heated discussion of the censorship of Cubism.[84] Artistic self-consciousness is also a frequent allusion, with, for example, theater listings found in numerous collages. But it is nowhere more amusingly introduced than in *Construction: Violin*, December 1913 (Fig. 89), where we are informed (one pictures Picasso and Apollinaire in their clown outfits of 1905) that the theater in question has "The most irresistible . . . The prettiest artists! The funniest scenes! The wittiest couplets!"[85]

The overall project of the collages, their subversion of the traditional art of oil painting on canvas and their denial of ordinary perception of objects in space, can be linked to the sorts of thematic concerns evident in the newspaper clippings. These intrusions of the real world not only shockingly deny traditions of "illusion" in two-dimensional art, they play tricks with subjects of immediate concern to Picasso, to his intimate circle, and to his larger society. Juxtaposing private with public madness in a setting of extraordinary violence wrought on images of the everyday world, they hold up a mirror, more than uncomfortably unpleasant for most, to the world that had produced him. It is precisely this understanding of the collages that is operative in a later Surrealist work such as Jean Arp's sculpture *Mutilated and Homeless*, 1936, whose title is taken from a newspaper headline pasted over the surface of the disturbing little form.[86] (At the same time, Arp's work plays with his own position in society, since the alienated avant-garde artist may be considered as mutilated, and mutilating, and without a country, *apatride*.) It is impossible to imagine Arp looking at Picasso's collages without also *reading* them.

Picasso the iconoclast revealed himself perfectly in his only use of a Spanish newspaper, in *Guitar*, spring 1913 (Fig. 103); a small circle of newsprint represents the hole of a guitar and features the words "libertador" and "escarnecedora": "liberator" and "mocker." Such political and socially critical consciousness embedded in the collages alerts us to a new level of meaning in Picasso's Cubist work, one that allows us to see its continuity with the rest of his artistic career and with the fabric of its own historical moment. It is worth mentioning, in conclusion, the small clipping that forms the sound hole in yet another *Guitar*, spring 1913;[87] small to begin with, and largely drawn over, only one word jumps out, upside down and in capitals: "BIOGRAPH."

79. *Portrait of Apollinaire*, 1905. Pen and ink on paper, 31 x 23 cm.

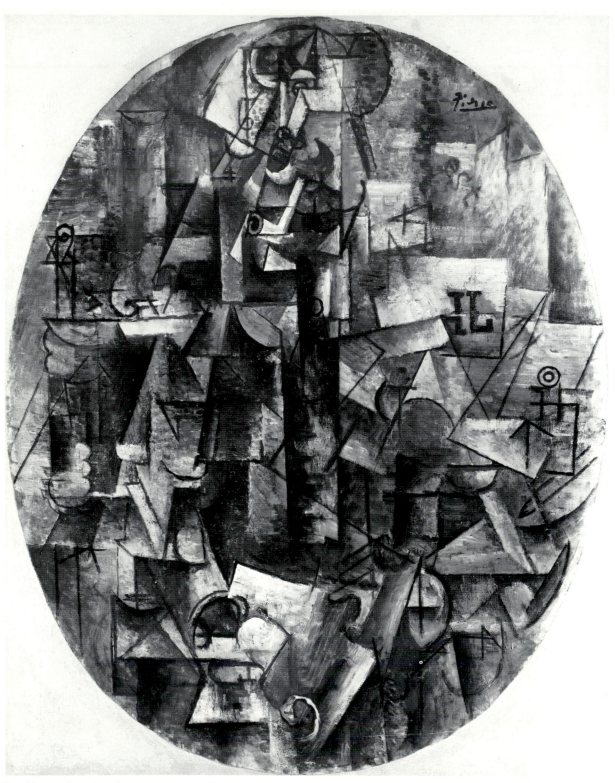

80. *Man with a Pipe*, Summer 1911. Oil on canvas, 90.7 x 70.8 cm.

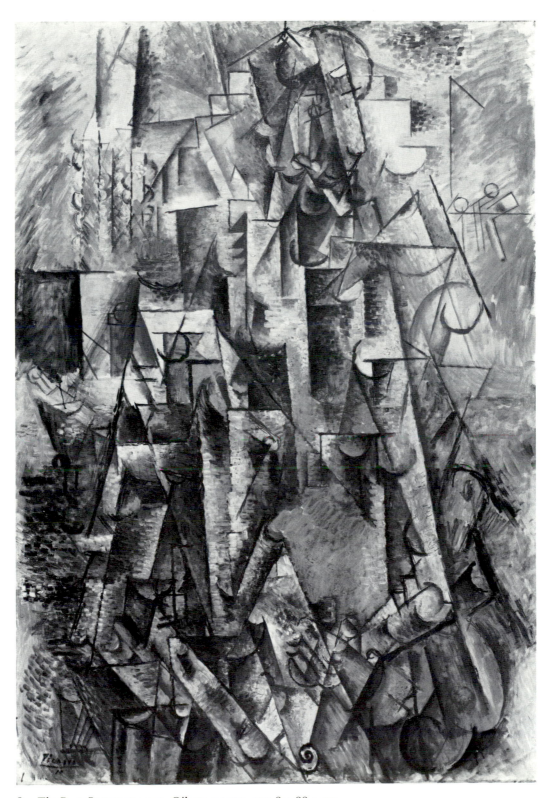

81. *The Poet*, Summer 1911. Oil on canvas, 130.8 x 88.9 cm.

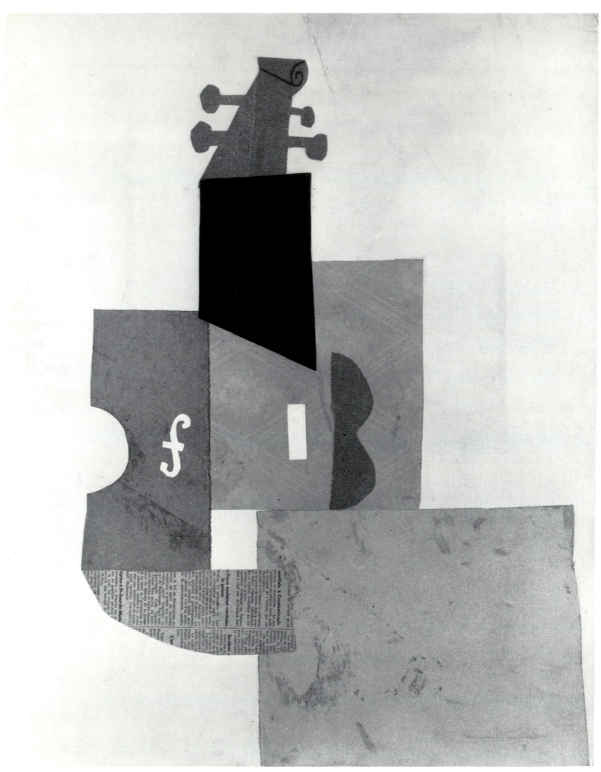

82. *Violin*, November 1912. Pasted papers on paper, 65 x 50 cm.

83. Detail of Pl. VIII, *Bottle of Suze*,
November 1912.

84. *Man with a Violin*, December 1912.
Pasted papers and charcoal on paper,
123.5 x 46 cm.

85. *Still-Life: Bottle and Glass on Table*, December 1912. Pasted paper,
ink, and charcoal on paper, 62.5 x 47.3 cm.

86. Detail of Fig. 85.

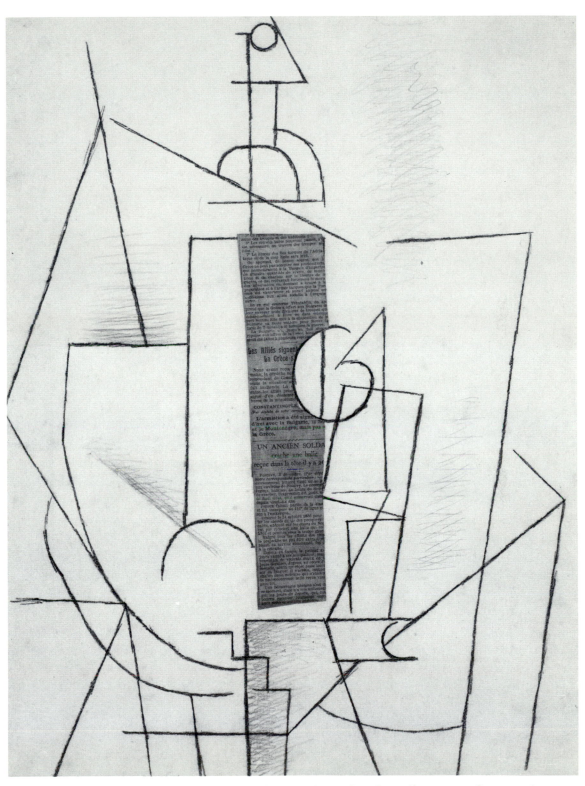

87. *Bottle and Wineglass*, December 1912. Pasted paper, charcoal, and pencil on paper, 60.5 x 45.8 cm.

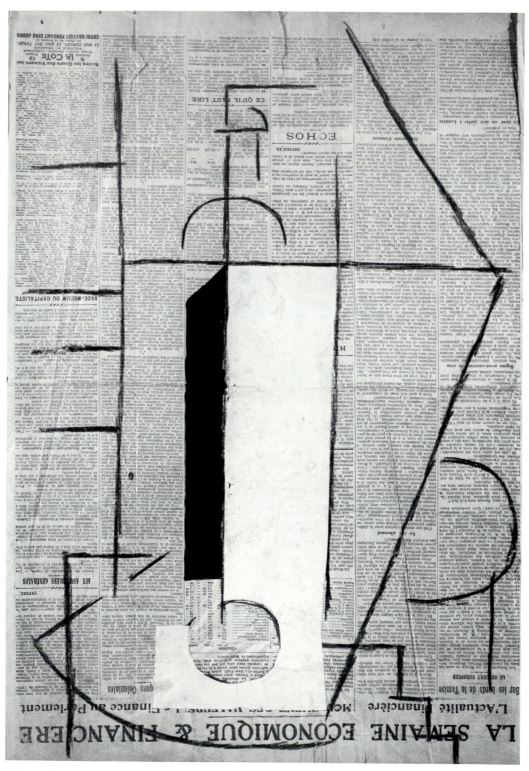

88. *Bottle on a Table*, December 1912. Pasted papers and charcoal on paper, 62 x 44 cm.

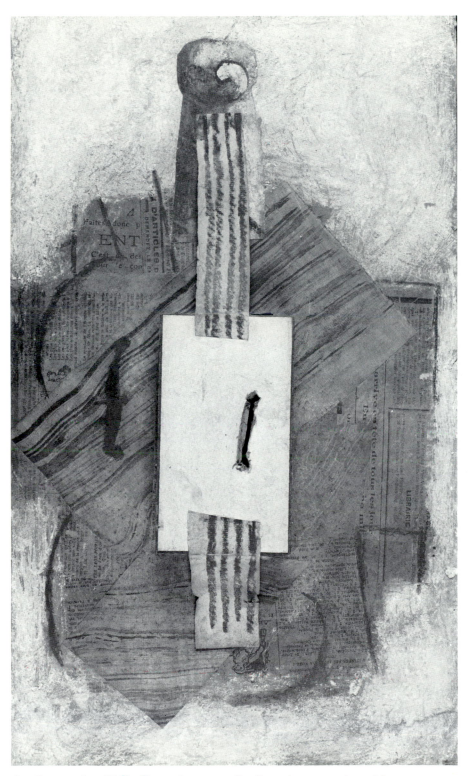

89. *Construction: Violin*, December 1913. Cardboard construction with
pasted papers, chalk, and gouache, 51 x 30 x 4 cm.

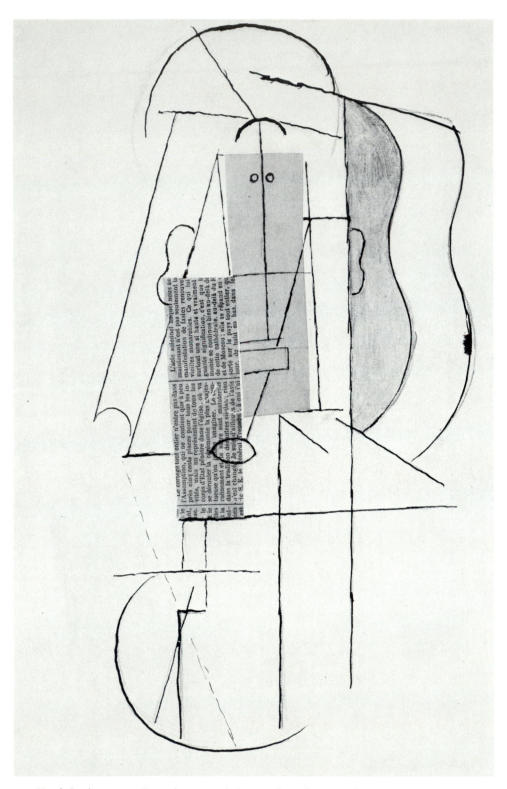

90. *Head*, Spring 1913. Pasted papers, ink, pencil, and watercolor on paper, 43 x 29 cm.

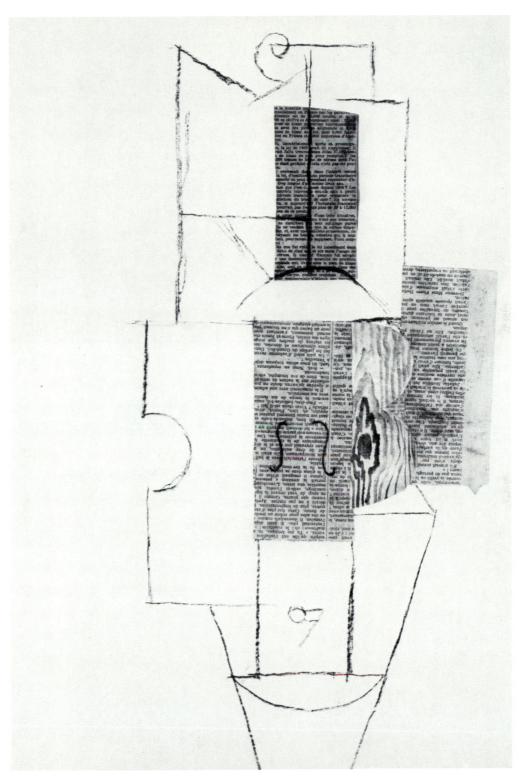

91. *Violin*, November 1912. Pasted papers, charcoal, and watercolor on paper, 62.5 x 48 cm.

92. *Raven Perforating the Skull of an Eminent Citizen*, 1903. Pen and ink on paper.

93. *Homuncule Attacking an Overdressed Old Man*, 1903. Pen and ink on paper.

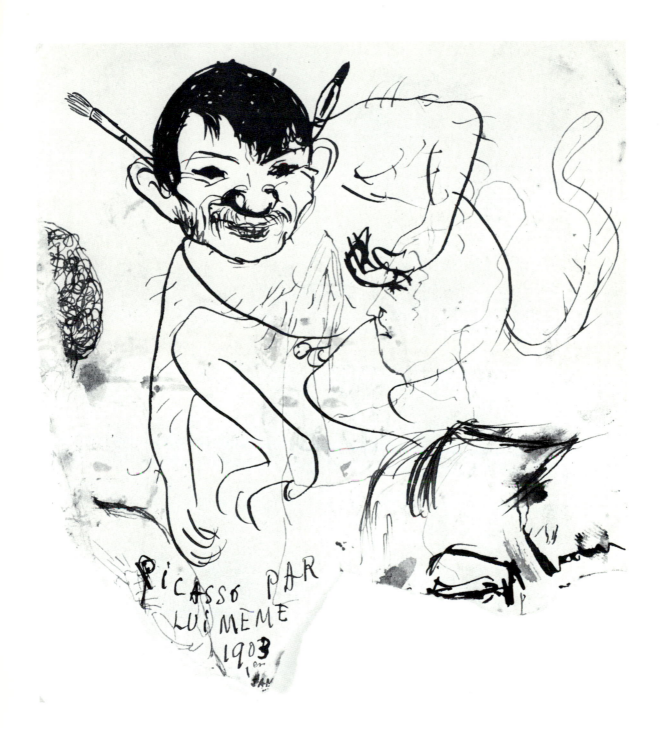

94. *Self-Caricature and Other Sketches*, 1903. Pen and ink on paper, 11.8 x 10.7 cm.

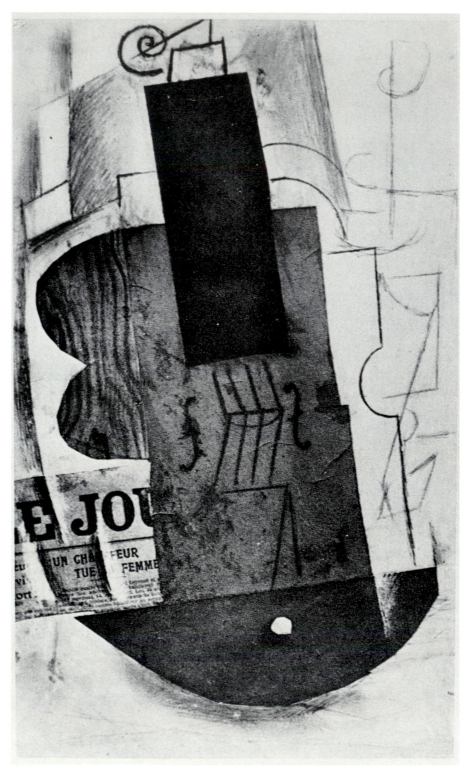

95. *Newspaper and Violin*, December 1912. Pasted papers and drawing on paper,
47 x 27.3 cm.

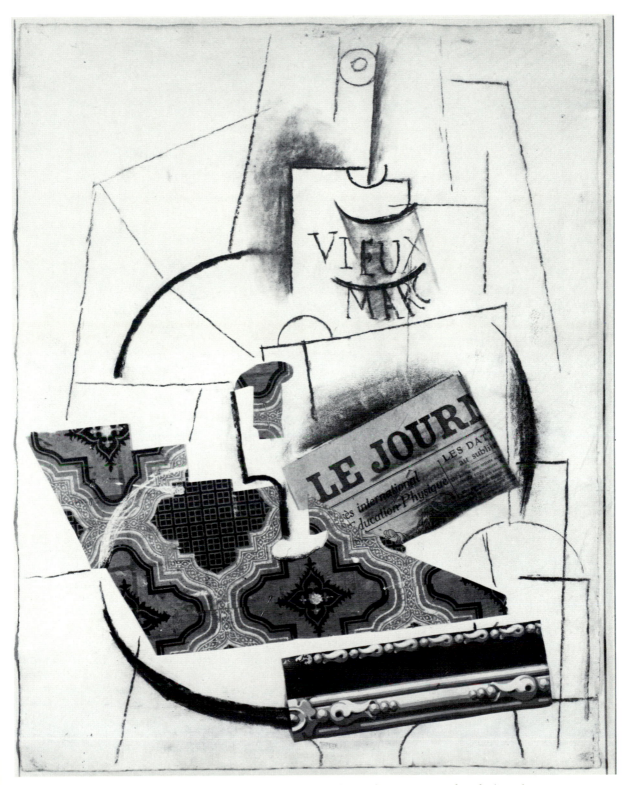

96. *Bottle of Vieux Marc, Glass and Newspaper*, Spring 1913. Charcoal, papers pasted and pinned on paper, 63 x 49 cm.

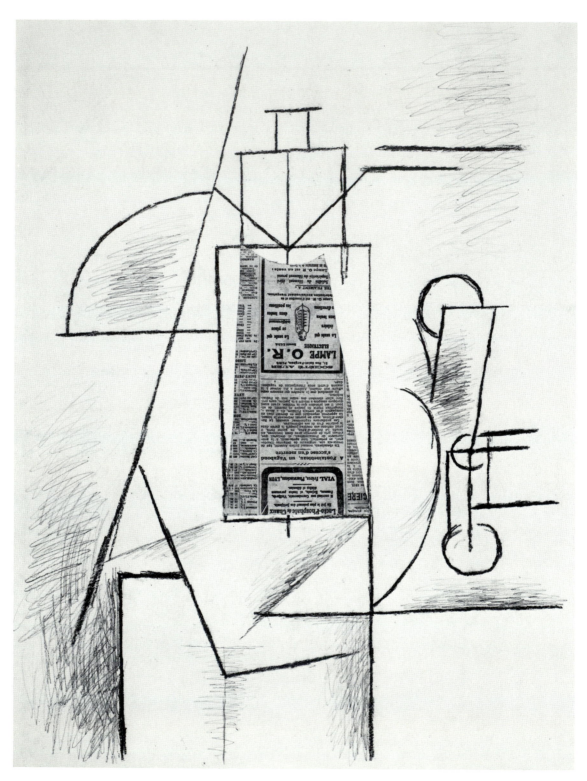

97. *Bottle and Wineglass*, December 1912. Pasted paper, charcoal, and pencil on paper, 60 x 46 cm.

98. Detail of Fig. 97.

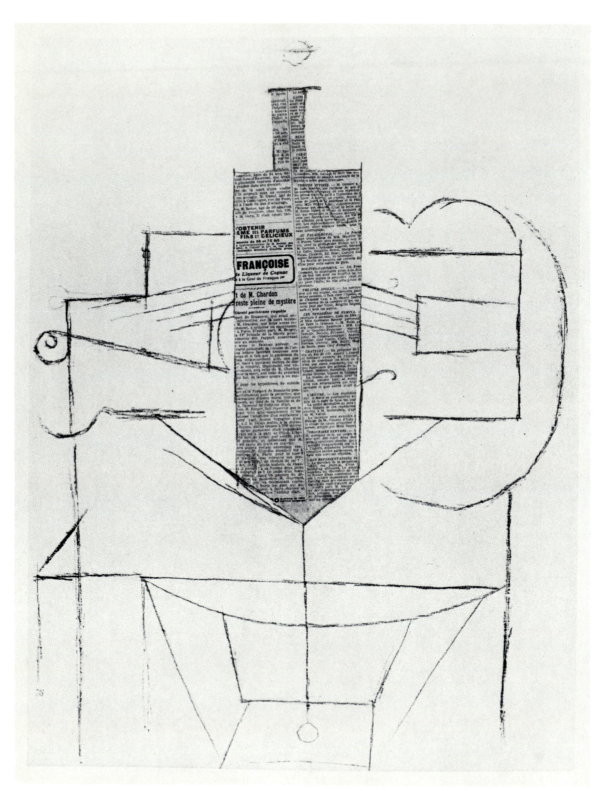

99. *Table with Bottle and Violin*, December 1912. Pasted paper and charcoal on paper, 63 x 48 cm.

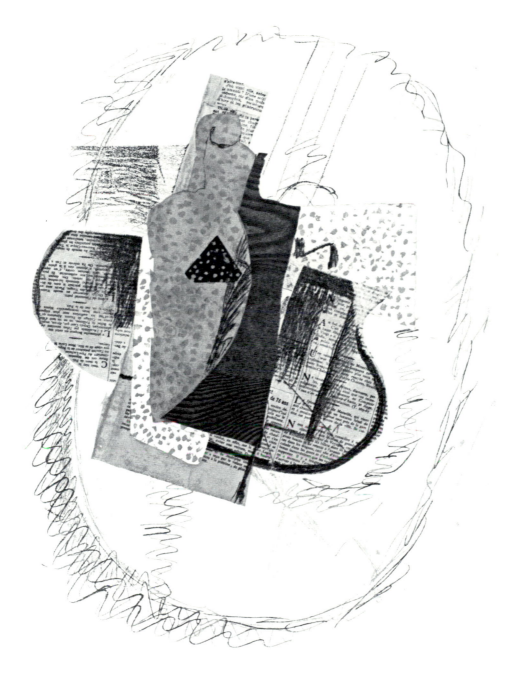

100. Georges Braque, *Still-Life with Guitar*, 1914. Pasted papers, gouache, and pencil on paper, 63 x 47 cm.

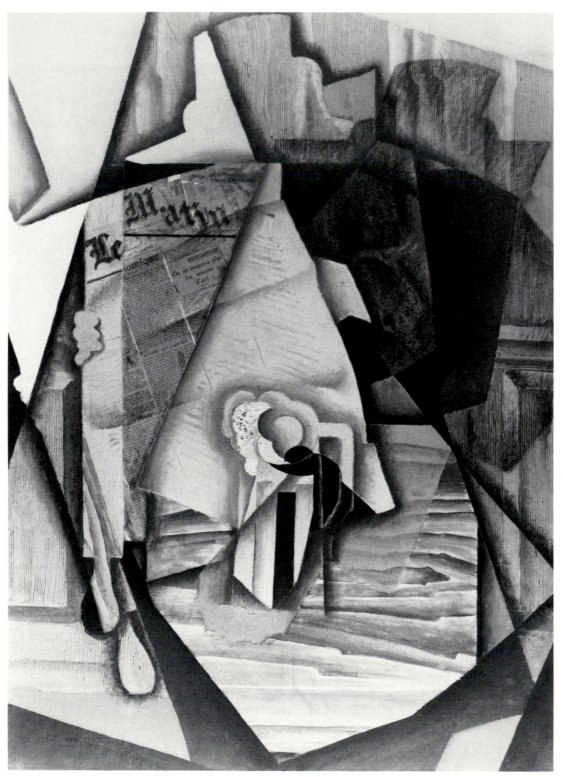

101. Juan Gris, *Man at the Café*, 1914. Oil and pasted papers on canvas, 99 x 72 cm.

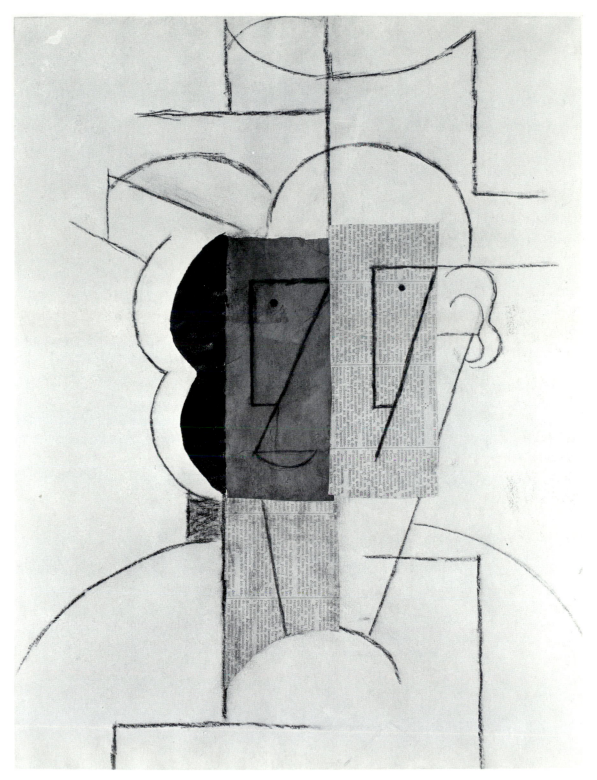

102. *Man with a Hat*, December 1912. Pasted papers, ink, and charcoal on paper, 62.3 x 47.3 cm.

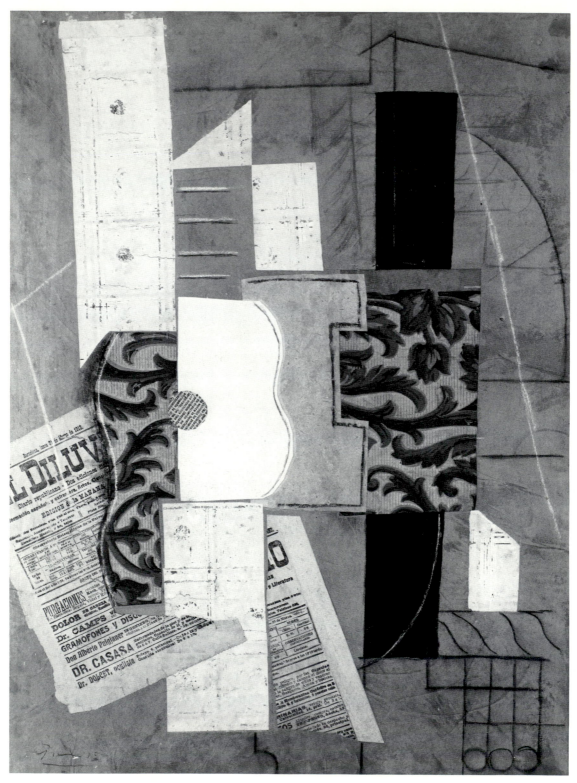

103. *Guitar*, Spring 1913. Pasted papers, charcoal, chalk, and India ink on paper mounted on canvas, 63.5 x 48 cm.

104. *Self-Portrait*, 1915. Pen and ink on paper, 15 x 11.5 cm.

105. *Harlequin*, Autumn 1915. Oil on canvas, 183.5 x 105 cm.

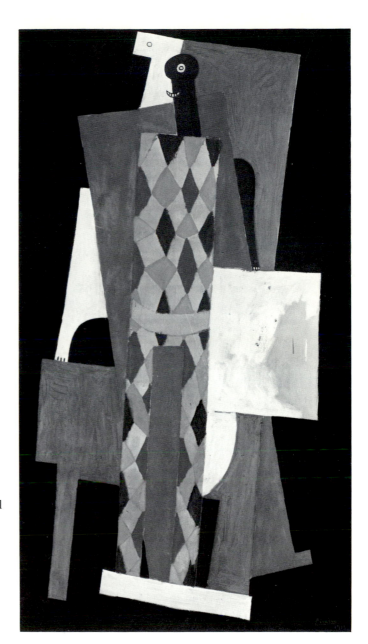

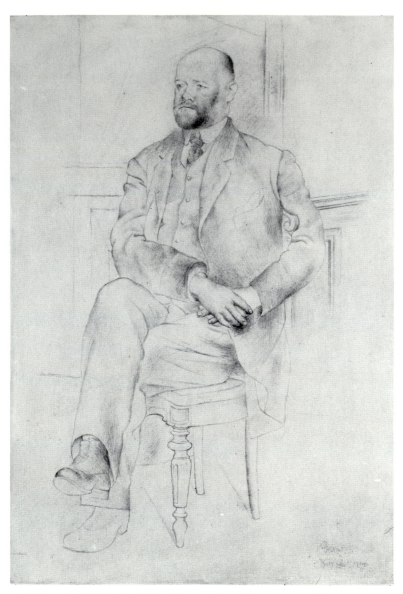

106. *Portrait of Ambroise Vollard*, 1915. Pencil on paper, 46.4 x 31.7 cm.

6. Epilogue

The War Years and After

Cubism, Vorticism, Imagism, and the rest never had their
fair chance amid the voices of the cannon——
—Ford Madox Ford, *The Good Soldier*

THE IMPLICATIONS of this study of Picasso's political roots in Barcelona anarchism are significant for his subsequent career, as well as for a revision of our view of his concerns throughout his early work, especially in the Cubist period. The scope of the investigations here is limited to the period 1897 to 1914. However, in conclusion, it will be fruitful to consider briefly the importance of Picasso's prewar anarchism for his work and thought during World War I and after, including his "aristocratic" period in the 1920s, his involvement with the Surrealists, his response to the Spanish Civil War, and his joining the French Communist party at the end of the German occupation of Paris in 1944.

World War I was not simply a cataclysm that affected everyone's life in the Western world, changing plans and, sometimes brutally, interrupting careers; it was also a political event to which one had a conscious relationship, particularly in Picasso's circle. Whatever political implications can be drawn from Braque's exaggeratedly "working-class" behavior—putting on a rough accent and, like Picasso, wearing factory-made workers' clothes[1]—it did not interfere with la patrie. Having already served his initial time in the army in 1901–1902, Braque responded immediately when his unit was called up on August 2, 1914.[2] Less than a year later, in May 1915, he was wounded in the head at Carency during the tragically fruitless Lens/Arras offensive and was trepanned. Although he was on the danger list, he did not inform his friends; by April 1916 he was much improved and sent south to convalesce. He did not hear from Picasso, but Gertrude Stein and Alice Toklas visited him there.[3] In January 1917 he was back in Paris, where his friends gave him a banquet, which Picasso attended. Though Braque's role in the war had been virtuous and manly, in step with his countrymen in their victory over the "threat to civilization," he came home rather broken and ill.

The appalling misdirection of the war by those in command complicated such gratification as many who survived may have expected to feel. The generals on both sides were convinced that common soldiers could not execute subtle maneuvers and so sent wave after wave of men straight into the face of machine-gun fire;

143

sixty thousand died thus on the first day of the battle of the Somme. Battles were won by *not* attacking.[4] Braque made few statements in his life that could be called "political," but he later criticized the French role in the war, commenting with bitterness, and some accuracy, that General Joffre had been imitating Vernet's battle pieces.[5]

Picasso, in such works as *Playing-cards, Wineglass and Bottle of Rum ("Vive la France")*, summer 1914–Paris 1915, with its crossed flags taken from the mobilization posters,[6] seemed to enjoy poking fun at his friends' patriotism in autumn 1914, when many thought like Poincaré that the war would be "short but glorious."[7] No longer the firebrand of earlier years, Picasso was the butt of a joke following an auction in March 1914, where his art brought relatively high prices; Salmon remembers that Picasso's friends sang in his honor "the royal Spanish hymn, Pablo being no longer revolutionary."[8] Yet, from a neutral country and, I would argue, in expression of his pacifist convictions, Picasso did not join up. Jacques Villon, who lost a brother in the war, later expressed what we have taken to be the general attitude to Picasso's remaining at home: "We never dreamt of holding against him that he did not go to war. We knew he was worth much more than that. And besides, it was not his country that needed defending."[9] Yet this held equally true for Apollinaire, a Polish citizen, who hastened to change his citizenship in order to join the French army.

The enthusiasm for the war exhibited by so many of his friends must have opened quite a gulf between Picasso and his old circle. It is entirely possible that the argument he and Braque reportedly had on the platform of the train station in Avignon on August 2, 1914, as Braque and Derain went off to join their military units—Picasso later claimed, "We never saw each other again"—may well have concerned Picasso's pacifism, or, in any case, his refusal to join in the war. Apollinaire received a postcard from Picasso depicting the apotheosis of the Provençal poet Frédéric Mistral, recently deceased. It rather sourly and all too prophetically read: "I will do the apotheosis of you."[10]

But Picasso's "neutrality" did not suffice as an excuse after the much publicized (and exaggerated) atrocities of the German march through Belgium.[11] Apollinaire, in an essay of March 1915 listing the scattered whereabouts of the French avant-garde, informed the interested public that Picasso was too ill to fight, in a context that reveals Apollinaire's intensely patriotic concerns:

> Derain is in a motorcycle unit in the North, Georges Braque was recently in Le Havre as a second lieutenant, Fernand Léger is at the front with the supply corps, Albert Gleizes has been at the front since the outbreak of the war, and Dufy is in Le Havre, waiting. . . . R. de la Fresnaye is doubtless still in Lisieux. Groult suffered an arm wound. The sculptor Duchamp-Villon is a medical aide in Saint-Germain; the painter and engraver Laboureur is at the Château

of Nantes, serving as an interpreter for the British army. . . . There was a rumor that Robert D[elaunay]. is in San Sebastián, but I cannot bring myself to admit the truth of this unlikely assertion. . . . Picasso, whose health is too weak to allow him to do anything other than his invaluable work as an artist, "has outdone Ingres in his admirable drawings without even trying," according to a letter I received [at the front].[12]

Picasso almost certainly never intended to fight.[13] His claims of ill health are now known to be hypochondriacal if not chimerical and are belied by photographs of the strapping young man that date from the same period.[14] But what is of interest here is the shift in justification for Picasso's noncombatant position: like many anarchists at the time, he was forced to a reevaluation of events in the face of the actual war. Picasso, we know, felt extremely lonely in Paris with the dying Eva, understandably obsessed with death and embarrassed in front of soldiers returned on leave or invalided out. In a drawing of 1915 (Fig. 104), he depicted himself standing in a deserted Paris, the only visible creatures a little dog and, in the distance, an overweight man with a cane, obviously unfit for active duty.[15]

The discomfort with his position and even the confusion Picasso felt at this time show clearly in his work. After seven years of slowly and consistently developing the Cubist style, and working extraordinarily closely with a French artist in this development, Picasso was suddenly left alone, and his work swung wildly in several directions. His Cubism teetered on the verge of complete abstraction— often only Kahnweiler's title seems to keep it in the experiential realm—and he began a simple, linear realism, as if to assure himself of his former powers (Figs. 105 and 106). His subject matter equally veered around, and he again became interested in overtly allegorical themes. A long series of harlequins in 1915–1916 (Fig. 105),[16] characteristically treated by Picasso as allegorical self-portraits, are depicted dramatically alone in most cases, the environment hostilely geometric and dark. He represents the same simplified geometric figure, without Harlequin's costume, seated in a chair reading *Le Journal* in two works of early 1916,[17] at a time when the paper would have been filled with little other than war news. The diversity of this period, while remarkably inventive, also evinces uncertainty and alienation from the avant-garde. It is arguable that there was no avant-garde during the war, but that is just the point: Picasso had to work in a vacuum while the avant-garde fought the war.[18]

In 1917 Picasso was helped out of this situation by Cocteau's offer to work for Diaghilev, a choice much scorned at the time by many in his earlier circle, including Braque.[19] But working for Diaghilev meant working communally—as Picasso had with Braque before the war and with his friends in Barcelona before he came to Paris—with a group of artists who seemed in ways more outrageously modern, or at least more outrageous, than even the Cubists. And he could do this without

feeling so alienated from his earlier self, with such adoring younger writers as Cocteau looking up to him: "I was on the way to what seemed to me the intense life—toward Picasso, toward Modigliani, toward Satie. . . . All those men who had given proof of their Leftism, and I had to do the same."[20]

Picasso cut himself off even more deeply from his old friends at the end of the war with his decamping, as it were, to the aristocracy—an act that powerfully contradicts his earlier "anarchist" self—and taking on the mantle of the "Grand Maître."[21] Married to a daughter of minor Russian nobility, Olga Koklova, Picasso began to move with his fashionable wife in wealthy and aristocratic circles in Paris and Biarritz. Braque considered it a betrayal of their earlier aims, an attitude that comments interestingly on the idealistic social revolutionary aspects of the Cubist invention, even for Braque. And it accounts to some extent for their estrangement after the war, when Picasso vindictively attempted to deprive Braque of the credit for his role in the formation of Cubism, styling him "Mme. Picasso."[22] He would perhaps have succeeded in this distortion but for Kahnweiler, whose *Der Weg zum Kubismus* set forth an accurate historical record that countered Picasso's self-aggrandizing myths during the 1920s. Picasso, like the critics discussed in Chapter 4, was also worked on by historical forces after the horror of World War I and was no more able to see a point in discussing meaning than they. His work, like that of so many postwar modernists, became classicizing and at times a form of Gallic patriotism. And Cubism, in retrospect, became a formal experiment. Picasso, like France, wanted to forget the war and everything that now seemed, by the cold light of postwar disillusion, the enthusiasms, hopes, and ambitions of prewar illusion.[23]

Picasso kept his "politics" at some remove during the 1920s (or, as some would have it, betrayed them); certainly they no longer played a central role in his thought or work of that decade. In the early 1920s he came to know André Breton and the Surrealists, on whom his art was extraordinarily influential and who often spoke of him and his work in reverential terms. During this period, Breton and most of the Surrealists embraced communism, though not in any way that was acceptable to the Parti Communiste Français (PCF). Nevertheless, Picasso again moved in a circle of artists who saw themselves as committed to a social revolution and who furthermore saw their artistic radicalism as serving these political aims. While there are enormous differences between anarchist and Marxist ideas about these issues, differences that Picasso may or may not have discerned, this milieu also represented a continuum of sorts with his earlier experience and effected a transformation of his left-wing allegiances.[24]

Picasso gradually moved back to the left during the 1930s and seemed to feel little or no contradiction when in 1937 new events compelled him to express a political position, this time publicly and overtly. In *Guernica*, as Picasso told Jerome Seckler in 1945, "there is a deliberate appeal to people, a deliberate sense of propaganda."[25] The painting responds to an atrocity in his Spanish homeland and was

the first such "propagandistic" work, but it was not the last.[26] *Guernica* announced Picasso's stand on the side of the "legally elected and democratic republican government of Spain," as he carefully described it in his statement of July 1937, in which he spelled out his abhorrence for the fascists in the Spanish Civil War. And he went on in this statement to express a conviction that would seem very curious without understanding its redolence of the anarchist esthetic he had long embraced:

> As to the future of Spanish art, this much I may say to my friends in America. The contribution of the people's struggle will be enormous. No one can deny the vitality and the youth which the struggle will bring to Spanish art. Something new and strong which the consciousness of this magnificent epic will sow in the souls of Spanish artists will undoubtedly appear in their works. This contribution of the purest human values to a renascent art will be one of the greatest conquests of the Spanish people.[27]

His involvement with the civil war was more than symbolic. Gertrude Stein described in *Everybody's Autobiography* (though with little understanding) Picasso's deep engagement with the conflict in Spain:

> And now this is the Spanish revolution. I do not have to talk to myself about the destruction of the El Greco paintings. Picabia has just been here with us and he had seen Picasso in Cannes, he said he said to him well how about their making you director of the Prado and Picasso did not answer him, Picasso woke him up at six o'clock in the morning to talk about Spain. It seems said Picabia that he has given the Madrid government two airplanes and that is the reason he was given the directorship of the Prado. . . . Oh it is just surrealism said Picabia and I said no I think it is Sarbates [*sic*] he knows Pablo would never go to Madrid and he could represent him, and Pablo hoping that his youth was coming back thought it would be rigolo [amusing] to do this thing.[28]

While Stein's word is not enough to establish Picasso's gift of the airplanes (and no other documentation specifically supports the statement),[29] it is possible that Picasso had been told of the disposition of his several gifts of money to the republic.[30]

Phyllis Tuchman has recently noted *Guernica*'s dependence on articles and photographs from a single newspaper, the French Communist party organ *L'Humanité*, for information and photographs of the bombing of the Basque town.[31] As with the collages, *Guernica* acknowledges and emphasizes Picasso's awareness of newspapers as vehicles of opinion and information. Not dependent on word of mouth or the already ubiquitous radio, he underscored his journalistic source by painting *Guernica* in black and white, the colors of newspaper print.[32] More important, the events of the civil war in general, including the fascist bombing of the Prado Museum, prompted statements from Picasso on his continuing—rather

than, as is usually assumed, his newly awakened—awareness of the importance of political events for the artist. The message he sent in 1937 to the American Artists' Congress, published in the *New York Times*, December 18, 1937, concludes: "It is my wish at this time to remind you that I have always believed, and still believe, that artists who live and work with spiritual values cannot and should not remain indifferent to a conflict in which the highest values of humanity and civilization are at stake."[33]

Picasso's deep conviction that, as he said in 1944, "My joining the Communist party is the logical outcome of my whole life, my whole work. . . . I am conscious of having always struggled by means of my painting, as a true revolutionary," stems from the anarchist ideas discussed above and expressed in the radical nature of his work from 1897 on. "But," he added, explaining how he had traveled from the implicitly political anarchist esthetics of his youth and early maturity to the explicitly political commitment to the Parti Communiste Français at age 62, "I have understood now that even that does not suffice; these years of terrible oppression have demonstrated to me that I must fight with not only my art, but my whole self."[34] In fact, though Picasso did make a number of official appearances at Communist conferences, for example the World Congress for Peace in Wroclaw, Poland, in 1948, along with Fernand Léger and Paul Eluard, his revolutionism remained in his painting: his most controversial political acts of the following years were his idealizing portrait of Stalin of 1953 and *Massacre in Korea* of 1951.[35]

Picasso does not seem to have sensed any incongruity between the anarchist ideas of his youth and those of the wartime PCF; he evidently felt that he was with the living revolutionaries in both cases. Just as the Symbolists and Picasso's generation before the Great War were affiliated with the anarchists, the Surrealists with whom he associated in the 1930s were affiliated with the communists. That he saw continuities between the left-wing politics of these decades is suggested by his citing as his "source," and proudly exhibiting, Jarry's original manuscript of *Ubu cocu* to the guests who in 1944 had just seen Picasso's "Surrealist"—and clandestine—play, *Desire Caught by the Tail.*[36] It is telling that during the horror of the occupation Picasso would turn to Jarry, with his black humor and political satire, for comfort and edification. Anarchism had been dead a long time: killed by the First World War in most of Europe, by the Bolsheviks in Russia, and by the civil war in Spain, where it had been even more vital and widespread. The story has come down that in 1917 Picasso "read only the funnies or gossip, until the outbreak of the Russian Revolution, when he suddenly grew passionately—unexpectedly—interested in the people overthrowing the czarist regime."[37]

While such a transfer of allegiance from anarchism to communism may seem either hard-nosed or ill-informed (Picasso was certainly manipulated to seem to support Soviet policies that he would have strongly censured at any earlier time),

his own views were generalized, indeed simplified, and his statements usually expressed positions more emotional than intellectual: "I stand for life against death; I stand for peace against war."[38] The complex issue of whether Picasso was promoting a Communist party line in his work after 1944 or making generally pacifist statements is still much debated. Whether or not he was successfully manipulated by the PCF, he viewed himself, in such works as *Massacre in Korea*, 1951, and the *War* and *Peace* murals, 1952, as once more taking a lifelong position—one strongly flavored with anarchist esthetics—on pacifism:

> To call up the face of war I have never thought of any particular trait, only that of monstrosity. Still less of the helmet or uniform of the American or any other army. I have nothing against the Americans. I am on the side of men, of all men. Because of that I could not imagine the face of war separated from that of peace. Even peace came to my mind only with the attributes of the absolute needs of humanity and the full liberty of everyone on earth. Art must put forward an alternative.[39]

PICASSO's general refusal to express himself clearly in words has combined with historical circumstances to obscure the depth, articulateness, and constancy of his lifelong political convictions. Yet no reading of these works can ignore ideas such as those presented here—and the many others suggested in recent criticism and noted throughout this study—without making Picasso out to be the unconscious, unintellectual, wholly intuitive artist he so often pretended to be after the First World War had discredited, everywhere except Spain, the idea of an anarchist utopia. Picasso—and other anarchists—certainly did embrace intuition, spontaneity, and naturalness as keys to creativity, though this obviously did not dictate his actual working procedures. An article on Picasso by his friend Carles Junyer Vidal in *El Liberal*, March 24, 1904, exemplifies this attitude perfectly: "If you know him well and consider his interpretation of Art, Beauty, Love, Morality; if you observe how development takes place in him naturally, spontaneously; if you know his habits, his way of approaching life, you see an infinite number of emanations, through which shine an imagination and spirit of the kind that imbues his work."[40]

Picasso's later denials that he "researched" or endorsed "theories" spring from this same conviction about what art should be. He said to Zervos in 1935, "A picture comes to me from miles away: who is to say from how far away I sensed it, saw it, painted it?"[41] Picasso did not use conscious, active words for himself when discussing such subjects—and neither do most of his critics. Words such as "thought," "considered," "made," "constructed" are replaced by words that distance art-making from conscious control: "sensed," "saw," "intuited." The following dialogue offers a superlative example of this anti-intellectual posturing:

PICASSO: One simply paints—one doesn't paste one's ideas on a painting.

I: Certainly, the painter paints things and not ideas.

PICASSO: Certainly, if the painter has ideas, they come out of how he paints things.[42]

The truth, of course, is somewhere in between this unrelentingly spontaneous genius and the crafty calculator one occasionally glimpses. The present study suggests a view of Picasso as more a part of his moment in history than he has often been seen, and as sharing ideas and themes with those artists, poets, and political theorists with whom he associated at various stages of his early career. Picasso was aware of and more deeply connected to current political events than we have hitherto imagined precisely because he embraced a body of social theory now largely ignored, not only among art historians.

Some art historians and critics, usually Marxists, have offered political interpretations of Picasso's role and work, though none have suggested the conscious political component of Picasso's relations to culture in his Cubist period.[43] Except for Sabartés's view of the Blue Period and the late overtly political works, Picasso's art has been seen as unrelievedly apolitical. Yet if much of his art—from the street sketches of 1897–1899 to the collages—has been viewed as mere formal experiment, it is true that Picasso himself later prompted us to see it that way. Apart from *Arte Joven* on the one hand and *Guernica* and later work on the other, Picasso's ambivalence about expressing himself unambiguously, in either artistic or verbal statements—such are the obligations of "modernism"—has generally masked his political convictions. He would not explain to those who could not see. Asked about *l'art nègre*, he snapped, "Connais pas!" Asked about his esthetic theory, he fired his gun. Asked about his politics one day by Kahnweiler, " 'I am a royalist,' replied Picasso without hesitation. 'In Spain, there is a king; I'm a royalist!' "—a witty pointing up of his distance from French culture that has sometimes been taken seriously.[44]

But this comic face Picasso turned to the world (we see again Gargallo's allegorical mask of Picasso as "Farce") hid a magnificently serious engagement with the anarchist view of the artist and his role in transforming society. Without an awareness of this, we miss a crucial aspect of the Cubist project. Picasso's adherence to anarchist attitudes and ideas in his early life, and his expression of them, however obliquely and allusively, in even his most radically abstract works, substantiates the affirmation he voiced in later years that he had always struggled, by means of his painting, "as a true revolutionary." This is the aspect of Cubism that Apollinaire, the true spiritual historian of the movement, so firmly grasped and so passionately expressed in *The Cubist Painters*, with a high and touching optimism only possible before the war:

Without poets, without artists, men would soon weary of nature's monotony. The sublime idea men have of the universe would collapse with dizzying speed. The order which we find in nature, and which is only an effect of art, would at once vanish. Everything would break up in chaos. There would be no seasons, no civilization, no thought, no humanity; even life would give way, and the impotent void would reign everywhere.

Poets and artists plot the characteristics of their epoch, and the future docilely falls in with their desires.[45]

Notes

Introduction

1. *Le Journal*, Nov.18, 1912, 1: "Leurs forces étaient à environ trois kilomètres de nos lignes avancées, dans la direction de Tchataldja, et un parti important de leurs troupes avait tenté, à la faveur de l'obscurité, de s'engager dans la vallée qui les séparait de nous. Cependant, les Turcs avaient vu le mouvement à temps. Les sentinelles donnèrent l'alarme, et, quelques instants plus tard, l'infanterie ottomane, bientôt sur pied, ouvrait le feu. Surpris de voir leur mouvement déjoué, les Bulgares se retirèrent derrière la colline qu'ils venaient de quitter. Leur artillerie entra en scène. C'était le signal d'une attaque générale" (author's trans.).

2. *Le Journal*, Nov.18, 1912, 1: "Bientôt j'aperçus le premier cadav[re] encore grimaçant de douleur et la fig[ure] presque noire. Puis j'en vis deux, qu[a]tre, dix, vingt; puis je vis cent cadavr[es.] Ils étaient allongés là où ils étaient tombés pendant la marche du sinistre co[n]voi, dans les fossés ou en travers [le] chemin, et les files de voitures chargé[es] de moribonds s'allongeaient toujou[rs] sur la route désolée.

"Combien de cholériques ai-je ain[si] rencontrés? Deux mille? Trois mille[?] Je n'ose pas donner un chiffre préc[is.] Sur une longueur d'une vingtaine [de] kilomètres, j'ai vu des cadavres jo[n]chant la route maudite où souffle u[n] vent de mort et j'ai vu des agonisan[ts] défiler lugubres au milieu des troupe[s] d'ailleurs indifférentes et qui se prép[a]raient au combat.

"Mais je n'avais encore rien vu" (author's trans.).

3. *Le Journal*, Nov.18, 1912, 2: "A une heure, des délégations arrivèrent de tous les quartiers de Paris et des localités de la banlieue, puis jusqu'à trois heures et demie les tramways, autobus et surtout le métropolitain, dont la station 'Pré-Saint-Gervais' est située à proximité de la porte du même nom et du terrain de la 'Butte du Chapeau Rouge,' déversèrent des milliers de pacifistes, syndicalistes et socialistes, accompagnés de leurs femmes et enfants. Ils envahirent non seulement le terrain réservé, mais toutes les buttes environnantes. Aussi est-il bien difficile d'évaluer la foule qui, de trois heures à quatre heures, évolua sur cet espace immense. . . . Les militants parlent de 100,000 personnes. Entre ce chiffre, peut-être exagéré, et celui de la préfecture—20,000—il y a place pour une appréciation intermédiaire et à peu près exacte de 40,000 ou 50,000 manifestants" (author's trans.).

4. S. Faure, ed., *L'Encyclopédie anarchiste*, Paris, n.d., 4 vols., trans. in Woodcock, 1977, 62.

5. It was the anarchists who, in fact, predicted that Russia was ripe for revolution, an assertion that contradicted Marx's theory that revolution would come only after the triumph of bourgeois industrialization, hence was to be looked for in countries like England and Germany. But those who attained power after the October Revolution followed Marx and made a point of destroying the anarchist movement there; see Joll, 184–93.

6. P. Kropotkin, *Paroles d'un révolté*, Paris, 1885, trans. in Kropotkin, 1970, 278.

7. G. Kahn, *Premiers poèmes*, Paris, 1897, 24, trans. in Herbert, 54.

8. See Golding, 1968; Rubin, 1977, 151–202; and Fry.

9. Significant recent studies include Rosenblum, "Picasso and the Typography of

Cubism," 1973b, and "The *Demoiselles d'Avignon* Revisited," 1973a; Steinberg, "The Philosophical Brothel"; Nochlin, "Picasso's Color: Schemes and Gambits"; Rubin, "From Narrative to 'Iconic' in Picasso: The Buried Allegory in *Bread and Fruitdish on a Table* and the Role of *Les Demoiselles d'Avignon*," 1983; Gedo, "Art as Exorcism: Picasso's 'Demoiselles d'Avignon'," 1980a; and Johnson, "The 'Demoiselles d'Avignon' and Dionysian Destruction," 1980a, and "Picasso's 'Demoiselles d'Avignon' and the Theater of the Absurd," 1980b.

10. See Henderson, "A New Facet of Cubism: 'The Fourth Dimension' and 'Non-Euclidean Geometry' Reinterpreted," 1971, and relevant sections of *The Fourth Dimension and Non-Euclidean Geometry in Modern Art*, 1983; see also Teuber, "Formvorstellung und Kubismus oder Pablo Picasso und William James."

11. While Peter Bürger's *Theorie der Avantgarde* (1974, 1980), locates the beginning of the avant-garde's repudiation of "the institution of art" in the cubist movement, and therefore acknowledges the adversarial impulses of the style for which I argue here, he bases his theory on a misunderstanding of the Symbolist movement that preceded it as wholly divorced from the praxis of life, which undermines its usefulness from a historical point of view. See also J. Spector, "Towards the Avant-Garde: Disjunction in Symbolist Painting, with Comments on Bürger and Benjamin," 1985.

12. I am grateful for discussions on this point with Edward Fry, Michael Fried, and Steven Helmling.

13. See R. Krauss, "Re-Presenting Picasso," 1980, and "In the Name of Picasso," 1981.

14. D. Kuspit, "Authoritarian Esthetics and the Elusive Alternative," 1981.

Chapter 1

1. For example, Penrose, 46ff.; Cabanne, 55; Boeck and Sabartés, 113; and Blunt and Pool, passim.

2. See Cervera; Litvak, 1981; and T. Kap-

lan's forthcoming *Red City, Blue Period* on political popular culture in Barcelona.

3. See E. Herbert, passim; Egbert, 45ff.; Lehmann, 181ff.; and Poggioli, 97ff. For Spain, see Cervera; Fontbona and Miralles; Cirici Pellicer, 1951; and Ràfols.

4. The best work in English on the anarchists is Joll. See also Maitron; Alvarez Junco; and Woodcock, 1962. Proudhon's most influential works were *Qu'est-ce que la propriété?*, Paris, 1840; *Système des contradictions économiques; ou Philosophie de la misère*, Paris, 1846; and *De la justice dans la révolution et dans l'église*, 3 vols., Paris, 1858.

5. Bakunin was best known for his activism but also wrote the influential *Dieu et l'état*, Geneva, 1882. See also E. Carr.

6. Kropotkin wrote extensively in numerous journals, including his own *Le Révolté* (Geneva) and its successor *La Révolte* (Paris); his writings were translated and reprinted throughout the nineteenth and early twentieth centuries in virtually all European languages. Among his most influential longer works were *La Conquête du pain*, Paris, 1892; *Mutual Aid: A Factor in Evolution*, London, 1902; and *Memoirs of a Revolutionist*, London, 1902.

7. See Joll, 78ff.; Brenan, chapter on anarchism, passim; Bookchin; and Kaplan.

8. See Brenan, 44–48 and 52–53.

9. See Ullman. This uprising took place while Picasso was in Horta de Ebro; he expressed intense excitement about this "revolution" in letters to Gertrude Stein, discussed in Chapter 4.

10. See Thomas; and for an enlightening eyewitness account see George Orwell's *Homage to Catalonia*, London, 1938.

11. See Fontbona and Miralles; Ràfols; *Catalunya en la España moderna*; Cervera; and McCully, 1978.

12. In addition to Cervera; Blunt and Pool; and McCully, 1978, see Fontbona and Miralles.

13. Alvarez Junco has compiled a complete bibliography of all anarchist journals published in Spain in the period (630–33); of all translations of anarchist and radical writers outside Spain in the political and lit-

erary press, excluding art journals (634–55); and a good bibliography, though not exhaustive, of translations of writings by artists and literary figures, and of articles on art and revolution (77–85 and 89–92).

14. *La Renaixença* (1871–1905); *La Ilustració Catalana* (1880–1903); *L'Avenç* (1881–1884; 1889–1893); *La Ilustración Ibérica* (1883–1898); *Catalunya* (successor to *L'Avenç*; 1898–1900); *Luz* (1898); *Hispania* (1899–1903); *Els Quatre Gats* (1899); *Pèl & Ploma* (successor to *Els Quatre Gats*, 1899–1903); *Joventut* (1900–1906); *Catalunya Artística* (1900–1905); *La Ilustració Llevantina* (1900–1901); *La Semana Catalanista* (1900); *Forma* (successor to *Pèl & Ploma*, 1904–1907). See also Cervera, Chapter VII, "Periodicals," passim.

15. See Domingo Marti y Julia, "L'Art a Catalunya," *Joventut*, Dec. 6, 1900, 673.

16. Ill. in Blunt and Pool, Fig. 39.

17. A. Opisso, "La Exposición General de Bellas Artes—Pt. III," *La Ilustración Ibérica*, June 2, 1894, quoted in Cervera, 199 (author's trans.).

18. Ill. in ibid., Fig. 38 (undated).

19. Ibid., 61–62.

20. See ibid., 62–64; Jardí, 58–62 and 102–10; and McCully, 1978, 50. For ills. see Cervera, Figs. 41 and 42; Jardí, Figs. 25–29 and 39–42; McCully, 1978, Figs. 22 and 23; Blunt and Pool, Fig. 63; and *1881–1981: Picasso y Barcelona*, Fig. 4B–16. Ravachol was one of France's most infamous anarchist bomb-throwers.

21. See Alvarez Junco, 634–55.

22. P. Picasso and F. Asis de Soler, "Arte joven," *Arte Joven*, Mar. 15, 1901, 1: "No es nuestro intento destruir nada: es nuestra misión más elevada. Venimos á edificar. Lo viejo, lo caduco, lo carcomido ya caerá por sí sólo, el potente hálito de la civilización es bastante y cuidará de derrumbar lo que nos estorbe. . . .

"Venimos á la lucha con mucho entusiasmo, con muchas energías, con un tesón que no podrán perdonar nunca los viejos.

"Venid, pues, á la lucha, que nuestro será el triunfo si con fe peleamos. Venid y no olvideis que *luchar es vencer*" (author's trans.).

23. A. Lozano, "Gotas de tinta," *Arte Joven*, Mar. 15, 1901, 3: "Yo soy en Arte un místico que tiene / trazas de ateo, porque altivo niega / autoridad á todos, y se burla / de antiguas teorías y modernas" (author's trans.).

24. J. Martínez Ruiz, "La Vida," *Arte Joven*, Apr. 15, 1901, 2–3: "El Estado es el mal; el Estado es la autoridad, y la autoridad es el tribute que esquilma al labrador, la fatiga que mata en la fábrica, la quinta que diezma los pueblos y deja exhaustos los campos, el salario insuficiente, la limosna humillante, la ley, en fin, que lo regula todo y lo tiraniza todo. . . . No queremos imponer leyes ni que nos impongan leyes; no queremos ser gobernantes ni que nos gobiernen. Monarquicos ó republicanos, reaccionarios ó progresistas, todos son en el fondo autoritarios. Seamos inertes ante la invitación á la politica. La democracia es una mentira inicua. Votar es fortalecer la secular injusticia del Estado. . . .

"Aceleremos este termino: trabajemos por esta aurora de paz y de derecho. El arte es libre y espontáneo. Hagamos que la vida sea artística. Propulsores y generadores de la vida, los artistas no queremos ni leyes ni fronteras. Nuestra bohemia libre, aspiramos a que sea la bohemia de la humanidad toda" (author's trans.).

25. *Pèl & Ploma*, Mar. 15, 1901, 7.

26. Blunt and Pool, 11.

27. "La Amnistía se impone," *La Publicidad*, Dec. 29, 1900, 1: "Viente mil españoles;—la flor de nuestra juventud—que recorre las tierras extranjeras en demanda de pan y de trabajo, viente mil compatriotas nuestros necesarios á la producción nacional, desertores y prófugos victimes de la infamia del servicio militar de los miserables han lanzado el grito de olvido, de reconciliación y de amnistía. . . .

"*El País*, ha pedido la amnistía amplia y completa,—digno comienzo de un siglo nuovo y de una era más feliz; la amnistía de los anarquistas de Jerez inocentes como los de Montjuich, la amnistía de los desertores y prófugos arrojados del suelo patrio por una ley malvada de privilegio para unos y de

muerte y ruina para los más; la amnistía generosa de los carlistas, solicitada por sus enimigos implacables, los propios demócratas y republicanos. . . .

"Las circunstancias todas imponen la amnistía. La conveniencia de Estado, el interés de Gobierno que supone la presencia de millares de hombres en la frontera desesperados, que si hoy suplican, conspirarán, amenazarán mañana.

"El comienzo de un siglo nuevo, con sus ansias de regeneración, de concordia y de vida más feliz y más fecunda. . . .

"Si fuéramos monárquicos, si ejerciéramos de consejeros leales de la realeza, ya habriamos puesto á la firma de la Regente el discreto transcendental y patriótico de la amnistía plena.

"Pero mientras el Gobierno duda y delibera prosigamos la campaña secundada en todas partes allí donde hay un hogar provisional, miserable y pobre, de un compatriota nuestro" (author's trans.).

28. "Manifiesto de la colonia española residencia en París," *La Publicidad*, Dec. 29, 1900, 1: "¡Compañeros! La razón nos asisle. . . .

"Tengamos fe y perseverancia, no dudando lograremos la justa petición que es fuerza exigir de los gobiernos.

"Nuestra deserción fué motivada por el horror que inspira el espectáculo de la guerra llevada á cabo por mezquinos fines. . . . La razón supo dictarnos que no era á la guerra donde debíamos ir.

"Respetamos al que lucha por su libertad, que es luchar por su vida, y antes que ser factores de una injusticia social, preferimos huir á extrañas tierras llevando en nosotros el doloroso sentimiento de abandonar á los seres que nos son más queridos.

"Al recuerdo de que somos hombres y partidarios del bienestar universal, protestamos ante tamaño proceder de las instituciones. Si al rededor de nuestros cadaveres y del llanto de los desesperados ancianos, se prestan á engordar los caníbales, diremos al que deseo la guerra que vaya él, ya que nosotros queremos paz y harmonía entre los pobladores de la tierra" (author's trans.).

29. O'Brian, 56.

30. "Au pays des moines," *Le Libertaire*, clipping stamped Aug. 27, 1904, in Archives de la Préfecture de Police, Paris, "Anarchistes En Espagne [1888–1914]"(B^A 1511).

31. Bozo, Figs. 1 and 2.

32. Cirlot, 27. See also the long-awaited and magnificent *Museu Picasso: Catàleg de pintura i dibuix*, Barcelona, 1984.

33. For illustrations of other members of this group, see McCully, 1978, Fig. 35; Cirlot, Figs. 247 and 164; Rubin, 1980, Figs. a-i [p. 19]; Rodriguez-Aguilera, Figs. 35 and 38.

34. Ill. in McCully, 1978, Fig. 7.

35. Picasso was apparently already familiar with the anarchist movement, suggested by his rather caricatural sketch of an anarchist meeting published in *Blanco y Negro* in about 1897, though his attitude soon became more sympathetic; see Blunt and Pool, Fig. 60 and text.

36. Ill. in Cervera, Fig. 63; see Tuchman, 113–14.

37. Baroja, 1924, 245.

38. Ill. in Cervera, Fig. 62.

39. Trans. in McCully, 1978, 14. Utrillo's review, "Los pintores españoles en el salón de Paris," appeared in *La Vanguardia*, July 7, 1890.

40. Azorín, "Los Jardines Abandonados," in S. Rusiñol, *Jardines Abandonados*, Madrid, n. d.[1900], "Todo aquel mundo viejo, solitarios jardines . . . ha desaparecido sin dar nos desendencia. Oh! Abominados padres que no dejais herencia!" (author's trans.).

41. Letter from Picasso to Miguel Utrillo, 1901, trans. in McCully, 1982.

42. See Cervera, 92ff.

43. Cervera, 61–62. See also Fontbona and Miralles, 20ff. ; and *1881–1981: Picasso y Barcelona*, Chapter A-4, "La marginación social," passim.

44. These drawings are variously dated 1897–1898 and 1898–1899 by Cirlot, though it seems more probable that they were done at the same time; the new catalogue of the Museu Picasso more correctly dates them to c. 1899.

45. Ill. in Cirlot, Fig. 597; see also Cirlot, Fig. 132, a study of the begging group.

46. See Cirlot, Figs. 162 and 528.

47. See also Cirlot, Figs. 101, 175, 652, 653, and 675.

48. See R. Carr, 389ff.; and Brenan, 22.

49. Ill. in Palau i Fabre, 1981, Fig. 532.

50. P. Baroja, *La lucha por la vida*, Madrid, 1904. The three volumes are *La busca* (*The Search*), *Mala hierba* (*Weeds*), and *Aurora roja* (*Red Dawn*). Quotation from Baroja, *Obras completas*, I, Madrid, 1946–1948, 288 (author's trans.).

51. Proudhon, *Système des contradictions économique; ou Philosophie de la misère*, Paris, 1923, II, 361.

52. Kropotkin in *La Conquête du pain*, 8.

53. Baroja, *Obras completas*, I, 359 (author's trans.).

54. Baroja, 1923, 212.

55. See ibid., 258.

56. Ibid., 344.

57. The Neo-Impressionists, most of whom were anarcho-communists, were also preoccupied with depicting Paris's zone; see R. Herbert, *Neo-Impressionism*, New York, 1968.

58. Blunt and Pool, 11–12 and Figs. 60–77, with text.

59. Jardí, 1969, 114.

60. McCully, 1978, 82.

61. For a complete list of all of Nonell's drawings published in the contemporary press, see Jardí, 1969, 318–31.

62. Tuchman, 114.

63. Jardí, 1969, 60. See also Cervera, Fig. 44.

64. See *Casagemas i el seu temps*, Figs. 57, 60, and 64; and *Picasso y Barcelona*, Fig. 4B-1.

65. See Cervera, 63; and Pincell, "Pablo R. Picasso," *Pèl & Ploma*, III, June 1901, 14–18.

66. Jardí, 1969, 102 and 106.

67. For ills., see Blunt and Pool, Fig. 66; and Jardí, 1969, Fig. 40.

68. See Jardí's catalog, 1969, 318–31, including nos. 235 and 248. See also his drawings, including no. 41, *Repatriado*, 1899.

69. This and following quotations from Baroja, 1923, 225–28.

70. Cervera, 64.

71. See McCully, 1978, Fig. 31; R. Nogueras Oller, *Les Tenebroses*, 1905, quoted in Jardí, 1969, 190.

72. C. Junyer Vidal, *El Liberal*, Sept. 14, 1903; A. Opisso, *La Vanguardia*, Sept. 13, 1903.

73. Of the major writers on Barcelona modernism, McCully downplays the left-wing political consciousness on the part of the artists, denying the primacy of social consciousness in the work of even Nonell (1978, 22): "Nonell's interests, however, lay less in social commentary than in the straightforward sketching and observation of life around him, and in experimentation with techniques." Cervera points to many of the political influences and social conditions that form a large part of the artistic environment in Barcelona; Pool, more than any other Anglo-American scholar, draws connections between specific works and political writing in Barcelona during this period. These discussions contrast sharply with the writings of the majority of Spanish and Catalan scholars of the period, for whom the political atmosphere is inseparable from the artistic bohemia; see Fontbona and Miralles; Cirici Pellicer; and Ràfols, passim. Jardí, 1969, 194, after a solid and enlightening discussion of Nonell's political concerns, anomalously concludes: "For Nonell all painting is simply a question of colour. . . . What counts for Nonell is the painting in itself, quite unconnected with any kind of meaning. Hence the radical failure of the majority of critics to comprehend the fact that, for this artist, the beggars, the gypsies and all those beings who were considered ugly, dirty and wretched were a mere pretext to enable him to work his material in an ample, generous way."

74. Daix and Boudaille, VII.13.

75. Salmon, 1920, trans. as *The Black Venus*, 1929, 14–15.

76. Trans. in Daix and Boudaille, 238. Nonell also painted Paris's zone, for exam-

ple, *The Market in the rue Lepic, Paris*, c. 1898, ill. in Jardí, 1969, Fig. 35.

77. See Daix and Boudaille, v.9.

78. Ibid., 56; see also ibid., 254.

79. Ibid., 206.

80. Salmon, 1955, 170: "quand il m'introduisit humainement au monde surhumain de ses affamés, de ses stropiats, de ses mères sans lait; le monde supra-réel de la *Misère bleue*" (author's trans.).

81. See also Daix and Boudaille, x.6 and VIII.1.

82. Ibid., D.IX.17.

83. See Blunt and Pool, Fig. 41 and text.

84. Quoted in ibid., n.p. (author's trans).

85. See also Daix and Boudaille, IX.31, D.IX.6, D.IX.23, IX.29, and IX.30.

86. See Gedo, 1980b, for an interesting psychobiographical approach to Picasso's work; she pays particular attention, 53, to "the multiple afflictions that curse the men depicted in these paintings." Penrose, 91–92, discusses the special meaning of blindness for Picasso throughout his life, but especially in the latter part of the Blue Period.

87. For example, *La morfina*, 1894, illustrated in McCully, 1978, Fig. 24. Rusiñol was himself addicted to morphine, ibid., 126.

88. Zervos, I, 62.

89. *Fille au café*, 1901, Daix and Boudaille, v.73.

90. Baroja, 1924, 138.

91. See also related works, Daix and Boudaille, IV.4, D.III.12, D.IV.2, VI.24, V.73, all 1901–1902.

92. Baroja, 1924, 68–69.

93. Daix and Boudaille, VII.22, D.VII.4, D.VII.6, and A.14.

94. Daix and Boudaille, VII.6; Sabartés, 1948, 67.

95. See Gedo, 1980b, 79.

96. Cirlot, 66. See his Figs. 569, 570, 571, and 576.

97. Blunt and Pool, 11 and Fig. 97 with text. See also Cirlot, Fig. 573. At the same time, they have strong parallels to Opisso's drawings of workers, see McCully, 1978, Figs. 22 and 23.

98. Cirlot, Figs. 873 and 581.

99. See Brenan, chapter on anarchism, passim; and Hobsbawm, chapter on "The Andalusian Anarchists," especially 83–88.

100. See Cirlot, Figs. 130, 133, 530, 531, and 532.

101. Ibid., Figs. 605 and 812.

102. Ibid., Fig. 660.

103. Zola, in *Germinal*, likewise presented a powerful portrait of the brutalized lives of the desperately poor and their frequent violence and moral decay. This was a favored theme among artists and writers of the Left.

104. See also ibid., Fig. 578.

105. *Sketch of a group of men fighting*, 1898, ill. in *1881–1981: Picasso y Barcelona*, Fig. 2A-17(R).

106. Blunt and Pool, 19.

107. Litvak, 1975, 31 and 106.

108. José Deleito Piñuela, "Arte triste," *Revista Contemporánea*, Mar. 1904, 266; trans. in Litvak, 1975, 109.

109. Quoted in Cervera, 67 (author's trans.).

110. Kropotkin was not the first scientist to put forward this idea; in his *Memoirs of a Revolutionist*, 299, he noted the importance for him of the following quotation from a lecture by the Russian zoologist Karl F. Kessler: "Mutual aid is as much a law of nature as mutual struggle; but for the *progressive* evolution of the species the former is far more important than the latter."

111. See T. H. Huxley, *The Struggle for Existence and Its Bearing Upon Man*, London, 1888.

112. Proudhon, *Du principe de l'art et de sa destination sociale*, quoted in Reszler, 17–18 (author's trans.).

113. From M. Bakunin, *L'Empire knautogermanique et la révolution sociale*, quoted in Reszler, 39 (author's trans.).

114. Ibid., 44.

115. Trans. in Kropotkin, 1942, 145.

116. P. Kropotkin, "Paroles d'un révolté," trans. in Kropotkin, 1970, 278.

117. See, for example, Fernand Pelloutier's call for didactic, agitational art in his *Art et la révolte*, Paris, 1896.

118. See Signac's anonymously published "Impressionistes et Révolutionnaires," *La*

Révolte, IV, June 13–19, 1891, and his un-published ms. of c. 1902 in the Signac Ar-chives, from which this line comes; and Pis-sarro, letters of Apr. 13, 1891, and May 5, 1891, in C. Pissarro, *Lettres à mon fils Lucien*, ed. J. Rewald, Paris, 1950, 233 and 236; parts trans. in R. and E. Herbert, 1960, 477 and 479.

119. P. Quillard, "L'Anarchie par la litté-rature," *Entretiens politiques et littéraires*, Apr. 1892, 150–51, trans. in Herbert, 1961, 129.

120. M. de Unamuno, "La dignidad hu-mana," *Obras completas*, III, 442, and "Sobre el cultivo de la demótica," *Obras completas*, VIII, 491; see Litvak, 1975, 15.

121. Litvak, 1975, 16–18.

122. J. Ruskin, "The Mystery of Life and Its Arts" (1868), *Sesame and Lilies*, London, 1871; repr. in Harrold and Templeman, 968–86.

123. Harrold and Templeman, 1645.

124. Litvak, 1975, 18.

125. Joan Maragall, *Obres completes*, II, Barcelona, 1960–1961, 119; trans. in Litvak, 1975, 16.

126. Litvak, 1975, 18–19.

127. W. Morris, *News from Nowhere; or, An Epoch of Rest*, London, 1891.

128. Sabartés, 1948, 43.

129. Kropotkin in *Memoirs of a Revolution-ist*, 132–35 and 147–48.

130. See also Cirlot, Figs. 136 and 598–603.

131. Ibid., Fig. 137.

132. See ibid., Fig. 592.

133. Ill. in Cirlot, 229. This drawing was published in *El Liberal*, August 10, 1903, to illustrate an article on "Art at the Paris In-ternational Exhibition" and was in imitation of, or a copy of, Puvis de Chavannes; see Pa-lau i Fabre, 1981, 351.

134. Trans. in Herbert, 1961, 191.

135. *Paroles d'un Révolté*, trans. in Kropot-kin, 1970, 278.

136. Daix and Boudaille, D.IX.15, D.IX.18, and D.IX.20.

137. Sabartés, 1948, 65.

138. See Ilie, passim.

139. Quoted in O'Brian, 71.

140. E. González Blanco in *Nuestro Tiempo*, IV, 1904, 290, quoted in Ilie, 86–87.

141. M. Navarro, *Nuestro Tiempo*, VIII, May 1908, 193; quoted in Ilie, 88.

142. Quoted in Ilie, 96 (author's trans.).

143. "Drawings of Sebastià Junyer Vidal and Other Figures," ill. in McCully, 1978, Fig. 32.

144. Gedo, 1980b, 90, presents a compel-ling discussion of this point.

145. *La Révolte*, IV, July 10–17, 1891, 2, trans. in E. and R. Herbert, 1960, 481.

146. See Fox, "Two Anarchist Newspa-pers of 1898," 167; R. Carr, 443; and Cer-vera, 228.

147. M. Raynal, *Le Point*, special issue, Souillac, Oct. 1952; quoted in Daix and Boudaille, 25.

148. C. Junyer Vidal, "Picasso y su obra," *El Liberal*, Mar. 24, 1904, 2, trans. in Mc-Cully, 1982, 42–45.

Chapter 2

1. See Maitron; Goldberg; Joll; Wood-cock, 1962; Tuchman; Lough; and, though it is weak on the distinctions between anar-chism and socialism, Herbert, 1961.

2. See Herbert, 1961; Lehmann, 181ff.; Egbert, 1970, 45ff.; and Poggioli, 97ff. See also J. Seigel's study of the interactions of political culture and bohemia in Paris from 1830 to 1930.

3. The art critics in the left-, centrist-, and especially right-wing press often discussed modern art in terms of radical politics. For specific equations of Cubism with anar-chism, revolutionism, amorality, and willful destruction of the past, see, for example, Coriolès, "A Propos de l'Internationalisme en Art," *Le Gaulois*, Jan. 3, 1910, 2; Péladan, "Le Salon d'automne," *La Revue hebdoma-daire*, XX, Oct. 1911, 405–16; André Pératé, "Le Salon d'automne," *Le Correspondant*, Oct. 25, 1911, 308–16; J. d'Aoust, "La Peinture Cubiste, Futuriste ... et au-delà," *Livres et Art*, I, Mar. 1912, 153–56; Camille Mauclair, "La Peinture 'nouvelle' et les Marchands," *La Revue*, XCVIII, Oct. 15, 1912, 429–42. For a contemporary discussion of such attitudes,

see Fernand Roches, "Le Salon d'automne de 1912," *L'Art décoratif*, XIV, Nov. 20, 1912, 281–328, and my discussion in Chapter 4.

4. The literature on the Dreyfus Affair is too vast for reiteration here; for general histories of the period, see Cobban; Lough; and—what amounts to the same thing, so superbly is it done—Goldberg.

5. Lough, 161.

6. Ibid., 182.

7. It was just the opposite in Belgium, also treated by Herbert, 1961, passim. Seurat cannot confidently be included since there is no documentation regarding his political ideas, but circumstances and his friends' assertions tend to support at least his strong sympathy; see R. and E. Herbert, "Artists and Anarchism: Unpublished Letters of Pissarro, Signac, and Others."

8. See Herbert, 1961, 86ff., for a thorough discussion of the theoretical disagreements and threads of argument among the various groups in the 1890s.

9. Joll, 166–73. Verhaeren, from Belgium, and Merrill, from America, emerged from differing political traditions in their own countries; see Herbert, 1961, 28ff.

10. Archives Nationales, "Listes d'Anarchistes" (F⁷12506); see also Joll, 167.

11. Woodcock, 1962, 314.

12. Ibid., 305. Grave claimed a weekly circulation for *La Révolte* and *Les Temps Nouveaux* of eight thousand on average; see Grave, 1930, 59 and 70.

13. Dardel, 10.

14. See discussion above, 39–40.

15. Woodcock, 1962, 305–6; Herbert, 1961, 100ff.

16. Reproduced in Reventós i Conti, 45; roughly translates as "Sir Cortada, Boss of the Separatist Committee." See Jardí, 1969, 92 and 120; Rubin, 1980, 28–29, 46, and 56; Cabanne, 1977, 90; and McCully, 1978, 42.

17. Archives de la Préfecture de Police, Paris, "Anarchistes, 1 jan. 1899–31 déc. 1900" (Bᴬ308), and "Anarchistes, 1 nov. 1903–31 déc. 1906" (Bᴬ309).

18. Rubin, 1980, 56–59; Cabanne, 1977, 91; and Penrose, 106 and 109–10.

19. Blunt and Pool, 13; and Rubin, 1980, 56.

20. See Golding, 1968, 23–24; Penrose, 143–44; Herbert, 1961, 102ff. See also M. Golberg, *La Morale des lignes*, Paris, 1908; and Aubery.

21. Salmon, 1955, 75. Picasso also had the poems of Mallarmé, Rimbaud, and Verlaine in his small library; Penrose, 145.

22. F. Fagus (pseudonym of Georges Eugène Faillet), *Testament de ma vie première*, Paris, 1898, 11 (author's trans.):
Tu fais pleuvoir aux éventaires,
Des petites marchandes de fleurs,
De si adorables horreurs
Que le bourgeois pris de coliques
Croit voir les splendeurs hérétiques
De van Gogh et de Pissarro,
Et recommande avec terreur,
En passant devant les boutiques
Des petites marchandes de fleurs,
Sa pauvre âme à Notre Seigneur,
A Notre Seigneur Bouguereau!

23. Fagus, 75–77 (author's trans.):
On nous mène à la bouch'rie;
Pourquoi? on n'nous l'a dit . . .
Il paraît qu'c'est la Patrie
Qu'a besoin qu'on donn' sa vie!
　Marche! march'! c'est la Patrie,
　Marche! march'! que nous
　　servons!
Mais notre mission est haute,
Si nous tuons, si nous mourons,
C'est pour les gros d'la haute
Dorment sur leurs picaillons!
　Marche! march'! c'est la Patrie,
　Marche! march'! que nous
　　servons!

For more on Fagus, see Salmon, 1955, 73ff.

24. Steegmuller, 35–36.

25. Adéma, 15; Shattuck, 1968, 257.

26. Published in *Le Matin* serially, *Que faire?* was a collaborative effort. Apollinaire, however, did most of the work and created the central character; see Shattuck, 1968, 254–58.

27. Salmon, 1956, 108–9.

28. Adéma, 65.

29. Steegmuller, 79ff.

30. Bibliothèque Nationale, MS, "Apollinaire, livre d'adresses" (n.a.fr.16285).

31. Salmon, 1955, 132.

32. Steegmuller, 101–2; Shattuck, 1968, 261–62.

33. See Steegmuller, 91–94 and 102–3, for an account of this bizarre friendship.

34. Adéma, 69.

35. *Apollinaire on Art: Essays and Reviews, 1902–1918*, ed. L. Breunig (Apollinaire, 1972), has a valuable bibliography on pp. 517–24.

36. See P. Caizergues, "La Collaboration d'Apollinaire à *La Démocratie sociale*," in Apollinaire, 1969.

37. Apollinaire, 1969, 24, gives a complete list of the periodicals Apollinaire reviewed in *La Démocratie sociale*.

38. *La Démocratie sociale* (Paris), nos. 7–15, Feb.–Apr. 1910; see Apollinaire, 1969, 25ff.

39. Apollinaire, 1969, 60–61 (author's trans.).

40. Caizergues, 1981a, 38 (author's trans.).

41. All page references are to the reprint edition of *Les Soirées de Paris*, Geneva, 1971: J. Tharaud, "La Guerre des Balkans," I, Nov. 1912, 289–92; A. Tudesq, "La Guerre des Balkans," I, Dec. 1912, 338–41; R. Dalize, "Impressions de Cour d'assises," II, Mar. 1913, 63–69; S. Voirol, "Paul Adam," II, Mar. 1913, 73–83; E. Zavie, "Les Journaux de Paris, III: 'L'Echo de Paris,'" II, May 1913, 119–26; A. Haas, "Souvenirs de la vie littéraire de Paris," III, May 1914, 251–74; and H. Céard, "Souvenirs—préface à *Un Communard* de Léon Deffoux," II, Mar. 1913, 37–42.

42. Salmon, "Observations déplacées," *Les Soirées de Paris*, I, Feb. 1912, (repr. Geneva, 1971, 28–30): "Lorsque j'avais vingt ans la vie était belle. . . . Tout était plus facile. Les vers libristes étaient réactionnaires [in 1912 this stood for "revolutionaries"] et les poètes réguliers républicains. Magre ou Vielé-Griffin, on pouvait choisir. C'était très commode. Aujourd'hui tout est plus compliqué, on a tout brouillé. On ne sait même plus qui est vers libriste; les républicains sont

réactionnaires et chacun est classique. C'est trop difficile, j'y renonce" (author's trans.).

43. Apollinaire, "The Salon des Indépendants," *La Revue des Lettres et des Arts*, May 1, 1908, trans. in Apollinaire, 1972, 44.

44. See, for example, Shattuck, 1968, 263, and Breunig, 9, who concludes: "What Apollinaire really espoused was avant-gardism. More important than the contents of this or that manifesto was the fact that what he championed was new. His most earnest desire was to form a common front in the fight against traditionalism, and his acrobatics with labels represent successive efforts by stretching the meaning of this or that 'ism' to designate the over-all trends of the moment. The last label he sought to impose, without much success in spite of its greater accuracy, was simply 'l'esprit nouveau.' "

45. Salmon, 1956, 109: "Je n'avais pas besoin d'être d'accord sur tous les points avec Guillaume flottant de Picasso à Matisse, tournant avec un peu d'inquiétude autour de Derain, et, je pense, éveillé au goût de l'art neuf par Vlaminck rencontré dans le train de Chatou. . . . J'aimais l'art de peindre; je situais quelques peintres au-dessus des autres; Guillaume Apollinaire se préoccupait avant tout de mettre en valeur tout ce qui l'aiderait à l'affirmation de cet *Esprit nouveau*" (author's trans.).

46. See Lipton, *Picasso Criticism, 1901–1939: The Making of An Artist-Hero*, Chapter 1.

47. As, for example, when he described his much admired Delaunay, to the latter's horror, as a "Futurist"; see Apollinaire, "The Salon des Indépendants," *L'Intransigeant*, Mar. 5, 1914, trans. in Apollinaire, 1972, 358–59 and (letters to the Editor) 503–6.

48. Trans. in Breunig's introduction to Apollinaire, 1972, xxiii.

49. Apollinaire, "The New Painting: Art Notes," *Les Soirées de Paris*, Apr.–May 1912, trans. in Apollinaire, 1972, 223–25.

50. Apollinaire, "Young Painters, Keep Calm!" *Bulletin de la Section d'Or*, Oct. 9, 1912, trans. in Apollinaire, 1972, 253. These

"appeals to the government" did indeed end in a heated debate over the censorship of Cubism, and its "foreignness," in the Chambre des Députés on December 3, 1912; see my discussion in Chapter 4.

51. Apollinaire, 1949, 23.

52. Apollinaire, "From Michelangelo to Picasso," *Les Marches de Provence*, Feb. 1912, trans. in Apollinaire, 1972, 196.

53. Breunig, introduction to Apollinaire, 1972, xxix. Apollinaire is quoting his friend the writer Ernest Hello, who one day remarked to Salmon, "I passed in front of the Tuileries this morning; it's curious, but they're still not burning," Salmon, 1959, 18 (author's trans.).

54. Apollinaire, "Picasso," preface to the *Catalogue de l'Exposition Matisse-Picasso*, Paul Guillaume Gallery, Jan. 23–Feb. 15, 1918, trans. in Apollinaire, 1972, 458.

55. See Shattuck, 1968, 303ff.

56. Ibid., 269–70.

57. Steegmuller, 167.

58. Shattuck, 1968, 295.

59. Apollinaire, "Anecdotiques," *Le Mercure de France*, trans. in Shattuck, 1968, 304.

60. See ibid., 294.

61. "La Jolie Rousse," the final poem in *Calligrammes: Poèmes de la paix et de la guerre (1913–1916)* (author's trans.).

62. "Le Larron" was originally published in *La Plume*, (2e *supplément poétique*), Aug. 1–15, 1903, 343–44; see Décaudin, 148 (author's trans.).

63. Caizergues, 1981b, 8.

64. Breunig, 14.

65. Shattuck, 1968, 339.

66. Breunig, 24.

67. See Steegmuller's notes in Apollinaire, 1964, 250; and Décaudin, 207.

68. Salmon, "Lettres adressées à Jean de Pierrefeu," Bibliothèque Nationale, MS (n.a.fr. 14688, f.585.): "les gens de 1895 m'avaient poussé à en tirer un manifeste: Ne pas mettre la vie dans l'art mais restituer l'art à la vie. Apollinaire, lui-même, songeait bien à quelque chose d'identique" (author's trans.).

69. All translations of *Alcools* are from Apollinaire, 1964.

70. Steegmuller, 252. Undoubtedly the attempt on the life of King Alfonso XIII of Spain during his visit to Paris in 1905 would have been relatively fresh in Apollinaire's mind, since he knew numerous people whom the police suspected of plotting the king's assassination; see discussion below on Salmon's memoirs, 70–71.

71. See Shattuck's enlightening discussion in "Apollinaire's Great Wheel," 1984.

72. Quoted in preface (Michel Butor) to Apollinaire, 1966, 7: "Quant aux *Calligrammes*, ils sont une idéalisation de la poésie vers-libriste et une précision typographique à l'époque où la typographie termine brillamment sa carrière, à l'aurore des moyens nouveaux de reproduction que sont le cinéma et le phonographe" (author's trans.).

73. Since Apollinaire is not the focus of this study, I have been able to look only briefly at his work. More consideration of this aspect of his work, however, is clearly needed; the same can be said of Jarry and Salmon.

74. Salmon, 1955, 155. See also Shattuck, 1968, Chapters 7 and 8 on Jarry.

75. See, for instance, Shattuck, 1968; LaBelle, 98–99; and Johnson, 1980b, 102.

76. A. Jarry, *Ubu colonial, Almanach illustré du Père Ubu*, Paris, 1901; sections trans. in Jarry, 1965.

77. Jarry, 1965, 53–54.

78. Ibid., 61–62. "Strumpot" is Shattuck and Taylor's translation of Jarry's confessedly untranslatable "gidouille." They see it as referring to Ubu's insatiable bourgeois belly—hence "strumpot" and "Hornstrumpot" for "cornegidouille"; it seems to me arguably more vulgar and sexual, hence my offer, below, of "hornsocket."

79. Cited by Shattuck, 1968, 237.

80. For Jarry's trip to Pont-Aven, see Shattuck, 1968, 245; Jarry also wrote three poems in Gauguin's honor; see Jarry, *Oeuvres complètes*, 1972, 252–54 and 1116, n. 2.

81. Sections trans. in Jarry, 1965, 136 (Book I, Chapter 5).

82. Ibid., 138–39.

83. LaBelle, 106. Pierre Quillard was an especially close friend.

84. "Être et vivre," Jarry, 1972, 343, and "Visions actuelles et futures," ibid., 337. Vaillant, who threw a relatively harmless homemade bomb of nails in the Palais Bourbon—symbol of parliamentary hypocrisy—was supported by Kahn, Fénéon, and others, including Tailhade, who called the bombing "the gesture of a liberator and a lover of justice," quoted in Herbert, 1961, 120. Henry, on the other hand, threw a deadly bomb into a common railway terminus café and was supported by only the most uncompromisingly doctrinaire radicals, including Fénéon and Tailhade.

85. Jarry, 1972, 430–31 (author's trans.): "LES TROIS HOMMES LIBRES: Nous sommes les hommes libres, et voici notre caporal.—Vive la liberté, la liberté, la liberté! Nous sommes libres.—N'oublions pas que notre devoir, c'est d'être libres. Allons moins vite, nous arriverions à l'heure. La liberté, c'est de n'arriver jamais à l'heure—jamais, jamais! pour nos exercices de liberté. Désobéissons avec ensemble. . . . Non! pas ensemble: une, deux, trois! le premier à un, le deuxième à deux, le troisième à trois. Voilà toute la différence. Inventons chacun un temps différent, quoique ce soit bien fatigant. Désobéissons individuellement—au caporal des hommes libres!"

"LE CAPORAL: Rassemblement!"

Ils se dispersent.

86. Parmelin, 1969, 72.

87. LaBelle, 4. Jarry was from Laval, near but not in Brittany.

88. Epigraph to *Ubu enchaîné*, Jarry, 1972, 427: "PERE UBU: Cornegidouille! nous n'aurons point tout démoli si nous ne démolissons même les ruines!" (author's trans.).

89. Salmon, 1955, 150–51: "Je goûte beaucoup les histoires militaires. *Il n'y a que ça de vrai dans notre littérature.* . . ." Jarry savourait particulièrement l'étonnement qu'il causait à autrui; c'était sa vraie joie et l'on verra comment il se tua, avec une héroïque, une glorieuse naïveté, pour cette joie d'étonner. Il reprit: "J'aime passionnément l'ar-

mée." Ma surprise allait croissant. "On me dit antimilitariste parce que j'ai écrit *Les Jours et les nuits*, roman d'un déserteur, mais ce n'est pas vrai."

Il dit "ce n'est pas vrai" sur le ton du Père Ubu . . . : "Que le clairon sonne en Notre rue Cassette de Notre bonne Ville de Paris et vous Nous verrez, instantanément, avec une grande précipitation, saisir le bâton à physique, le croc à merdre et le crochet à nobles et, debout sur le petit voiturin à phynances, Nous placer bien en vue, en tête de Nos troupes de Notre République française" (author's trans.).

90. Jarry, 1972, 427: "Or je n'y vois d'autre moyen que d'en équilibrer de beaux édifices bien ordonnés" (author's trans.).

91. Shattuck, 1968, 226–27.

92. Salmon, 1955, 155.

93. Penrose, 118.

94. Salmon, 1945, 35; and Salmon, 1955, 186.

95. Palau i Fabre, 1966, 148.

96. Jacob, 1956, 48–49; trans. in Johnson, 1980a, 103.

97. Apollinaire, 1964, 234.

98. Salmon, 1955, 148.

99. Salmon, 1956, 252: "Picasso a dit que 'peintres et poètes s'influençaient tour à tour'"; and Salmon, 1920b, 90. See also LeMaitre, 65.

100. Salmon, 1955, 24.

101. See Shattuck, 1968, 66–69, for an account of the banquet.

102. See Stein, 1933, 126–32; and Salmon, "Testimony Against Gertrude Stein," *transition*, trans. in Shattuck, 1968, 70.

103. Salmon, 1955, 188: "On s'amusait bien. Et davantage quand on apprit que Matisse déjà classé grand homme menait une discrète enquête pour savoir quelle main ou quelles mains écrivait ou écrivaient sur les murs et palissades de Montmartre: 'Matisse rend fou! . . .' 'Matisse est plus dangereux que l'alcool. . . .' 'Matisse a fait plus de mal que la guerre! . . .'" (author's trans.). Salmon, 1920b, 90, names Van Dongen, *farceur*, as the author of the repeated "Matisse rend fou!"

104. Salmon, 1956, 199: "Il y eut un esprit de blague et d'atelier dès 1903 [misprinted 1913], au Bateau-Lavoir, où, en même temps, se préparaient sérieusement le modernisme, l'orphisme, le cubisme" (author's trans.).

105. Salmon, 1956, 82: "On se trouvait à une époque d'esprit révolutionnaire mais relativement gai. On connaissait alors des syndicalistes résolus mais à dire aussi rigolos. Je ne trouve pas d'autre expression adéquate. Des socialistes plus ou moins nuancés d'anarchie" (author's trans.).

106. Salmon, 1956, 162; and Salmon, 1955, 122, 220, 303, and 104: "ancien anarchiste par la bande, collaborateur des braves, petits journaux à 'deux rondes,' du *Père Peinard* à l'*En-dehors* . . . , chaque époque ayant ses convulsionnaires, Octave Mirbeau était aimé pour ses idées généreuses. . . ." (author's trans.).

107. Salmon, 1955, 37ff., 103ff., and 245. See *A la Mémoire de Pierre Quillard*, Paris, 1912, a biography and various speeches delivered at his funeral on February 16, 1912, by Jean Ajalbert, André Fontainas, et al.

108. Salmon, 1956, 283.

109. Salmon, 1955, 57; Salmon, 1956, 116ff.; see also Steegmuller, Chapter 6, passim. The story is closely followed on the front page of *Paris-Journal*, Salmon's paper, from August 29 through September 13, 1911. See my discussion in Chapter 3.

110. Salmon, 1955, 107–8: "On s'est communiqué des poèmes. On a discuté des doctrines. . . . On a proféré des âneries, mais il faut de tout pour constituer un nouvel univèrs poétique" (author's trans.).

111. See Salmon, 1955, 42, where he adopts the apologetic tone with which he continually dismisses his political romanticism throughout the book; nevertheless, he returns obsessively, and unavoidably, time and again to the subject: "En mon bel âge de la belle époque, j'ai suivi des cheminots en grève"; see also Salmon, 1956, 22–23.

112. See Salmon, 1956, 270–80; quote on 278: "meurtrier, non pas assassin vulgaire, une sorte de héros faubourien d'un temps suffisamment anarchique. . . . Ah! c'est des histoires d'avant la première guerre. On ne les comprend plus toujours trop bien, maintenant" (author's trans.).

113. Archives de la Préfecture de Police, Paris, "Anarchistes, 1 nov. 1903—31 déc. 1906," (B^A309), a daily log of surveillance activity; "Listes et états des Anarchistes, 1900 à 1912" (B^A1500); and "Ferrer, Francisco," 2 dossiers (B^A1075). Reading these police reports on the activities of the Spaniards, one finds it hard not to believe that Ferrer and others were indeed implicated in the assassination attempt on Alfonso's life on May 31, 1905, given the volume of activity and the quite cleverly elusive tactics they had developed for traveling undetected between Paris and Barcelona. Ferrer, pamphleteer and founder of the libertarian Escuela Moderna, was the center of an enormous outcry four years later, when he was executed by the Spaniards for plotting the antimilitarist riots that swept Barcelona in the summer of 1909, at which time he was in London (and Picasso more or less trapped, but rather thrilled, in Horta de Ebro; see my discussion in Chapter 4).

114. See Penrose, 60ff.

115. Salmon, 1955, 167: "Pendant ce temps, Zo d'Axa, Roinard et les rédacteurs de *L'En Dehors* fumaient leurs pipes, prophétisant de terribles chambardements, très écoutés par des jeunes gens dont plusieurs atteignirent au pouvoir. Parce que les amis dans la dèche pouvaient venir réclamer leur portion d'un modeste festin, on se disait 'partageux'; parce qu'on ne daignait garder rancune au copain négligent de restituer une redingote empruntée pour 'aller dire des vers dans le monde,' on niait la propriété, très haut. Dans le même temps, Ravachol le vagabond et le polytechnicien Emile Henry démontraient le danger des explosifs alors comparables, sur un autre plan, aux baïonnettes quand elles se mêlent d'être intelligentes. La police opéra une descente dans la cabane des trappeurs, asile du rêve. En vain chercha-t-elle des bombes et des armes. Les locataires du 13 prirent un bel air fatal de persécutés. Plusieurs déménagèrent" (author's trans.).

116. Tuchman, 92; Herbert, 1961, 118–19, 121, and 153.

117. See G. Diehl, *Van Dongen*, Milan, n.d. [1969], 49; and Elderfield, 66.

118. Warnod, 69.

119. Trans. in Vlaminck, 11–12.

120. Salmon, 1955, 188: "Sans blague? Et moi qui étais venu pour vous épater!" (author's trans.).

Chapter 3

1. Palau i Fabre, 1966, 148.
2. Rubin, 1980, 88.
3. Cabanne, 1977, 107.
4. Ill. in Rubin, 1980, 59.
5. Cabanne, 1977, 129.
6. J. Gonzales, *Cahiers d'Art*, 1935, trans. in Daix and Boudaille, 143.
7. Olivier, 1964, 27–30.
8. Daix and Boudaille, 70; and letter from Casagemas to Ramon Reventós, Oct. 25, 1900, in McCully, 1982, 27–30.
9. Reff, 30, includes Manolo's account of Casagemas's suicide; and Palau i Fabre, 1981, 213; see my discussion above, 71–72.
10. Daix and Boudaille, 159.
11. Olivier, 1964, 36.
12. Salmon, 1959, 462.
13. Olivier, 1964, 27–28.
14. Barr, 1946, 37.
15. Daix and Boudaille, 254.
16. Ibid., XII.8.
17. McCully, 1978, 130. See Rusiñol's *L'alegría que passa*, 1898, ibid., Fig. 43.
18. Daix and Boudaille, XII.16.
19. Olivier, 1964, 51; Palau i Fabre, 1981, 400, presumes it lost; see Daix and Boudaille, XII.18; and Geiser, 9b. See also the excellent discussion by E. A. Carmean, Jr., of the relation of these studies for the *Saltimbanques* to the final work, "The *Saltimbanques* Sketchbook No. 35, 1905," *Je suis le cahier*, 9–19.
20. See T. Clark, *The Absolute Bourgeois: Artists and Politics in France, 1848–1851*, Greenwich, Connecticut, 1973, chapter on Daumier, 99–123.
21. Palau i Fabre, 1981, 416.

22. See, for example, Johnson, 1977, 90–95; Reff; and McCully, 1980.

23. See also Daix and Boudaille, XI.3; and Zervos, XXII, 120.

24. See also *Young Acrobat and Child*, Daix and Boudaille, XII.15.

25. See ibid., XII.25 and XIII.11.

26. See ibid., XV.3, XV.4, XV.5, XV.6, XV.8, and Zervos, XXII, 312 and VI, 714. Daix's date of summer 1906 is now accepted for this major canvas, though it was dated 1905 by Zervos, I, 304.

27. Daix and Boudaille, XII.12, XII.13, XII.14, XII.15, XII.16, and XII.17.

28. Ibid., XIV.14, XIV.15, XIV.16; and Geiser, 10b.

29. Daix and Boudaille, XIII.13; Salmon, 1912, 41–42.

30. Daix and Boudaille, XIII.20 and XIII.21.

31. Daix and Boudaille, 286, notes: "We cannot say whether this work is the end of this series or a step toward the monumental *Watering Place (L'Abreuvoir)*, which never materialized."

32. See Goldwater's study, *Primitivism in Modern Art*; and Rubin, ed., *"Primitivism" in 20th Century Art*, 1984, especially J. Paudrat, "The Arrival of Tribal Objects in the West from Africa," 125–75, and Rubin, "Picasso," 241–343.

33. See Goldwater, passim; for Klee and child art, see 199. See also J. Laude, *La Peinture française (1905–1914) et "l'art nègre"*, 1968; and Palau i Fabre, 1981, 491–92, for an interesting discussion of the possible influence of North American Indian art exhibited in Barcelona in 1892 for the fourth centenary of Columbus's departure from Spain.

34. See Cervera, 230.

35. See Arribas, *The Iberians*, 23.

36. Sweeney cites J. Mélida's series of articles in the *Revista de archivos, bibliotecas y museos* in 1900, 1903, and 1904, and H. Sanders, "Pre-Roman Bronze Votive Offerings from Despeñaperros in the Sierra Morena, Spain," *Archaeología*, LX, 1906, 69–92. His strongest candidate is P. Paris, *Essai sur l'art et l'industrie de l'Espagne primitive*, 2 vols.,

Paris, 1903–1904, which Picasso possibly saw; but it seems more likely that Picasso saw the Catalan publications earlier, such as the reproduction of the *Lady of Elche* in *Ilustración Ibérica*, xv, Oct. 16, 1897, 659, and visited the Louvre.

37. Ibid., 191.

38. Ibid., 192–93. The *Lady of Elche* and the greater portion of the Osuna sculptures were returned to Spain by the Pétain government in February 1941; Arribas, 256.

39. Sweeney, 194.

40. See, for example, Barr, 1946; Golding, 1968; Daix and Boudaille; Penrose; Rubin, 1972; and Rubin, 1984.

41. Dixon, 2ff.; Arribas, 61.

42. A. Engel and P. Paris, *Une forteresse ibérique à Osuna*, Paris, 1906.

43. Golding, 1968, 52–54.

44. See Steegmuller, 186ff.

45. Olivier's amusing account of this episode reveals Picasso's extreme—and in this case not unwarranted—fear of the police.

46. Jarry's answer to this law was to carry his weapons openly, two pistols shoved into his belt and a carbine over his shoulder; see Salmon, 1955, 154–55.

47. Salmon, 1956, 116. Part of the "wit" here is that there was a large department store on the rue de Rivoli, Aux Magasins du Louvre, on whose name Géry-Piéret was playing; no one mistook his meaning. Before the scandal he seems to have been treated as the group's pet outlaw.

48. See discussion above, 45–46.

49. Quoted in Johnson, 1980a, 98.

50. Daix and Boudaille, xv.22 and xv.27.

51. Palau i Fabre, 1981, 439–40.

52. E. d'Ors, "Artistic Reasons," trans. in Palau i Fabre, 1981, 440.

53. Daix and Boudaille, xvi.9.

54. See also ibid., xvi.26, xvi.27; and Zervos, ii**, 592.

55. See also Daix and Boudaille, xvi.22, xvi.23, and xvi.24.

56. In Daix and Rosselet, 9, Daix notes that if he had to do his two catalogues raisonnés over again, he would end the first volume with the summer in Gósol and include the autumn of 1906 with the movement toward *Les Demoiselles d'Avignon*.

57. Trans. in Herbert, 1961, 54.

58. Zervos, i, 312 and xxii, 348; ill. in Palau i Fabre, 1981, Figs. 1323, 1324 (previously unpublished), and 1326.

59. The oxen are first seen in a drawing done in Gósol, *Oxherd with Basket*, spring–summer 1906, Zervos, i, 338; ill. in Palau i Fabre, 1981, Fig. 1320.

60. Ibid., 439. For a thorough discussion of this question, see Barr, 1946, 48 and 256.

61. See also its study, Zervos, xxvi, 169.

62. W. Lieberman, *The Nelson A. Rockefeller Collection*, New York, 1981, 28.

63. Daix and Boudaille, 23.

64. See Golding, 1968, 49ff.; and Fry, 14–15.

65. Rubin, 1980, 59 and 86; and Daix, 1983, 25. These issues are discussed at greater length in Golding, 1968, 48–49; Barr, 1946, 53; Daix and Rosselet, 16; and Palau i Fabre, 1981, 506.

66. Barr, 1946, 56–57; and Fry, 12ff. Golding, 1968, 47, while he notes that it is "not, strictly speaking a Cubist painting," affirms that it is "the logical point to begin a history of Cubism."

67. Steinberg, 20–29 and 38–47; Rosenblum, 1973a, 45–48; Johnson, 1980a and 1980b; and Gedo, 1980a, 70–82.

68. Zervos, *Pablo Picasso, Supplément aux années 1907–1909*, xxvi, 1973.

69. Zervos, ii**, 637 and ii**, 644, ill. in Palau i Fabre, 1981, Figs. 1540 and 1548.

70. To Daix, Daix and Rosselet, 185; and to Rubin, who told Steinberg, quoted in Steinberg, 38. I agree with Gedo's doubts on this point, 1980a, 72.

71. Zervos, xxvi, 45, xxvi, 86, and xxvi, 75; ill. in Palau i Fabre, 1981, Figs. 1442, 1444, and 1445.

72. Steinberg, 39. See Barr, 1946, 57; Penrose, 135–36; Daix and Rosselet, 15; Reff, 26; Gedo, 1980a, 75–77; and Johnson, 1980b, 98.

73. Cabanne, 113, but no source is cited. Picasso may also have been aware of the contemporary Christian socialism of Léon Bloy and Georges Rouault—who also dealt with

prostitutes in his work; nothing would have been anachronistic about the association of the skull with a vanitas motif and the book with a Bible.

74. See the following studies: Zervos, VI, 904 and XXVI, 16, 45, 67, 75, and 449; ill. in Palau i Fabre, 1981, Figs. 1442, 1445, 1467, 1507, 1508, and 1512.

75. Palau i Fabre, 1981, 500; see also Zervos, XXVI, 16, 67, and 449.

76. See Zervos, II, 20, II**, 19, 21, and 632–44 inclusive, VI, 980 and 981, and XXVI, 59, 69–71 inclusive, 82, 90, 91, 98, and 129; ill. in Palau i Fabre, 1981, Figs. 1469, 1509, 1510, 1511, 1515, 1516, 1517, 1518, 1521, 1523, 1526–33 inclusive, 1537–44 inclusive, and 1548.

77. See also Zervos, XXVI, 21, 22, 102–9 inclusive, 113, 115, 117, 118, and 121–24 inclusive.

78. See Steinberg; and Gedo, 1980a.

79. Goldwater, 144–45 and 161; and Rubin, 1984, 248.

80. *Action*, III, Apr. 1920, 26.

81. Zervos, II, 10 (author's trans.).

82. See Sweeney, 196–97; Barr, 1946, 56; Penrose, 137–38; Golding, 1968, 55ff.; Fry, 13 and 47–48; Rubin, 1980, 87; and, most recently and thoroughly considered, Rubin, 1984, 254ff., who notes that Picasso also mentioned to him that Derain advised him to go see the Musée d'Ethnographie. Only Daix (Daix and Rosselet, 24–27, and Daix, 1983, 31) and Johnson, 1980a, 105, see the change in style as due to combinations of other sources.

83. Malraux, 10–11.

84. P. Eluard, "Je parle de ce qui est bien," *Cahiers d'Art*, 1936, 30. Of the Cubist period, Eluard wrote: "Picasso created fetishes with their own life. They were not only intercessionary signs, but signs in movement."

85. None of the lengthy and badgering debates on the appropriateness of this term and concept, raised by the exhibition " 'Primitivism' in 20th Century Art" at the Museum of Modern Art in 1984, alter the fact that Picasso and others saw tribal art as "primitive" and were attracted to it for that

reason. The subject of the modernists' views of tribal art is of legitimate historical interest, as Rubin rightly pointed out in his introduction to the catalogue (see Rubin, 1984, 5–6); its pursuit reveals not "inherent racism" on the historian's part but an interest in understanding the past.

86. Salmon, 1912, 43.

87. Ibid., 44–51 (author's trans.).

88. Vallier, 14 (author's trans.).

89. Jarry's health began seriously to deteriorate in 1905; he died, after a long period of incapacity, on Nov. 1, 1907; Shattuck, 1968, 219–22.

90. This configuration is reminiscent of Kota reliquary figures that Picasso could conceivably already have seen, though Paudrat, 141, notes that the evidence is very uncertain regarding Picasso's and others' awareness of African art as early as 1905.

91. The economic benefits of colonialism provided one of the few issues that unified the left and right wings of political opinion in France at the turn of the century; only the anarchists, the furthest left, criticized the colonialist position; see, for example, *L'Assiette au beurre*, special issues on colonialism, no. 140, Dec. 5, 1903, and no. 181, Sept. 17, 1904 (text by André Salmon). See R. Betts, *Assimilation and Association in French Colonial Theory, 1890–1914*, New York, 1961; and C. Ageron, *L'Anti-colonialisme en France de 1871 à 1914*, Paris, 1973.

92. Daix and Rosselet, 201.

93. Some early works were shown at the Galerie Notre-Dame-des-Champs in 1908–1909, Daix and Boudaille, 228; for the May 1910 exhibition, see Fry, 57–58, review by Léon Werth describing probably *Bowls of Fruit with Wineglass* and *The Factory at Horta de Ebro* (Daix and Rosselet, nos. 209 and 279); see also ibid., 247; the last show is indicated by Salmon's review in *Le Journal* on Dec. 22, 1910, of a show of Picasso's recent work, possibly at Galerie Vollard, ibid., 259. For further consideration of this question, see the discussion in Chapter 5.

94. O'Brian, 151; Palau i Fabre, 1981, 508. Berger, 1968, 73, goes so far as to call

it "almost—to use an old anarchist term—an example of 'propaganda by deed.'"

95. Critics of the 1890s and early 1900s typically saw departures from artistic tradition in political terms; for example, Lehmann, 181, quotes the critic Recolin, *Anarchie Littéraire*, Paris, 1898, xii, hostile to vers libres and defender of "le vieux bon sens français": "L'anarchie est évidente. Elle est logique aussi. Elle a ses causes, dont les deux principales sont: la rupture avec la tradition et l'individualisme." And though no critics discussed *Les Demoiselles d'Avignon* in the contemporary press, Cubism was immediately equated with anarchism; see discussion below in Chapter 4.

96. Trans. in Fry, 81–84.

97. Penrose, 133–34.

98. Cabanne, 1977, 119.

99. Kahnweiler, 1961, 46; trans. in Palau i Fabre, 517.

100. Kahnweiler, 1971, 39.

101. Salmon, 1920b, 90 (author's trans.). A slight variation appeared in his *L'Art vivant* of 1920, 123.

102. Olivier, 1933, 120 (author's trans.).

103. Penrose, 133; Olivier, 1933, 97; Cabanne, 1977, 119.

104. See Rubin's article, "Cézannisme and the Beginnings of Cubism," 1977.

105. See Rosenblum, "The *Demoiselles*: Sketchbook No. 42, 1907," in *Je suis le cahier*, 59; it has always been thought that Braque saw only the final version, meeting Picasso in Oct. or Nov. 1907.

106. Rubin, 1977, 196 (note 25).

107. The past against which Picasso rebelled was the immediate past, the tyranny of the past, and not the idea of the old masters as a standard that Picasso et al. wanted to rival; see M. Fried, "How Modernism Works: A Response to T. J. Clark," *Critical Inquiry*, 9, Sept. 1982, 217–34.

108. I agree here with the dating in Rubin, 1980, 459.

109. For example, Daix and Rosselet, nos. 73 and 74. See Rubin, *"Primitivism" in 20th Century Art*, 1984, especially Paudrat, "The Arrival of Tribal Objects in the West from Africa," 125–75, and Rubin, "Picasso," 241–

343. Rubin and Paudrat provide extremely valuable chronologies of exactly what is known to have been available to Picasso's view. Paudrat, 137–42, is convincing in placing the date of Picasso's first real engagement with African art in 1906. Rubin, 262 and note 69, excluded a number of works traditionally cited in reference to *Les Demoiselles d'Avignon*, including this one. Yet he proves, according to the known arrival dates of specific works, only the unlikelihood of Picasso's having seen such works; it cannot be absolutely proven that Picasso did *not* see them, which is where the burden of proof would lie in order to dismiss the close visual correspondence between this mask and, for example, the right-hand figure in the *Demoiselles* and the faces in the *Mother and Child*. One is otherwise left, uncomfortably, with the conclusion that Picasso invented such forms immediately prior to first viewing comparable African masks. Such a conclusion would then be comparable to Picasso's "discovery" of the African masks in the Trocadéro, which Rubin concludes is "another case of Picasso's famous 'prescience,' here exercised in regard to the kinds of solutions his instinct told him were needed to resolve his dissatisfaction with the *Demoiselles*," 254. Rubin is entirely correct, however, in emphasizing the fact that Picasso felt free to alter such forms in any direction appropriate to his own purposes.

110. Daix and Rosselet, no. 25.

111. Ibid., no. 76.

112. Daix and Boudaille, XII.6.

113. Daix and Rosselet, no. 82.

114. Ill. in H. Hope, *Georges Braque*, ex. cat., Museum of Modern Art, New York, 1949, 26. Daix (Daix and Rosselet, 37ff.) presents a convincing argument on the influence of Picasso's *Nude with Drapery* on this work.

115. Unillustrated works as follows: Daix and Rosselet, nos. 116, 128, 131, and 159; see also nos. 161 and 162.

116. Ibid., no. 70; Rubin, 1980, 105, dates this work to autumn 1907.

117. Reff, 27; Daix and Rosselet, no. 172.

118. Apollinaire to Salmon, quoted in

Salmon, 1956, 232: "Innovez violemment!" (author's trans.).

119. Apollinaire, "Pablo Picasso," *Montjoie!*, I, 3, Mar. 14, 1913, trans. in Chipp, 231–32.

Chapter 4

1. See, for example, Gray; and Henderson, 1983.

2. Interview with Pol Gaillard, *L'Humanité*, Paris, Oct. 29–30, 1944 (author's trans.).

3. Complete statement trans. in Barr, 1946, 247–48.

4. Picasso to Harriet and Sidney Janis, Mar. 1946, quoted in Janis, 7.

5. M. Robin, "Les Arts," *Les Hommes du jour*, 69, May 15, 1909, n.p. [6]; H. Guilbeaux, "Paul Signac et les Indépendants," *Les Hommes du jour*, 170, Apr. 22, 1911, 1–3: "Picasso a produit des résultats grotesques, ridicules, faits semble-t-il pour épater le bourgeois"; C. Mauclair, "Le Prolétariat des peintres," *La Revue hebdomadaire*, XXII, 1, Jan. 1913, 354–69; Péladan, "Le Salon d'Automne," *La Revue hebdomadaire*, XX, 10, Oct. 1911, 405–16 (author's trans.).

6. Coriolès, "A Propos de l'Internationalisme en Art," *Le Gaulois*, Jan. 3, 1910, 2: "d'esprit volontiers révolutionnaire, voire de tendances anarchiques"; J. d'Aoust, "La Peinture Cubiste, Futuriste . . . et au-delà," *Livres et Art*, I, Mar. 1912, 153–56. See also André Pératé, "Le Salon d'Automne," *Le Correspondant*, Oct. 25, 1911, 308–16; and for a contemporary discussion of this politicized attitude, see Fernand Roches, "Le Salon d'Automne de 1912," *L'Art décoratif*, XIV, Nov. 20, 1912, 281–328 (author's trans.).

7. U. Gohier, "Notre Peinture," *Le Journal*, Oct. 10, 1911, 1: "Ce n'est pas notre faute si la vie était alors magnifique . . . tandis que la vie est aujourd'hui mesquine, étriquée, miteuse. . . .

"Les scènes et les personnages de nos tableaux ne sont pas sortis de notre imagination, mais pris sur le vif, dans une humanité neurasthénique, hystérique, épileptique, alcoolique, éthéromane, opiomane, morphinomane, alimentée de poisons, abreuvée de poisons, injectée de poisons, adonnée à toutes les causes de détraquement, et sans vigueur pour y résister.

"Alors, ces anatomies bizarres, ces déformations, ces contorsions, ces visages ternes ou forcenés, ce sont les vôtres. Notre peinture est fidèle . . . nos descendants auront une idée exacte de ce que sont les hommes, la société, la vie d'aujourd'hui en regardant nos toiles" (author's trans.).

The reference is to Apollinaire's essay, "The New Painting: Art Notes," *Les Soirées de Paris*, May 1912, trans. Breunig, 1972, 223–25, and discussed in Chapter 2, 58.

8. G. Mourey, "Au Salon d'Automne," *Le Journal*, Sept. 30, 1912, 2: "On poursuit en ce moment les syndicats d'instituteurs qui propagent dans la jeunesse la haine de la patrie; quel dommage qu'il n'existe pas de loi permettant d'engager une action judiciaire contre les peintres qui propagent dans le public la haine de la beauté!" (author's trans.).

9. "M. Lampué s'indigne contre le Salon d'Automne," *Le Journal*, Oct. 5, 1912, 1: "une bande de malfaiteurs qui se comportent dans le monde des arts comme les apaches dans la vie ordinaire" (author's trans.).

10. *Journal officiel de la Chambre des Députés*, Dec. 3, 1912, 2918: the resolution proposes "de donner à M. le préfet de police le droit d'interdire toute pièce de théâtre ou toute chanson de café-concert qui ferait l'apologie du crime de l'antipatriotisme. . . ." (author's trans.).

11. Ibid., 2924:

M. JULES-LOUIS BRETON: "Depuis quelques années, sous prétexte de rénover l'art, de moderniser ses procédés, de créer des formes nouvelles, des formules inédites, certains exploiteurs de la crédulité publique se sont livrés aux plus folles surenchères d'extravagances et d'excentricités.

"Je ne songe nullement à leur en contester le triste droit, mais je ne puis admettre que notre administration des beaux-arts se prête à ces plaisanteries de très mauvais goût et livre gracieusement nos palais nationaux pour des manifestations qui risquent de

compromettre notre merveilleux patrimoine artistique. (*Très bien! très bien! sur divers bancs.*)

"Et cela d'autant plus que ce sont pour la plupart des étrangers qui viennent ainsi chez nous, dans nos palais nationaux, jeter consciemment ou inconsciemment le discrédit sur l'art français. . . .

"Je ne demande pas non plus à M. le sous-secrétaire d'Etat [des beaux-arts] d'exercer lui-même un contrôle direct, absolument impossible à réaliser, sur les oeuvres exposées.

"Mais je lui demande tout simplement d'exiger des sociétés concessionnaires [le Salon d'Automne] des garanties indispensables, notamment en ce qui concerne la constitution de jury d'admission et de les prévenir que si, à l'avenir, le scandale de cette année se renouvelait, il se verrait alors dans l'obligation de leur refuser la concession du Grand Palais.

"Il est en effet, messieurs, absolument inadmissible que nos palais nationaux puissent servir à des manifestations d'un caractère aussi nettement antiartistique et antinational. (*Applaudissements*)" (author's trans.).

12. Ibid., 2924–26:

M. MARCEL SEMBAT: ". . . Le Salon d'automne a eu, cette année, l'honneur, toujours périlleux et flatteur, d'être un objet de scandale. C'est aux peintres cubistes qu'il a dû. . . .

"Je suis bien heureux qu'en réponse à ces campagnes véhementes, le Salon d'automne ait trouvé auprès de M. le sous-secrétaire d'Etat [des beaux-arts] et auprès de tous ceux qui le connaissent bien et s'intéressent à . . . un mouvement qui a exercé sur l'art moderne une si profonde et si heureuse influence. . . .

"M. Breton ne va pas jusqu'à proposer le rétablissement de la censure. Je l'en remercie. . . . Quand M. Lampué a écrit sa fameuse lettre, c'était bien ce but qu'il poursuivait. On mettait le sous-secrétaire de l'Etat en demeure de nous fermer les palais nationaux. C'était une façon de rétablir la censure, la plus vilaine et la plus brutale de toutes, je crois! . . .

"Qui donc contestera, même dans les milieux où l'on est le plus vite alarmé sur la [*sic*] tendances révolutionnaires, la valeur des [juges] et la sûreté de leur goût? Et alors je demande à M. Breton comment il se fait que des gens de goût si sûr et de talent si prouvé . . . aient ouvert la porte à des novateurs qu'il juge si dangereux? . . .

"Voilà pourquoi je répète qu'il faut tenir compte de l'avenir lorsqu'on voit une tentative d'art. . . ."

M. JULES-LOUIS BRETON: "Vous ne pouvez pas appeler ce que font les cubistes une tentative d'art!"

M. MARCEL SEMBAT: ". . . lorsqu'on voit une tentative d'art qui vous scandalise. . . ."

M. CHARLES BEAUQUIER: "On n'encourage pas l'ordure! Il y a des ordures dans les arts comme ailleurs. . . ."

M. MARCEL SEMBAT: "Mon cher ami, quand un tableau vous semble mauvais, vous avez un incontestable droit: c'est de ne pas le regarder, d'aller en voir d'autres; mais on n'appelle pas les gendarmes!" (author's trans.).

13. Ibid., 2928.

14. Archives Nationales, "Budget 1913. Coupures de Presse de 4 déc 1912" (F²¹4015). Louis Vauxelles, in *Gil Blas*, Dec. 4, 1912, 2, took the opportunity to declare his position, strongly flavored with anarchism, on the subject: "Alors quoi, me direz-vous? Mon dieu, oserai-je avouer que j'estime délétère l'intrusion de l'Etat dans la production artistique, et que je souhaiterais voir l'art, libre, s'épanouir dans l'Etat libre, doctrine individualiste des Goncourt, de Nietzsche et de Stirner" (author's trans.).

15. C. Morice in *Mercure de France*, Dec. 16, 1908, 736–37, trans. in Fry, 52.

16. Burgess, 405.

17. J. Metzinger, "Note sur la peinture," *Pan*, Oct.–Nov. 1910, 649–51, trans. in Fry, 60. Fry notes, 61, that Metzinger almost certainly knew Picasso by 1909, though that does not mean that we are hearing in this Picasso's own words. Roskill, in Part One of *The Interpretation of Cubism*, has pointed out the divergences between Cubism and its "theory" as "related but essentially indepen-

dent manifestations of the same time period and the same ongoing cultural context" (13).

18. Olivier-Hourcade, "La Tendance de la peinture contemporaine (notes pour une causerie sur l'art contemporain)," *Revue de France et des Pays français*, Feb. 1912, 35–41, trans. in Fry, 74; Raynal, preface, *Salon de juin: Troisième exposition de la Société normande de Peinture Moderne*, catalogue, Rouen, June 15–July 15 1912, 9–11, trans. in Fry, 91; Salmon, *La jeune peinture française*, Paris, 1912, trans. in Fry, 81–90; Apollinaire, *Les Peintres cubistes: méditations esthétiques*, Paris, 1913; Gleizes and Metzinger, *Du Cubisme*, Paris, 1912, trans. in Fry, 105–11.

19. Raynal, "Qu'est-ce que . . . le 'Cubisme'?" *Comoedia illustré*, Dec. 20, 1913, trans. in Fry, 130.

20. P. Reverdy, "Sur le cubisme," *Nord-Sud*, Mar. 15, 1917, 5–7, trans. in Fry, 145.

21. George, "Vorwort zur 93. Sturm-Ausstellung," *Der Sturm*, Berlin, Jan. 1921, 1–3, repr. in *L'Esprit Nouveau*, Feb. 1921, 520, trans. in Fry, 161. None of these writers openly discuss the change that has quite obviously taken place.

22. Ozenfant, *Foundations of Modern Art*, New York, 1952 (orig. Paris, 1928), 64 and 76. For a discussion of this characteristic in the prose of Ozenfant and Jeanneret, see Silver, 1977.

23. Cocteau, 1923, 227.

24. Cobban, 114–19.

25. Silver, 1981, passim.

26. R. Huelsenbeck, *En Avant Dada: A History of Dadaism*, Hanover, 1920, trans. in R. Motherwell, *The Dada Painters and Poets: An Anthology*, Boston, 1981, 36. My thanks to Teresa Carbone, whose report in my seminar, "Cubism and Its Critics," in fall 1982, gathered together an impressive number of such references and made clear to what a large extent the Dadaists and Surrealists considered Cubism their starting point.

27. Aragon, 44: "La grandeur du cubisme à cette époque est là: n'importe quoi, sans se préoccuper si c'est périssable, sert à ces peintres pour s'exprimer, et tant mieux si cela n'a pas de valeur, si cela dégoûte son monde" (author's trans.).

28. Tzara, 62.

29. Rubin, 1977, 154.

30. One notable exception to this view of Picasso's Cubist works is the suggestive study by Anne Edgerton, "Picasso's 'Nude Woman' of 1910," in which she argues that the *Nude Woman* is in fact a meditation on the mother-and-child theme, with the child merged into the mother's body.

31. See Meyer Schapiro, "Nature of Abstract Art," *Marxist Quarterly*, I, Jan. 1937, 77–98, repr. in M. Schapiro, *Modern Art, 19th and 20th Centuries: Selected Papers*, New York, 1978, 185–211. Although he attributed no particular conscious meaning to the artists themselves, Schapiro suggested that in the reiteration of still life in the Cubist period we can see the importance of the material surroundings of their artistic bohemia. See also Reff; and Edgerton.

32. Daix and Rosselet, nos. 104, 116, 131, and 128; see also nos. 126 and 127.

33. Daix (ibid., 220) has suggested that Picasso is also playing on Manet's *Déjeuner sur l'herbe*; the little boat in the foreground supports this.

34. Daix and Rosselet dates this in the summer, while Rubin, 1980, 116; dates it to "late 1908"; but both agree that it was painted after the return from La Rue des Bois.

35. Daix and Rosselet, nos. 133, 184, 231, 232, and 232b. *Three Women* of summer 1908 (reworked Nov. 1908–Jan. 1909), and its studies of spring–summer 1908 (see ibid., nos. 131, 116, 120, 123, 124, and Zervos, XXVI, 328 and 336), are less figures in a landscape than figures in an abstract setting, sometimes of landscape hues.

36. See ibid., nos. 216, 217, 218, 219, and 220; see also C. Geelhaar, "Pablo Picassos stilleben *Pains et compotier aux fruits sur une table*, Metamorphosen einer Bildidee," *Pantheon*, XXVIII, 1970, 127–40; and Rubin, 1983.

37. Palau i Fabre, 1966, 150; he goes on to note that Picasso told him that he had invented the palms.

38. Daix and Rosselet, 66 and 242; Fry, "Letter to the Editor," *Art Bulletin*, LXV, Mar.

1983, 146; Palau, 1966, 150, states that he has "searched in vain" for traces of this *fábrica*.

39. Palau i Fabre, 1966, 145.

40. See *The Oil-mill*, spring 1909, and *Mill at Horta*, spring–summer 1909, Daix and Rosselet, nos. 277 and 281.

41. Apart from the problematic questions raised by Paul Tucker, "Picasso, Photography and the Development of Cubism," *Art Bulletin*, LXV, June 1982, 288–99, regarding Picasso's use of photographs as models or aids in the composition and treatment of the Horta landscapes, the remoteness of this rural village in 1909 casts considerable doubt on whether the photographs could have been developed there, hence whether Picasso could have seen them before his return to Paris. The upheaval in Catalonia prevented Picasso and Olivier from traveling, as they make clear in the same letters to Gertrude Stein in which Picasso anxiously and repeatedly asks whether she had received the photographs. He might very well have been more anxious about the photographs if, as seems more likely, he had sent the undeveloped film to Paris, since the mail went through Barcelona, then at the center of the convulsion.

42. Brenan, 34; Ullman, 25; Palau i Fabre, 1981, 31 and 310.

43. O'Brian, 56.

44. Joll, 236.

45. Brenan, 34; Peers, 159.

46. Ullman, 284.

47. Kedward, 68; see also my discussion above, 70 and 164, n. 113.

48. Ullman, 284.

49. The following quotes from letters of Picasso and Olivier to Stein are exact transcriptions, as far as possible, including incorrect accents, spelling, and punctuation; neither wrote correct French, and Picasso tended to conflate French and Spanish. [?] indicates an illegible word: "Mes chers amis je ne vous le [?] pas ecrit avant [?] par ce que il parait que nous avons eté en Espagne en plein revolution et je avais [?] peur de que me [?] letres ne arrivera à votre [?] aujour-dui de [?] journaux comencent à arriver ici

et on dit que ce fini," Stein Collection, Beinecke Rare Book Library, Yale University, AL #22 (Horta) (author's trans.). It is evident that the present tentative date of this letter and several others must be revised from "May? 1909?" to July–August 1909. The major uprising took place in the second week of July. Given the remoteness of Horta, it must have been later in July by the time Picasso heard the news that the "revolution" was over, but not so far into August that Stein could not still plan to come to Spain.

50. "Nous avons vu en Espagne une grande revolution Maintenant ce fini je pensais que notre voiyage en Espagne allait etre fini," Stein Collection, AL #23 (Horta). Again "May? 1909?" should be changed to July–August 1909 (author's trans.).

51. "Ma chère Gertrude—Je crois avoir repondu a vos deux lettres. Mais les evenements qui se sont passés dans toute l'Espagne et principalement à Barcelone nous ont isolés du monde pendent une dizaine de jours et comme [?] le gouvernement empêchait toutes relations exterieures les lettres qui je vous ai envoyés [?] ont du vous parvenir de longtemps après que je les ai envoyees. Il pârait que le peuple avait demoli des ponts [?] de chemin-de-fer entrant a Barcelone. Je ne sais si vous êtes tres au courant de cela mais cela a eté tres grave," Stein Collection AL #24 (Horta), "May? 1909?" should be changed to July–August 1909 (author's trans.).

52. Cabanne, 1977, 134–35; Goldberg, 452; and Archives of the Préfecture de Police, Paris, "Manifestations en faveur de Ferrer, 31 oct. 1909" (Bᴬ1642). I have found no record of Gris's sentiments on Ferrer, but that his relationship to the Spanish military was identical to Picasso's is made clear in a letter he wrote to Kahnweiler at the outbreak of World War I, in J. Gris, *Letters of Juan Gris, Collected by D.-H. Kahnweiler*, trans. D. Cooper, London, 1956, 7: "But where shall I go? And How? The trains have been requisitioned for mobilization. Paris? It's risky. Spain? You know it might be unpleasant for me." Cooper notes that "Gris had not

done his military service in Spain and had not paid the exemption tax."

53. O'Brian, 170–71; Asis de Soler was now dead. See discussion in Chapter 1, 19–21, and *Arte Joven*, segunda época, Sept. 1909; as far as I can tell, this was the only issue to appear.

54. See Spector.

55. Bürger, 20.

56. G. Kahn, *Premiers poèmes*, Paris, 1897, 24, trans. in Herbert, 54.

57. R. Shiff, *Cézanne and the End of Impressionism*, Chicago, 1984, xiv.

58. See D. Robbins, "From Symbolism to Cubism: The Abbaye of Créteil," *Art Journal*, XXIII, Winter 1963, 111–16, and *Albert Gleizes: 1881–1953*, ex. cat., Guggenheim Museum, New York, 1962. Gleizes later discussed the failure of the Abbaye in "The Abbaye de Créteil, A Communistic Experiment," *The Modern School*, Oct. 1918, 300: "Parallel with certain outbursts of individualism, in complete accordance with outward anarchy—unconsciously following the general impulse destructive of the collectivist groups that were alone capable of restoring a higher sanction to art—there was on one occasion a real attempt at regeneration, an awakening of the collectivist conscience seeking to vindicate itself and to find itself once again." But, he concluded, 307, "Let it be at once admitted. Our anarchist tendencies, our independences, so imperious, did not bend easily to discipline, as such an affair required. Almost as soon as we felt the weight of orders and of our atavistic instincts, our constitutions hindered us from restraining the tendencies of our ideas of freedom."

59. Naum Gabo, "The Realistic Manifesto," Aug. 5, 1920, trans. in Chipp, 325–30. See also F. T. Marinetti, "The Founding and Manifesto of Futurism 1909" (first pub. in *Le Figaro*, Feb. 20, 1909), and U. Boccioni, C. Carrà, et al., "Manifesto of the Futurist Painters 1910," and "Futurist Painting: Technical Manifesto 1910," Apr. 11, 1910, trans. in U. Apollonio, ed., *Futurist Manifestoes*, New York, 1973, 19–31. See also

C. Taylor, *Futurism: Politics, Painting and Performance*, Ann Arbor, 1979; and M. Martin.

60. See discussion above, 98–101.

61. C. Mauclair, "Le Proléteriat des peintres," *La Revue hebdomadaire*, XXII, Jan. 1913, 354–69.

62. Kropotkin, "An Appeal to the Young," trans. in Kropotkin, 1970, 278.

63. See, for example, Johnson, 1977; Reff; and McCully, 1980.

64. See Nochlin, who looks at Picasso's personal symbolism in his use of color in the Marie-Thérèse paintings, 120–23 and 177–80.

65. See G. Schiff, *Picasso: The Last Years, 1963–1973*, New York, 1983.

66. G. Burgess, "The Wild Men of Paris," *Architectural Record*, May 1910, which was first discovered and analyzed by Edward Fry in "Cubism 1907–1908: An Early Eyewitness Account," *Art Bulletin*, XLVIII (Mar. 1966), 70–73; and M. de Zayas, *Pablo Picasso*, New York, Apr. 1911, ex. cat. 291 Gallery, published in a more lengthy version in Spanish as "Pablo Picasso," *América, revista mensual ilustrada*, New York, VI, May 1911, 363–65. Although extremely valuable, both are written in paraphrase and therefore must be used carefully. The de Zayas is particularly interesting since he could speak Spanish with Picasso and was deeply sympathetic with his artistic attitudes, though in my opinion he tended to conflate Picasso's ideas with his own; my thanks to William I. Homer for generously bringing the Spanish version to my attention.

67. Picasso's first official utterance on the subject was an interview with Florent Fels, "Propos d'artistes: Picasso," *Les Nouvelles littéraires, artistiques et scientifiques*, Aug. 4, 1923, with selections published in English as "Picasso Speaks," in *The Arts*, May 1923 and partly reprinted in F. Fels, *Propos d'artistes*, Paris, 1925, 139–45. Marius de Zayas's claim, canonized by Alfred Barr in *Picasso: Forty Years of His Art*, New York, 1939, that this interview was conducted by him in Spanish has recently been convincingly refuted by William Rubin in "Picasso," 1984, 260 and notes 63 and 64.

68. Gilot, 135.

69. Penrose, 191; H. Guilbeaux, "Le Cubisme et MM. Urbain Gohier et Apollinaire," *Les Hommes du jour*, no. 99, Nov. 11, 1911, 8.

70. Penrose, 204.

71. Barr, 1946, 270–71.

72. *Ogoniok*, Moscow, May 1926, trans. and repub. in *Formes*, 1930, 2–5, and *Creative Art*, June 1930, 383–85; repr. in Picasso, *Two Statements*, New York, 1936, M. Armitage, ed., 23–49, from which this quote is taken, 31. (Picasso, in 1939, characteristically denied this letter's authenticity, Barr, 1946, 286.)

73. *Quelques intentions du cubisme*, Paris, 1919, trans. in Fry, 151–53.

74. For a study of this question, see Lipton. See also John Berger, *The Success and Failure of Picasso*, 1965, for an interesting and lengthy essay on the subject of Picasso's "image."

75. Rubin, 1972, 72.

76. Golding, 1968, 73, note 2.

77. Reff, 19; McCully, 1980, 66–67, suggests that the recurrence of the Harlequin motif in 1909 may relate to Picasso's acquaintance with circus performers, based on a letter from Olivier to Gertrude Stein. Since Picasso, however, had known circus performers since 1905, with no recorded hiatus, this suggestion seems tenuous.

78. Reff, 28; see Daix and Rosselet, nos. 222, 232b, 242, 258, 259, 260, 261, and 263.

79. Daix and Rosselet, no. 618. Reff incorrectly dates this work to 1912; see Jardot, no. 39, and Daix and Rosselet, 308.

80. See my discussions in Chapters 1 and 3.

81. Rubin, 1983, 639, suggests the possibility that the figure may represent Braque but sees him as merely the mediator for Cézanne's influence. I depart from Rubin's argument on the identification of a number of figures in this work.

82. Daix and Rosselet, no. 215; the work has sometimes been called *Still-Life with Hat (Cézanne's Hat)*, though it is extremely unlikely that Picasso named this painting himself.

83. Daix and Rosselet, 252.

84. It was Barr, 1946, 270, who suggested the renaming of the work in 1939.

85. The title presumably underscores the bullfight motifs evident in such references as LE TORERO, though Picasso wrote "Portrait d'homme/Sorgues 1912/Picasso" on the back, Daix and Rosselet, no. 500; see ibid., 285.

86. Ibid., nos. 534, 536, and 537.

87. Daix and Rosselet, nos. 617 and 618.

88. Braque later remarked, "I was seeking a tactile, palpable space as I like to call it, and musical instruments, as objects, also have this characteristic, you can bring them to life by touching them," Vallier, 173–78.

89. See Braque's *Still-Life with Musical Instruments*, 1908, ill. in Golding, Fig. 29B; Daix notes this in Daix and Rosselet, 241.

90. Daix and Rosselet, nos. 341 and 346.

91. See Zervos I, 178 and 186, and VI, 348; ill. in Palau i Fabre, 1981, Figs. 924, 925, and 926.

92. Penrose, 145.

93. Steegmuller, 141 and 152, quotes Braque and Picasso, who later called Apollinaire "King among poets and jester among art critics." Picasso also said to Douglas Cooper, after having seen the new collected volume of Apollinaire's art criticism in 1960, "It was sad to find how shallow they were, how little sense they contained, when one remembered how important they had seemed to be at the time of publication," ibid., 143 and 356. For a discussion of Apollinaire's support of revolutionism in art, see Chapter 2.

94. Apollinaire, *Calligrammes: Poèmes de la paix et de la guerre (1913–1916)*, 1966, 184.

95. Daix and Rosselet, 269.

96. Just such a pipe rack reappears on the upper left in Picasso's *Pipes, Cup, Coffepot and Carafe*, summer 1911, and at the very top of his *Bottle, Glass and Fork*, winter 1911–1912, ibid., nos. 417 and 447; also noted by Daix and Boudaille, 268.

97. Ill. in Monod-Fontaine and Carmean, Fig. 43.

98. Steegmuller, 176.

99. Despite much persuasive material

and argument regarding the meaning of the presence of these pipes in A. Martin, "Georges Braque and the Origins of the Language of Synthetic Cubism," in Monod-Fontaine and Carmean, 61–73, I disagree on a number of crucial points. The pipe could not have been a "personal attribute" for Braque (65–69) since the little white clay pipes were also the ever-present props of Picasso, Salmon, and Apollinaire, as well as thousands of other Parisians. See, for instance, Picasso's two self-portraits with a pipe of 1904–1905 (Daix and Boudaille, D.XI.28 and 29) and his drawing of Salmon of 1907 (Caizergues, 1981a, 20, Fig. 2), as well as the drawings of Apollinaire discussed here.

100. Breunig, 31–32; and Shattuck, 1968, 263 and 274–75.

101. Shattuck, 1968, 266.

102. Olivier, 1964, 62.

103. Gabriel Arbouin, "Devant l'idéo-gramme d'Apollinaire (1)," *Les Soirées de Paris*, III, July–Aug. 1914, 383–85. Do the initials of this author suggest that he is actually the poet? Needless to say, given the date, neither the second part of this article nor another issue of *Les Soirées* ever appeared. For an enlightening discussion of "Lettre-Océan" as a major statement of modernism, see Shattuck, "Apollinaire's Great Wheel," 1984, 240–62; see also Perloff for a consideration of the relations between the poetry and painting in this period.

104. Quoted in Steegmuller, 142; it is unclear whether the coauthor is Steegmuller himself or a quoted source.

105. Formal discussions of how precisely this was done in Cubist canvases have brilliantly and adequately explored this stylistic revolution. In my view Golding, 1968, and Rosenblum, 1960, are especially thorough, imaginative, observant, and well argued, and I feel no need in this study to add to this aspect of the literature on which I am building.

106. This can also be seen in such other high modernists as Pound, Eliot, Joyce, Schoenberg, and Duchamp, where radical subversion always proceeds in relation to an inverted or hidden norm; my thanks to Edward Fry for discussion on this point.

Chapter 5

1. In response to strikes by miners of the Nord and the Pas-de-Calais in 1906, by dockers of Nantes, vineyard workers of the Midi, and electricians of Paris in 1907, and by construction workers in 1908, the government dispatched military troops who fired on the assembled strikers, killing twenty and wounding 667 in these three years. The fact that the Radical government of Georges Clemenceau lent its police power to the employers encouraged disillusionment and class hatred. Even the old socialist Aristide Briand, in the name of national defense and patriotism, used government power to break an important transport strike in 1910 by conscripting the railroad workers into the army and threatening them with court-martial. See Tuchman, 515–16 and 532; and Goldberg, 353–68. For an extended discussion, see Dolléans, Vol. II.

2. Goldberg, 368; Joll, 202ff.

3. See Goldberg, 342ff.

4. See ibid., 429ff.; and E. Helmreich, *The Diplomacy of the Balkan Wars, 1912–1913*, Cambridge, Massachusetts, 1938 (repr. 1969).

5. Proudhon, letter to Romain Rolland, June 3, 1861; trans. in Joll, 69.

6. Goldberg, 380ff.

7. Quoted in Maitron, 349: "Quand on vous commandera de décharger vos fusils sur vos frères de misère . . . travailleurs, soldats de demain, vous n'hésiterez pas, vous n'obéirez pas. Vous tirerez, mais non sur vos camarades. Vous tirerez sur les soudards galonnés qui oseront vous donner de pareils ordres. . . . Quand on vous enverra à la frontière défendre le coffre-fort des capitalistes contre d'autres travailleurs abusés comme vous l'êtes vous-mêmes, vous ne marcherez pas. Toute guerre est criminelle. A l'ordre de mobilisation, vous répondrez par la grève immédiate et par l'insurrection" (author's trans.).

8. Goldberg, 351; Maitron, 350.

9. Goldberg, 382–83 and 442.

10. Kahnweiler, 1971, 23.

11. Steegmuller, 281ff. André Salmon, in *La Terreur noire*, 500ff., discussed the atmosphere in the days of the mobilization: Jaurès was dead and "Kropotkin était d'accord avec les poilus [soldiers]." Passions ran high at that time. Vlaminck, who was fiercely pacifist and did his war service by working in a factory, was horrified by the enthusiasm for the war of his longtime friend and artistic collaborator André Derain, and he claimed it completely ended their friendship; see A. Derain, *Lettres à Vlaminck*, intro. and commentary by M. Vlaminck, Paris, 1955, 213–20.

12. See Monod-Fontaine and Carmean for a complete catalogue of Braque's collages.

13. See Boccioni, Carrà, et al., "The Exhibitors to the Public," ex. cat., Bernheim-Jeune, Paris, Feb. 5–12, 1912, trans. in Taylor, 127–29, where they accuse the Cubists of traditionalism in contrast to their own "violently revolutionary" art, which is "the result of absolutely futurist conceptions, ethical, aesthetic, political and social." See also M. Martin, 123–30. Later Picasso, by gluing pieces of the Futurists' journal *Lacerba* into two collages of spring 1914 (Daix and Rosselet, nos. 701 and 702), literally incorporates them in his work and, so to speak, enframes them in his own art. In the second collage, *Wineglass, Bottle of Wine, Newspaper, Plate and Knife ("Purgativo")*, unusually large and clear images of an empty plate, fork, and knife suggest that Picasso has purged himself of worry about the Futurists' attacks on him by consuming them, another level of "incorporation."

14. Daix and Rosselet, perhaps following Rosenblum's lead in "Picasso and the Typography of Cubism," read much of the newsprint in the collages, usually for purposes of dating, and pointed out some (but not all) of the allusions to the Balkan Wars, which has been of invaluable help in this study; but they did not go on to consider the possible political relevance of the subject's reiteration for Picasso.

Daix, 287, mistakenly notes this newspaper clipping as from the Nov. 10, 1912, edition of *Le Journal*. The witty play with the several meanings of the headline suggests that Daix's sequence is correct; but in that it is drawn from the same issue, Nov. 18, 1912, as *Violin* and *Bottle of Suze* (Fig. 82 and Pl. VIII), it is less definitively the first than Daix asserts.

15. Author's trans., as it reads in the collage: "Bientôt j'aperçus le premier cadav[re] encore grimaçant de douleur et la fig[ure] presque noire. Puis j'en vis deux, qu[a]tre, dix, vingt; puis je vis cent cadavr[es.] Ils étaient allongés là où ils étaient tombés pendant la marche du sinistre con[n]voi, dans les fossés ou en travers [le] chemin, et les files de voitures chargé[es] de moribonds s'allongeaient toujou[rs] sur la route désolée.

"Combien de cholériques ai-je ain[si] rencontrés? Deux mille? Trois mille[?] Je n'ose pas donner un chiffre préc[is.] Sur une longueur d'une vingtaine [de] kilomètres, j'ai vu des cadavres jo[n]chant la route maudite où souffle u[n] vent de mort et j'ai vu des agonisan[ts] défiler lugubres au milieu des troupe[s] d'ailleurs indifférentes et qui se prép[a]raient au combat.

"Mais je n'avais encore rien vu."

16. "Les plus écoutés sont d'abord les étrangers, et parmi eux M. Scheidemann, qui affirme 'que les prolétaires allemands ne tireront pas sur leur frères français' . . ."; "M. Sembat termine son discours en affirmant que les travailleurs ne doivent pas se faire tuer 'pour les capitalistes et les fabricants d'armes et munitions' . . ."; "En présence des menaces d'une guerre [euro]péene généralisée. . . ." (author's trans.).

17. All numbers Daix and Rosselet: *Violin* (no. 524); *Wineglass, Violin and Newspaper* (no. 527); *Head of a Man* (no. 532); *Man with a Violin* (no. 535) (Fig. 84); *Head of a Man* (no. 538); *Table with Bottle, Wineglass and Newspaper* (no. 542); *Bottle and Wineglass* (no. 544); *Bottle and Wineglass* (no. 549); *Table with Bottle and Guitar* (no. 550); *Bottle on a Table* (no. 551) (Fig. 88); *Table with Bottle and Wineglass* (no. 554). Documentary photo-

graphs of Picasso's studio, illustrated in ibid., 358, indicate that he may have worked on many of these simultaneously.

18. "Toutefois, si une tierce puissance intervenait, l'Allemagne jetterait son épée dans la balance"; "campagne antimilitariste" and "l'extrême gauche" (author's trans.).

19. *Table with Bottle and Guitar* (Daix and Rosselet, no. 550). See also ibid., nos. 543, 544, 546, 547, 552, and 553.

20. Zervos, XXVIII, 307 (not in Daix and Rosselet). See Tuchman, 537, for a discussion of the three-year law.

21. "Le gouvernement français a compris l'éten[d]u[e] et urgence de son devoir en présence des formidables préparatifs de guerre de l'empire allemand. Il reconnaît la nécessité de réparer au plus vite et à tout prix les défauts de notre organization militaire. Pour améliorer le matériel, il demande des crédits extraordinaires—plusieurs centaines de millions—et pour accroître les ef[f]ectifs de l'armée active, il [ir]a au besoin, dit-on, jusqu'à proposer le rétablissement du service de trois ans" (author's trans.).

22. I have been unable to obtain photographs with legible details of eleven of the fifty-two collages, several of which are destroyed or lost. It is likely that some of them would raise the percentage of political clippings further.

23. See Daix and Rosselet, nos. 514, 515, and 516; and 506, 508, 509, 510, 511, and 512.

24. *Notre Avenir est dans l'Air* (Anon.), Paris, Feb. 1, 1912, Imprimerie Charaire, Sceaux. Daix and Rosselet, nos. 463, 464, and 465. See also Nochlin.

25. See discussion in Chapter 2, 55.

26. Daix and Rosselet, nos. 451 and 466.

27. Ibid., nos. 555 and 630. Both of these constructions are now visible in the Musée Picasso in the Hôtel Salé, Paris.

28. Paul Signac, a longtime anarchist supporter and close friend of the leading French anarchist intellectual Jean Grave, expressed his extreme disillusionment at Grave's support for the French cause when the war actually came and wrote him c. 1918–1919: ". . . laissez-moi vous confier,

mon cher ami, qu'un de mes grands chagrins de ces horribles temps, a été causé par votre évolution au début de la guerre. Nourri de vos principes, de ceux de Reclus, de ceux de Kropotkine,—car c'est vous qui m'avez formé—je n'ai pu comprendre que vous admettiez la guerre, et que vous ne protestiez pas contre le déchaînement de cette horreur, que vous puissiez faire une différence entre la bonne et la mauvaise guerre—Vous m'avez enseigné que la guerre est mauvaise, toujours, atroce. . . . Les résultats actuels doivent vous prouver que vous êtes trompé, si vous avez cru un moment qu'il fallait se battre pour la noble cause de la fin du militarisme." (Undated letter from Signac, Fonds Jean Grave, Institut Français d'Histoire Sociale, Paris; pub. in Herbert, 1960, 520.)

29. Steegmuller, 281ff. André Salmon in *La Terreur noire*, 500, discussed the impact of Kropotkin's outspoken call to defend the Allied cause against the Germans, a shocking reversal of his lifelong position against any and all wars.

30. J. Crespelle, *La Vie quotidienne à Montparnasse à la grande époque, 1905–1930*, Paris, 1976, 98.

31. Letters written to Gertrude Stein as early as 1909 show that Picasso's French, while not perfect, was perfectly adequate to understand the subtleties of the articles pasted into these works; in comparison with letters written to Max Jacob in 1902, his French had considerably improved after his move to Paris. The only use of a Spanish newspaper that I have found is a sheet of advertisements and a small circular piece of text from *El Diluvio*, a Spanish daily, edited by his anarchist friend Jaume Brossa, of March 31, 1913, both of which Picasso incorporated into *Guitar*, Céret, spring 1913 (Fig. 103).

32. Salmon, 1956, 154; Dardel, 9. The other three major dailies of this size were *Le Petit Journal*, *Le Petit Parisien*, and *Le Matin*, none of which Picasso incorporated into the collages.

33. See Daix and Rosselet, 259, and

Rubin, 1980, 122; see also my discussion in Chapter 3.

34. Herbert, 1961, 188.

35. Penrose, 104–5.

36. See Dardel, 46.

37. Herbert, 1961, 50.

38. M. Baxandall, *Patterns of Intention: On the Historical Explanations of Pictures*, London and New Haven, 1985, 53–55, rightly notes: "The most striking thing about Picasso's choice in the market was that he elected to have nothing at all to do with the black Salons: their catalogues without his name in them are the nearest thing to a firm verbal document of Picasso's intention in these years," and concludes, "This had not been an easy road and certainly cannot be presented as a commercially directed strategy."

39. From a manuscript of c. 1902 in the Signac archive, quoted in R. Herbert, "Les Artistes et l'anarchie," *Le Mouvement social*, July–Sept. 1961, 9: "Le peintre anarchiste n'est pas celui qui représentera des tableaux anarchistes, mais celui qui, sans souci de lucre, sans désir de récompense, luttera de tout son individualité contre les conventions bourgeoises et officielles par un apport personnel" (author's trans.).

40. See Rosenblum's landmark article "Picasso and the Typography of Cubism," 1973b.

41. Apollinaire, 1949, 21.

42. See my discussion in Chapter 2.

43. See *Les Soirées de Paris*, Feb. 1912–July-Aug. 1914, repr. Geneva, 1971 (page references are to repr. edition): J. Tharaud, "La Guerre des Balkans," I, Nov. 1912, 289–92; Tharaud, "Nos Collaborateurs dans les Balkans," I, Nov. 1912, 320; A. Tudesq, "La Guerre des Balkans," I, Dec. 1912, 338–41; Anon., "Sur l'Albanie," II, 50–56.

44. Salmon, 1956, 123; Tudesq also wrote for *Le Journal* and *Montjoie!*. See A. Tudesq, "Notes de campement," *Montjoie!*, I, 1913, 2.

45. Trans. in B. Cendrars, *Selected Writings of Blaise Cendrars*, ed. and intro. W. Albert, New York, 1966, 139–41.

46. See Soby, 11–12, and Rosenthal, 11–12; see also S. Appelbaum, *French Satirical Drawings from 'L'Assiette au beurre'*, New York, 1978, 74–77.

47. See Gris, *Letters of Juan Gris, Collected by D.-H. Kahnweiler*, trans. Douglas Cooper, London, 1956.

48. See Soby, Figs. 46 and 60; see also ibid., Fig. 39; and Rosenthal, nos. 15, 23, and 35. L. Kachur, in his review of Rosenthal, *Burlington Magazine*, 126, June 1984, 382, points out how highly intentional Gris's use of collage elements was.

49. R. Huelsenbeck, "En Avant Dada: A History of Dadaism," 1920, trans. in R. Motherwell, *The Dada Painters and Poets: An Anthology*, 2nd ed., New York, 1981, 32. Hans Arp was particularly enamored of Picasso's work; see discussion below, 142.

50. See J. Elderfield, *Kurt Schwitters*, London, 1985, 73; and A. Nill, "Weimar Politics and the Theme of Love in Kurt Schwitters' *Das Bäumerbild*," *Dada-Surrealism*, no. 13, 1984, 17–36.

51. Apollinaire, "Letter from Paris," *Le Passant* (Brussels), Nov. 25, 1911, trans. in Apollinaire, 1972, 189–91.

52. Trans. in Jarry, 1965, 59.

53. Shattuck, 1968, 248.

54. Ibid., 249.

55. "Picasso Speaks," *The Arts* (New York), May 1923, repr. in Barr, 1946, 270.

56. Zervos, "Conversation avec Picasso," *Cahiers d'Art*, 1935, trans. in Barr, 1946, 274.

57. O'Brian, 81.

58. "Picasso Speaks," in Barr, 1946, 271.

59. Olivier, 1964, 139.

60. Sabartés, 1948, 67.

61. Ibid., 68.

62. Malraux, 110–11.

63. *Action*, III, Apr. 1920, 26.

64. Sabartés, 1948, 145–46.

65. Penrose, 167–68.

66. Fels, 1923, trans. in Barr, 1946, 270.

67. Zervos, 1935, trans. in Barr, 1946, 274.

68. *Ogoniok* (Moscow), xx, May 16, 1926; trans. with punctuation as given in *Formes*, II, Feb. 1930, 5. According to Barr, 1946, 286, "Picasso says (1939) that the letter is spurious."

69. Rosenblum, "Picasso and the Corona-

tion of Alexander III: A note on the dating of some *Papiers collés*," 1971, discovered that this work and related ones (Daix and Rosselet, nos. 583, 591, 604, and 605) utilized an issue of *Le Figaro* dated May 28, 1883, which makes these five works anomalous among the collages as a whole; this clipping reads, in part, "la cérémonie la plus majestueuse qu'on puisse imaginer. . . . dans la tradition des autres siècles" (author's trans.).

70. See Palau i Fabre, 1981, Figs. 865, 868, 1006, and 1009.

71. Salmon, 1920, 79; Salmon, 1955, 371–74, notes that he wrote this novel in 1907–1908, though it was not published until 1920.

72. Daix and Rosselet, 290, dates this work (no. 526) to "autumn 1912"; the clipping comes from December 1, 1912.

73. Ibid., no. 546.

74. Ibid., no. 557.

75. Ibid., no. 545.

76. Salmon, 1956, 56.

77. See *Gargallo: Exposició del Centenari*, ex. cat., Palau de la Virreina, Barcelona, 1981, Figs. 9a-d; and Cabanne, 1977, 193–94, whose text somewhat confusingly indicates, incorrectly, that the heads were done in 1913, the date of a quite similar portrait of Picasso.

78. Monod-Fontaine and Carmean, no. 44.

79. This item is reminiscent of Jarry, who has Shakespeare visit Stratford-on-Avon to find them exhibiting his "skull at the age of five," Jarry, 1972, 768–69. Roskill, 71–75, considers other instances of Braque's use of newsprint and letters in this period.

80. Rosenthal, Fig. 12.

81. "On ne truquera plus les oeuvres d'art" (author's trans.). Rosenthal, 58, points to other instances of Gris's wit in the collages.

82. Daix and Rosselet, nos. 600, 603, 604, 605, 611, 701, and 705.

83. Ibid., no. 547.

84. See my discussion in Chapter 4.

85. "Les plus irrésistibles . . . Les plus jolies artistes! Les scènes les plus drôles! Les couplets les plus spirituels!" (author's trans.).

86. Ill. in P. Waldberg, *Surrealism*, New York, n.d., Fig. 124.

87. Daix and Rosselet, no. 598.

Chapter 6

1. Olivier, 1933, 125–26.

2. Cabanne, 1977, 170.

3. Ibid., 173.

4. See P. Fussell, *The Great War and Modern Memory*, New York, 1976, 7–18.

5. J. Russell, *Georges Braque*, London, 1959, 23.

6. Daix and Rosselet, 337 and no. 782.

7. Goldberg, 429.

8. Salmon, 1956, 260: "l'hymne royal espagnol, Pablo n'étant pas encore révolutionnaire" (author's trans.).

9. Quoted in Cabanne, 1977, 171.

10. Ibid., 170. Apollinaire was wounded in the head in 1916 and never fully recovered; in his weakened condition he succumbed to the Spanish flu in November 1918.

11. See B. Liddell Hart's lucid account of the war, *A History of the World War 1914–1918*, London, 1934; and Silver, 1981, for an analysis of the quick move toward patriotism among avant-garde artists at the beginning of the war.

12. G. Apollinaire, "Living Art and the War," *Le Petit Messager des Arts et des Industries d'Art*, Mar. 1, 1915, trans. in Apollinaire, 1972, 439–40. Robert Delaunay was in neutral Portugal in 1915–1916, an act which Apollinaire implies is cowardly and therefore not believable.

13. Cabanne, 1977, 172, reports that Picasso considered joining the Foreign Legion—a telling, if authentic, later fiction.

14. See documentary photographs in Daix and Rosselet, 359.

15. Cabanne, 1977, 172. Daix, 1977, notes to Pl. 21, suggests that this figure represents Diego Rivera, another foreigner exempt from service, though I find the identification improbable given the cane and extreme obesity of the figure.

16. See also Daix and Rosselet nos. 845, 846, 849, 850, and 856.

17. See Daix and Rosselet, nos. 873 and 874.

18. Other artists of the prewar avant-garde also remained in Paris, including Gris, Gino Severini, Diego Rivera, and Henri Matisse, though their presence neither represented an ongoing avant-garde movement nor mitigated very much their individual isolation.

19. Berger, 1965, 90. Though Braque later worked for Diaghilev, too, la bande à Picasso had always preferred working-class entertainments like the circus.

20. Quoted in Steegmuller, *Cocteau: A Biography*, Boston, 1970, 149.

21. See Silver, 1981, 142ff.; and Lipton.

22. Gilot and Lake, 135. Picasso's Nietzscheanism has here translated to a narrow egotism.

23. See Nochlin; and Silver, 1977. Even during the war, in 1915, Picasso contributed to the first issue of Ozenfant's new and specifically patriotic art journal *L'Elan*, whose opening editorial chauvinistically announced that "it will fight against the enemy wherever it finds it, even in France . . . our only goal being the propaganda of French art, of French independence, in sum of the true French spirit," *L'Elan*, Apr. 15, 1915, 2. See also my discussion above, 103–4. Christopher Green's *Cubism and Its Enemies: Modern Movements and Reaction in French Art, 1916–1928*, New Haven and London, 1987, came into my hands only as this book went to press.

24. See W. Rubin, *Dada and Surrealist Art*, New York, n.d. [1968], 210–12, for a discussion of the dramatic political arguments and controversies that raged among the Surrealists over issues of collectivism vs. individualism. See also S. Stitch, "Picasso's Art and Politics in 1936," *Arts*, LVIII, Oct. 1983, 113–18; and Seigel, 384–89, who discusses the anarchist component of Breton's and other Surrealists' revolutionism.

25. Zervos, IX, 65; trans. in Ashton, 140.

26. Later "propagandistic" works include *The Charnel House*, 1945—sold for the benefit of the Spanish Refugee Relief in 1946, Janis, 11—and *Massacre in Korea*, 1951. The immediately preceding "Surrealist" *Dream and Lie of Franco* of January 1937, although it lacked the clarity of *Guernica*'s statement, was sold for the profit of the Spanish republican government, Penrose, 305.

27. Trans. in Ashton, 143–44.

28. Stein, 1937, 131.

29. My thanks to Lydia Gasman for this information.

30. See Barr, 1946, 263, who records at least two separate gifts of 100,000 francs for unknown supplies and 400,000 francs for relief supplies.

31. P. Tuchman, "Guernica and 'Guernica,'" *Artforum*, XXI, Apr. 1983, 44–51.

32. Tuchman (ibid., 45) offers different suggestions for the exclusive use of black, white, and gray in this work, among them the thought that the Spanish pavilion was itself "in mourning."

33. Repr. in Ashton, 145.

34. Repr. in Barr, 1946, 267–68 (author's trans.).

35. See Caute, 188.

36. Rubin, 1980, 352–53. Picasso took his own writing, and Jarry's, extremely seriously, later telling a Spanish friend, Miguel Acoca, that after his death encyclopedias would read, "Picasso, Pablo Ruiz—Spanish poet who dabbled in painting, drawing and sculpture," trans. in McCully, 1982, 196.

37. Cabanne, 1977, 173.

38. Caute, 188: "It was in 1949 that Stalin Peace Prizes were initiated. As Casanova made clear in September, the aims of the Movement, far from being general and idealistic, were specifically designed to discredit the Atlantic Pact, rearmament [of the West], the new West German state and Marshall aid. Picasso's white dove crowned the edifice." Caute, 228, notes, however, that Picasso and nine other communist intellectuals in France issued a letter of protest to the PCF regarding its manipulation of information about the Hungarian uprising in 1956.

39. Picasso, speaking at the unveiling of

his *War* and *Peace* panels in the chapel at Vallauris, trans. in Ashton, 158.

40. Carles Junyer Vidal, *El Liberal,* Mar. 24, 1904, trans. in Palau i Fabre, 1981, 515–16.

41. Zervos, 1935, 173–78, trans. in Barr, 1946, 274.

42. R. Guttoso, *Journals,* trans. in Ashton, 17.

43. See M. Schapiro, "Nature of Abstract Art," *Marxist Quarterly,* 1, Jan. 1937, 77–98, repr. in Schapiro, *Modern Art, 19th and 20th Centuries: Selected Papers,* New York, 1978, 185–211; C. Greenberg, "Avant-Garde and Kitsch," orig. pub. 1939, and "On the Role of Nature in Modernist Painting," orig. pub. 1949, both repr. in Greenberg, *Art and Culture: Critical Essays,* Boston, 1961; J. Berger, *The Success and Failure of Picasso*; M. Raphael, *Proudhon, Marx, Picasso: trois études sur la sociologie de l'art,* Paris, 1933, trans. in G. Schiff, *Picasso in Perspective,* Englewood

Cliffs, New Jersey, 1976, 106–16; and A. Hauser, *The Social History of Art,* Vol. iv, New York, 1951, 230–34. This is not to suggest that these works do not offer many valuable insights into Picasso's art, especially, in my view, Schapiro and Berger; but they all share an assumption of Picasso as apolitical in his early period. Even Berger, in *The Moment of Cubism and Other Essays,* 27, who sees the step taken by the inventors of Cubism as "revolutionary," cannot credit them with full consciousness of their act, insisting with unfounded confidence: "I must emphasize again that the Cubists were not aware of all that we are now reading into their art. Picasso and Braque and Léger kept silent because they knew that they might be doing more than they knew."

44. See *Action,* iii, Apr. 1920, 26; Jacob, 1927, 48–49; Salmon, 1945, 35; Penrose, 118; and "Picasso et la Politique," 9 (author's trans.).

45. Trans. in Apollinaire, 1949, 14–15.

Selected Bibliography

Primary Sources

A la mémoire de Pierre Quillard. Paris, 1912.

Action, III, Apr. 1920, 26 [statement by Picasso].

Albert, Charles. *L'Art et la société.* Paris, 1896.

——. *Qu'est-ce que l'Art?* Paris, 1909.

d'Aoust, J. "La Peinture cubiste, futuriste . . . et au-delà," *Livres et Art,* I, Mar. 1912, 153–56.

Apollinaire, Guillaume. *Alcools: Poems 1898–1913,* intro. and notes Francis Steegmuller, trans. William Meredith. New York, 1964.

——. *Apollinaire et "La Démocratie sociale",* ed. and intro. Pierre Caizergues. Paris, 1969.

——. *Apollinaire on Art: Essays and Reviews, 1902–1918,* ed. Leroy Breunig, trans. S. Suleiman. New York, 1972.

——. *Calligrammes: Poèmes de la paix et de la guerre (1913–1916).* Paris, 1918 (repr. 1966).

——. *Les Peintres cubistes: méditations esthétiques.* Paris, 1913 (trans. Leon Abel, New York, 1949).

——. *Selected Writings,* trans. Roger Shattuck. New York, 1950.

Aragon, Louis. *La Peinture au défi.* Paris, 1930.

Arbouin, Gabriel. "Devant l'idéogramme d'Apollinaire (1)," *Les Soirées de Paris,* III, July-Aug. 1914 (repr. Geneva, 1971, 383–85).

Archives Nationales, "Listes d'Anarchistes"; "Budget 1913. Coupures de Presse de 4 déc. 1912."

Archives de la Préfecture de Police, Paris, "Anarchistes en Espagne [1888–1914]"; "Anarchistes, 1 jan. 1899–31 déc. 1900"; "Anarchistes, 1 nov. 1903–31 déc. 1906"; "Listes et états des Anarchistes, 1900 à 1912"; and "Ferrer, Francisco," 2 dossiers.

Ashton, Dore. *Picasso on Art: A Selection of Views.* New York, 1972.

L'Assiette au beurre, 1901–1912; see especially issues on colonialism, no. 140, Dec. 5, 1903, and no. 181, Sept. 17, 1904 [text by André Salmon].

Bakunin, Mikhail. *Dieu et l'état.* Geneva, 1882 (trans. New York, 1916, repr. New York, 1970).

Baroja, Pío. *Caesar or Nothing.* New York, 1976.

——. *Obras completas.* 8 vols. Madrid, 1946–1968.

——. *Red Dawn.* New York, 1924.

——. *Weeds.* New York, 1923.

Bibliothèque Nationale, Salle des manuscrits, "Apollinaire, livre d'adresses"; "Lettres adressées à Jean de Pierrefeu."

Brassaï (Gyula Halász). *Picasso and Company.* New York, 1966.

Burgess, Gelett. "The Wild Men of Paris," *Architectural Record,* XXVII, May 1910.

Cocteau, Jean. "Interview with Jean Cocteau," *Writers at Work: The Paris Review Interviews,* Third Series. New York, 1967.

——. *Picasso.* Paris, 1923.

Coriolès. "A Propos de l'Internationalisme en Art," *Le Gaulois,* Jan. 3, 1910, 2.

Crosse en l'air, le mouvement ouvrier et l'armée, 1900–1914. Paris, 1970 [facsimile pamphlets].

Derain, André. *Lettres à Vlaminck,* intro. and commentary by Maurice Vlaminck. Paris, 1955.

Eluard, Paul. "Je parle de ce qui est bien," *Cahiers d'Art,* XI, 1936, 30.

Fagus, Félicien. *Testament de ma vie première.* Paris, 1898.

Fels, Florent. *L'Art vivant de 1900 à nos jours.* Geneva, 1950.

———. *Propos d'artistes.* Paris, 1925.

Le Festin d'Esope: Revue des belles lettres, ed. Guillaume Apollinaire. Nos. 1–9, Nov. 1903–Aug. 1904.

George, Waldemar. *Picasso.* Paris, n.d.

Gilot, Françoise, and Carlton Lake. *Life with Picasso.* New York, 1964.

Gleizes, Albert, and Jean Metzinger. *Du Cubisme.* Paris, 1912.

Gohier, Urbain. "Notre Peinture," *Le Journal,* Oct. 10, 1911, 1.

Golberg, Mécislas. *La Morale des lignes.* Paris, 1908.

Grave, Jean. *Contre la folie des armaments.* Paris, 1913.

———. *Le Mouvement libertaire sous la Troisième République (Souvenirs d'un révolté).* Paris, 1930.

Gris, Juan. *Letters of Juan Gris, Collected by D.-H. Kahnweiler.* Trans. Douglas Cooper, London, 1956.

Guilbeaux, Henri. "Le Cubisme et MM. Urbain Gohier et Apollinaire," *Les Hommes du jour,* Nov. 11, 1911, 8.

Institut Français d'Histoire Sociale. *L'Anarchisme: catalogue des livres et brochures des* xixe *et* xxe *siècles.* Paris, Munich, and New York, 1982.

Jacob, Max. "Souvenirs sur Picasso," *Cahiers d'Art,* ii, 1927, 199–202.

———. *Chronique des temps héroïques,* Paris, 1956.

Jarry, Alfred. *Oeuvres complètes,* ed. Michel Arrivé. Paris, 1972.

———. *Selected Works of Alfred Jarry,* ed. Roger Shattuck and Simon Taylor. New York, 1965.

Journal officiel de la Chambre des Députés, Dec. 3, 1912, 2918–29 [debate on censorship and Cubism].

Kahnweiler, Daniel-Henry. *Der Weg zum Kubismus.* Munich, 1920 (trans. Henry Aronson, New York, 1949).

———. *Mes galeries et mes peintres.* Paris, 1961 (trans. Helen Weaver, New York, 1971).

Kropotkin, Peter. *La Conquête du pain.* Paris, 1892 (trans. London, 1972).

———. *Fields, Factories and Workshops.* London, 1899.

———. *Memoirs of a Revolutionist.* London, 1902 (repr. New York, 1962).

———. *Mutual Aid: A Factor in Evolution.* London, 1902.

———. *Revolutionary Pamphlets,* ed. Roger Baldwin. New York, 1970.

———. *Selections from His Writings,* ed. Herbert Read. London, 1942.

Lévy, Louis. *Comment ils sont devenus socialistes.* Paris, 1932.

Lozano, Alberto. "Gotas de tinta," *Arte Joven,* Mar. 15, 1901, 3.

Malraux, André. *La Tête d'obsidienne.* Paris, 1974 (trans. June and Jacques Guicharnaud, New York, 1976).

Maragall, Joan. *Obres completes.* Barcelona, 1960–1961.

Martínez Ruiz, J. "La Vida," *Arte Joven,* Apr. 15, 1901, 2–3.

Mauclair, Camille. "La Peinture 'nouvelle' et les Marchands," *La Revue,* xcviii, Oct. 15, 1912, 429–42.

———. "Le Prolétariat des peintres," *La Revue hebdomadaire,* xxii, Jan. 1913, 354–69.

———. *Servitudes et grandeurs littéraires, 1890–1900.* Paris, 1922.

Méric, Victor. *A travers la jungle politique et littéraire.* 2 vols. Paris, 1930.

Nietzsche, Friedrich. *The Will to Power,* trans. W. Kaufman and R. Hollingdale. New York, 1967.

Notre Avenir est dans l'Air. Paris, Feb. 1, 1912 (Imprimerie Charaire, Sceaux).

Olivier, Fernande. *Picasso et ses amis.* Paris, 1933 (trans. Jane Miller, London, 1964).

Ortega y Gasset, José. *La Deshumanización del arte e Ideas sobre la Novela.* Madrid, 1925 (trans. Helene Weyl, Princeton, 1948, repr. 1968).

Ozenfant, Amédée, and Charles-Edouard Jeanneret. *La Peinture moderne.* Paris, 1925.

Parmelin, Hélène. *Picasso dit . . .* Paris, 1966 (trans. Christine Trollope, London, 1969).

Péladan, Sâr. "Le Salon d'Automne," *La Revue hebdomadaire,* xx, Oct. 1911, 405–16.

Pelloutier, Fernand, *L'Art et la Révolt*. Paris, 1897.

Pératé, André. "Le Salon d'Automne," *Le Correspondant*, Oct. 25, 1911, 308–16.

Picasso, Pablo, and Francisco Asis de Soler, "Arte joven." *Arte Joven*, Mar. 15, 1901, 1.

——. *Carnet Catalan*, intro. and notes Douglas Cooper. Paris, 1958.

——. Interview with Pol Gaillard, *L'Humanité*, Oct. 29–30, 1944.

——. "Letter on Art," *Ogoniok* (Moscow), May 1926, trans. in "Letter from Picasso," *Formes*, Feb. 1930, 2–5.

——. Letters to Gertrude and Leo Stein, 1906–1914, The Gertrude Stein Collection in the Collection of American Literature, The Beinecke Rare Book and Manuscript Library, Yale University.

Proudhon, Pierre-Joseph. *Système des contradictions économiques; ou Philosophie de la misère*, 2 vols. Paris, 1846.

——. *Du principe de l'art et de sa destination sociale*. Paris, 1865.

La Publicidad. "La Amnistía se impone" and "Manifiesto de la colonia española," Dec. 29, 1900 [signed by Picasso].

Raynal, Maurice. *Picasso*. Paris, 1922.

——. *Quelques intentions du cubisme*. Paris, 1919.

Reverdy, Pierre. "Sur le cubisme," *Nord-Sud*, 1, Mar. 15, 1917.

——. *Pablo Picasso*. Paris, 1924.

Roches, Fernand. "Le Salon d'Automne de 1912," *L'Art décoratif*, XIV, Nov. 20, 1912, 281–328.

Rusiñol, Santiago. *Jardines Abandonados*. Madrid, n.d. [1900].

Sabartés, Jaime. *Picasso: Documents Iconographiques*. Geneva, 1954.

——. *Picasso. Portraits et souvenirs*. Paris, 1946 (trans. Angel Flores, New York, 1948).

Salmon, André. *L'Air de la Butte*. Paris, 1945.

——. *L'Art vivant*. Paris, 1920.

——. *La jeune peinture française*. Paris, 1912.

——. "Montmartre, 1906–1920," *Vell i Nou* (Barcelona), 1, June 1920, 90–92.

——. *La Négresse du Sacré-Coeur*. Paris, 1920 (trans. Slater Brown, New York, 1929).

——. "Observations déplacées," *Les Soirées de Paris*, 1, Feb. 1912 (repr. Geneva, 1971, 28–30).

——. *Souvenirs sans fin, première époque (1903–1908)*. Paris, 1955.

——. *Souvenirs sans fin, deuxième époque (1908–1920)*. Paris, 1956.

——. *La Terreur noire*. Paris, 1959.

Stein, Gertrude. *The Autobiography of Alice B. Toklas*. New York, 1933.

——. *Everybody's Autobiography*. New York, 1937 (repr. 1973).

——. *Picasso*. Paris, 1938; New York and London, 1939 (repr. Boston, 1959).

"Testimony Against Gertrude Stein," *transition*, 1934–1935, supplement, statements by Georges Braque, Henri Matisse, André Salmon, and Tristan Tzara.

Tharaud, J. "La Guerre des Balkans," *Les Soirées de Paris*, 1, Nov. 1912 (repr. Geneva, 1971, 289–92).

Tudesq, André. "La Guerre des Balkans," *Les Soirées de Paris*, 1, Dec. 1912 (repr. Geneva, 1971, 338–41).

Tzara, Tristan. "Le Papier collé ou le proverbe en peinture," *Cahiers d'Art*, VI, 1931.

Uhde, Wilhelm. *Picasso and the French Tradition*. Paris and New York, 1929.

Unamuno, Miguel de. *Obras completas*. 14 vols. Madrid, 1958.

Vallier, Dora. "La Peinture et nous," *Cahiers d'Art*, XXIX, 1954 [interview with Georges Braque].

Vauxelles, Louis. *Gil Blas*, Dec. 4, 1912, 2.

Verhaeren, Emile, and Dario Regoyos. *España negra*. Barcelona, 1899.

Vlaminck, Maurice. *Tournant dangereux*. Paris, 1929 (trans. M. Ross, intro. D. Sutton, New York, 1961).

Wagner, Richard. *Richard Wagner's Prose Works*. Vol. 1, trans. W. A. Ellis. London, 1892.

De Zayas, Marius. *Pablo Picasso*, ex. cat., 291 Gallery. New York, 1911.

——. "Pablo Picasso," *América, revista mensual illustrada* (New York), VI, May 1911, 363–65.

——. "Picasso Speaks," *The Arts* (New York), May 1923.

Zervos, Christian. "Conversation avec Picasso," *Cahiers d'Art*, X, 1935.

Secondary Sources

Adéma, Marcel. *Apollinaire*, trans. D. Folliot. New York, 1955.

Ageron, Charles-Robert. *L'Anti-colonialisme en France de 1871 à 1914*. Paris, 1973.

Alvarez Junco, José. *La ideología política del anarquismo español (1868–1910)*. Madrid, 1976.

Anthropos (Barcelona), spec. issue, "Centenario P. Picasso (1881–1973)," 6 Nov. 1981.

Appelbaum, Stanley. *French Satirical Drawings from 'L'Assiette au beurre'*. New York, 1978.

Arribas, A. *The Iberians*. New York, 1964.

Aubery, Pierre. "Mécislas Golberg et l'art moderne," *Gazette des Beaux Arts*, LXVI, Dec. 1965, 339–44.

L'Avenç (Barcelona), spec. issue, "Picasso, Barcelona, Catalunya," 1981.

Barr, Alfred. *Cubism and Abstract Art*. New York, 1936.

——. *Picasso: Fifty Years of His Art*. New York, 1946.

——. *Picasso: Forty Years of His Art*. New York, 1939.

Baxandall, Michael. *Patterns of Intention: On the Historical Explanations of Pictures*. London and New Haven, 1985.

Berger, John. *The Moment of Cubism and Other Essays*. New York, 1969.

——. *The Success and Failure of Picasso*. London, 1965.

Betts, Raymond. *Assimilation and Association in French Colonial Theory, 1890–1914*. New York, 1961.

Bloch, G. *Pablo Picasso: Catalogue de l'oeuvre gravé et lithographié, 1904–1969*. 2 vols. Bern, 1968–1971.

Blunt, Anthony, and Phoebe Pool. *Picasso, The Formative Years: A Study of His Sources*. London, 1962.

Boeck, Wilhelm, and Jaime Sabartés. *Picasso*. New York, 1955.

Bookchin, Murray. *The Spanish Anarchists: The Heroic Years 1898–1936*. New York, 1977.

Bozo, Dominique, ed. *Picasso: oeuvres reçues en paiement des droits de succession*, ex. cat., Grand Palais. Paris, 1979.

Brenan, Gerald. *The Spanish Labyrinth*. Cambridge, 1943.

Breunig, Leroy C. *Guillaume Apollinaire*. New York and London, 1969.

Bürger, Peter. *Theorie der Avantgarde*. Frankfurt, 1974, 1980 (trans. M. Shaw, Minneapolis, 1984).

Cabanne, Pierre. *Pablo Picasso: His Life and Times*. New York, 1977.

——. *Le Siècle de Picasso*, 4 vols. Paris, 1975.

Caizergues, Pierre. "Apollinaire journaliste," *Cahiers du Musée Nationale d'Art Moderne*, VI, 1981, 16–39.

——. "Elements de chronologie," *Cahiers du Musée Nationale d'Art Moderne*, VI, 1981, 8–9.

Camón Aznar, José. *Picasso y el cubismo*. Madrid, 1956.

Carlson, Victor. *Picasso: Drawings and Watercolors, 1899–1907, in the Collection of the Baltimore Museum of Art*. Baltimore, 1976.

Carr, Edward Hallett. *Michael Bakunin*. London, 1937.

Carr, Raymond. *Spain 1808–1939*. London, 1966.

Casagemas i el seu temps, ex. cat., Daedalus. Barcelona, n.d. [1979].

Catalunya en la España moderna, 1714–1983, ex. cat., Centro Cultural de la Villa de Madrid. Madrid, 1983.

Caute, David. *Communism and the French Intellectuals*. New York, 1964.

Cervera, Joseph Phillip. *Modernismo: The Catalan Renaissance of the Arts*. New York, 1976.

Chipp, Herschel B. *Theories of Modern Art: A Source Book by Artists and Critics*. Berkeley, Los Angeles, and London, 1968.

Cirici Pellicer, Alexandre. *El arte modernista catalán*. Barcelona, 1951.

——. *Picasso antes de Picasso*. Barcelona, 1946 (trans. Marguerite de Floris and Ventura Gosol, Geneva, 1950).

Cirlot, Juan-Eduardo. *Birth of a Genius*. New York, 1972.

Cobban, Alfred. *A History of Modern France, Vol. 3: 1871–1962*. Baltimore, 1965.

Cooper, Douglas. *The Cubist Epoch*. New York, 1971.

Cowart, Georgia. "Wagner's Theories of Artistic Synthesis." Unpublished essay, 1971.

Crespelle, Jean. *La Vie quotidienne à Montparnasse à la grande époque, 1905–1930*. Paris, 1976.

Daix, Pierre. *Cubists and Cubism*. Geneva, 1982 (trans. R.F.M. Dexter, London, 1983).

——, and Georges Boudaille. *Picasso: The Blue and Rose Periods. A Catalogue Raisonné, 1900–1906*. Greenwich, Connecticut, 1967.

——, and Joan Rosselet. *Picasso: The Cubist Years 1907–1916, A Catalogue Raisonné of the Paintings and Related Works*. Boston, 1979.

——. *La Vie de peintre de Pablo Picasso*. Paris, 1977.

Dardel, Aline. "Catalogue des dessins et publications illustrées du journal anarchiste *Les Temps Nouveaux*, 1895–1914," 2 vols. Ph.D. diss., L'Université de Paris, IV, 1980.

Décaudin, Michel. *Le dossier d' "Alcools": Edition annotée des préoriginales avec une introduction et des documents*. Paris and Geneva, 1965.

Diehl, Gaston. *Van Dongen*. Milan, n.d. [1969].

De Maig i moviment obrer, 1890–1981, ex. cat., Ajuntament de Barcelona. Barcelona, 1981.

Dixmier, Elizabeth and Michel, *L'Assiette au beurre, 1901–1912*. Paris, 1974.

Dixon, Pierson. *The Iberians of Spain*. London, 1940.

Dolléans, Eduard. *Histoire du mouvement ouvrier*. 3 vols. Paris, 1936–1953.

Edgerton, Anne. "Picasso's 'Nude Woman' of 1910," *Burlington Magazine*, CXXII, July 1980, 499–500.

Egbert, Donald Drew. "The Idea of 'Avant-garde' in Art and Politics," *American Historical Review*, LXXIII, Dec. 1967, 339–66.

——. *Social Radicalism and the Arts: Western Europe, A Cultural History from the French Revolution to 1968*. New York, 1970.

1881–1981: Picasso y Barcelona, ex. cat., Ayuntamiento de Barcelona. Barcelona, 1981.

Elderfield, John. *The "Wild Beasts": Fauvism and Its Affinities*, ex. cat., Museum of Modern Art. New York, 1976.

Fontbona, Francesc, and Francesc Miralles, *Història de l'art català, Volum VII: del Modernisme al Noucentisme, 1888–1917*. Barcelona, 1985.

Four Americans in Paris: Collection of the Steins, ex. cat., Museum of Modern Art. New York, 1970.

Fox, Edward Inman. "Two Anarchist Newspapers of 1898," *Bulletin of Hispanic Studies*, 41, 1964, 160–68.

Fry, Edward F. *Cubism*. London and New York, 1966.

Fussell, Paul. *The Great War and Modern Memory*. New York, 1976.

Gamwell, Lynn. *Cubist Criticism*. Ann Arbor, Michigan, 1980.

Gedo, Mary. "Art as Exorcism: Picasso's 'Demoiselles d'Avignon,'" *Arts*, LV, Oct. 1980, 70–82.

——. *Picasso: Art as Autobiography*. Chicago, 1980.

Geiser, Bernhard G. *Picasso: peintre-graveur, catalogue illustré de l'oeuvre gravé et lithographié, 1899–1931*. Bern, 1955.

Glimcher, Arnold and Marc, eds. *Je suis le cahier: The Sketchbooks of Picasso*, ex. cat., Pace Gallery. New York, 1986.

Goldberg, Harvey. *The Life of Jean Jaurès*. Madison, Wisconsin, and London, 1968.

Golding, John. *Cubism: A History and An Analysis, 1907–1914*. London, 1958 (rev. ed. 1968).

——. "Picasso's Cubist Years," *Burlington Magazine*, CXXII, July 1980, 928.

Goldwater, Robert. *Primitivism in Modern Art*. New York, 1967.

Gray, Christopher. *Cubist Aesthetic Theories*. Baltimore, 1953.

Greenberg, Clement. *Art and Culture: Critical Essays*. Boston, 1961.

——. "The Pasted-Paper Revolution," *Art News*, LXVII, 1958.

Guérin, Daniel. *Anarchism. From Theory to Practice*. New York and London, 1970.

Habasque, Guy. *Cubism: A Biographical and*

Critical Study, trans. Stuart Gilbert. New York, 1959.

Harrold, Charles Frederick, and W. Templeman, eds. *English Prose of the Victorian Era*. New York, 1938.

Henderson, Linda Dalrymple. *The Fourth Dimension and Non-Euclidean Geometry in Modern Art*. Princeton, 1983.

——. "A New Facet of Cubism: 'The Fourth Dimension' and 'Non-Euclidean Geometry' Reinterpreted," *Art Quarterly*, XXXIV, Winter 1971, 410–33.

Herbert, Eugenia W. *The Artist and Social Reform: France and Belgium, 1885–1898*. New Haven, 1961.

Herbert, Robert and Eugenia. "Artists and Anarchism: Unpublished Letters of Pissarro, Signac, and Others," *Burlington Magazine*, CII, Nov. 1960, 473–82, and Dec. 1960, 517–22.

Hobsbawm, Eric. *Primitive Rebels: Studies in Archaic Forms of Social Movement in the Nineteenth and Twentieth Centuries*. New York, 1959.

Hope, Henry. *Georges Braque*, ex. cat., Museum of Modern Art. New York, 1949.

Hughes, H. Stuart. *Consciousness and Society: The Reorientation of European Social Thought, 1890–1930*. New York, 1958.

Ilie, Paul. "Nietzsche in Spain: 1890–1910," *Publications of the Modern Language Association*, LXXIX, Mar. 1964, 80–96.

Janis, Harriet and Sidney. *Picasso: The Recent Years, 1939–1946*. Garden City, New York, 1946.

Jardí, Enric. *J. Mir.* Barcelona, 1975.

——. *Nonell*. New York, 1969.

Jardot, Maurice. *Picasso: Peintures, 1900–1955*. Paris, 1955.

Johnson, Ronald. "The 'Demoiselles d'Avignon' and Dionysian Destruction," *Arts*, LV, Oct. 1980, 94–101.

——. "Picasso's 'Demoiselles d'Avignon' and the Theater of the Absurd," *Arts*, LV, Oct. 1980, 102–13.

——. "Picasso's Parisian Family and the 'Saltimbanques,'" *Arts*, LI, Jan. 1977, 90–95.

Joll, James. *The Anarchists*. New York, 1966.

Kahnweiler, Daniel-Henry. "Negro Art and Cubism," *Horizon*, XVIII, Dec. 1948, 412–20.

Kaplan, Temma. *Anarchists of Andalusia, 1868–1903*. Princeton, 1977.

Kedward, Roderick. *The Anarchists*. London, 1971.

Kerrigan, Anthony. "The World of Pio Baroja," intro. to *The Restlessness of Shanti Andia and Other Writings of Pio Baroja*, trans. Anthony Kerrigan. Ann Arbor, Michigan, 1959.

Kibbey, Ray Anne. *Picasso: A Comprehensive Bibliography*. New York, 1977.

Krauss, Rosalind. "In the Name of Picasso," *October*, Spring 1981, repr. in *The Origin of the Avant-Garde and Other Modernist Myths*, Cambridge, Massachusetts, and London, 1985, 23–40.

——. "Re-Presenting Picasso," *Art in America*, LXVIII, Dec. 1980, 91–96.

Kuspit, Donald. "Authoritarian Esthetics and the Elusive Alternative," lecture delivered at Rutgers University, Oct. 28, 1981.

LaBelle, Mark. *Alfred Jarry: Nihilism and the Theater of the Absurd*. New York and London, 1980.

Laude, Jean. *La Peinture française (1905–1914) et "l'art nègre"*. Paris, 1968.

Lehmann, A. G. *The Symbolist Aesthetic in France: 1885–1895*. Oxford, 1950.

Leighten, Patricia. "The Dreams and Lies of Picasso," *Arts*, LXII, Oct. 1987, 50–55.

——. "Picasso: Anarchism and Art, 1897–1914." Ph.D. diss., Rutgers University, 1983.

——. "Picasso's Collages and the Threat of War, 1912–1913," *Art Bulletin*, LXVII, Dec. 1985, 653–72.

——. "*La Propagande par le rire*: Satire and Subversion in Apollinaire, Jarry, and Picasso's Collages," *Gazette des Beaux-Arts*, LXXXVIII, Oct. 1988, 163–72.

LeMaitre, Georges. *From Cubism to Surrealism in French Literature*. New York, 1941.

Leymarie, Jean. *Picasso: The Artist of this Century*. New York, 1972.

Liddell Hart, B. H. *A History of the World War 1914–1918*. London, 1934.

Lipton, Eunice. *Picasso Criticism, 1901–1939:*

The Making of an Artist-Hero. New York, 1976.

Litvak, Lily. *A Dream of Arcadia: Anti-industrialism in Spanish Literature, 1895–1905.* Austin, 1975.

——. *Musa libertaria: arte, literatura y vida cultural del anarquismo español, 1880–1913.* Barcelona, 1981.

Lough, J. and M. *An Introduction to Nineteenth-Century France.* London, 1978.

Maitron, Jean. *Histoire du mouvement anarchiste en France (1880–1914).* Paris, 1951.

Martin, Alvin. "Georges Braque and the Origins of the Language of Synthetic Cubism," in I. Monod-Fontaine and E. A. Carmean, Jr., *Braque: The Papiers Collés,* ex. cat., National Gallery of Art. Washington, D. C., 1982, 61–75.

Martin, Marianne. *Futurist Art and Theory.* Oxford, 1968 (rev. ed. 1978).

McCully, Marilyn. *Els Quatre Gats: Art in Barcelona Around 1900.* Princeton, 1978.

——. "Magic and Illusion in the Saltimbanques of Picasso and Apollinaire," *Art History,* III, Dec. 1980, 425–34.

——, ed. *A Picasso Anthology: Documents, Criticism, Reminiscences.* Princeton, 1982.

Mintz, Jerome. *The Anarchists of Casas Viejas.* Chicago, 1982.

Monod-Fontaine, Isabelle, and E. A. Carmean, Jr. *Braque: The Papiers Collés,* ex. cat., National Gallery of Art. Washington, D.C., 1982.

Muller, Joseph-Emile. *Fauvism.* New York, 1967.

Museu Picasso. *Museu Picasso: Catàleg de pintura i dibuix.* Barcelona, 1984.

Nash, J. M. "The Nature of Cubism, A Study of Conflicting Explanations," *Art History,* III, Dec. 1980, 435–57.

1913, ex. cat., Bibliothèque Nationale. Paris, 1983.

Nochlin, Linda. "Picasso's Color: Schemes and Gambits," *Art in America,* LXVIII, Dec. 1980, 105–23 and 177–83.

O'Brian, Patrick. *Pablo Ruiz Picasso.* New York, 1976.

Palau i Fabre, Josep. *Picasso en Cataluña.* Barcelona, 1966.

——. *Picasso i els seus amics catalans.* Barcelona, 1971.

——. *Picasso: Life and Work of the Early Years, 1881–1907.* Oxford, 1981.

Paudrat, Jean-Louis. "The Arrival of Tribal Objects in the West from Africa," *"Primitivism" in 20th Century Art,* ex. cat., Museum of Modern Art, ed. William Rubin. New York, 1984.

Peers, Edgar A. *Catalonia Infelix.* Westport, Connecticut, 1970.

Penrose, Roland. *Picasso: His Life and Work.* London, 1958 (rev. ed. New York, 1973).

Perloff, Marjorie. *The Futurist Moment: Avant-Garde, Avant Guerre, and the Language of Rupture.* Chicago and London, 1986.

Picasso, 1881–1973: Exposicio antologica, ex. cat., Ayuntamiento de Barcelona. Madrid and Barcelona, 1981.

"Picasso et la politique," *Le Crapouillot,* May–June 1973.

Picasso: 67 acuarelas, dibujos, gouaches de 1897 a 1971, ex. cat., Sala Gaspar. Barcelona, 1974.

Poggioli, Renato. *The Theory of the Avant-Garde,* trans. G. Fitzgerald. Cambridge, Massachusetts, 1968.

Ràfols, J. F. *Modernisme i modernistes.* Barcelona, 1949 (repr. 1982).

Raphael, Max. *Proudhon, Marx, Picasso: trois études sur la sociologie de l'art.* Paris, 1933.

Raynal, Maurice. *Modern French Painters.* New York, 1928.

——. *Picasso: Biographical and Critical Studies.* Geneva, 1953.

Read, Jan. *The Catalans.* London, 1978.

Reff, Theodore. "Themes of Love and Death in Picasso's Early Work," *Picasso in Retrospect,* eds. Roland Penrose and John Golding. New York, 1973, 5–30.

Reszler, André. *L'Esthétique anarchiste.* Paris, 1973.

Reventós i Conti, Jacint. *Picasso i Els Reventós.* Barcelona, 1973.

Rodriguez-Aguilera, Cesareo. *Picassos in Barcelona.* Barcelona, n.d.

Rojas, Carlos. *La Barcelona de Picasso.* Barcelona, 1981.

Rosenblum, Robert. *Cubism and Twentieth-Century Art*. New York, 1960.

———. "*The Demoiselles d'Avignon* Revisited," *Art News*, LXXII, Apr. 1973, 45–48.

———. "Picasso and the Coronation of Alexander III: A note on the dating of some Papiers collés," *Burlington Magazine*, CXIII, Oct. 1971, 604–6.

———. "Picasso and the Typography of Cubism," *Picasso in Retrospect*, eds. Roland Penrose and John Golding. New York, 1973, 33–47.

Rosenthal, Mark. *Juan Gris*, ex. cat., University Art Museum, University of California, Berkeley. New York and Berkeley, 1983.

Roskill, Mark. *The Interpretation of Cubism*. Philadelphia, London, and Toronto, 1985.

Rubin, William. "Cézannisme and the Beginnings of Cubism," *Cézanne—The Late Work*, ex. cat., Museum of Modern Art, ed. Rubin. New York, 1977.

———, ed. *Pablo Picasso: A Retrospective*, ex. cat., Museum of Modern Art. New York, 1980.

———. "From Narrative to 'Iconic' in Picasso: The Buried Allegory in *Bread and Fruitdish on a Table* and the Role of *Les Demoiselles d'Avignon*," *Art Bulletin*, LXV, Dec. 1983, 615–49.

———. "Picasso," *"Primitivism" in 20th Century Art*, ex. cat., Museum of Modern Art, ed. Rubin. New York, 1984.

———. *Picasso in the Collection of the Museum of Modern Art*. New York, 1972.

———, ed. *"Primitivism" in 20th Century Art*, ex. cat. Museum of Modern Art. New York, 1984.

Russell, John. *Georges Braque*. London, 1959.

Salas, Xavier de. "Some Notes on a Letter of Picasso," *Burlington Magazine*, CII, Nov. 1960, 482–84.

Schapiro, Meyer. "Nature of Abstract Art," *Marxist Quarterly*, I, Jan. 1937, 77–98.

Seigel, Jerrold. *Bohemian Paris: Culture, Politics, and the Boundaries of Bourgeois Life, 1830–1930*. New York, 1986.

Shapiro, Theda. *Painters and Politics: The European Avant-Garde and Society, 1900–1925*. New York, Oxford, and Amsterdam, 1976.

Shattuck, Roger. "Apollinaire's Great Wheel," *The Innocent Eye: On Modern Literature and the Arts*. New York, 1984, 240–262.

———. *The Banquet Years: The Origins of the Avant-Garde in France, 1885 to World War I*. New York, 1955 (rev. ed. 1968).

Un Siglo de Arte Español (1856–1956), ex. cat., Dirección de Bellas Artes. Madrid, 1955.

Silver, Kenneth E. "Esprit de Corps: The Great War and French Art, 1914–1925." Ph.D. diss., Yale University, 1981.

———. "Purism: Straightening up after the Great War," *Artforum*, XV, Mar. 1977, 56–63.

Soby, James Thrall. *Juan Gris*, ex. cat., Museum of Modern Art. New York, 1958.

Spector, Jack J. "Towards the Avant-Garde: Disjunction in Symbolist Painting, with Comments on Bürger and Benjamin," *Avant-garde Art and Literature*, proceedings of the International Conference, Hofstra University, New York, Nov. 14–16, 1985.

Spies, Werner. *Picasso Sculpture* (catalogue raisonné). New York and London, 1972.

Steegmuller, Francis. *Apollinaire: Poet Among the Painters*. New York, 1963.

Steinberg, Leo. "The Philosophical Brothel," *Art News*, LXXI, Part 1, Sept. 1972, 20–29, and Part 2, Oct. 1972, 38–47.

Sweeney, James Johnson. "Picasso and Iberian Sculpture," *Art Bulletin*, XXIII, Sept. 1941, 191–98.

Taylor, Joshua. *Futurism*, ex. cat., Museum of Modern Art. New York, 1961.

Teuber, Marianne. "Formvorstellung und Kubismus oder Pablo Picasso und William James," *Kubismus*, ed. S. Gohr. Köln, 1982.

Thomas, Hugh. *The Spanish Civil War*. New York, 1961.

Trend, John B. *The Civilization of Spain*. London, 1944.

———. *A Picture of Modern Spain: Men and Music*. Boston and New York, 1921.

Tuchman, Barbara. *The Proud Tower: A Portrait of the World Before the War, 1890–1914*. New York, 1966.

Tucker, Paul. "Picasso, Photography and the

Development of Cubism," *Art Bulletin*, LXV, June 1982, 288–99.

Ullman, Joan Connelly. *The Tragic Week: A Study of Anticlericalism in Spain, 1875–1912*. Cambridge, Massachusetts, 1968.

Vicens Vives, Jaime. *An Economic History of Spain*. Princeton, 1969.

Warnod, Jeanine. *Washboat Days*. New York, 1972.

Weber, Eugen. *France, Fin de Siècle*. Cambridge, Massachusetts, and London, 1986.

Woodcock, George. *Anarchism: A History of Libertarian Ideas and Movements*. New York, 1962.

——, ed. *The Anarchist Reader*. Glasgow, 1977.

Zervos, Christian. *Pablo Picasso. Oeuvres*. Vols I–XXXI. Paris, 1932–1978.

Index